D1195951

COLOR RUSH

American Color Photography from Stieglitz to Sherman

Edward Steichen experiments with the dye imbibition process in 1939–40 (see pages 44, 48–49)

COLOR RUSH

American Color Photography from Stieglitz to Sherman

KATHERINE A. BUSSARD & LISA HOSTETLER

with contributions by
Alissa Schapiro, Grace Deveney, & Michal Raz-Russo

MILWAUKEE ART MUSEUM *aperture*

TABLE OF CONTENTS

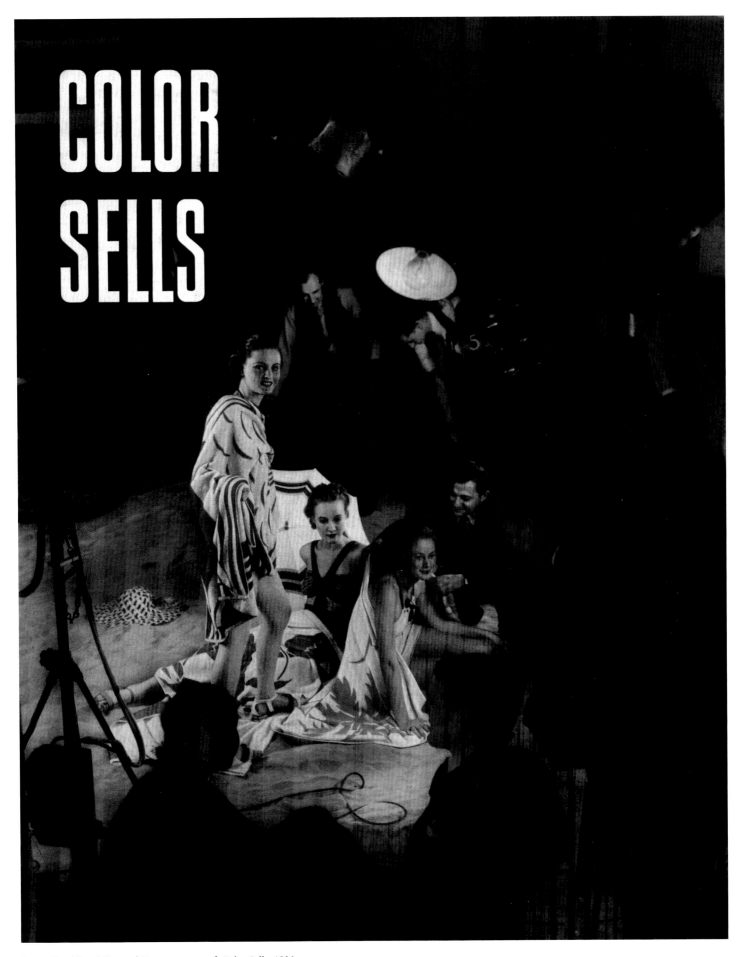

Anton Bruehl and Fernand Bourges, cover of *Color Sells*, 1935

FOREWORD

by **Daniel T. Keegan** DIRECTOR, MILWAUKEE ART MUSEUM

Today color photography is so ubiquitous that it is hard to believe there was a time when this was not the case. *Color Rush: American Color Photography from Stieglitz to Sherman* explores the historical developments that led to its prominence. In the process, *Color Rush* emphasizes the many ways color photographs circulated and appeared at the time of their making. From magazine pages to gallery walls, advertisements to photojournalism, this project charts the interconnected history of color photography in the United States from 1907 to 1981. During these years, color photography captured the popular imagination through its visibility in magazines such as *Life* and *Vogue*, as well as through its accessibility on the marketplace thanks to companies such as Kodak. Color photography also drew a number of artists, who incorporated the medium into their creative practice while experimenting with the new possibilities it offered. *Color Rush* acknowledges all of these developments, noting their interrelationships as well as their divergences.

The Milwaukee Art Museum demonstrated an early interest in color photography when, in 1979, curator Verna Posever Curtis organized *Color: A Spectrum of Recent Photography*. Featuring photographs by William Christenberry, William Eggleston, Joel Meyerowitz, John Pfahl, Stephen Shore, and Neal Slavin, among others, the exhibition looked at the emergence of color photography in the art world. *Color Rush* updates this treatment substantially, expanding its purview to include historical precedents and enlarging its field of vision to address color photography's use in popular and commercial contexts, as well as in artistic ones. The museum is especially grateful to the efforts of cocurators Katherine A. Bussard of the Art Institute of Chicago and Lisa Hostetler of the Smithsonian American Art Museum (formerly curator of photographs at the Milwaukee Art Museum) for bringing their knowledge to bear on this fascinating chapter in the history of photography.

We are especially proud of the groundbreaking aspects of this project, which include the first extended chronology of significant moments in American color photography and a checklist that takes into consideration the commingling of artistic and commercial practices. We are also pleased to bring together artists who have rarely been seen in the same context: Ansel Adams and William Eggleston, Eliot Porter and Cindy Sherman, Edward Steichen and Stephen Shore. In doing so, *Color Rush* traces a new history for color photography, one that more fully accounts for color's pervasive presence today.

Major funding for *Color Rush* has been provided by the Herzfeld Foundation, which has been a steadfast supporter of photography at the museum for over twenty years. We are sincerely grateful for their ongoing commitment to our photography exhibitions, acquisitions, and programs. Additional support has been provided by Christine A. Symchych and James P. McNulty, the David C. and Sarajean Ruttenberg Arts Foundation, the Robert Mapplethorpe Foundation, Kenneth and Christine Tanaka, and the Milwaukee Art Museum's Photography Council. Thanks to the generosity of these donors, we are able to present the story of color photography in America as it has never been told before.

PREFACE
by Katherine A. Bussard & Lisa Hostetler

On June 22, 2009, Kodak announced it would no longer manufacture Kodachrome, the oldest surviving and arguably most famous brand of color film. The company's remaining color slide films were discontinued in 2012, and supplies for traditional color printing—negative film, chemistry, and color paper—become more rare and elusive with each passing month. The presentation of *Color Rush: American Color Photography from Stieglitz to Sherman* at the precise moment when so many modes of color photography are being rendered obsolete is fitting. What better moment to recall—and perhaps even reconstruct—the once truly exceptional appearance of color photography?

Color Rush begins in 1907 with the public introduction of the autochrome, the first commercially available color photographic process, and it ends in 1981, by which time color photography had been absorbed into mainstream culture and contemporary artistic practices, as signaled by Sally Eauclaire's landmark exhibition and catalog, *The New Color Photography*.[1] Throughout the course of this history, color photography played many roles: it was an artist's medium; a commercial publisher's enticement to consumption; an amateur photographer's pursuit; and the public's choice for recording moments in time. These many roles, along with other applications, are necessary to construct a full history of color photography's place in twentieth-century American culture. *Color Rush* demonstrates this diversity.

In the process of exploring its subject, this project focuses on the circulation and appearance of color photographs at the time of their making, rather than on the various technological advances that underlay them. This latter story has been told before, but the former has been addressed only summarily and often in accounts devoted exclusively to the 1970s.[2] While there is no doubt that the art world of the 1970s stood up and took notice of color photography, artists had been seriously exploring it for decades. As the American public made personal snapshots on 35 mm color slides, László Moholy-Nagy and Saul Leiter, among others, were using the same materials for their art. Both practices are important for understanding color photography's eventual trajectory, as is the constant translation of color photographs onto the printed page. During a large part of the history that *Color Rush* examines, the line between art and commercial photography remained thin. While color photography was conquering magazines in the 1930s, photographers such as Anton Bruehl and Nickolas Muray made work that straddles this line. The present exhibition and book recognize this by including the magazines in which the work appeared.

In such cases, the focus is on the visibility of the work and its context. In general, *Color Rush* attempts to account for color photography between 1907 and 1981 by noting what could have been seen during that time. In a few select instances, we have been able to secure the same images that appeared in important exhibitions, such as Beaumont Newhall's *Photography, 1839–1937* at the Museum of Modern Art, New York, in 1937. While such an approach admittedly excludes some color photographs, it reasserts others, such as those by Syl Labrot and Pete Turner, whose work has faded to the edge of art-historical awareness despite being well known in its day.

1.
Sally Eauclaire, *The New Color Photography* (New York: Abbeville Press, 1981).

2.
For a recent history of color photography focusing on its processes, see Pamela Roberts, *A Century of Colour Photography from the Autochrome to the Digital Age* (London: Andre Deutsch, 2007). For consideration of the 1970s, see Eauclaire, *New Color Photography*, and Kevin Moore, *Starburst: Color Photography in America 1970–1980* (Ostfildern, Germany: Hatje Cantz; Cincinnati: Cincinnati Art Museum, 2010).

Because the history of color photography comprises myriad formats and multiple practitioners, *Color Rush* is necessarily a series of excerpts from a larger narrative. Each of the sixty photographers it presents contributed in important ways to the development of color photography in America. For some, such as Eliot Porter and Joel Meyerowitz, color photography remained a central, if not dominant, concern throughout their careers. For others, including Walker Evans and Bruce Nauman, color has been a less obvious concern but makes an appearance in revelatory works. The variety of artists gathered in *Color Rush* serves as a reminder that there was no self-conscious group effort on the part of these artists to create a movement; they each became interested in color photography for their own reasons and on their own terms. Nevertheless, taken together, they reveal color photography moving steadily to the fore of American culture. It had conquered popular culture by the middle of the twentieth century and the art world by the early 1980s.

Katherine A. Bussard's essay, "Full Spectrum: Expanding the History of American Color Photography," restores some of the nuance, complexity, and fluidity that characterized conversations around color photography. The details of this journey involve its appearance in magazine pages and on museum walls, at the New York World's Fair, and in New York's Grand Central Station. In these overlapping contexts, Bussard allows for a new understanding of color photography as an art form. In addition, her essay respects the enormous impact the medium had on American culture both inside and outside the art world.

Color photography's emergence brought with it conversations about the nature of representation in photography, namely the relationship between color and realism. Lisa Hostetler's essay, "Real Color," explores this issue. As Hostetler follows debates about the relative artificiality or literalism of color photography, the significance of photography's fraught relationship with art becomes apparent.

These essays are followed by detailed entries on the artists in the exhibition, as well as on those entities that so dramatically impacted color's visibility, including *National Geographic* and Kodak. Written by Bussard, Grace Deveney, Hostetler, Michal Raz-Russo, and Alissa Schapiro, these entries describe individual attitudes toward color photography in specific instances and the impact the work had in its day. Collectively, the entries lend cadence and nuance to the larger overview that the essays provide.

Finally, a chronology by Schapiro considers the years 1907 to 1981 by weaving together key technological developments with landmark exhibitions and publications. It reveals intriguing simultaneities and notes numerous "firsts" in order to complete the picture of color photography in America during these years. While it is not meant to be entirely comprehensive, it is an ambitious attempt to collate important moments and major milestones, providing a broad perspective on significant events.

Together, the multiple elements of this catalog complement one another and, at times, reveal differences of opinion that reflect diverse modes of thinking. Now that color photography—often digital in origin and displayed on a screen—saturates our world, the insights *Color Rush* provides are especially relevant. The history of photography is so complex that it is often impossible to isolate a moment of origin or articulate a definitive meaning. As a result, this history must be considered in a way that suggests its subtleties and overlapping contours. This project therefore looks at color photography in America very broadly. In addressing itself to a diverse array of imagery, it allows for a deeper understanding of color photography's effects on American culture and demonstrates how it has shaped our knowledge of much of the twentieth century. *Color Rush* makes clear that while we may be at the end of an era with many color processes, the analysis of their historical impact has just begun.

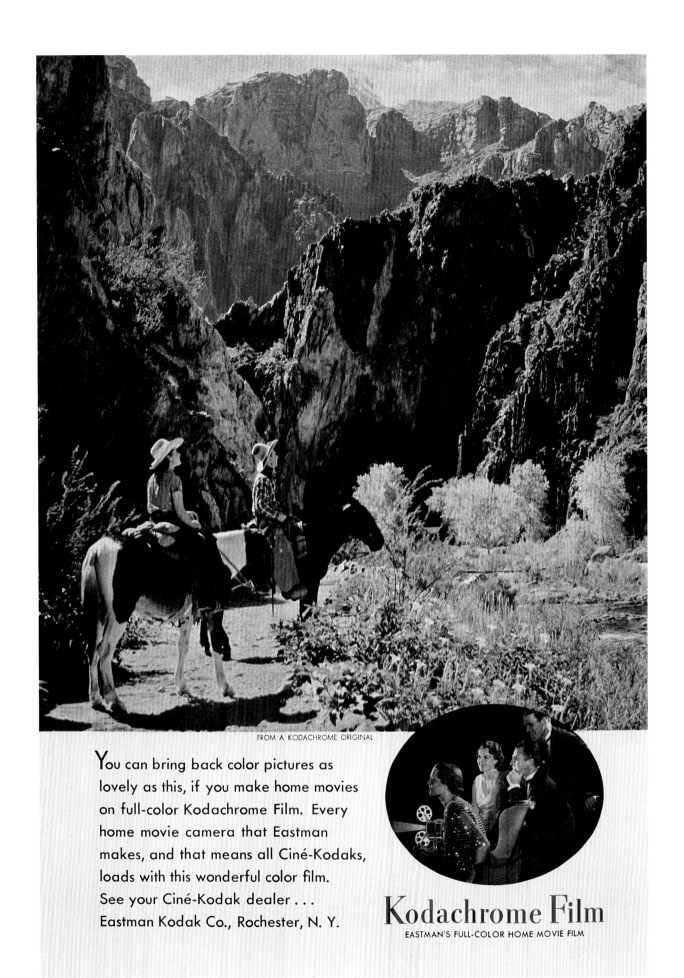

FROM A KODACHROME ORIGINAL

You can bring back color pictures as lovely as this, if you make home movies on full-color Kodachrome Film. Every home movie camera that Eastman makes, and that means all Ciné-Kodaks, loads with this wonderful color film. See your Ciné-Kodak dealer ... Eastman Kodak Co., Rochester, N. Y.

Kodachrome Film
EASTMAN'S FULL-COLOR HOME MOVIE FILM

Kodachrome film advertisement, 1940

FULL SPECTRUM:
Expanding the History of American Color Photography
by Katherine A. Bussard

In 1977 *New York Times* photography critic Gene Thornton began one of his columns with the declaration: "Color photography is clearly here to stay, in museums, in galleries, as well as in magazines and books." Thornton went on to contemplate the exact nature of color photography as a medium for high and low art forms. In his analysis, he labeled the previous decades of work "old color photography," which

> celebrated the Wonders of the Wilderness Unspoiled by Man. It is what used to appear in the pages of *Life* and still does appear in Sierra Club publications. It is Ansel Adams in color. The old color photography was big on spectacular effects of sunlight, clouds and reflections in water. It had to be to get a little variety into the pictures, because most of the Wonders of the Unspoiled Wilderness had been painted and photographed almost to death long before the advent of Kodachrome. . . . The old color photography is still alive today and can be seen . . . in the gargantuan Kodak advertisements in Grand Central Station. . . . The new color photography, on the other hand . . . is what is shown at the Museum of Modern Art, and the smartest East Side and SoHo galleries. It is picture postcards and snapshots and various kinds of commercial photography seasoned with Walker Evans and Atget and turned into Art.[1]

Although Thornton too narrowly assigned the subject matter of "old color photography," he successfully encapsulated for both old and new versions a complicated confluence of practices: those framed for the walls of art institutions and those reproduced on the printed page; those serving artistic ambition and those in the service of corporations; those defined in relation to painting and those awash in photographic history; those aspiring to so-called high culture and those accepting of their relegation to the low. The great range

1.
Gene Thornton, "Photography View: The Wonders of Urban Sprawl," *New York Times*, November 20, 1977, p. 29.

and relations suggested by Thornton are all the more remarkable when situated within the historical conversations about American color photography, which for decades have been too often marked by an almost insistent absence of the nuance, complexity, and hybridity that have been accorded to so many other chapters of photo-history. For this reason, as much as for the fact that today it has become hard to imagine a time when color photography was new—let alone an issue of debate or controversy—this essay and indeed this entire catalog set out to rectify the problematic if prevailing notion that color photography prior to the 1970s was either amateur or commercial and recognized only as such.[2]

In fact, color photography prior to the 1970s was rarely, if ever, exclusively "high" or "low." The flexibility of the medium is demonstrated in its wide range of applications, from the 1907 debut of the first mass-marketed color photographic process through the consistent mid-century displays of color photographs at the Museum of Modern Art, New York, which included advertisements, journalism, and fashion and fine-art abstractions. Even after color photography arrived on the art market in the 1970s, it enjoyed a fluidity of boundaries between high and low art forms (as Thornton made clear), which occurred at precisely the same moment that photography in general was being celebrated for a similar permeability. A contextualized history of color photography would therefore demonstrate that conversations surrounding American color photography were never simple, never definitive. This exhibition offers such a historically informed version of the complicated and overlapping nature of color photography over seventy-five formative years.

The ability to capture a scene in color had been desired since the earliest recorded photographs.[3] Experiments in applying color to black-and-white images as well as processes for obtaining more automatically the semblance of color abounded in the second half of the nineteenth century. Applying color by hand was laborious and required an enormous amount of skill; even so, many of the resulting images seem only tinted with color. Early chemically based processes for achieving native color in photographs were incredibly costly, highly specialized, and unavailable to the public. This all changed on June 10, 1907, when a Parisian audience including Edward Steichen witnessed the unveiling of the Lumière brothers' patented autochrome, the first color process to be widely commercially available and manageable for nonspecialists.[4] The autochrome—a glass plate treated to be receptive to color without the need for a special camera—made it possible to photograph automatically in color and then develop one's own transparencies. Although autochromes could be viewed only as projections or more intimately in a diascope (a backlighting device), enthusiasm and hope for the process was immediate. Writing in October 1907, the very month the autochrome became available on the American market, photographer, gallery owner, and publisher Alfred Stieglitz began his essay in the photography journal *Camera Work*: "Color photography is an accomplished fact. The seemingly everlasting question whether color would ever be within the reach of the photographer has been definitively answered."[5] The cost and fragility of autochromes made both their exhibition and reproduction difficult. Nevertheless, Stieglitz debuted his own autochromes as well as those by Steichen at 291 Gallery in September 1907, exhibited further autochromes by Steichen over the next seven months, and eventually published three of them in the April 1908 issue of *Camera Work*.

Stieglitz's exhibition and publication of Steichen's autochromes is instructive, as it establishes early support by artists for color photography and overturns the longstanding perception that early color photography was exclusively tethered to mass media and consumer culture. Thus, the relatively high-culture journal *Camera Work* reproduced color photographs years before the more popular "low culture" periodical *National*

2.
Sally Eauclaire claimed this in her 1981 introduction to *The New Color Photography*, but it was more recently reinforced in Kevin Moore's catalog for the 2010 exhibition *Starburst*. Sally Eauclaire, *The New Color Photography* (New York: Abbeville Press, 1981), p. 7, and Kevin Moore, "Starburst: Color Photography in America 1970–1980," in *Starburst: Color Photography in America 1970–1980* (Ostfildern, Germany: Hatje Cantz; Cincinnati: Cincinnati Art Museum, 2010), pp. 8, 14.

3.
See Beaumont Newhall, *Photography 1839–1937* (New York: Museum of Modern Art, 1937), p. 81.

4.
Earlier experiments had involved special cameras and complicated color separations so laborious that a 1932 article celebrated the diminishment from three-color negatives and printing plates to two. See "Color Photographs Easily Made by New Process," *Science News Letter*, July 9, 1932, p. 17.

5.
Alfred Stieglitz, "The New Color Photography—A Bit of History," *Camera Work* (October 1907), repr. in *Camera Work: The Complete Illustrations, 1903–1917*, ed. Simone Philippi (New York: Taschen, 1997), p. 376.

Geographic, which published an autochrome in 1914 and one of the earliest examples of a color photo-essay in 1916: Franklin Price Knott's series of thematically related autochromes in the article "The Land of the Best: A Tribute to the Scenic Grandeur and Unsurpassed Natural Resources of Our Own Country" (pages 42–43). Knott's autochromes present an array of landscapes and portraits that celebrate color photography as much as national pride in a widely read periodical that would continue to champion color photography in the decades to come. These two distinct acceptances of the earliest automatic color process indicate a range of purpose and circulation that color photography enjoyed from the start.

For all its promise, the autochrome faded from popularity by the late 1920s, replaced by ever more refined technological developments that would allow the myriad uses of color photography to be revealed, explored, and maximized in the 1930s. By that time, it had become difficult to imagine a magazine without color plates. This was due in large part to the groundbreaking efforts of the publishing firm Condé Nast, which employed photographers Anton Bruehl and Fernand Bourges, as well as a group of engravers and printers. Together, this team arrived at a lush and meticulous means of reproducing color photography in magazines, putting an end to unnatural colors, hard outlines, and unexciting effects.[6] Condé Nast immediately discerned the impact as well as the possibilities of their method. With nearly two hundred editorial and five hundred advertising color photographs created by 1934, Condé Nast reproduced the best images in *Color Sells*, its oversize seventy-two-page promotional catalog (page vi).[7] Headlines proclaim, "Color Portrays Jewels to Justify Cost," "Color Opens the Pocketbook," "Color Captures the Hostess," and "Color Sets a Modern Palette," while the text encourages manufacturing and advertising companies to feature products via the precise mode of color photography reproduction offered by Condé Nast. Only in this way could the textures of luxurious fabrics be "real enough to covet, and buy."[8] Another statement beneath one display of gift items reads: "The Christmas shopper, the advertising man and the technical expert view this stunning photographic triumph from three different angles. To the woman, . . . each object looks real enough to lift from the page to its place in the home. The advertising man sees it as sales-promotion to satisfy his client's most burning desire for detailed presentation. . . . The expert senses the balanced arrangement and the skillful lighting; he knows that only a master-engraver could have turned out such faultless plates."[9] The insistent salesmanship pivoted on the skill required to achieve the desired appearance on the magazine page. The craft of a Bruehl-Bourges photograph, the intensity of its colors, is also precisely what prompted curator Beaumont Newhall to include two of them in MoMA's seminal 1937 exhibition *Photography 1839–1937*, the first survey of the history of photography.

At the same time that *Color Sells* lured companies to consider the lucrative possibilities of color photographs of products, developments in color film accelerated. In 1935 Kodak debuted its first commercially successful amateur color film, Kodachrome. The initial Kodachrome was 16 mm movie film (8 mm film and 35 mm color slides followed in 1936[10]), and although it required long exposures, it was otherwise easy to use and broadly distributed. The research director for Kodachrome declared:

> When you see the Kodachrome film on the screen you will realize how wonderfully colored the world is. An artist, of course, knows this, but most of us are not artists and we don't realize the subtle colors that occur in everyday scenes—flowers and foliage, and summer landscapes, where bright colors strike the eye. But the new Kodachrome process has been brought to perfection during the

6.
Condé Nast claimed both to have launched "the new art of color photography" on the pages of its magazines and to have contributed the most important development in publishing and printing. See "The Launching of a New Art," in *Color Sells*, ed. Anton Bruehl and Fernand Bourges (New York: Condé Nast Publications, 1935), n.p.

7.
Ibid.

8.
Ibid.

9.
Ibid. Elsewhere, the author pointed out that "a poor color reproduction—due either to uninteresting composition, ineffective lighting, or second-rate engraving—repels the reader and injures the advertiser's prestige." See "Color Photography Sells Goods," in *Color Sells*, n.p.

10.
Ansco would not release its 8 mm color home movie film until 1951, its creation prompted by a scarcity of Kodachrome supplies immediately after the war. See Jacob Deschin, "Color Film for Movies," *New York Times*, May 27, 1951, p. 83.

winter, and it has taught us to look for the purple-brown of the winter woodland, and the blue of the ice and the shadows in the snow, so that I realized as everyone will soon realize, that it is only in color that we can make any adequate representation of the world about us.[11]

This official commentary squares perfectly with the threefold message about color photography's possibilities that Kodak continued to present to its prospective customers: fleeting personal moments, artistic aspirations, and naturalistic colors combined to inform nearly every Kodachrome and Ciné-Kodak ad from the late 1930s on. While capturing the passage of time—whether favorite moments from a vacation or seasonal outings—had long been marketing hooks for the company, Kodak underscored the artistic possibilities and lifelike quality of documenting these scenarios in color. One such advertisement from 1936 features a large black-and-white image of a dramatic sunset (left). Under the tagline "add color with Kodachrome," the text addresses the magazine reader directly: "You have yet to realize one of the keenest thrills of picture making if you have not made and seen your first sunset in Kodachrome. For here, indeed, is a subject that loses none of its grandeur when reproduced on a colored rectangle against the darkened background of your living-room." These and other Kodachrome enticements appeared frequently on the pages of *Fortune*, *National Geographic*, and *New Yorker* magazines throughout the late 1930s (page 89). A truly grandiose celebration of Kodachrome's revolutionizing of domestic photography, meanwhile, appeared inside the Eastman Kodak building at the 1939 New York World's Fair. The Great Hall of Color featured a continuous show of 35 mm slides projected by eleven different machines across a nearly two-hundred-foot-long screen. The "kaleidoscopic procession" included Kodachrome images of leisure, travel, animals, and still-lifes, and it was accompanied by a sound recording of commentary and music.[12] This enormous public display foreshadowed not only future Kodak efforts but also artists' slide shows of the 1970s.

In addition to its fervent and immediate embrace by hobbyist and amateur photographers, Kodachrome also appealed to professionals in their artistic, commercial, and journalistic practices. In 1937 color photographs made their mark in museums and newspapers alike. They appeared on the walls of the Art Institute of Chicago and in Newhall's *Photography 1839–1937* at MoMA. In the section devoted to color photography, Newhall not only included historic autochromes by Steichen but also featured very contemporary color images by such disparate creators as Bauhaus luminary László Moholy-Nagy, who had little interest in color's documentary veracity, and Condé Nast duo Bruehl-Bourges, who had developed color as a marketing tool.[13] The full scope of Paul Outerbridge's practice was represented by, on one end, an image of wallpaper taken for *House Beautiful* and, on the other end, the classical still-life *Avocado Pears* (page 69). Newhall included the categories of press, aerial, and scientific photographs as well as movie stills; although these were not color examples, they certainly could have been (and would be in later editions of his accompanying publication), given the relative ease with which events could now be recorded in color. Earlier that year, the *Milwaukee Journal* printed the first candid color news photograph, and the dramatic May explosion of the Hindenburg dirigible appeared in full color on the pages of the *New York Sunday Mirror* (pages 77–79). Beginning in the mid-1930s, yet another paper, the *New York Daily News*, dedicated weekly space in its *Sunday News* magazine to color photographic portraits of newsworthy subjects. The possibilities of color photography reportage seemed so rich that *National Geographic* endorsed Kodachrome film in 1937. It was one of the first American publications to do so, and it used the film for numerous color photographs published in subsequent issues.

Kodachrome film advertisement, 1936

11.
Dr. C. E. Kenneth Mees, quoted in "Home Color Movies May be Made Without Camera Filters," *Science News Letter*, April 20, 1935, p. 246.

12.
Robert W. Brown, "Camera Show at Fair," *New York Times*, April 30, 1939, p. 195.

13.
It should be noted that Newhall exhibited Steichen's autochromes not as glass plates, but in their reproduced form from the pages of *Camera Work*.

Still from the film *Becky Sharp*, 1935

Simultaneous with Kodachrome's ascendancy, the movie-going public of the 1930s found themselves swept away by color motion pictures. The three-color Technicolor process was first used for the short film *La Cucaracha* in 1934 and for the feature film *Becky Sharp* in 1935 (left). The cinematic trailer for *Becky Sharp* prepared audiences well, offering a technological demonstration during which a voice-over declares: "Here is the screen as you now know it in its customary shades of black and white. Here it is flooded with the rich reality of natural color." Without doubt, however, no film better dramatized the arrival of color than *The Wizard of Oz* (page 65). The hard existence of Dorothy's life in dust bowl Kansas, an all-too-familiar plight for many Americans in 1939, is demarcated from her fantastic adventures in the Land of Oz by a shift from black-and-white imagery to Technicolor. Between what Kodachrome and Technicolor made possible, color photography's multifaceted mass consumption was completely assured at the dawn of World War II.

During the war, color photography's presence only expanded. Ivan Dmitri's influential *Kodachrome and How to Use It* was published in 1940, and Paul Outerbridge's *Photographing in Color* appeared in 1940; each text was illustrated mostly with the author's own color images. Dmitri's book was aimed at the growing number of amateur photographers who were making use of color processes, while Outerbridge's text addressed the full range from amateur to professional. In 1941 *Life* magazine finally joined *National Geographic*, *Vogue*, *Harper's Bazaar*, and a host of other photographically oriented magazines that printed color either on their covers or in their pages (page 101). Kodak began to make prints from customers' Kodachrome slides, and in 1942 they released Kodacolor negative film specifically intended to yield multiple prints. This wartime debut could not have been more striking, and Kodak made the most of it in advertisements featuring a soldier's hand holding color photographic keepsakes, capitalizing on the notion that a color snapshot provided even greater domestic and emotional comfort to those in foreign combat zones (page 92). Moreover, by 1942 color photographs had "been obtained by the Air Corps from altitudes of 12,000 to 15,000 feet and it [was] expected by photographic experts that within the next few months color photographs [could] be made from airplanes flying five or six miles above the earth."[14] Throughout the war years, MoMA also continued its initial and diverse enthusiasm for displaying color photography. These efforts ranged from presenting a short color film of a helicopter to the museum's first monographic exhibition devoted to color photographs (by Eliot Porter), from new acquisitions of Kodachromes by commercial photographers to a continuous slide show of winning images in Kodak's "American Snapshot" competition. By World War II, color photography was in flux, presented in myriad ways on both museum walls and magazine pages.

Art critic Jacob Deschin began his *New York Times* column on May 14, 1950, by declaring: "The first attempt to present a picture of what is being achieved by color workers in the United States is offered in an exhibition of color photographs, color transparencies and reproductions."[15] Referencing MoMA's *Color Photography*—the first survey of color photography in the United States, including over three hundred images by eighty-five photographers curated by Steichen—Deschin's article details the full scope of color photographs shown in the exhibition: backlit autochromes against which modern color prints could distinguish themselves; works by a variety of professionals, including photojournalists and experimental art photographers; painterly still-life studies side by side with aerial photographs of Earth (on public view for the first time); and abstractions intended to showcase the latest thinking by artists such as Harry Callahan alongside magazine spreads signaling "color photography as a mass medium."[16] More important, Deschin's column, like the exhibition whose range it charts, captures the tenor of color

14.
"Color Photographs at Six Miles Soon to Be Possible," *Science News Letter*, April 18, 1942, p. 243.

15.
Jacob Deschin, "Pictures in Color," *New York Times*, May 14, 1950, p. 123.

16.
Ibid. In a later press release, the museum also noted that this exhibition had presented "the complete range of color photography." "'Experimental Photography in Color' to Be Discussed by Edward Steichen" (press release, Museum of Modern Art, New York, February 9, 1957), p. 1. www.moma.org/learn/resources/press_archives/1950s/1957.

photography at that moment. Another contemporary review concurs: "Of the incredible upswing in color photography in the last fifteen years and especially during the war, even landscape pictures richest in glimmering tone or the variegated exotic fashion studies in magazines like *Life* and *Vogue* give no complete idea." The reviewer continued, stating that Steichen's exhibition (in conjunction with others he planned to follow it) would be the first to "measure the extent of the thematic possibilities, coloristic interludes and intensities, and above all, the artistic arbitrariness of color photography."[17] Both reviews, then, point explicitly to the air of experimentation and the attendant uncertainty about how to evaluate the scope of works on view, echoing Steichen's own sense of his curatorial efforts, which he described as asking more questions than providing answers.[18] Steichen was especially attuned to the overall question of color:

> Is [color photography] a new medium for the artist or is it a means of supplementing or elaborating the recognized attainments of black and white photography? . . . In any attempt to evaluate the present status of color photography, one must recognize that color was introduced into films as well as into stills after they had been established and fully accepted as black and white . . . today's new photography medium, is, unfortunately, being handicapped by the same black and white precedent. . . . Color has been an integral part of all other visual arts from the beginning.[19]

Color Photography's checklist included works by Steichen himself, as well as Ansel Adams, Harry Callahan, Louise Dahl-Wolfe, Eliot Elisofon, Walker Evans, Russell Lee, Paul Outerbridge, Irving Penn, Eliot Porter, and Edward Weston. Among these artists—and sometimes even among the works by just one of these artists—a range of practices was represented on the wall, from high to low art forms, from unique images to those intended for reproduction, from individual pursuits to those sponsored by corporations such as Kodak. Add autochromes of the early twentieth century, work for *Life* magazine by Fritz Goro and Andreas Feininger (pages 102 and 103), as well as the latest microscopic color photographs of amoeba, and it is little wonder that the diversity of styles, intentions, and outlets of these works gave Steichen pause. What is clear, however, is his commitment to the belief that a better understanding of color photography could *only* be accomplished through such a rich and wide-ranging presentation.

At the time of Steichen's exhibition, even New York—then the most active photographic city in the nation—still offered few places to see original photographs. Apart from exhibitions mounted by the membership-based cooperative of the Photo League from 1936 to 1951 and the few commercial galleries sporadically showing photography in these years, MoMA stood alone with its dedicated exhibitions and study room for viewing photographs from the collection.[20] New York was also home to two of the nation's most widely circulating newspapers, the *New York Daily Mirror* and the *New York Times*, the latter of which had a dedicated column on photography as early as 1938. Offering brief reviews, exhibition listings (in both the metropolitan region and upstate), and lecture announcements in its initial years, the *Times*' photography column expanded to include longer reviews and articles of a more art-historical nature in subsequent decades. This varied coverage made photography a regular feature in the *Times*. To be sure, newspapers in other urban centers—demographic concentrations of photographers and photo-enthusiasts—regularly reported on photography. Likewise, other major institutions such as the Art Institute of Chicago and George Eastman House, Rochester, New York, regularly mounted photographic exhibitions, among them a handful that celebrated the

17.
Willi Wolfradt, "Color Camera," *Aufbau*, May 26, 1950, n.p. Translated from German by MoMA staff. MoMA exhibition archives, CUR 445. Steichen did not curate subsequent exhibitions as intended, perhaps because he consistently included color works in so many of his curatorial efforts after 1950.

18.
Quoted in "Museum's First Exhibition of All Color Photography to Be on View May 10 through June 25" (press release, Museum of Modern Art, May 4, 1950), p. 2. www.moma.org/learn/resources/press_ archives/1950s/1950.

19.
Ibid.

20.
Christopher Phillips, "The Judgment Seat of Photography," in *The Contest of Meaning: Critical Histories of Photography*, ed. Richard Bolton (Cambridge, Mass.: MIT Press, 1989), pp. 15–16.

arrival and accomplishments of color photography. Nevertheless, to understand the state of photography historically, one has to begin with New York and MoMA for the most concentrated and consistent embrace of the medium.

A mere five days after the opening of Steichen's exhibition, Kodak unveiled another grandiose effort: the Colorama. Measuring eighteen feet high by sixty feet long, this changing installation of enormous backlit color transparencies—eventually 565 total images—glowed high above the bustling suburban commuter crowds inside New York's Grand Central Station for decades beginning in 1950 (left). Intended to help Kodak's target audience—then predominantly white, middle-class, or affluent suburban families—imagine that they too were "able to make the same wonderful photo,"[21] in the words of one company vice president, the Colorama continued Kodak's successful advertising campaign to make picture-taking an indispensable component of American life. More specifically and regardless of which of the thirty-four photographers had taken the featured image—be it Ansel Adams, Ernst Haas, or Eliot Porter—the Colorama series in Grand Central continued Kodak's threefold message about what color photography could capture: fleeting personal moments, artistic aspirations, and naturalistic hues. As with Kodachrome and CinéKodak ads, the presence of a camera in the photograph remains a leitmotif, a constant reminder that families should not only travel with their cameras to great American vistas but also keep them close at hand for backyard parties and holidays at home.

Ansel Adams, who later dismissed his Colorama work as "aesthetically inconsequential but technically remarkable,"[22] nevertheless accepted color photography's "importance as a medium of communication,"[23] and thus obliged this marketing message by fusing the domestic snapshot ritual with the natural landmarks for which he had become famous as a black-and-white photographer. Adams's Coloramas feature Yosemite Valley, Bryce Canyon, and Zabriskie Point (pages 130–31). These works, perhaps more than those by any other photographer, combine the two motivations outlined by Thornton at this essay's beginning: they are faithful records of the wonders of nature as well as picture-postcard snapshots. Given this concurrence, one wonders why Thornton so resolutely placed the Colorama—and Adams—squarely in the former category. As curator Alison Nordström has summarized: "The Coloramas taught us not only what to photograph, but how to see the world as though it were a photograph. They served to manifest and visualize values that even then were understood as nostalgic and in jeopardy, salvageable only through the time-defying alchemy of Kodak cameras and film."[24] Even so, or perhaps precisely because of this, Kodak's spectacular Colorama installations made everyone who passed through Grand Central take notice, including Steichen, who, at the start of a decade in which he would showcase color in almost half the photography exhibitions he curated at MoMA, telegraphed Kodak: "EVERYONE IN GRAND CENTRAL AGOG AND SMILING. ALL JUST FEELING GOOD."[25]

The nearly simultaneous opening of Steichen's *Color Photography* and the debut of the Colorama heralded the dominant themes of discussions surrounding color photography in the 1950s: the characterization of color's "proper" artistic aesthetic and the explosion of color's proficient deployment and widespread consumption. These two themes evolved into an increasingly oppositional relationship. If Steichen's exhibition had offered more questions than answers, photographers soon began parsing those questions themselves in order to analyze and criticize what different color photographs communicated. For example, a debate arose at the Society of Magazine Photographers meeting in 1953 regarding the use of filters in color photography and whether results achieved in this way might not be "truthful." The same report ruefully acknowledges that when Eliot Elisofon, who partook in the debate and defended his use of filters, presented a public

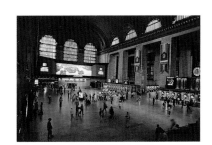

Norm Kerr, Colorama #553 on display in Grand Central Terminal, August 15–September 22, 1988

21.
Alison Nordström, "Dreaming in Color," in *Colorama: The World's Largest Photographs from Kodak and the George Eastman House Collection* (New York: Aperture, 2004), p. 6.

22.
Ansel Adams, *Ansel Adams: An Autobiography* (Boston: Little, Brown, 1985), p. 162.

23.
Ansel Adams, "Color Photography as a Creative Medium," *Image: Journal of Photography and Motion Pictures of the George Eastman House* 6, no. 9 (November 1957), p. 217.

24.
Nordström, "Dreaming in Color," p. 6.

25.
Quoted in ibid., p. 8.

slide show of his work the week before, no such complaints had arisen.[26] Similar questions emerged in photography competitions in the early 1950s: What did it mean for a color slide to be sufficiently colorful? Could the color pictures submitted have been taken just as well, if not better, in black and white? Why did efforts to produce creative color photography reduce their subject matter down to patterns, reflections, and other design effects, eliminating entirely subjects of human interest?[27]

As much as these and other questions were pursued at the level of camera club conversations, it fell most often to professional color photographers themselves to put their opinions into print (pages 124, 128–29). A 1956 symposium on the topic "The Future of Color" included participants from N. W. Ayer & Son advertising agency, the *Milwaukee Journal, Life* magazine, and Kodak's research division, in addition to photographers. When asked if color would "take the place of black-and-white entirely in ten years," most participants replied negatively, saying color would merely make great progress in the coming decade.[28] Irving Penn was the lone dissenter, arguing that it "seemed likely" that it was only a matter of time until the costs associated with color processes were lowered enough to make it the new standard. The advertising executive said such a replacement would never happen; the newspaperman said no paper would ever be more than 50 percent color; and the Kodak representative thought that the economy of black and white would hold sway with amateurs.[29]

Elisofon handily summarized the debate surrounding color photography:

> Most people are happy enough to make color photographs simply as a record. They give little or no thought to technique or esthetics; they make snapshots of trips, friends, pets, without ever thinking that such photographs, handled creatively, might result in material worthy of an exhibition or of reproduction in a magazine. . . .
> We have been flooded with calendars and postcards in which color has not portrayed nature faithfully, much less interpreted it. The plethora of uniform, clean, well-exposed pictures with bright blue skies has reached a monotony of millions, and the few interesting deviations have been due mostly to the accidents of nature. "Get the sun over your left shoulder, set the exposure for 1/50th at F5.6, push the button, and the lab does the rest." From this advice has come a stream of snapshots that are not unpleasant to look at but cannot be termed art.[30]

Elisofon not only captured the extent of color photography's use and popularity at the time but also distinctly implied that exhibitions and publications were the arbiters of color photography as art in the face of the threat of triviality. Moreover, Elisofon linked these high and low art forms, establishing a symbiotic relationship. The more that amateurs produced color photographs, the more there was a need to articulate the medium's place in an art-world context; conversely, the more that the artistic vehicles of exhibition and publication singled out color photographs, the more there was a need to distinguish these color photographs from those created by the masses.

One way in which artists navigated this relationship was to emphasize the craft of color photography, a strategy that was already well established among photographers working in black and white who looked to differentiate their works from those of amateurs. As articulated by critic Max Kozloff, there was a "long tradition of individualized, self-executed and crafted photographic production," specifically, "a goal of optimum personal control was inbred into their minds, and reached, perhaps, its apogee in the razor-sharp

26.
Jacob Deschin, "Question of Color," *New York Times*, May 10, 1953, p. 9. Elisofon would later publish a version of these opinions: "Where does originality begin and reporting end? . . . I believe in color selection and color control. I believe that the photographer has the privilege and the right to interpret his subject." Eliot Elisofon, *Color Photography* (New York: Viking Press, 1961), p. 10.

27.
The Osborne Company's "Color Transparency" contest was open only to camera club members and was the first such national event sponsored by a calendar company. For more on that competition, as well as other competitions in 1953, see Jacob Deschin, "Amateur's Dilemma," *New York Times*, September 6, 1953, p. 12; Jacob Deschin, "Calendar Prizes," *New York Times*, February 22, 1953, p. 14; and Jacob Deschin, "Human Interest," *New York Times*, December 20, 1953, p. 15.

28.
"The Future of Color—A Symposium," *Color Photography Annual* (1956): p. 13.

29.
Ibid., pp. 13–14. For more, see also pp. 15–16, 155, 169–70.

30.
Elisofon, *Color Photography*, pp. 9–10. Elisofon's book moves from this astute opening overview to an inventory of reductively simplistic and pseudopsychological evocations of particular colors inspired by painting (red suggests vigor and/or violence, for example).

31.
Max Kozloff, "Photography: The Coming to Age of Color," *Artforum*, January 1975, p. 32.

32.
Adams, "Color Photography," p. 217.

33.
Ibid., and Eauclaire, *The New Color Photography*, p. 9, respectively. Eauclaire wrote that color efforts by Adams, Callahan, Evans, Steichen, and Weston had been consigned to history—and were therefore of no relevance to the generation of photographers on which she focused—due to the "recognition that they singularly lack the authority of more solid images in black and white" rather than color's "impure commercial amateur applications." Later in the catalog essay, however, she seemed to retract this claim: "However many noncommercial works Outerbridge and others produced in color, the idea persisted that color photography was mainly entertainment." Eauclaire, *The New Color Photography*, p. 12.

34.
The color photographs could be submitted as transparencies or prints. Kodak had released Ektacolor printing paper in 1955, making improvements and releasing the Rapid Color Processor Model 16-K in 1963. By the 1964 New York World's Fair, Polaroid had introduced a more affordable option with Polacolor, the first instant color film, but of course this was not an acceptable format for submission to Kodak's competition.

35.
Jacob Deschin, "World Contest," *New York Times*, August 18, 1963, p. 118.

36.
Jacob Deschin, "Kodak at Fair," *New York Times*, April 19, 1964, p. 21.

37.
By late 1977, a financial study indicated that color film use in the United States, Japan, and Western Europe was at a high level, with broad segments of those populations owning cameras. Moreover, the analysis indicated that the overall market for photography products was divided fairly evenly between amateur and applied photography. A. L. Pakkala, "The Market for Amateur Photography," *Financial Analysts Journal* 33, no. 5 (September–October 1977): p. 48.

edges and clinically adjusted gradations of Ansel Adams."[31] Indeed, Adams concluded his 1957 essay "Color Photography as a Creative Medium"—written at the height of his production of rainbow-hued vistas for Kodak (pages 128–129)—with a plea along these very lines: "I believe that color photography, while astonishingly advanced technologically, is still in its infancy as a creative medium. We must remain objective and critical, plead for greater opportunity for control, and constantly remind ourselves that the qualities of art are achieved in spite of conditions and media—never because of them."[32] Adams's text reveals a key problem with the emphasis on craft: it risked quickly devolving into personal opinion about how a color print stands up to the "happy blend of perception and realization" or "the authority of more solid images in black and white" in a culture that was becoming increasingly saturated with color photography.[33] By the 1960s, almost every cover of *Life* magazine was a color photograph, its issues and those of other magazines were full of color spreads, and movies and television programs were increasingly filmed in color.

The 1964 New York World's Fair, with its emphasis on spectacle, new technology, and mass consumption, indicated the popular place of color photography and imagined its future trajectory. Kodak created a competition with a global theme ("The World and Its People," a nod to the fair's theme "Peace Through Understanding") and demonstrated a new openness to submissions by professionals and amateurs alike, as well as a shift from black and white to color.[34] The selection of jurors confirmed color photography's existence at the crossroads of art and industry: Norman Cousins, editor of the *Saturday Review*; Donald McMaster, president emeritus of the Royal Photographic Society; James J. Rorimer, director of the Metropolitan Museum of Art, New York; Herbert S. Wilburn, Jr., the illustrations editor at *National Geographic*; and Peter J. Braal, manager of the Photographic Illustrations Division at Kodak.[35] This group's range of backgrounds, expertise, and employers was not only perceived to productively engage color photography writ large in 1964 but also unintentionally echoed the guiding philosophy of inclusion and contextualization evidenced by Steichen's exhibition program in the preceding years. George Eastman House, one of the few standout venues for color photography in the 1950s, also played a role at the fair, lending the exhibition *Applied Photography*, which was followed by a display of the three hundred winning entries of Kodak's competition. These displays occurred inside a building capped with the Picture Tower, a beacon of five fully illuminated color photographs, each measuring thirty by thirty-six feet. This multidirectional (if nonpanoramic) Colorama effect intentionally signaled "the variety and range" of photographic shows distributed in the pavilion.[36] Certainly Kodak had a product to sell—color photography enjoyed increasing global demand, with greater affordability and options for output—and its pavilion at the fair served this purpose.[37] The pavilion, however, also engaged and reflected the full scope of color photography's context in these years, from museums to magazines, from pseudobillboards to fine dye transfer prints, from professional photographs to amateur snapshots. At this time, these contexts were not fixed or oppositional but rather associations that images might variously engage in their circulation. One of the early examples of this fluidity is Steichen's inclusion of massive color enlargements by Adams and Weston in the 1948 exhibition *In and Out of Focus: A Survey of Today's Photography*. These images—such as Adams's *Grand Tetons* and Weston's *Point Lobos* photographs (pages 129 and 124)—contemporaneously graced Kodak advertisements in popular magazines. Even into the 1960s, color photography continued to enjoy a fluidity of presentation across mainstays of so-called low and high culture. The same photographs that appeared in *Life* and other magazines were celebrated in MoMA's 1965 exhibition *The Photo Essay*, which placed special emphasis on color photography by devoting one wall to color

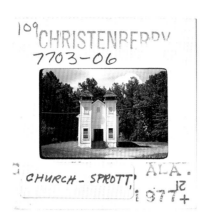

William Christenberry, slide of *Church, Sprott, Alabama*, 1977

Dan Graham, *Housing Development, Bayonne, New Jersey*, 1966

38.
See the chronology in this catalog for further details.

39.
Darsie Alexander, introduction to *Slide-Show* (Baltimore: Baltimore Museum of Art; University Park, Pa.: Pennsylvania State University Press, 2005), x. See also pp. 9–11 for a characterization of the deployment of slide shows in the 1960s.

40.
Moore, "Starburst," pp. 10–11.

41.
A. D. Coleman, "'I Have a Blind Spot About Color Photographs,'" *New York Times*, August 19, 1971, p. D26.

42.
A. D. Coleman, "More on Color: Readers Speak Out,'" *New York Times*, November 7, 1971, p. D16.

43.
Coleman, "'I Have a Blind Spot," p. D26.

44.
Coleman, "More on Color," p. D16.

45.
Lee DaJasu, quoted in Coleman, "More on Color," p. D16.

double-page spreads and projecting enlarged color photo-essays onto the museum's walls. The world had become fully saturated in color photography; the Kodak pavilion merely embodied this exciting new reality.

Color photography's prevalence and pervasiveness allowed for, and perhaps even encouraged, flexibility and experimentation among artists. In the early 1960s William Christenberry started recording the South's vernacular architecture via color slides in addition to other formats (above left). In 1965 Dan Graham embarked on a pivotal project he would later title *Homes for America*, which he developed as both a slide lecture and a layout for the commercially printed magazine page (below left). Three years later, Ed Ruscha began creating color photobooks that riffed on banal and ubiquitous modes of color photography as much as on the seriality that created a supposed narrative in photographic publications (page 166). The economy, efficiency, and sequential display of color slide shows, facilitated by the newly available carousel tray accommodating eighty slides, became a temptation for many in this period—Harry Callahan, Dan Graham, Saul Leiter, and Helen Levitt—regardless of subject matter or artistic approach.[38] Art historian Darsie Alexander articulated that, while a slide was an image, a slide show was an event, calculated by the artist and experienced by viewers: "Magnification, speed of delivery, and sequence become variables of the medium; artists can manipulate and tweak them at any stage of the process. This flexibility generated widespread experimentation with the process itself, resulting in works that could just as easily reside in a live theater as in an art gallery—a blurring of lines that artists welcomed."[39]

It would be hard to pinpoint the exact moment at which there was no escaping the debate about color photography's place in the art world (which, more generally, involves commentary about its place in visual culture). Nevertheless, it is clear that exhibitions and criticism of the early 1970s made an escape increasingly less likely. Curator Kevin Moore, in his 2010 exhibition catalog, *Starburst: Color Photography in America 1970–1980*, claimed that 1970s color photography can be "characterized as the chaotic and disparate search, a heterogeneous effort encompassing diverse bodies of work. . . . Color became an umbrella of sorts, sheltering a range of photographic behaviors, involving new types of subject matter and new forms of photographic expression. Banal, artificial, pointless, kitsch, commercial, and other milder pejorative terms such as beautiful, romantic—these were used to describe a range of photographs that were, in fact, some of the most challenging and prescient images of their day."[40] The all-inclusive artistic deployment of color photography in the 1970s outlined by Moore represents a historical transition, wherein the fluidity and complexity that had once ranged across high- and low-culture uses of color photography were now fully realized in artistic practices.

In a 1971 column for the *New York Times*, A. D. Coleman offered a contemporaneous example of the confounding challenge of color photography, which he found to be a personal critical "blind spot."[41] While Coleman saw the potential of color—he noted he treasured Eliot Porter's *In Wilderness Is the Preservation of the World* long before he began writing about photography[42]—he felt unable to comment critically on it. He listed the three possible explanations he had discovered in contemplating this quandary: too many pretty color pictures; too much complexity in the "psychological/emotional/aesthetic factors" as applied to color imagery; and, finally, too little abstraction of the kind so long associated with black-and-white photographs, thereby making color photography "too damn 'realistic' for its own good."[43] Coleman invited his readers to respond, and respond they did, so much so that he wrote a follow-up column acknowledging that he had touched a "sore spot."[44] One reader proposed that color photography had been burdened by being "more keenly tied to painterly solutions and conventions, whereas black and white was freer sooner."[45] Another posited that the only

acknowledged tradition in color photography was commercial and yet, "the hordes of home shutterbugs never question the validity of color. They want a photograph of their family, house, swimming pool, or dog. When color film became available they used it. Now we have millions of color images that document a way of life. This giant body of work constitutes a valid tradition in photography. The home-picture-taker is the first to accept color photography as, simply, photography."[46] This radical proposition clearly extends back to the mass availability of Kodachrome in the 1930s, but by the 1970s it was also a tenable proposition for all photographers, not merely the family snapshooter who more readily embraced technological flaws in order to achieve the approximation of reality. By the time of the debate addressed in Coleman's 1971 columns, technological problems surrounding accuracy in color photographs had been minimized; if anything, their sense as transparent documents of the observed world played an integral role in the debate. Color technology seemed less a translation or mediation, as it had with the more exaggerated and fantastic colors associated with Hollywood, television, and other forms of popular entertainment.

Indeed, in his important 1975 *Artforum* article declaratively titled "Photography: The Coming to Age of Color," Max Kozloff wrote: "Black and white imagery for a movie audience (or, for that matter, a TV audience) lingers as a primitive situation or a historical phenomenon. Yet, who enters a current show of photographs and anticipates that they shall be in color? . . . Serious still photography in black and white offers a very archaic spectacle. How fascinating and peculiar that it has dominated its field even to such a farfetched moment as today."[47] After this remarkable opening musing, Kozloff charted a condensed history of color photography, including its "earlier hierarchical judgments," arriving at the current excitement surrounding color photography. Importantly, Kozloff noted the appearance of traits associated with low art forms in high art forms—"Technicolor stylishness and amateur insouciance"—but he argued that the distinction between master print and amateur snapshot, though sometimes elusive, was not invisible. The distinction lay not only in carefully crafted images—a view resonant with that of Adams twenty years prior—but also in careful, attentive looking by viewers. This very sentiment concluded another 1975 article, "New Frontiers in Color," in *Newsweek* magazine—a far more popular and widely circulating publication than *Artforum*— and so all the more remarkable for reproducing works by Marie Cosindas, Walker Evans, Ernst Haas, Helen Levitt, and Eliot Porter: "At its best, color photography recreates a world that is sensuous and mysterious, thereby deepening our perception of the world itself."[48]

On May 24, 1976, MoMA opened *William Eggleston*, an exhibition curated by John Szarkowski containing seventy-five of Eggleston's unsparing color photographs of mundane objects and everyday scenes (pages 173–75). The show was mistakenly heralded as a "historic breakthrough," the first serious exhibition of color photography at the institution, a false claim that was perpetuated in decades of subsequent writing.[49] The accompanying catalog, entitled *William Eggleston's Guide*, however, was MoMA's first publication dedicated to color photography (page 165). Although it is important to note that the book reproduces fewer works than were in the exhibition, and is therefore differently sequenced, Szarkowski's intention seems constant across both formats: he believed that Eggleston's images overcame a specific flaw of earlier color photography. Previously, Szarkowski argued, there had been either a lack of form or a lack of content in color photographs; Eggleston, in turn, was "a more confident, more natural, and yet more ambitious spirit, working not as though color were a separate issue, a problem to be solved in isolation (not thinking of color as photographers seventy years ago thought of composition), but rather as though the world itself existed in color, as though the blue

46.
Peter Clagdon, quoted in Coleman, "More on Color," p. D16.

47.
Kozloff, "Coming to Age of Color," p. 31.

48.
Douglas Davis with Mary Rourke, "New Frontiers in Color,'" *Newsweek*, April 19, 1976, p. 56.

49.
In fact, MoMA's first presentation of an exhibition dedicated to color photography occurred in 1943: *Birds in Color: Flashlight Photographs by Eliot Porter*. "Historic breakthrough" is Hilton Kramer's phrase, though he used it in the context of Eggleston's exhibition only to express disappointment. Hilton Kramer, "Art: Focus on Photo Shows,'" *New York Times*, May 28, 1976, p. 62.

and the sky *were* one thing."[50] Few critics appreciated, let alone agreed with, this stance. Instead, most were incensed by the Eggleston exhibition, which one deemed "the most hated show of the year."[51] The conservative critic Hilton Kramer rebuffed Szarkowski's claim that Eggleston's photographs were "perfect": "Perfectly banal, perhaps. Perfectly boring, certainly." Kramer elaborated: "The truth is, these pictures belong to the world of snapshot chic—to the post–Diane Arbus, antiformalist esthetic that is now all the rage among many younger photographers. . . . To this snapshot style, Mr. Eggleston has added some effect borrowed from recent developments in, of all things, photorealist painting—a case, if not of the blind leading the blind, at least of the banal leading the banal."[52]

Janet Malcolm, writing a year later in the *New Yorker*, also decried this relationship, in which so-called "Photo-Realist photography" was based on a painting style based on photographs, and determined that "puny" color photographs could not stand up against larger painted canvases.[53] When her interest shifted away from a comparison of photography to painting, Malcolm found reasons for praise. Even if Eggleston's photographs "looked inartistic, unmodern, [and] out of place in an art museum," she agreed with Dan Meinwald's review in *Afterimage* that Eggleston's particular treatment of commonplace subject matter revealed the photographer's hand and should not be overlooked. The standard-issue suburban tricycle that graces the cover of *William Eggleston's Guide* is triumphantly presented from below, creating an aggrandizing scale shift that no hobbyist photographer would have sought out.[54] Eggleston recorded another subject, an older lady seated on an outdoor couch, in such a way that "it is a color picture about color photography. . . . [In black and white] these patterns—and, so to speak, the woman, the chaise, the leaves, the flagstone—would cease to exist."[55] Despite acknowledging these accomplishments, Malcolm remained tethered to an assessment based in comparison—to painting, to black-and-white photography—that could not and did not make connections between earlier decades of color photography and the decade for which the Eggleston exhibition served as a lightning rod. It was with some disbelief, if not a good deal of missed opportunity for connection and complexity, that she noted: "Color photography, which up to now had been associated with photography's most retrograde applications—advertising, fashion, *National Geographic*–type travel pictures, nature pictures, old-fashioned arty abstractions of peeling walls and European traffic signs—suddenly became the medium's most advanced form of all."[56]

In a December 1976 article on the ten most outstanding events and developments in the photography world that year, Gene Thornton provided a more contextualized assessment of the Eggleston exhibition. Fourth on his list is a trend toward what Thornton called "formalistic photography" as exemplified in its newest incarnation by "the snapshot-like work" of Eggleston as exhibited by MoMA. Thornton not only reveled in the connection between Eggleston's photographs and the "color slides made by the man next door" but also deftly linked the negative critical response to Eggleston to that relationship.[57] Moreover, he did so against a backdrop of marketplace shifts that were seismic for photography. Topping Thornton's list was the presentation of photography in major art galleries that had previously shown only painting and sculpture as well as the debut of galleries devoted exclusively to photography. In the year leading up to Thornton's review, photography had appeared on the walls of painting-and-sculpture strongholds Knoedler, Marlborough, and Sidney Janis galleries. No fewer than three galleries dedicated to photography had opened their doors in the preceding months, including Images, which specialized in color photography. Yale University Art Gallery had organized an exhibition dedicated to the history of color photography. Harry Callahan, William Christenberry, Jan Groover, Ernst Haas, John Pfahl,

50.
John Szarkowski, untitled essay, in *William Eggleston's Guide* (New York: Museum of Modern Art, 1976), p. 9.

51.
Gene Thornton, "Photography View: Photography Found a Home in Art Galleries," *New York Times*, December 26, 1976, p. 29.

52.
Kramer, "Focus on Photo Shows," p. 62.

53.
Janet Malcolm, "Photography: Color," *New Yorker*, October 10, 1977, p. 108. For more on Photo-Realism and accusations of artistic mimicry, see Eauclaire, *New Color Photography*, pp. 14–15.

54.
See both Malcolm, "Photography: Color," pp. 108–9, and Dan Meinwald, "Reviews: Color Me MoMA," *Afterimage*, September 1976, p. 18.

55.
Malcolm, "Photography: Color," pp. 110–11.

56.
Ibid., p. 107.

57.
Gene Thornton, "Photography View: Photography Found a Home," p. 29.

Stephen Shore, and Neal Slavin all received solo exhibitions at important venues (the Corcoran Gallery of Art, Washington, D.C.; George Eastman House; International Center of Photography, New York) or major New York galleries (LIGHT, Max Protetch, and Zabriskie).[58] All this in 1976 alone. Thus, a potentially pithy year-end "top ten" list was, with Thornton's insights, transformed into one of the most astute assessments of photography's productive relationship to its past forms, its contemporaneous transitions, and its marketable future.

The groundwork for the explosive visibility for photography in general and color photography specifically had already been laid in such New York art-world occurrences as the opening of Witkin Gallery in 1969, the establishment of LIGHT Gallery in 1971, and the daring exhibition of a lone Bruce Nauman color photograph at Leo Castelli Gallery in 1968 (page 170). Thanks to these and other examples of color photography's ascendancy in the art market, color photography achieved an unprecedented prominence in 1976 and 1977.[59] Bill Jorden, writing in *Afterimage* about the near-simultaneous opening of exhibitions devoted to color photography in 1977, said: "I felt like I was watching that marvelous transition in *The Wizard of Oz* when Dorothy, after being swirled through a colossal tornado, wakes up in a Technicolor land that is definitely not dust-bowl Kansas."[60] Jorden's reaction wonderfully conveys a sense of the drama and decisiveness associated with the moment: Eggleston showed a dozen years' worth of color photographs at Castelli Graphics; Jan Groover showed her Kitchen Still-Lifes at Sonnabend; Helen Levitt exhibited dye transfer prints and color slides, as well as her black-and-white photographs, at Carlton Gallery; Joel Meyerowitz debuted his important color series of Cape Cod pictures at Witkin Gallery; and Stephen Shore displayed his latest color work at LIGHT Gallery.

Two further compelling and open-ended considerations of color photography appeared in 1977. George Eastman House presented *Kodachrome*, an exhibition featuring work by Anton Bruehl, Fernand Bourges, Ivan Dmitri, Victor Keppler, and Nickolas Muray. Sally Stein, the exhibition's curator, charted the technological history of the legendary product that would soon become the inspiration for Nan Goldin's *Ballad of Sexual Dependency*. And Castelli Graphics presented a scattershot survey, *Some Color Photographs*, which boldly incorporated works by John Baldessari and Ed Ruscha alongside those by Eggleston, Groover, and Levitt. In addition to these exhibitions, three photographers—Ernst Haas, Jay Maisel, and Pete Turner—came together to found the Space Gallery, which joined Images in its exclusive dedication to color photography. Although the particulars of color photography's phenomenal visibility in 1976 and 1977 have been minimized in all but the most recent of histories, the timing of this rush is likely yet another reason that MoMA's Eggleston show served as both a lightning rod and the embodiment of contemporary concerns. The Eggleston exhibition has for too long been the convenient emblem of a far more sweeping, historicizing, and elaborate moment in color photography's history. It should instead be understood as one of many separate instances in which artistic practice embraced the hybridity that had long characterized color photography.

This expansive moment of color's prominence only intensified the debates surrounding color. Critics posed challenges to and expressed worries about color photography as an artistic medium. Szarkowski's proposal that Eggleston's photographs represent the acceptance of the world existing *in color* prompted anxiety that it might "lead to barren ground" where photography would cease to have emotional and meaningful content.[61] When it came to content, what was more appealing: the subject itself, or the way it was photographed?[62] And how did viewers respond to the seemingly random assortment of commercial photographs in two vitrines in the exhibition *Some Color Photographs*,

58.
See the chronology in this catalog for exact dates, titles, and venues.

59.
Stephen Shore's *American Surfaces* at LIGHT Gallery in 1972 may have been equally radical, but it did not elicit the same onslaught of critical response.

60.
Bill Jorden, "Three Wizards at Odds: New York Color," *Afterimage*, February 1978, p. 19.

61.
Ibid., p. 21.

62.
For more, see Phil Patton, "Captioned Pictures, Pictured Captions," *ARTnews*, January 1977, p. 109.

with their provocative and challenging proximity to works by Baldessari, Eggleston, Groover, and Ruscha? In his review of that show, Thornton commented extensively on this display at Castelli Graphics:

> These include . . . a *National Geographic* photograph of jolly Eskimos; a frozen food package; . . . a snapshot of dogs; a color postcard reproduction of a Holbein painting; [and] a mail-order card for easy-to-install photographic murals of tropical sunsets and mountains. . . . These are the kinds of color photographs that we all grew up with, environed as we were by the art of the mass media, and we are not entirely surprised to see them in the gallery that made Pop art famous. . . . If the show of color photography at Castelli Graphics is any indication, it is only a matter of time before photographs of tropical sunsets, jolly Eskimos and faithful dogs will come out of the vitrine and take their places on the gallery walls.[63]

Thornton's dismay over a dissolution of boundaries between high and low art forms with regard to color photography nevertheless acknowledged that neither artistic practice nor the modalities of display had an interest in maintaining those boundaries.

Critic and curator Sally Eauclaire's 1981 exhibition at the International Center of Photography and accompanying catalog, *The New Color Photography*, was the single most concerted response to the expansiveness of the late 1970s and the debates it intensified. Featuring work by forty-eight photographers, the exhibition encompassed multiple generations of artists whose practices ranged from straight photography (Joel Meyerowitz and Stephen Shore) to serialized work (Jan Groover and Eve Sonneman) to outright manipulation (John Pfahl and Lucas Samaras). Eauclaire made plain that such expansiveness served as a prompt to organize the exhibition, noting in the opening paragraph of her catalog introduction: "The explosion of exhibitions, publications, course enrollments, museum acquisitions, symposiums, and grants attests to the view that color is *the* issue in contemporary photography. . . . Rather than indiscriminately promote this pluralism, I have attempted in *The New Color Photography* to elucidate color photography's unique visual syntax and to focus on those color photographers who best exploit the medium's assets and overcome or minimize its deficiencies."[64]

Eauclaire's efforts assembled those who had come to prominence in the art world through museum and gallery exhibitions in the preceding decade—a noticeable change from Steichen's survey efforts of an earlier moment, in which artists were featured for their prominence in publications and mass media.[65] Eauclaire did not directly comment on this unifying principle, remarking instead on the absence of the commercial photographer's mandate to make a subject pop on the page. Regarding vernacular photography, Eauclaire carefully differentiated between it and the new color photography on the basis of intention: "Though often inspired by an amateur's accidents, their works are as similar to snapshots as Abstract Expressionist paintings are to oil spills."[66] In her adamant defense of the separation of a causal link between generations of color photographers, Eauclaire ended up advocating for an isolationist understanding of 1970s color photography. Such an outlook also imposed an unrealistic insularity. Already by 1981, photographic discourse had been exponentially challenged and expanded by such broader art movements as Pop and Conceptualism as well as within such burgeoning fields as visual culture and cultural studies. A more accurate and less defensive summation of 1970s color photography can thus be found in the concluding sentence of a *Newsweek* column on

63.
Gene Thornton, "Photography View: New Color Photography Is a Blurry Form of Art," *New York Times*, July 10, 1977, p. 73. This was not Thornton's first commentary on vernacular photography in art galleries. When Stephen Shore assembled found photographs for a 1971 exhibition in a New York gallery, Thornton wrote that the effort served as "a healthy, if possibly somewhat unwelcome, reminder of the part that photography really plays in the world." Gene Thornton, "From Fine Art to Plain Junk," *New York Times*, November 14, 1971, p. D38.

64.
Eauclaire, *The New Color Photography*, p. 7.

65.
Thornton also noted this shift in his review of *The New Color Photography*: "There is, therefore, a difference in intention between the new color photographers and the old that leads one to the mass media and the other to the museum. Art lovers tend to assume that the ones in the museum are better than the ones in the mass media, but on the basis of this exhibition, I am not sure that is necessarily so." Gene Thornton, "Photography View: Is the New Color Work So Different from the Old?" *New York Times*, November 8, 1981, Section 2, p. D27.

66.
Eauclaire, *The New Color Photography*, p. 13.

The New Color Photography: "Color, now, is simply a means to an artistic end."[67] There were artists trained in painting, such as William Christenberry, Jan Groover, Robert Heinecken, and Barbara Kasten. There were those interested in the possibilities of performance art, including John Baldessari, Nan Goldin, Bruce Nauman, and John Pfahl. There were others who continued to capitalize on photography's reproducibility, albeit to incredibly different ends, among them Susan Meiselas, Ed Ruscha, and Neal Slavin. All agreed that color photography had arrived, but it had not done so in a way as isolated and insular as *The New Color Photography* suggested. Instead, it retained much of the fluidity, hybridity, and complexity that had been associated with it since the early decades of the century.

A contextualized history of color photography revels in the connections between Steichen and Callahan, Adams and Kodak, Eliot Porter and John Pfahl, Victor Keppler and Laurie Simmons, *National Geographic* and Ruscha's *Nine Swimming Pools*, or between Kodachrome projections at the New York World's Fair and Goldin's performance of *The Ballad of Sexual Dependency* slide show. Approaching color photography in this manner, it becomes possible to chart the emergence and growth of an art market for photography, including color, as much as photography's centrality to art movements of the 1960s and '70s. Restoring contemporaneous conversations surrounding color photography—from the moment it became available as a mass medium to the moment when it no longer seemed an unusual choice for artists—allows a new understanding of that history. This exhibition and catalog attempt all of the above, perhaps quite imperfectly, as a way to start a new conversation about color photography's history.

In his review of Eauclaire's *The New Color Photography*, Thornton expressed regret that "the kind of color photography that normally appears in magazines like *National Geographic*, *Vogue* and *Life*, . . . the art photography of Edward Steichen and Alfred Stieglitz in the days of the Autochrome process, . . . the work of such masters of the carbro color process as Paul Outerbridge and Nikolas Muray, and . . . the work for publication of photographs of the era of Eliot Porter, Irving Penn and Ernst Haas" were "not to be mentioned in the same breath as Eggleston."[68] This exhibition and catalog resolutely believe that they should be, and they offer a long-overdue answer to Thornton's lament. Perhaps even more important, they attempt to restore the nuance, complexity, and fluidity that characterized conversations around color photography for three-quarters of a century.

67.
Douglas Davis, "A Call to the Colors," *Newsweek*, November 23, 1981, p. 115.

68.
Thornton, "Is the New Color Work So Different," p. D27.

Photographer unknown, [Three Women in Winter], ca. 1910s

REAL COLOR

by Lisa Hostetler

In the West, since Antiquity, colour has been systematically marginalized, reviled, diminished and degraded. Generations of philosophers, artists, art historians and cultural theorists of one stripe or another have kept this prejudice alive, warm, fed and groomed. As with all prejudices, its manifest form, its loathing, masks a fear: a fear of contamination and corruption by something that is unknown or appears unknowable.

—David Batchelor, *Chromophobia*[1]

Color is vexing. It is often considered a superficial effect, yet its absence renders a representation seemingly incomplete. Color in photography has had a particularly checkered history. Although photographs in color had been desired since the medium's invention in the nineteenth century, commercially viable color photographic processes were not available until the early twentieth century. By that time, monochromatic photography had become a common part of everyday life, so much so that black-and-white images seemed "real" despite their chromatic deficiencies. As color photographic technologies developed, discussions about the realism of black and white versus color emerged. At times, color photography was deemed too artificial to be real; at others, it was too literal to be artistic. Throughout, the commentary invoked various definitions of realism, from surface resemblance to existential truth. This history is complex, and its interpretation has been far from consistent. But following one aspect of the narrative—that of the medium's perceived relationship to notions of realism between the introduction of the autochrome in 1907 and color photography's establishment in the art world by 1981—lends insight into the nature and status of photographic representation in twentieth-century American art and culture.

When the invention of photography was announced to the French public in 1839, people were astonished at the mechanical accuracy of the medium, but its lack of color was noted as a liability. An 1843 article in the *Edinburgh Review* declared photography

1.
David Batchelor, *Chromophobia* (London: Reaktion, 2000), p. 22.

to be "as great a step in the fine arts, as the steam-engine was in the mechanical arts." Yet while marveling at its ability to render the world accurately, the writer lamented that nature's "gay colours are wanting."[2] Nevertheless, photography was considered by most to be a faithful representation of reality, and the medium has long had a nearly axiomatic reputation for veracity. Even today, in an era replete with color photographs and saturated with images altered in Photoshop, photography's basic truth value is still a common premise (albeit one subject to more skepticism now than in the past).

Why people were willing to overlook photography's chromatic deficiency when they assumed its fundamental truthfulness is a psychological and philosophical question that has no definitive answer. What is clear is that photography's lack of color was a problem that interested many scientists. These include James Clerk Maxwell, who demonstrated in 1861 a theory of color in which the full spectrum could be perceived from red, green, and blue component data. To show this, he made three black-and-white slides of a tartan ribbon, each photographed through a different colored filter—red, green, and blue. Then he projected the slides through those same filters, so that a full-color photograph appeared. Other experimental processes included those developed by Louis Ducos du Huron in 1869, Gabriel Lippmann in 1891, and John Joly in 1893, among others. But these processes were all complicated, expensive, and not readily available.[3]

With the Lumière autochrome's introduction to the market in 1907, the public was finally able to access the realm of color photography. Excitement for the process—which produced a glass plate bearing a unique color image visible when backlit—was palpable, and amateur photography journals soon exploded with articles about it. Authors offered practical advice and encouragement as well as speculation about the effect photography in color would have on more traditional arts. One 1908 article sought to soothe the consternation the autochrome was causing:

> Anxious inquiry is made as to the effect upon art of the Lumière process of photography in color. There is not now, and never will be, any cause for anxiety as to the effect on art of any invention. That any artist or lover of art should feel anxiety on this score indicates a fundamental misapprehension of what art is. . . . Painters may be helped or harmed by an invention such as the Lumière process, but not art. . . . Art, like religion, is mainly an affair of the spirit.[4]

In other words, it was not the technique that determined whether a work was art; it was something more ineffable. Amateur photographer Clarissa Hovey, in an address to the Women's Federation of Photography in Philadelphia, described this something as "the 'man or woman behind the camera.' If you have a sense of color combinations, and of composition and posing, you cannot fail to produce some charming plates. Your autochromes will be characteristic of your work, be that original and artistic, or commonplace and commercial."[5] The goal was to get beyond the realism of the colors to something more evocative and more imbued with the subjectivity of the photographer.

Alfred Stieglitz, the leader of the Photo-Secession—a prominent group of photographers devoted to the advocacy of photography as a fine art founded at the turn of the twentieth century—reiterated the importance of the photographer's sensibility in overcoming the accuracy of color photographs. After declaring the definitive arrival of color photography in the October 1907 issue of *Camera Work*, he praised Edward Steichen's autochromes, citing them as proof that artistic results could be achieved in the new medium. At the same time he warned, "soon the world will be color-mad. . . .

2.
"The Edinburgh Review, January 1843: An Excerpt," in *Photography in Print*, ed. Vicki Goldberg (Albuquerque: University of New Mexico Press, 1981), p. 52.

3.
For more on these early experiments, see Pamela Roberts, *A Century of Colour Photography: From the Autochrome to the Digital Age* (London: Andre Deutsch, 2007), pp. 10–19.

4.
William Howe Downes, "Influence of the Autochrome Process upon Art," *Photo-era* 20 (January 1908): p. 41.

5.
Clarissa Hovey, "Color Photography," *Photographic Times* 64, no. 9 (September 1912), p. 354.

The difference between the results that will be obtained between the artistic fine feeling and the everyday blind will even be greater in color than in monochrome."[6] Stieglitz did not give an explicit reason for his prediction, but it may be inferred that the "everyday blind" results would appear too literal or realistic. In the same article, Stieglitz made a point of distinguishing between the "mechanical" and the "automatic," pointing out that, though the autochrome is a mechanical process, good results are not automatic: "Given a Steichen and a Jones to photograph the same thing at the same time, the results will, like those in black and white, in the one case reflect Steichen, and in the other case probably the camera and lens—in short, the misused process."[7] In other words, the "Jones" would be too straightforward a rendering of what was in front of the camera. Thus while lauding the autochrome's realism—"the pictures themselves are so startlingly true that they surpass anyone's keenest expectations"[8]—Stieglitz nevertheless insisted that the medium admitted room for the artist's vision: "Color work in the camera is not altogether an automatic process . . . it can be made to answer the demand of the artist to a remarkable degree of perfection."[9]

All of these comments suggest the complex relationship between realism and photography that has hovered persistently around the medium throughout its history. The introduction of color photography intensified this discussion, raising questions about the line between reproducing nature and interpreting it. In her book about Realism in nineteenth-century art, Linda Nochlin described a "manifestation of Realism . . . in which the latent subjectivity implied by 'nature viewed through a temperament,' with its emphasis on individual perception rather than conventional, learnable rules for art" was the operative descriptor.[10] This brand of realism lent itself particularly well to photography, which recorded nature but was subject to the sensibility of the photographer, as the preceding comments by Stieglitz and Hovey assert. The autochrome in particular was amenable to this kind of art because it produced images in color, making it both more reflective of the natural world and a step closer to the fine art of painting than traditional monochrome photography. This furthered the goal of the Photo-Secession, which sought to prove that photography could be a fine art equal to painting. The play of light in Stieglitz's autochromes *Two Men Playing Chess* (page 33) and *Frank Eugene Seated at Table* (page 31) emphasizes the light-based nature of color and demonstrates the appeal that autochromes had for photographers who aspired to their medium's acceptance as a fine art.[11]

Despite the potential of the autochrome's artistic application, the fact that autochrome plates had to be viewed through transmitted light made it a rather unwieldy form of photography. The clamor for a way to readily reproduce autochromes on paper elicited a defensive response from Hovey, who expressed her frustration with those who lodged complaints about the inability to print an autochrome on paper:

> I am always irritated when people insist on saying that it is too bad we cannot print [autochromes] on paper. The transparencies are so beautiful. Supposing you *do* have to go to a window and look through them. You cannot enjoy a miniature across a large gallery, nor could you enjoy Sorolla's enormous canvas of the oxen which is in the Metropolitan Museum, in your own 2 x 4 living-room of your apartment.[12]

Hovey's assumption of the autochrome's artistic accomplishment is clear here in the comparison of autochromes with paintings and miniatures. But the difficulty of printing color photographs on paper was a problem that would continue to plague color photography until negative-positive color printing processes were developed during and after World War II.[13]

6.
Alfred Stieglitz, "The New Color Photography—A Bit of History," *Camera Work* (October 1907), p. 22.

7.
Ibid., p. 24.

8.
Ibid., p. 21.

9.
Alfred Stieglitz, "The Success of Color Photography," *The Craftsman* (March 1912), p. 687.

10.
Linda Nochlin, *Realism* (London: Penguin, 1971), p. 235.

11.
In addition, the autochrome's juxtaposition of primary colored grains of starch as the basis for creating a full spectrum of colors was comparable to Impressionism's and Neo-Impressionism's method of painting spots of pure color next to each other in order to create the chromatic effects of light. In fact, one writer asserted that the autochrome was proof of Impressionism's theory of color. See Downes, "Influence of the Autochrome," p. 41.

12.
Hovey, "Color Photography," p. 355.

13.
In fact, autochromes could be reproduced on paper, but the process was expensive and required the expertise of specialists, such as those at *National Geographic*, which began reproducing autochromes in their magazine as early as 1914. Agfa introduced color negative film in 1939, and Kodak came out with its own version, Kodacolor, in 1942. Both allowed for making positive chromogenic prints on paper. For more on the technical history of color processes, see Robert Hirsch, *Exploring Color Photography from Film to Pixels* (Oxford, England, and Burlington, Mass.: Focal Press, 2011), pp. 25–27.

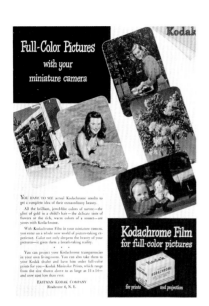

Kodachrome film advertisement, 1946

The difficulty of storing and transporting autochrome plates also limited their feasibility for advertising and editorial use. As Sally Stein has shown, however, there was significant pent-up demand for color photographic images in the commercial world.[14] Throughout the 1920s, manufacturers incorporated advances in industrial dyes into their products (especially in the automobile and kitchen/bath product industries), which allowed them to produce their merchandise in a wider variety of colors. This created the desire for advertisements to appear in color as well.[15]

While many advancements in commercial color photographic processes were made by Anton Bruehl and Fernand Bourges at Condé Nast,[16] other photographers were making names for themselves in the industry as well. Nickolas Muray's images for a double-page spread in the June 1931 *Ladies' Home Journal*, "Diverting Beach Days in Divers Colorful Ways" (page 55)—an early use of carbro prints as the source for color reproduction—celebrate the compositional possibilities of color. Shades of red tie the many parts of the image together, creating a dynamic scene out of a heterogeneous mélange of people and poses. Its underlying theme is a "picture perfect" day by the pool, a slice-of-life from a fantasy in which color plays a key role. Similarly, Paul Outerbridge's still-life *Images de Deauville* (page 71) uses color to evoke an imagined modernist reverie. Both of these reproductions—along with many other color advertising and editorial magazine images—spin perfect worlds with chromatic threads, underlining the association between color and fantasy.

The connotation of color with fantasy persisted even after Kodak introduced color slide film in 1936,[17] which allowed the average person to document their experiences, and despite Kodak's emphasis on the realism of color photography in its advertising. The tag line, "Lifelike in black-and-white. . . . It *lives* in Kodachrome," appeared on a 1936 ad for Kodachrome movie film, and this theme was followed up in a 1939 ad that boasted, "Seems as if she could walk right out of the picture" (page 89). By the mid-1940s the emphasis in Kodak's advertising was on the beauty of color photographs in addition to their realism. A 1946 ad proclaimed, "You have to see actual Kodachrome results to get a complete idea of their extraordinary beauty. . . . Color not only deepens the beauty of your pictures—it gives them a breath-taking reality" (above left). As part of this emphasis, Kodak enlisted Ansel Adams and Edward Weston to make color photographs using its film. They then presented the results in advertisements, such as those in the May 1947 (Weston) and March 1948 (Adams) issues of *Popular Photography* (pages 124 and 128). The copy encouraged readers to join these famous photographers in "expressing themselves in color." The implication was that color photography could be an artistic medium, a subtle argument against the common assumption that it was only of commercial utility. By associating Adams and Weston with color materials, Kodak suggested the aesthetic viability of color photographs. They also suggested that the colors achieved were "real" enough for these two photographers, who were specifically known for their straightforward approach to photography. This association of Adams's and Weston's work with both realism and beauty loosened the coupling of color with commercial photography.

Nevertheless, black and white maintained a reputation for greater veracity, partly due to the success of the documentary photographs produced by the Historical Section of the Farm Security Administration (FSA). Headed by Roy Stryker, who employed a group of photographers, including Jack Delano, Walker Evans, Dorothea Lange, and Marion Post Wolcott, among others, the organization was established as the Resettlement Administration in 1935 to expose the need for and to promote the accomplishments of the New Deal agencies tasked with revitalizing the agricultural economy during the Depression. The division produced photographs of 1930s and early '40s America that have become

14.
See Sally Stein, "The Rhetoric of the Colorful and the Colorless: American Photography and Material Culture between the Wars" (PhD diss., Yale University, 1991), pp. 52–183.

15.
Ibid., chap. 4, "Simulating the Rainbow," pp. 130–83.

16.
For more on Bruehl and Bourges, see Katherine A. Bussard's essay, p. 3, as well as the entry on Anton Bruehl, pp. 58–63, in this book.

17.
Kodak introduced Kodachrome for 16 mm movie film in 1935; sheet and 35 mm Kodachrome slide film appeared the following year. The stability of the process was significantly improved in 1939.

icons of the age, from Lange's *Migrant Mother* to Evans's *Allie Mae Burroughs*. These and other well-known FSA images are in black and white, but FSA photographers did make color slides, and there was a demand for color images, especially among regional FSA offices.

As Sally Stein, who discovered the color FSA slides in the Office of War Information files at the Library of Congress in 1978,[18] has shown, however, there was a prejudice against color when it came to documentary photography: "In the new Depression era, modern industrial color came under a cloud of suspicion as a marked sign of the profligate commercial culture which threatened to divide the social fabric."[19] In the visual rhetoric of documentary photography, monochrome photography's distortion of reality—its removal of the colors of everyday life—was not perceived as a falsification. Instead, it "produced a leveling effect, creating a great sense of parity between disparate phenomenon [*sic*] . . . documentary fostered the impression that color was of little consequence to thirties culture, that color had faded with other reckless illusions that characterized an earlier era of prosperity. However fitting such a sign of dispossession may seem for the Depression, it was a sign that corresponded more closely to a symbolic current of the era than to the material conditions of thirties culture."[20] According to Stein, the reality of American life during the Depression was less monochromatic than documentary photographs make it seem.

The color slides made by FSA photographers John Collier, Jack Delano, Russell Lee, Arthur Rothstein, John Vachon, and Marion Post Wolcott between 1939 and 1943 are a corrective balance to the familiar black-and-white version of Depression-era America (pages 95–99). Although their color images were not as widely seen as their black-and-white ones, such works provide previously unacknowledged insight into the character of American life during this period. The fact that they were not well known stems from Stryker's inability to get them published,[21] likely because of the above-mentioned bias against depicting serious social subjects in color:

> Already by 1942, the authority of documentary's realist claims were closely tied to its conservatively monochrome appearance in what can only be described as a tautological relation: documentary appeared to present the unmediated truth because it was in black and white, and black and white acquired a new currency as the reigning values of contemporary reality because it served as the conventional form of documentary. This tautology would continue to govern the ensuing tradition of documentary and its reception.[22]

Thus in the documentary era—the 1930s and early '40s—monochrome photography's association was with reality and truth, while color photography was usually associated with superfluous fantasy and commercial extravagance.

Exceptions to this rule existed, however, especially among a few avant-garde artists. László Moholy-Nagy, for one, took color photography seriously, but in his case, "serious" did not imply a documentary idiom. Consistent with his Bauhaus-inspired pedagogy, Moholy-Nagy advocated an integration of art with life as a means to progressive social change. As part of that goal, he sought "an education of the senses, the ability to articulate feeling through the means of expression."[23] Part and parcel of this was to reject conventional approaches to viewing the world, and for him, the camera was an integral part of this. It was a thoroughly modern tool that allowed for refreshed ways of seeing because it transcribed light—the most fundamental component of vision—directly, without the intervention of human subjectivity. Since a primary component of light was color,

18.
Her findings were first published in Sally Stein, "FSA Color: The Forgotten Document," *Modern Photography* (January 1979): pp. 90–98, 162–64, 166.

19.
Stein, "The Rhetoric of the Colorful," p. 183.

20.
Ibid., pp. 191–92.

21.
Ibid., p. 209. Although no color images by FSA photographers were published, the FSA did create slide shows for its regional offices. Stein speculated that many more slides than those found in the FSA files existed, but were possibly never returned to the Washington office. Ibid., p. 210.

22.
Ibid., pp. 206–7.

23.
László Moholy-Nagy, *Vision in Motion* (Chicago: Paul Theobald, 1946), p. 5.

24.
"Any object with combined concave-convex or wrinkled surfaces may be considered a light modulator since it reflects light with varied intensity depending upon its substance and the way its surfaces are turned toward the light source." Ibid., p. 198. In addition to using pieces of paper and the human face as light modulators, Moholy built a kinetic metal and wood sculpture that he called a Light Modulator and filmed it in motion.

25.
Ibid., p. 172.

26.
On Moholy's production of black-and-white and color photography, see Hattula Moholy-Nagy, "The Rediscovery of Moholy-Nagy's Color Photography," in László Moholy–Nagy: Color in Transparency; Experiments in Color 1936–1946, ed. Jeannine Fiedler and Hattula Moholy-Nagy (Göttingen, Germany: Steidl; Berlin: Bauhaus-Archiv, 2006), pp. 7–10.

27.
See especially László Moholy-Nagy, "Paths to the Unleashed Colour Camera," Penrose Annual 39 (1937): pp. 25–34, and Moholy-Nagy, Vision in Motion, pp. 170–76. His practice of standing in the middle of traffic at night to make his color slides became popular among the students and faculty of the Photography and Light Workshop at the School of Design. Fiedler and Moholy-Nagy, Color in Transparency, p. 158. Both Harry Callahan and György Kepes made color slides in this fashion.

28.
See the chronology in this catalog for a listing of exhibitions that included color photographs at MoMA and elsewhere.

29.
Quoted in "Museum's First Exhibition of All Color Photography to Be on View May 10 through June 25" (press release, Museum of Modern Art, New York, May 4, 1950), p. 2. www.moma.org/learn/resources/press_archives/1950s/1950/1.

30.
Ibid.

31.
Jacob Deschin, "Steichen on Color," New York Times, March 3, 1957. These comments suggest that the color Callahan photographs that Steichen showed in 1957 were more like the storefront in Detroit (page 114) than like the light abstractions he had included in Color Photography. Deschin described Callahan's series in Color Photography as "wiggly-line abstractions, in which color sensation appears to be the chief motif." Jacob Deschin, "Pictures in Color," New York Times, May 14, 1950.

32.
Quoted in Deschin, "Steichen on Color."

Moholy-Nagy saw great potential in color photography, particularly if its subjects were nonrepresentational. To that end, he proposed experimenting with photograms (cameraless photographs), unusual points of view, and light modulators,[24] rather than photographing ordinary scenes in color. Moholy-Nagy's goal, and the instruction he instilled in others, was to create a visual impression purely by color and light, "not in order to create an illusion of a naturalistic scene but to build up a new feeling of space."[25] Thus Moholy-Nagy's color photography is distinct both from the realism of documentary photography and from the fantasy world portrayed in color advertising photography.

Between 1937 and his death in 1946, Moholy-Nagy made over two hundred color slides and transparencies, which composed the majority of his photographic output after he immigrated to America in 1937 (pages 86–87).[26] These slides are primarily abstract arrangements of light and color—headlights and neon signs on Chicago streets at night, "light-box" studies, images of sculptures made specifically to capture and reflect light—although they also include everyday scenes viewed from unusual vantage points. Moholy-Nagy showed these slides in lectures and classes at the Institute of Design in Chicago, where they had a broad impact, and wrote about color photography in his last book, Vision in Motion.[27] For Moholy-Nagy, as well as for later artists like Hy Hirsh (page 140–41), color photography offered entry to an alternate reality, one where color and light were not abstractions of reality, but reality itself.

Around World War II, color photographs began to enter the art world, initiating a debate about their place there. In 1937 Beaumont Newhall included color photographs in his exhibition Photography 1839–1937, at the Museum of Modern Art, New York, and in 1943 MoMA held its first exhibition devoted to a single photographer that featured a significant number of color photographs, Birds in Color: Flashlight Photographs by Eliot Porter. Under the guidance of MoMA's director of photography, Edward Steichen, color photographs were regularly included in subsequent exhibitions, including the landmark 1950 show Color Photography.[28] Steichen wrote that the exhibition "asks more questions than it answers, for in spite of fine individual attainments and rich promise, color photography as a medium for the artist is still something of a riddle."[29] The reason, Steichen suggested, was that "neither the photographer nor the public has as yet overcome the unconscious conditioning firmly established by the black and white photograph."[30] In other words, despite decades of color photography's availability to amateur and professional photographers, it was still seen as a novelty.

In 1957 Steichen gave a lecture entitled "Experimental Photography in Color," in which he reflected further on the nature and direction of color photography. No transcript of the lecture remains, but New York Times photography writer Jacob Deschin reported that Steichen drew a distinction between Ernst Haas's work in color and that of Harry Callahan, "in whose pictures Mr. Steichen found the photographic image intact. In commenting on slides by Ernst Haas, he noted treatments derivative of painting."[31] Deschin went on to quote Steichen further: "Any form of local interference with the photographic image constitutes an invasion of the other graphic arts. Today we must recognize the possibility that much experimental photography is moving into a more serious aberration when the influence of concepts of modern painting leads to imitating concepts that are actually peculiar to painting."[32] This dichotomy between color photographs in which the photographic image was "intact" versus those that were "derivative of painting" was echoed in much writing about color photography at the time.

The color photography that was considered "derivative of painting" was usually abstract or nondocumentary, such that by Syl Labrot (pages 150–53). However, even artists who photographed recognizable subjects in color, such as Ernst Haas, Saul Leiter, and Arthur Siegel, were often referred to as "painterly" photographers, and their work was

commonly described as "unreal" or "surreal." The November 20, 1950, issue of *Life* magazine presents Siegel as a painter with a camera—"With camera for a palette, Arthur Siegel rivals the work of contemporary painters"—and compares his images to work by Georges Braque, Claude Monet, and Jackson Pollock.[33] This, despite the fact that the work itself does not appear particularly abstract, as that selection of painters would indicate, suggests that it was the color that earned it its "painterly" moniker. The text introducing Haas's 1953 portfolio of color photographs for *Life* states that Haas photographed patterns and reflections "so as to make the real seem unreal";[34] however, many of the images appear to be more realistic than "unreal" today. Similar comments were made about Leiter's work in color. The 1960 *Color Photography Annual* published a portfolio of his images under the title "Saul Leiter's Dream World," in which H. M. Kinzer wrote that his pictures "make us say 'unreal' or 'weird,'" and that they are "not readily described or discussed."[35] Yet again, the subjects are identifiable and relatively straightforward, if evocatively seen.

In the same article on Leiter, Kinzer asserted that "the images strike a responsive chord somewhere in the unconscious."[36] This connection between color and the unconscious, or color and emotion, also surfaced regularly in writing about color photography. As late as 1969, Irv Tybel wrote in that year's *Color Photography Annual*: "Black-and-white images tend to be intellectual and cold, while color is anti-intellectual and warm . . . Color images seem meant to be caressed with the eyes—to be felt rather than thought about. Sensual. Emotional. Virtually a visual narcotic."[37] Joel Meyerowitz also understood color photography in a more emotional register than black and white:

> When I committed myself to color exclusively, it was a response to a greater need for description. . . . When I say description, I don't only mean mere fact and the cold accounting of things in the frame. I really mean the *sensation* I get from things—their surface and color—my memory of them in other conditions as well as their connotative qualities. Color plays itself out along a richer band of feelings—more wavelengths, more radiance, more sensation.[38]

Meyerowitz's work bears this out. In photographs like *Red Interior* (page 205), the varied rendering of multiple sources of light—the moon, a streetlight, the car's interior light, the lights on the cottages, and the headlights entering the scene from the lower left—creates a specific, twilit mood on color film that would not be the same in black and white.

Throughout the 1950s and 1960s, perceptions of color photography wavered between its being too "painterly" and its being too literal. Both qualities were understood to limit the medium's artistic potential. The bias against color photography's ability to produce images that were "real" enough to eschew the "painterly" or artificial label was in part technical. Photographers could neither develop nor print most color materials themselves; they had to send them to a lab for processing, depriving the photographer of the ability to make adjustments in the darkroom, as was common in black-and-white photography. As Bruce Downes pointed out in the 1960 *Color Photography Annual*, there were also many variables in the processing of color film—from the chemicals' temperature to the nature and character of light in the original exposure—that made the results unpredictable.[39] Such unpredictability inhibited the acceptance of artistic intention in color photography.

The situation was complicated by the simultaneous perception that these same technical constraints produced results that were too literal. The 1957 *Color Photography Annual* took on this question directly in the symposium "How Creative Is Color Photography?"[40] Thirteen photographers and commentators—Bill Brandt, Don Briggs,

33.
"Modern Art by a Photographer," *Life*, November 20, 1950, pp. 78–84.

34.
"Images of a Magic City," *Life*, September 14, 1953, p. 108.

35.
H. M. Kinzer, "Saul Leiter's Dream World," *Color Photography Annual* (1960): p. 46. To his credit, Kinzer went on to suggest expanding our notion of the "real" to encompass this more ephemeral realm: "If they make us say 'unreal' or 'weird,' that may only reflect our own misunderstanding of the 'real.' For Leiter, these are images of actuality, drawn from the most significant layers of awareness, seen in the truest perspectives."

36.
Ibid.

37.
Irv Tybel, "How to Think about Color," *Color Photography Annual* (1969): p. 50.

38.
Joel Meyerowitz, "A Conversation: Bruce K. MacDonald with Joel Meyerowitz, July 22–26, 1977," in *Cape Light: Color Photographs by Joel Meyerowitz* (Boston: Museum of Fine Arts; New York: New York Graphic Society, 1978), n.p.

39.
Bruce Downes, "Color's Frustrations," *Color Photography Annual* (1960): p. 21.

40.
"How Creative Is Color Photography?" *Color Photography Annual* (1957): pp. 13–25, 169–70.

Jacob Deschin, Eliot Elisofon, Ralph Evans, Ed Feingersh, Fritz Henle, Wilson Hicks, Arnold Newman, Robert Stein, Bert Stern, Paul Strand, and Minor White— participated, and many of them based their comments on the perceived literalism of color photography. Strand asserted that color photography was not yet controllable enough to elicit works of art. He went on to question its realism as well: "So far as I see it, the kind of color which is naturalistic and largely uncontrollable . . . does not give us a greater sense of reality. On the contrary, it tends to diminish the vitality of the photographic image, replacing the dramatic and imaginative possibilities of the black-and-white relationships with a partial and more or less corny verisimilitude."[41] Brandt called color photography "hit-and-miss," and Newman thought it was too intractable to be a truly expressive medium.[42] For some of the symposium participants, then, color photography's limited allowance for manipulation during development made it too literal. At the same time, this literalism was not realism per se but "corny verisimilitude," in Strand's phrase.

Others admitted the creative possibilities of color in the right hands: "If a photographer approaches the *presence of color* in [a] creative way, how can color then be 'too flagrantly literal,' as some photographers charge? . . . Literalness is much more a state of mind than the attribute of a medium."[43] Deschin agreed: "The notion that color photography is too realistic and too literal a medium to offer creative possibilities has been disproved so often . . . that one wonders how it can persist."[44] Fashion photographer Stern acknowledged color photography's literalism but embraced it: "We experience life in color. Color is closer to reality than black-and-white. Many photographers feel that color is too realistic and tends to be pretty, and that black-and-white is more graphic. . . . However, if color is more realistic, then can't it be used to make fantasy and illusion more believable?"[45] Hicks questioned the realism of both color and black-and-white photography, noting that both were distortions of reality.[46] In the final analysis, there seemed to be two arguments: One was that color photography was too literal and too difficult to control to be creative; the other was that color photography was realistic but that this did not inhibit its ability to be expressive. For his part, in another article in the same *Color Photography Annual*, Haas suggested a new "color consciousness" outside of traditional notions of realism and the painterly: "As we had to create a consciousness for black-and-white representing color, we now have to try to create a color consciousness in itself . . . color photography I feel lends itself especially to expressing a visual kind of poetry."[47]

While this argument was raging in the photography world, artists who came to color photography from other media ignored the complaints and caveats lodged against color photography as art. Saul Leiter came to photography from painting, and he accepted the unpredictability of color in 35 mm slide film as another element in his creative toolkit. After studying as a painter in the 1950s, Marie Cosindas took up Polacolor film in 1962, using it to make portraits and still-lifes.[48] Rather than being daunted by the film's self-contained, relatively instantaneous development, she asserted control over her materials by extending development times, adjusting lighting, using filters, and controlling the temperature in the room. Her efforts were successful enough that MoMA exhibited her work in a solo show in 1966. Neither Leiter nor Cosindas was intimidated by the perceived literalness of color photographs.

By the late 1960s and '70s, the "corny verisimilitude" of color photography was being used by some as an artistic asset. William Eggleston and Stephen Shore relied on the literalness of color photography and the ubiquity of color snapshots as a reference point for their work. With the emergence of Pop art and Photo-Realism in the 1960s and '70s, the color photography of Eggleston and Shore gained context in the art world.

41.
Ibid., p. 169.

42.
Ibid., p. 14 (Brandt), p. 25 (Newman).

43.
Robert Stein, in ibid., p. 169.

44.
Ibid., p. 16.

45.
Ibid., p. 169.

46.
Ibid., p. 23.

47.
Ernst Haas, "Haas on Color Photography," *Color Photography Annual* (1957): p. 30.

48.
Although Polacolor film did not go on the market until 1963, Cosindas was one of about a dozen photographers to whom Polaroid supplied the film for experiment and feedback in 1962.

These photographers' deadpan realism and appeal to popular and commercial forms held much in common with those two painting styles. Janet Malcolm identified Eggleston's terrain as "Photo-Realist country" and described its features:

> Photo-Realist country is defined by the presence of recently made structures, machines, and objects; by people dressed in clothes of the cheap, synthetic, democratic sort; by the signs and the leavings of fast food, fast gas, fast obsolescence; by the inclusion of the very parts of the landscape that photographers used to try to eliminate, edging the bridal couple away from the parked cars, angling the lens to exclude the Laundromat sign encroaching on the quiet tree-lined street. Such props have become the Cézanne apples, the Monet poppies, the Cassatt white dresses of Photo-Realism.[49]

Malcolm suggested that Eggleston's work was derivative of Photo-Realist painting, but a more charitable interpretation of Eggleston's accomplishment would recognize that he was a kindred spirit rather than a secondary follower. Both he and Photo-Realist painter Robert Bechtle, for example, drew inspiration from their everyday surroundings, but whereas Bechtle translated vernacular snapshots into enlarged painted equivalents, Eggleston embodied the snapshot aesthetic in his own photographs. Both asserted the primacy of photographic seeing in contemporary visual culture, yet their separate approaches inflected the meaning of their works differently. For Bechtle, the psychological intensity of the painted surface becomes the focus of the work; for Eggleston, the reality of seeing the mundane details of the world as photographs takes precedence.

In addition to photographers who capitalized on the literalism of vernacular color photographs, a host of other color photographers emerged in the 1970s as more museums and galleries opened their doors to photography. These ranged from Jan Groover and Barbara Kasten to Nan Goldin and Lucas Samaras, among many others.[50] The broad diversity of such artists' work began to break down the "painterly" versus "literal" categorization of color photography that arose in the immediate postwar years. In addition, the fact that photographs in general were gaining currency in the art world pushed discussions about color photography beyond the issue of a narrowly understood definition of realism. The relative accuracy or unreality of the colors in Groover's Kitchen Still-Lifes (pages 201 and 203), for example, was not a main topic of commentary about her work. Instead, they were discussed in terms of formalism, modernism, and even feminism—terms that were not reserved for photography alone. In the realm of photojournalism, the question of realism lingered. However, photographers known for working in color, such as Larry Burrows in the 1960s and Susan Meiselas in the late 1970s, paved the way for the further acceptance of color photojournalism in the 1980s.

In his 1975 article "The Coming to Age of Color," Max Kozloff described photographs by Joel Meyerowitz, Stephen Shore, and Neal Slavin as "expressive realism."[51] He also connected these photographers' work both to a history of color photography that he had articulated earlier in his essay—one in which vernacular and commercial applications were dominant—and to the tradition of black-and-white art photography, which he saw as the primary reference point for their work. In bringing these two trajectories to bear in commenting on contemporary color photography, Kozloff effectively provided a context for the work. At the same time, by labeling the culmination of these two lineages "expressive realism," he suggested a new kind of realism for color photography, one that acknowledged the medium's early connotations while recognizing

49.
Janet Malcolm, "Photography: Color," *New Yorker*, October 10, 1977, repr. in *Diana and Nikon: Essays on Photography* (New York: Aperture, 1997), pp. 83–84.

50.
For a thorough account of color photography's rise during the 1970s, see Kevin Moore, *Starburst: Color Photography in America 1970–1980* (Ostfildern, Germany: Hatje Cantz; Cincinnati: Cincinnati Art Museum, 2010).

51.
Max Kozloff, "Photography: The Coming to Age of Color," *Artforum*, January 1975, p. 35.

its capacity for accurate description. This kind of photography, and the term he used to describe it, inhabited the space between the painterly and the literal, identifying fertile ground for further development.

By 1981, when Sally Eauclaire attempted to assess and evaluate the state of color photography in the art world with her book *The New Color Photography*, the medium had come to embody a wide swath of work. Although Eauclaire made an effort to include a variety of works that describe a problematic cornucopia of artistic exploration, her book and the exhibition that it accompanied established color photography as an artistic domain with a critical mass of notable practitioners. Add the increasing numbers of Conceptual artists who made color photographs part of their creative work, including Bruce Nauman and John Baldessari, as well as artists who used color photography to make their imagined scenarios seem commonplace, such as Cindy Sherman, and the result is an art world filled with color photographs. The efficacy of such works often depends on color photography's ability to invoke a documentary mode. By that time, color photographs could do so because they had been a ubiquitous part of everyday life for several decades. In the 1980s, color photography left debates about its realism behind. Embraced both by artists and the public at large, the medium had come into its own, and color became an integral component of both poetic and prosaic representations of the world.

As the story of color photography's relationship to realism demonstrates, the acceptance of the medium had a long and challenging history in America. Often, in order to find a place in the art world, it had either to overcome or to make a virtue of its associations with artifice and popular culture. Even when color photography did seem real—as opposed to novel or decorative—there was still a prejudice against its literalism. It took decades of photographers' persistent use of color photography for its allegorical possibilities to be fully embraced. Now that they are, it is easy to forget how controversial the realism of color photography once was.

1

EARLY AUTOMATIC COLOR

A practitioner and champion of fine-art photography, Alfred Stieglitz ushered in the possibility and promise of color photography even before the technology was available in America. While in France in June 1907 he came across the recently established Lumière autochrome, the first commercially available color photographic process. Stieglitz quickly embraced the technology and experimented with autochromes during a trip to the Bavarian town of Tutzing, Germany, to visit fellow photographer Frank Eugene. While there, Stieglitz taught the color process to Eugene and created his first series of autochromes, consisting of snapshot-style photographs of Eugene and his companions (pages 31–33).

Stieglitz's excitement about the autochrome led him to organize the first American exhibition of the color process. The exhibition was presented at 291, the gallery of the Photo-Secession, a group founded by Stieglitz to raise photography to the status of painting and sculpture. The show featured the color plates made in Europe by Eugene, Edward Steichen, and Stieglitz. Stieglitz's haste in exhibiting this new color work came from a belief in its aesthetic potential. He wrote in the October 1907 issue of the group's journal, *Camera Work*, "We venture to predict that in all likelihood what the Daguerreotype has been to modern monochrome photography, the Autochromotype will be to the future color photography. We believe the capitalist, who has for obvious reasons fought shy of color 'fanatics,' will now, in view of the beautiful and readily obtained practical results with the Autochrome plate, untie his purse-strings and support the color experimenters whose numbers are already legion."[1]

The press release for this first exhibition of autochromes stressed the novelty not only of the color photographs themselves but also of the display of such work in an American gallery.[2] As Stieglitz predicted, the realistic quality of the color plates greatly intrigued the American public, prompting a *New York Times* review of the exhibition to recount the autochrome's chromatic truthfulness to nature: "To the layman it seemed that he was simply looking through a window at the person or thing reproduced. One picture showed a little girl sitting on the grass among some flowers. It was just the girl and the grass and the flowers, color and all."[3]

Stieglitz presented exhibitions of the color process at 291 in November–December 1907, March 1908, January 1909, February 1909, and January–February 1910.[4] By the early 1910s, Stieglitz had almost entirely ceased creating autochromes, possibly due to the difficulty of producing and exhibiting the plates and the high cost of the medium. Despite Stieglitz's short-lived color career, his early promotion of the autochrome established a precedent for the artistic success of future color processes in America.

A. S.

1.
Alfred Stieglitz, "The New Color Photography—A Bit of History," *Camera Work* (October 1907), repr. in *Camera Work: The Complete Illustrations, 1903–1917*, ed. Simone Philippi (New York: Taschen, 1997), p. 376.

2.
Ibid., p. 381.

3.
"Nature Reproduced by New Color Plates," *New York Times*, October 5, 1907, p. 8.

4.
John Wood, *The Art of the Autochrome: The Birth of Color Photography* (Iowa City: University of Iowa Press, 1993), p. 47.

ALFRED STIEGLITZ

Alfred Stieglitz, *Frank Eugene*, 1907

Alfred Stieglitz, *Mrs. Selma Schubart*, 1907

Alfred Stieglitz, *Frank Eugene Seated at Table*, 1907

Alfred Stieglitz, *Two Men Playing Chess*, 1907

GEORGE SEELEY

1.
For more on Seeley's engagement with the Photo-Secession and his transition to color photography, see George Dimock and Joanne Hardy, *Intimations and Imaginings: The Photographs of George H. Seeley* (Pittsfield, Mass.: Berkshire Museum, 1986).

2.
J. Nilsen Laurvik, "The New Color Photography," *The International Studio* 34, no. 133 (March 1908): pp. 20–23.

George Seeley created autochromes with a straightforward approach that eschews symbolism in favor of a realistic representation of color and texture. In contrast to Seeley's earlier use of Pictorialism—a style of photography that employed the camera for allegorical ends—his autochromes explore the physical qualities of the objects they depict.[1] Precarious bowls filled with colorful items frequently appear in his autochromes, creating a juxtaposition of luminescent surfaces and sumptuous textures that enhance the unique translucent quality of the glass plate (right). At the same time, there is a suggested kinship between the autochrome and still-life painting, as they both rely on the same formal language.

Seeley learned the autochrome process from artist and critic J. Nilsen Laurvik, who praised the Photo-Secessionists for their mastery of the medium in his 1908 article "The New Color Photography."[2] Although the article was written two years prior to Seeley's first autochromes, Laurvik's description of the "pioneering" efforts of Seeley's Photo-Secession colleagues resonates with Seeley's work: "The colors have been reproduced with surprising fidelity and with a richness and brilliance that, in some cases, rival those of oil painting." Furthermore, in contrast to Stieglitz (pages 30–33), who used the autochrome to make casual portraits of family and friends in color, Seeley exclusively photographed still-lifes. He continued to produce autochromes throughout the 1920s, after Photo-Secession members had largely abandoned the medium, and his work is a testament to the relationship between painting and color photography initiated by the autochrome.

G. D.

George Seeley, [Red Bowls with Red Beads, Green Fabric], 1909

Arnold Genthe, *Rainbow at the Grand Canyon*, 1906–12

1.
Arnold Genthe, *As I Remember* (New York: Reynal and Hitchcock, 1936), p. 119.

2.
Ibid., p. 106.

3.
Collier's Weekly, March 30, 1912, p. 12.

In 1904 Arnold Genthe traveled to the Grand Canyon with the intention of creating photographs, but refused to take a single shot, concluding, "unless it can be done in color it would be a desecration."[1] Shortly after color photographs became commercially available to American photographers, Genthe incorporated autochrome production into his existing practice, using the medium to create vivid landscapes and colorful portraits throughout the country, including an eventual return to the Grand Canyon. Genthe made his first autochrome plates in Carmel, California, depicting a number of a sea- and landscapes, including poppy fields (right). Of the experience, he wrote, "My first trials with the medium were made at Carmel where the cypresses and rocks of Point Lobos, the always varying sunsets and the intriguing shadows of the sand dunes offered a rich field for color experiments. I gradually made myself familiar with the intricacies and uncertainties of the process."[2] The photographs resulting from this excursion, as well as portraits of friends and stage celebrities, were exhibited in 1911 at the Vickery Galleries in San Francisco, as well as in Genthe's New York studio a year later. In response to the fragile nature of the autochrome, Genthe devised both lighting and cooling mechanisms, which allowed him to project his images without overheating them.

While Genthe's autochrome plates were well received by the press and public alike, they reached a wider audience in 1912, when his photograph of a rainbow sweeping over the Grand Canyon (above left) was reproduced in full color in *Collier's Weekly*, including the caption: "The Rainbow: This, the first color photograph of a rainbow is reproduced from a Lumiere [sic] plate made in the Grand Canyon of Arizona by Dr. Arnold Genthe."[3] Genthe's images, which were printed by the Beck Engraving Company of Philadelphia, were the first of a number of his color photographs to be reproduced in publications, including *American Magazine*, *Delineator*, and *Town and Country*. Although Genthe continued to produce monochrome photographs throughout his career, the autochrome allowed him to capture specific subjects that seemed to demand representation in color.

G. D.

ARNOLD GENTHE

Arnold Genthe, *Poppies*, 1912

NATIONAL GEOGRAPHIC

National Geographic was one of the first American publications to consistently use color photographs. Although the magazine featured hand-colored photographs beginning in 1910, its first published autochrome appeared in the July 1914 issue. The image, depicting a garden from the Horticulture Hall at the World's Fair in Ghent, Belgium, was accompanied by a caption that demonstrates the novelty of color photographs: "This photograph, taken on a Lumiére Autochrom [sic] plate . . . makes one wonder which the more to admire—the beauty of the flowers or the power of the camera to interpret the luxuriant colors so faithfully."[1] Shortly thereafter, in 1915, the magazine hired two illustration editors specifically charged with furthering the magazine's use of state-of-the-art photographic processes.

In 1916 the magazine's first series of multiple autochromes appeared in the article "The Land of the Best: A Tribute to the Scenic Grandeur and Unsurpassed Natural Resources of Our Own Country" (pages 42–43).[2] These twenty-three autochromes by Franklin Price Knott depict a wide range of subjects from portraits to landscapes. Given that the magazine often took an international focus, it is noteworthy that the first extensive use of color photography is exclusively dedicated to the United States.

The magazine continued to celebrate American subjects in color in 1923 and 1928, when it featured Colorado-based photographer Fred Payne Clatworthy's vivid Western landscapes and portraits of Native Americans. The popularity of his photographs inspired the magazine to raise the price paid to photographers, from $10 to around $62 per image.[3] The importance of color photography to the magazine is further demonstrated by the choice made in 1927 to include autochromes in every issue.

Although the United States is a repeated subject during the magazine's early use of color, eight autochromes by Helen Messinger Murdoch illustrate the March 1921 article "From London to Australia by Aeroplane: A Personal Narrative of the First Aerial Voyage Half Around the World."[4] Murdoch translated conventions of monochromatic documentary to the autochrome through straightforward presentations of iconic sights and ethnographic images attuned to differences in dress and custom (page 41).

National Geographic offered a unique opportunity to see far-flung regions reproduced in full color soon after this became a technical possibility. Knott summarized the impact of this decision: "By color photography, millions who read this magazine may glimpse the glories of Nature—God's own great studio. Like an artist's brush, now the camera catches every tint and shade from Arizona desert or Alpine sunset to the gorgeous panoply of Indian rajah courts and the bronze beauty of jungle maids asplash lotus pools."[5] *National Geographic* continued to endorse color, becoming one of the first American publications to print images taken with 35 mm Kodachrome film, and by the 1960s, the magazine was synonymous with color photography of exotic locales. In 1962 *National Geographic* had the distinction of being the American magazine that published the largest number of color images.

G. D.

1.
National Geographic, July 1914, vol. 26, p. 49.

2.
Gilbert Grosvenor, "The Land of the Best: A Tribute to the Scenic Grandeur and Unsurpassed Natural Resources of Our Own Country," *National Geographic*, April 1916, vol. 29, pp. 327–430.

3.
C. D. B. Bryan, ed., *The National Geographic Society: 100 Years of Adventure and Discovery* (New York: Harry N. Abrams, 1987), p. 171.

4.
National Geographic, March 1921, vol. 39, pp. 281–88.

5.
Quoted in Bryan, *National Geographic Society*, p. 169.

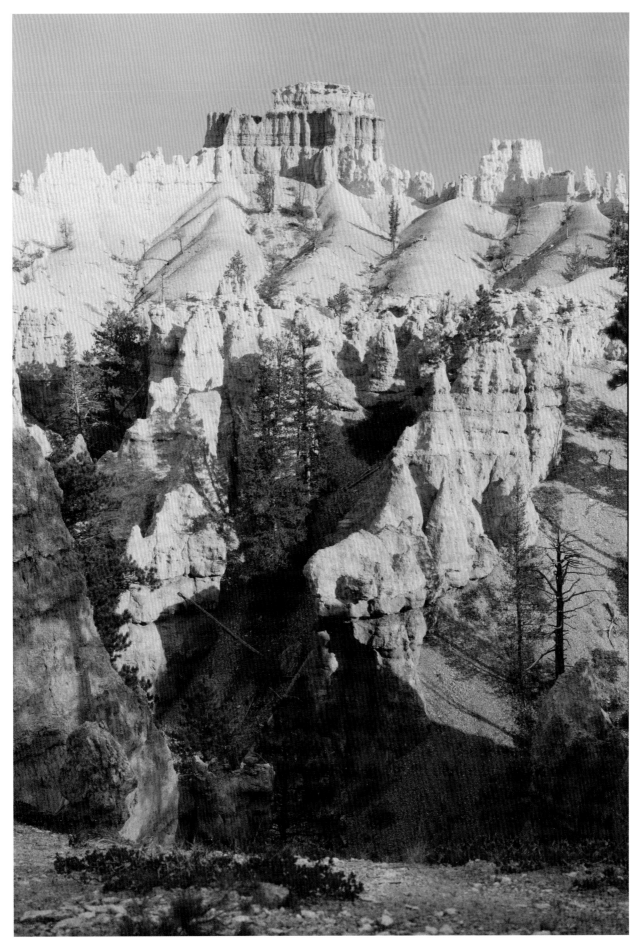

Fred Payne Clatworthy, *And Huge Aerial Palaces Arise, Like Mountains Built of Unconsuming Flame,* ca. 1924

Fred Payne Clatworthy, *Sunset*, ca. 1915

Helen Messinger Murdoch, *A Maid and Bride of Kandy, Ceylon*, 1914

Autochrome by Franklin Price Knott

A STRIKING POSE IN THE EAST INDIAN DANCE,
"THE GARDEN OF KAMA"

382

Autochrome by Franklin Price Knott

THE POETRY OF MOTION AND THE CHARM OF COLOR

383

Franklin Price Knott, spread in *National Geographic*, April 1916

Autochrome by Franklin Price Knott

THE BIRTHPLACE OF THE RAINBOW

Man cannot unscramble eggs, but a single drop of water can unscramble light, and the effect of this process at the Bridal Veil Falls of the Yosemite is both sublime and beautiful. The Yosemite contains four other falls as magnificent as the subject of this picture, the Vernal Fall (drop 317 feet), the Nevada Fall (drop 594 feet), the Illilouette Fall (drop 370 feet), and the Yosemite Falls (upper fall, drop of 1430 feet; lower fall, drop of 320 feet). The Bridal Veil Falls has a drop of 620 feet. Each one of these five remarkable waterfalls surpasses in grandeur and the magic play of light and water, any waterfall of Switzerland or on the continent of Europe.

404

Autochrome by Franklin Price Knott

CONSIDERING THE LILIES: MT. SHASTA IN THE DISTANCE

Mount Shasta, according to an Indian legend, was the first mountain made by the Creator as His masterpiece, and with this as a model He designed the other mountains of the world. The ascent of Shasta is difficult, but with competent guides is not perilous. With the little town of Sisson as a base, there is a good horseback trail to Timberline Camp, an overnight rest six miles away. Starting from this camp very early the next morning, the experienced mountaineer can make the ascent and return to Sisson in a day.

405

Franklin Price Knott, spread in *National Geographic*, April 1916

Edward Steichen, *Frances Farmer*,
September 21, 1937

1.
For more information on Steichen's color
fashion and advertising photography,
see Alison Nordström and Jessica Johnston,
"A New Slice of the Archive," in *Steichen
in Color: Portraits, Fashion and Experiments*
(New York: Sterling Innovation, 2010),
pp. 13–32.

2.
Steichen's inclusion of color photographs
at MoMA built on the legacy of
Beaumont Newhall, the museum's first
curator of photography, who featured
color photographs, including Steichen's
autochromes and a carbro print, in his
1937 survey exhibition of photography.

Edward Steichen championed the development of color photography in American art from its introduction via the autochrome in 1907, through its commercial dominance on the printed page in the 1920s and 1930s, to its initial appearance in museums in the 1940s. Over a career spanning nearly six decades, Steichen remained committed to the potential of color photography to thrive in both the aesthetic and commercial realms.

After attending the initial presentation of the Lumière autochrome process in Paris in June 1907, Steichen mastered the technique, creating dozens of autochromes over the summer months alongside Alfred Stieglitz and Frank Eugene (right). They were displayed that September in the first American exhibition of autochromes at Stieglitz's Little Galleries of the Photo-Secession (known as 291). Steichen's autochromes were subsequently shown in several exhibitions at 291 through 1910 and reproduced in multiple issues of the Photo-Secession's journal, *Camera Work*.

Steichen's next engagement with color photography came in the 1920s and '30s with his mastery of several new color techniques such as carbro printing and dye imbibition processes. During this period, he worked primarily for commercial magazines and advertising firms, becoming chief photographer for Condé Nast's *Vogue* and *Vanity Fair* in 1932. Steichen's color photographs were among the first published in these magazines, and their popularity helped convince Condé Nast to invest heavily in color printing technology. It also led to Steichen's significant output of celebrity portraits (left) and fashion photographs in color.[1]

Steichen retired from commercial photography in 1938, shortly before joining the Navy to fight in World War II. During the war, Steichen began curating exhibitions for the Museum of Modern Art, New York, and in 1947 he was named the museum's director of photography. In this role, he created an exhibition program that regularly included color work by some of America's most celebrated photographers, suggesting color photography was an important part of the history of the medium.[2] One of Steichen's first exhibitions as director, *In and Out of Focus: A Survey of Today's Photography* (1948), featured mural-size color transparencies by Edward Weston and Ansel Adams. Two years later Steichen devoted a group exhibition to color photography, the first of its kind at any major American museum. The show, simply titled *Color Photography*, featured 342 color prints and transparencies by eighty-five photographers and examined the various roles of color photography in amateur practice, consumer culture, and fine art. Steichen continued his support of color photography by presenting color images in nearly half of the exhibitions he curated during his fifteen-year tenure at MoMA.

Steichen left MoMA in 1962 shortly after curating his own retrospective, *Steichen the Photographer* (1961), in which he presented many of his color photographs alongside his black-and-white work, reinforcing his legacy as a lifelong practitioner, curator, and patron of color photography.

A. S.

EDWARD STEICHEN

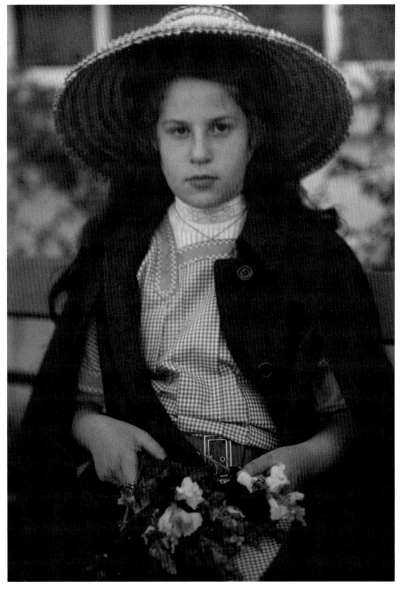

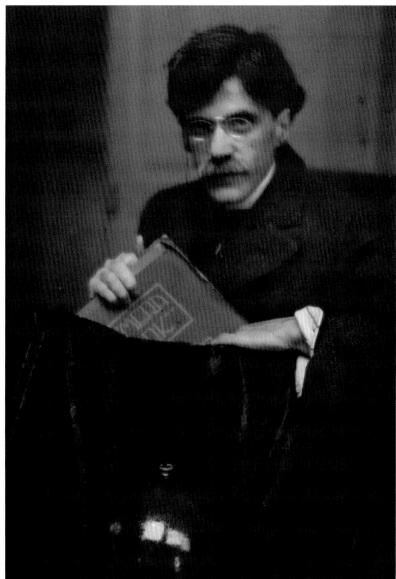

Edward Steichen, *Katherine Stieglitz*, 1907

Edward Steichen, *Alfred Stieglitz*, 1907

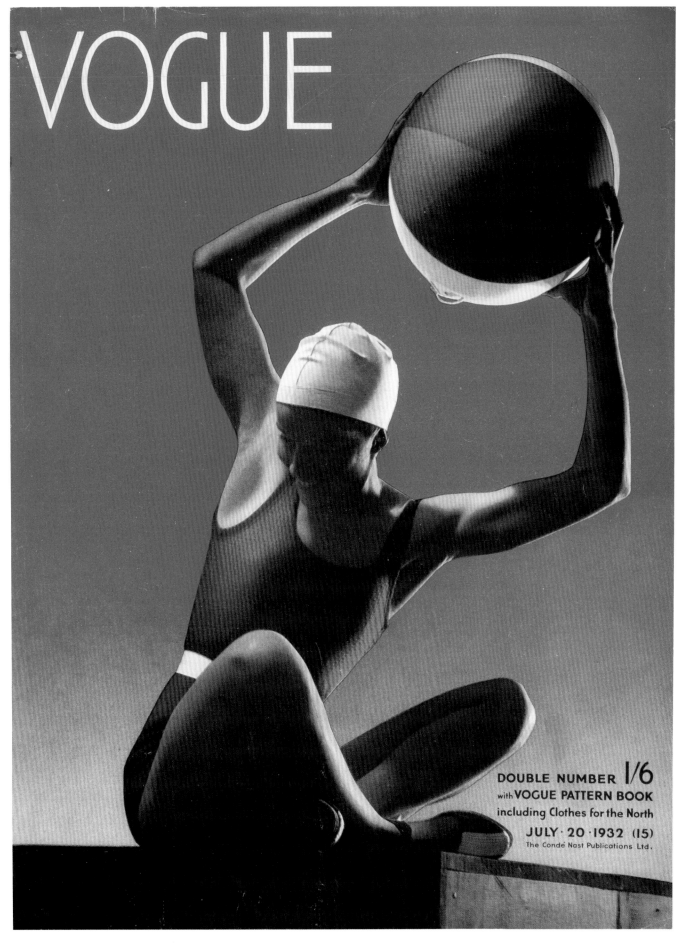

Edward Steichen, cover of *Vogue*, July 20, 1932

Top row (left to right):
Edward Steichen, *Bouquet of Flowers—Normal Print #5*, January 8, 1940
Edward Steichen, *Bouquet of Flowers*, 1939–40
Edward Steichen, *Bouquet of Flowers*, 1939–40
Edward Steichen, *Bouquet of Flowers*, January 8, 1940 (a detail of this image is used on the jacket of this book)

Bottom row (left to right):
Edward Steichen, *Bouquet of Flowers—Negative Image*, December 8, 1939
Edward Steichen, *Bouquet of Flowers—Negative Image*, December 8, 1939
Edward Steichen, *Bouquet of Flowers—Negative Print #5*, January 8, 1940
Edward Steichen, *Bouquet of Flowers—Negative Print #4*, January 8, 1940

Edward Steichen, *Bouquet of Flowers—Natural Color,* January 8, 1940

2

CONSUMING COLOR

NICKOLAS MURAY

Nickolas Muray, Seabrook Farms creamed onions package, ca. 1950

1.
Quoted in Robert A. Sobieszek, *Nickolas Muray* (Rochester, N.Y.: International Museum of Photography at George Eastman House, 1974), n.p.

2.
Ibid.

Nickolas Muray's illustrious career as a color advertising photographer established his place as an aesthetic and technical pioneer of commercial color photography. Before coming to America at the beginning of World War I, Muray studied color photoengraving and worked for a publishing firm in Germany. He put his professional publishing and printing background to work when he arrived in New York, where he was hired as a magazine color technician, engraver, and photographer.

Summarizing his theory of color, Muray stated, "Color calls for a new way of looking at people, at things, *and* a new way of looking at color."[1] He brought this philosophy to the printed page in the early 1930s, with his first color milestone in the June 1931 issue of *Ladies' Home Journal*. The magazine included a double-page color spread featuring Muray's photograph of models wearing swimsuits in Miami (pages 55–57). The publication of this image marked the first color reproduction made from a color carbro photograph,[2] a revolutionary step in color printing that would soon be copied by nearly every popular American lifestyle and fashion magazine. Though carbro printing was complicated and expensive, requiring the combination of three separate negatives to create the color tonality of the final print, Muray regularly employed the process due to its ability to reproduce vibrant, eye-catching hues that captured the attention of readers.

Muray quickly began receiving contracts to create color photographs for both publications and specific commercial products. He was hired by *McCall's* magazine to create color images for their homemaking and food features, further disseminating his color work and bolstering his reputation in the industry as a master color-advertising photographer and carbro printmaker. He received commissions to create color advertising campaigns for quintessential American brands, including Lucky Strike, Coca-Cola, and Dodge. He was also hired by large manufacturers to take color photographs for the packaging of their products, often foodstuffs for companies such as Seabrook Farms (left and right). In these packaging photographs, Muray anticipated the marketing needs of the companies, altering his aesthetic to incorporate a plain background and adding space around his still-lifes in order to create an easily recognizable and reproducible brand or product logo.

Muray's advertising photography made its debut at a fine-art institution when Beaumont Newhall included two of his carbro prints in the color section of the 1937 exhibition *Photography 1839–1937* at the Museum of Modern Art, New York. Though displayed alongside carbro prints by photographers such as Edward Steichen and Paul Outerbridge, Muray's prints were the only advertising photographs in the exhibition that were commissioned by commercial brands. Muray was such an accomplished practitioner that it was no surprise his work was chosen by Newhall as the model of carbro color photography in advertising.

A. S.

Nickolas Muray, *Seabrook Farms, Creamed Onions*, ca. 1950

Nickolas Muray, *Christmas Cakes and Cookies*, ca. 1935

Nickolas Muray, spread in *Ladies' Home Journal*, 1931

Nickolas Muray, *Bathing Pool Scene, Ladies' Home Journal*, 1931

Nickolas Muray, *Bathing Pool Scene*, *Ladies' Home Journal*, 1931

Anton Bruehl and Fernand Bourges, cover of *Color Sells*, 1935

1.
Gael Newton, ed., *In the Spotlight: Anton Bruehl Photographs 1920s–1950s* (Canberra, Australia: National Gallery of Art; Seattle: University of Washington Press, 2010), p. 30.

2.
Ibid.

3.
Anton Bruehl and Fernand Bourges, *Color Sells* (New York: Condé Nast Publications, 1935), n.p.

4.
Joe Deal, "Anton Bruehl," in *Image* 19, no. 2 (June 1976): p. 2.

5.
Bonnie Yochelson, "Anton Bruehl," in *Anton Bruehl* (New York: Howard Greenberg Gallery, 1998), p. 18.

In 1931, Condé Nast appointed Anton Bruehl as its chief color photographer, thereby commencing the collaboration between the photographer and the publisher's team of engravers and colorists, particularly Fernand Bourges. Bruehl, who had not yet worked in color, was likely hired because of the meticulous, modern aesthetic he cultivated as a student and then faculty member at Clarence White's school of photography. In creating the Bruehl-Bourges process for reproducing color photographs, Bruehl put his previous work as an electrical engineer to use in constructing a strong lighting system to compensate for the slow speed of color film.[1] In addition to optimizing the studio through lighting, Bruehl and Bourges innovated the engraving transfer process through the use of three glass transparencies for each of the primary colors, which gave engravers a more precise way of rendering natural color.

The results of the Bruehl-Bourges collaboration first appeared in *Vogue*'s May 1932 issue and later also appeared in *Color Sells*, a large-format Condé Nast book created to promote the process to advertisers (left). The book featured sixty-five Bruehl-Bourges photographs and argued for the merit of the process through punchy slogans, including "Color is like dynamite: dangerous, unless you know how to use it."[2] This publication went beyond a general endorsement of color photography, however, and urged advertisers to specifically choose the Bruehl-Bourges process because of its unique accuracy.

Ultimately, between May 1932 and December 1934, nearly two hundred Bruehl-Bourges photographs appeared in Condé Nast magazines, and each image cost around $1,500 to produce.[3] Under the stipulations of their Condé Nast contracts, Bruehl, Bourges, and the Condé Nast engravers were required to work together on any outside work. Together, the team created advertisements independently from Condé Nast magazines beginning in 1933.[4] Although the collaboration ended in 1936, the Bruehl-Bourges process set the bar for high quality color reproductions in both fashion and advertising, and it produced the most accurate color reproductions available prior to Kodak's Kodachrome slide film, introduced in 1936.

After the conclusion of the Bruehl-Bourges collaboration in 1936, Bruehl's color photographs appeared in commercial print advertisements for a wide array of products. His images for Four Roses Whiskey, which he began creating in the late 1930s, demonstrate his approach to photographing commercial products: they frequently feature whiskey cocktails placed in and around miniature models Bruehl constructed. The intricate setup of these pages was so central to the marketing campaign that one advertisement (page 60) was dedicated to describing the process. It ran in *Life* on January 19, 1939, and was one of the earliest of around fifty ads Bruehl would go on to create for Four Roses.

Following his tenure at Condé Nast, Bruehl created a series of theatrical scenes for *Esquire* magazine during World War II. In order to produce photographs that would specifically offer a space of escapism for the men of the armed forces, Bruehl used the same theatrical setups he had perfected while at Condé Nast to create a series of staged acts for a feature called "Esquire Canteen." His most famous, *Harlem Number*, appeared in the July 1943 issue (page 63).[5]

G. D.

ANTON BRUEHL

Anton Bruehl, cover of *House & Garden*, July 1932

*Watch us
take a picture for a
Four Roses ad*

1. A few weeks ago, we dropped in at the studio of Anton Bruehl, the famous photographer, to watch him take a color photograph for a Four Roses ad.

As he arranged his equipment, Bruehl remarked: "In making a picture, I combine several lights into one light that has every effect I want." It struck us that here was a certain similarity to the way we make Four Roses: by combining several fine straight whiskies into one whiskey that's finer still.

So we asked Bruehl to demonstrate and here is the result:

2. "First," explained Bruehl, "I put the 5,000-watt floodlight in position. But it's easy to see that one light is not enough, just as you say one whiskey is not enough in making Four Roses.

3. "So I spot several other lights, in such a way that unwanted shadows disappear. Now the set begins to take on warmth and depth.

4. "Finally, by carefully combining the lights in just the right way, I highlight the important elements that I want to bring out sharply in the finished photograph. Now I'm ready to take the picture." And . . .

5. Here's the way the photograph turned out—a picture with every quality it should have, because the photographer skillfully combined several lights to achieve the one perfect light he needed.

In much the same way, we couldn't hope to achieve the perfect whiskey by using just a single fine straight whiskey. Instead, we take several straight whiskies, each selected for some special virtue. Then, with the skill of 74 years guiding our hand, we combine them to make one whiskey that we believe is America's finest—Four Roses!

Ask for Four Roses, at your favorite bar or package store, today. It may cost a trifle more—but once you've tried it, we doubt if you'll ever let the slight difference in price stand between you and this magnificent whiskey!

FOUR ROSES

*A blend of straight whiskies—90 proof—Every drop is whiskey.
Frankfort Distilleries, Incorporated, Louisville & Baltimore*

WE BELIEVE FOUR ROSES IS AMERICA'S FINEST WHISKEY—BAR NONE

Anton Bruehl, Four Roses Whiskey advertisement, 1939

Anton Bruehl and Fernand Bourges, spread in *Vogue*, December 1932

Anton Bruehl, cover of *Vanity Fair*, March 1933

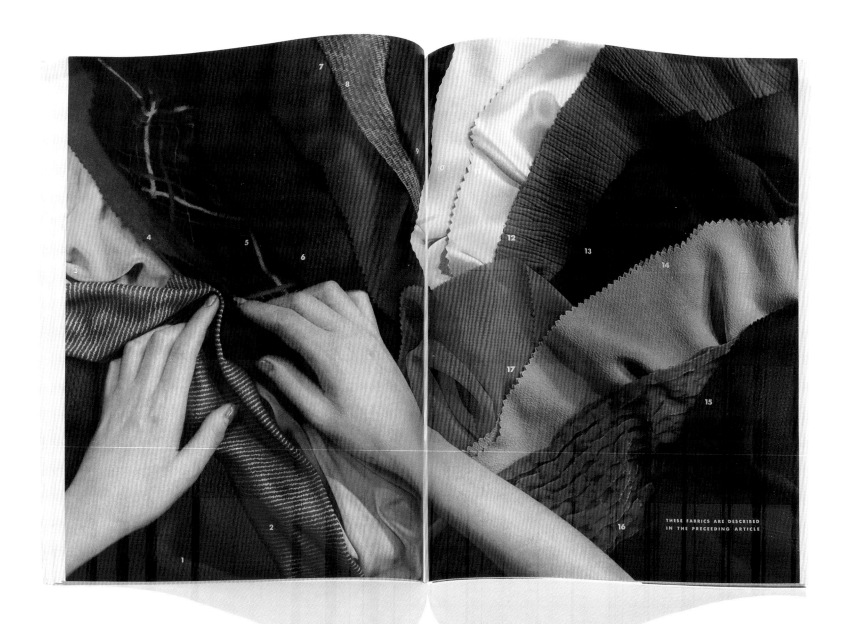

Anton Bruehl and Fernand Bourges, spread in *Vogue*, September 1932

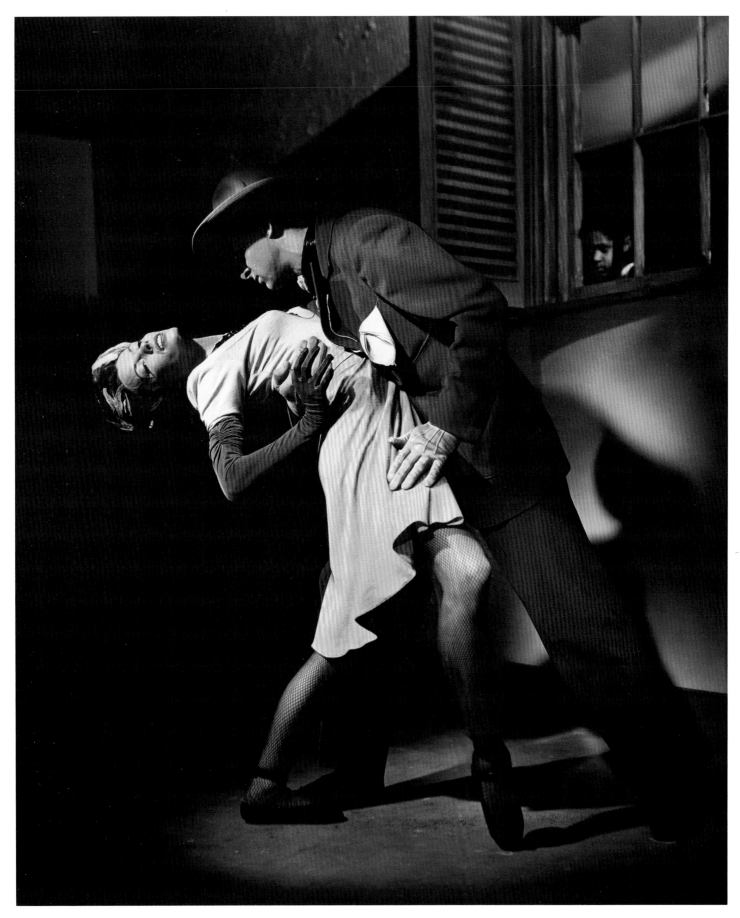

Anton Bruehl, *Harlem Number*, 1943

HOLLYWOOD

Still from the film *The Toll of the Sea*, 1922

1.
Quoted in "New Color Production," *New York Times*, May 4, 1924, p. X5.

2.
For more information about the evolution of the Technicolor process, see Fred E. Basten, *Glorious Technicolor: The Movies' Magic Rainbow* (Camarillo, Calif.: Technicolor, 2005).

3.
Theatrical trailer for *Becky Sharp*. Directed by Rouben Mamoulian. (1935; Los Angeles: Pioneer Pictures).

Experimentation with color technology in motion pictures began even before color photography became a staple of commercial advertising in the 1930s. Due to technical limitations, however, the two fields developed alongside each other in the interwar period, as each discovered the creative, as well as financial, potential of capturing the world in vivid color.

Although it was not the first color motion picture film on the market, Technicolor, created by the Technicolor Corporation in 1915, quickly became the industry standard for color movies. The Technicolor Corporation released its first color film, *The Gulf Between*, in 1917, using a patented two-color technology that was replaced by a more advanced version in 1922. *Toll of the Sea* (left), the earliest movie to use this updated two-color technology, proved to be the company's first profitable endeavor.

This latter system was also utilized in important sequences of popular films in the early 1920s such as *The Ten Commandments* and *The Phantom of the Opera* (page 66). Irvin Willat—producer of *Wanderer of the Wasteland*, filmed entirely with the improved two-color Technicolor system—prophetically claimed in a 1924 *New York Times* article that soon "there will be a great public demand for colored pictures. They will be classified in the minds of photoplay patrons as the art product of the industry, and the resulting competition will bring about their widespread production. They will occupy the same place in the film world as colored printing does in the publishing world."[1]

The first Technicolor camera equipped with a three-color process—and a refined procedure for dye transfer printing of its film—generated the saturated, rich colors that inaugurated the "Glorious Age of Technicolor" in 1932.[2] The release of *Becky Sharp* (page 67), the first full-length movie created entirely in three-color Technicolor, emphasized the groundbreaking contribution of shooting in natural color and its impact on the viewing experience. The film's trailer featured a scene of the movie's star fanning herself first in black and white before transitioning to color, exclaiming: "This specially prepared scene of Miriam Hopkins as Becky Sharp shows her transform from phantom shadows into the breathless beauty of living color by the greatest achievement in motion pictures since the advent of sound."[3] The success of early feature films that used this easier and improved three-color technology, such as *The Wizard of Oz* (right), solidified the public's fascination with Technicolor and established color movies as the future of Hollywood filmmaking.

A. S.

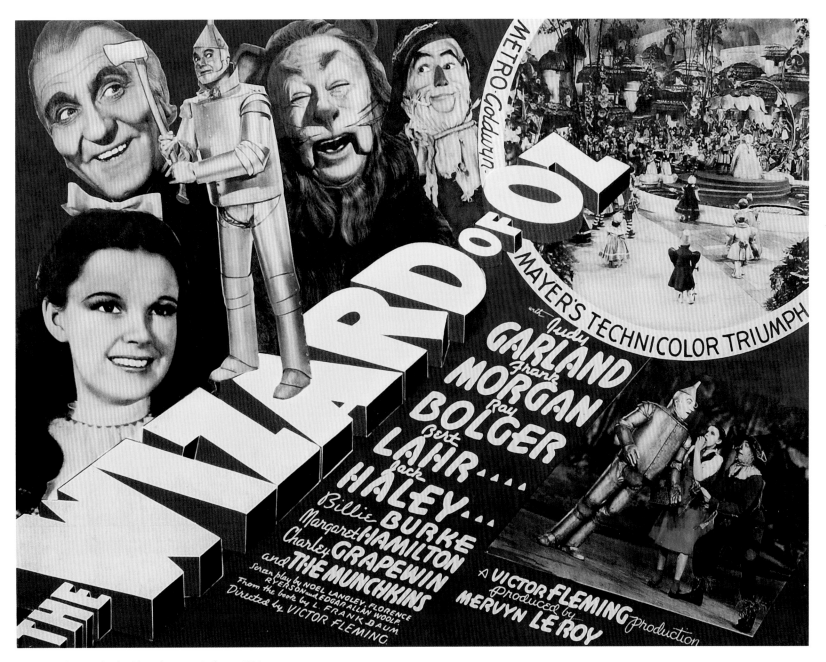

Promotional poster for the film *The Wizard of Oz*, 1939

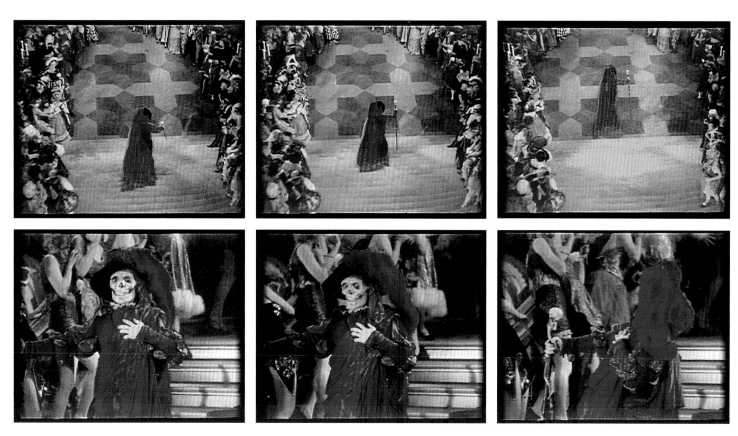

Stills from the film *The Phantom of the Opera*, 1925

Still from the film *Becky Sharp*, 1935

Paul Outerbridge, Jr., *Woman with Claws*, 1937

1.
Sally Stein, "The Rhetoric of the Colorful and the Colorless: American Photography and Material Culture between the Wars" (PhD diss., Yale University, 1991), p. 152.

2.
Paul Outerbridge, Jr., *Photographing in Color* (New York: Random House, 1940), p. 8.

3.
Beaumont Newhall, *The History of Photography from 1839 to the Present Day* (New York: Museum of Modern Art, 1982), p. 184.

4.
Tom Maloney, "Color," *U.S. Camera* 2 (New York: Duell, Sloan, and Pearce, 1940): p. 19.

5.
Outerbridge, *Photographing in Color*, p. 55.

Despite his burgeoning career as a black-and-white photographer, Paul Outerbridge, Jr. became so intent on mastering color photography that in 1933 he stopped publishing his work altogether for two years. The transition from monochromatic to color photography was prompted by Outerbridge's desire to make a name for himself as a commercial photographer, as Condé Nast publications had begun using color imagery to attract customers during the Great Depression. Outerbridge's work was unique for its spare presentation of objects; at the same time, American advertising was largely dominated by images that used the dramatic techniques associated with Hollywood films.[1] Although there were a few color techniques available in the 1930s, Outerbridge learned the intricate carbro process, which he described as "the most time-consuming, the most temperamental, and the process capable of rendering the most beautiful results."[2]

Shortly after perfecting the process, Outerbridge became a pioneer in the field of color nude photography, and he dedicated a section of his 1940 book, *Photographing in Color*, to the pitfalls color's realism presented for treating the nude artistically, rather than pornographically. As *Woman with Claws* (left) demonstrates, Outerbridge often cropped his photographs in order to depersonalize the body and incorporated props and poses, which lend an idiosyncratic air to his compositions. Despite Outerbridge's passion for the nude, his most widely circulated photographs were those he created as a commercial photographer. In 1936 he contributed three photographs to *House Beautiful*, leading to a partnership that resulted in fifty-five of his color works running in the magazine over the next three years. Additionally, as a freelance photographer, Outerbridge created color photographs for a variety of companies, including the A&P supermarket chain's Eight O'Clock Coffee (page 70).

The circulation of Outerbridge's *Avocado Pears* (right) demonstrates the porous nature of the boundary between color photography's reception and display at the time. This photograph was included in Beaumont Newhall's 1937 exhibition *Photography 1839–1937*, as well as in a subsequent publication that offered a historical survey of the medium. *Avocado Pears* illustrates Newhall's discussion of "straight" photography as a demonstration of attention to form and accurate presentation of subject.[3] The image was also reproduced in Outerbridge's *Photographing in Color*, which introduced both amateurs and professionals to color photography. The book, which received advanced praise as a "masterpiece of technical instruction," sold all five thousand copies in the year of its release.[4] *Avocado Pears* appears in the chapter "Composition and Picture Material." Although the photograph does not expressly advertise a product, Outerbridge described the importance of form and staging for creating a successful color photograph, while lamenting the division between fine art and advertising: "After all, advertising is concerned with sales, not with fine art. Of course, the more successfully attempts are made at combining these two frequently divergent elements the better all around," suggesting that ideally, advertising, like art, should use composition and form to connect with the viewer.[5]

G. D.

PAUL OUTERBRIDGE, JR.

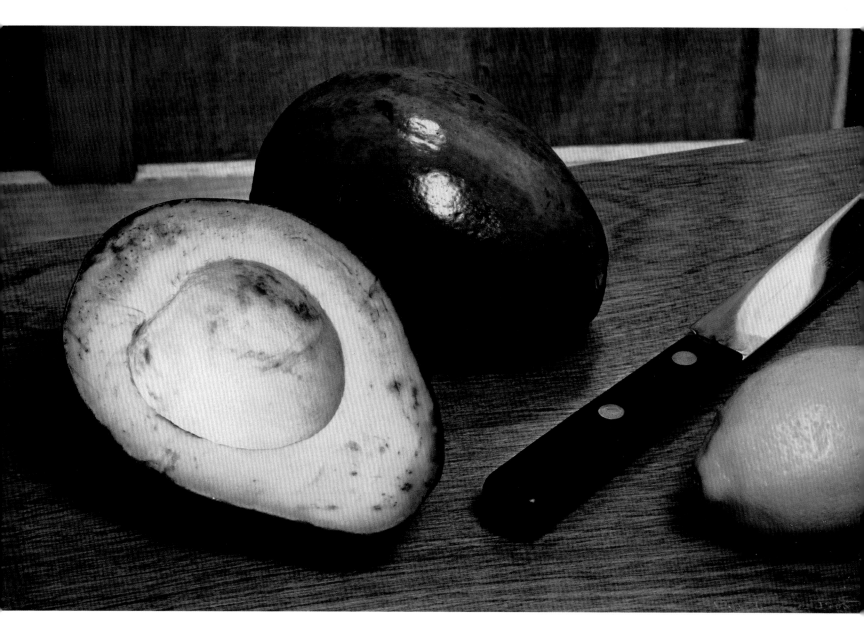

Paul Outerbridge, Jr., *Avocado Pears*, 1936

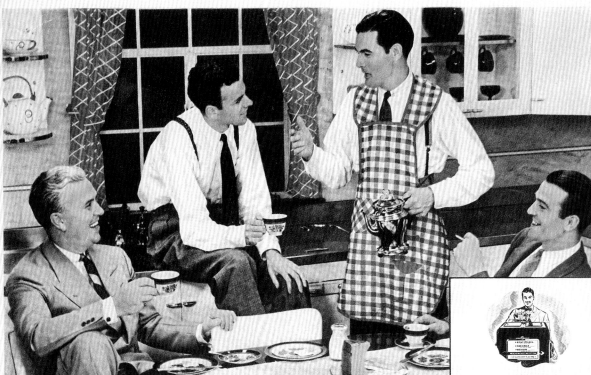

Bill: HOW DID YOU LEARN TO MAKE
SUCH SWELL COFFEE, DICK?

Dick: SIMPLE, IT'S BEAN COFFEE, <u>CUSTOM GROUND</u>*

Just to end the suspense, let's say right away that it's A&P Coffee—the coffee that's always freshly roasted, sold in the flavor-sealed bean, and custom ground for *your* coffee pot when you buy it. No wonder your friends say it's so delicious, no wonder you discover new delights in your two cups at breakfast, no wonder your coffee is the best part of every meal! No wonder that (now you know the "secret") you'll buy A&P Coffee, have it *Custom Ground!*

AT ALL A&P FOOD STORES

**NO OTHER COFFEE GIVES YOU
ALL THESE ADVANTAGES**

• Coffee that's the pick of plantations.
• Selected and bought by A&P's own resident experts in South America.
• Roasted to flavor peak in A&P's exclusive flavor control roasters.
• Sold in the flavor-sealed bean in A&P stores.
• Custom ground when you buy . . . exactly right for *your* coffee maker, to bring out all the magnificent flavor.

Today **BUY A&P COFFEES AT THE LOWEST PRICES IN HISTORY**

✳ **Custom Ground** coffee is A&P coffee correctly ground for your coffee pot by the special mill in your A&P Food Store.

A&P COFFEE SERVICE

COFFEE OF MAGNIFICENT FLAVOR—
ENJOYED BY EVERY 7th FAMILY IN AMERICA

**ONLY THE RIGHT GRIND GIVES
YOU ALL THE FINE FLAVOR**

The brewing of good coffee is a simple matter—just bringing ground coffee and hot water together for the right length of time. The time differs according to the type of coffee pot used. Some pots hold the water against the grounds constantly, some intermittently, some just passing through. Where the contact is constant the ground coffee should be coarse, where not constant the grind should be finer.

In the **regular pot**, boiling water is in constant contact with coffee. Have your A&P Coffee ground **coarse**.

Percolators force water over the coffee intermittently, so use **medium** ground A&P Coffee in your percolator.

In **drip pots** water goes through the grounds only once, so have your A&P Coffee ground **fine**.

In **vacuum pots** the contact is briefest of all—up goes the water, down comes the coffee. Use A&P Coffee ground **extra fine**.

Paul Outerbridge, Jr., Eight O'Clock Coffee advertisement, November 1940

Paul Outerbridge, Jr., *Images de Deauville*, 1936

VICTOR KEPPLER

Victor Keppler, cover of *Saturday Evening Post*, March 6, 1937

1.
Victor Keppler, *The Eighth Art: A Life of Color Photography* (New York: William Morrow and Company, 1938), p. 252.

2.
Victor Keppler, *Man + Camera: A Photographic Autobiography* (New York: Amphoto, 1970), p. 83.

Victor Keppler once proclaimed, "Color photography makes commonplace objects look glamorous, and glamorous subjects even more enchanting. Black and white photography gives an object *verity*. Color gives an object *reality*."[1]

While a student in New York City in 1925, Keppler became exposed to the world of photographic illustration, working as the assistant to a photographer specializing in advertising. This experience solidified his belief in the seductive power of images, particularly those in color, and their commercial viability. Keppler quickly put his advertising experience to work when he employed color photography for the first time in a 1929 advertisement for Electrolux gas refrigerators, after successfully convincing the company's art director that a color photograph would be more appealing than a color painting. From that point on Keppler continued to shoot mostly in color, establishing a reputation for his color carbro prints of portraits and advertisements. Despite the economic hardships of the Great Depression, Keppler's color work remained in high demand throughout the 1930s. He recalled that the desire "for a new kind of advertising gimmick—color photographs—in the depression years helped push me on my way."[2]

Keppler's color photographs and advertisements were widely circulated in magazines and often featured on the covers of important publications throughout the decade. In 1936 he was asked to shoot all the color fashion covers for the lifestyle magazine *New York Woman*, and the following year he provided the *Saturday Evening Post* with the first color photograph to run on its cover (left), a place often reserved for illustrations by Norman Rockwell.

As one of the most prolific practitioners of color photography, Keppler assumed the responsibility of writing a manual on the subject for professional and amateur photographers. *The Eighth Art: A Life of Color Photography*, published in 1938, is an extensive technical and practical history of color photography. Alongside the detailed text, Keppler reproduced many of his photographs commissioned by companies, including General Electric, Campbell's Soup, Camel Cigarettes, and Seagram's Whiskey, as well as his color covers for publications such as *New York Woman*, *Hollywood Woman*, and *Ladies' Home Journal*, as examples of his commercial color practice (right).

A. S.

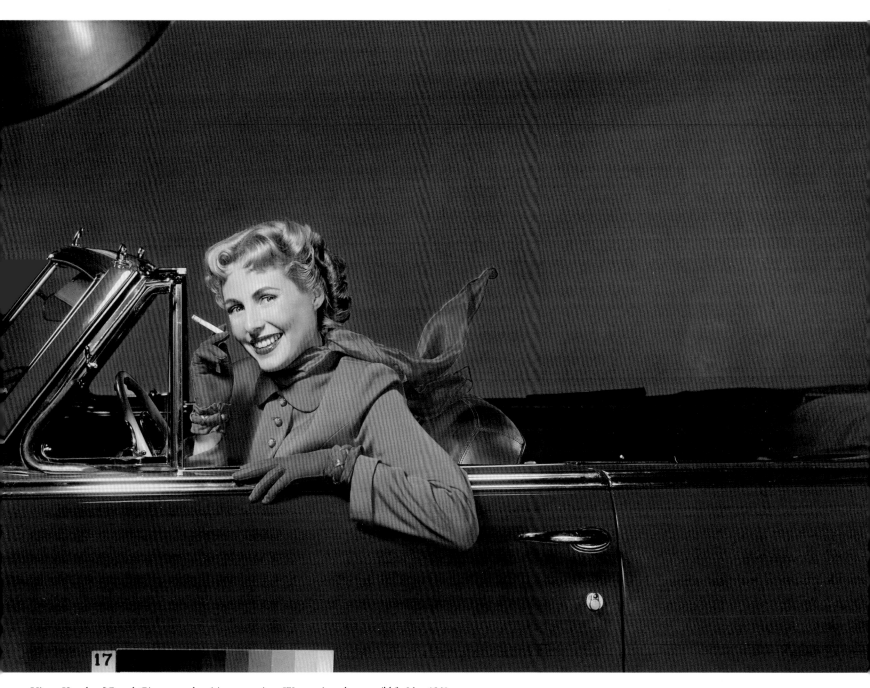

Victor Keppler, [Camel Cigarettes advertising campaign, Woman in red convertible], May 1951

Victor Keppler, spread in *The Eighth Art: A Life of Color Photography*, 1938

Victor Keppler, General Mills advertising
campaign, Apple PyeQuick, 1947

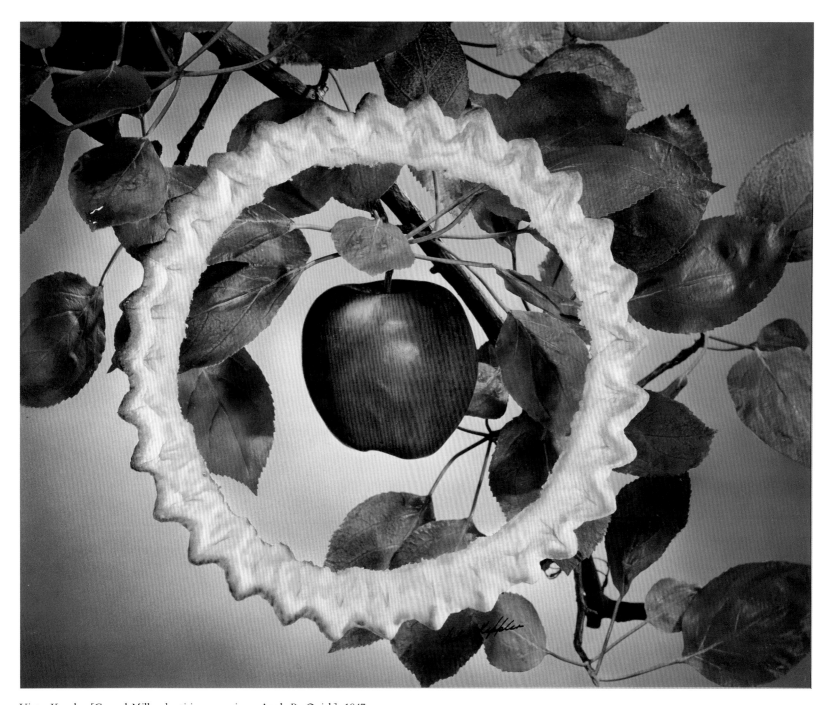

Victor Keppler, [General Mills advertising campaign—Apple PyeQuick], 1947

Despite the difficulty and expense of reproducing color photographs, newspapers began printing photojournalistic images in color by the late 1930s. On January 10, 1937, the *Milwaukee Journal* pioneered the use of color when it published what is likely the first candid color news photograph to appear in a newspaper's regular run.[1]

Four months later, a series of color photographs taken by Gerard Sheedy was featured in the *New York Sunday Mirror*. Sheedy made headlines when he loaded his camera with Kodachrome film and captured in color the fiery burning of the German airship the *Hindenburg*. Despite being "knocked down by the blast of the explosion when the *Hindenburg* crashed, Sheedy managed to expose his roll of film, which was flown to Rochester for development and then back to New York."[2] These color photographs were published in the May 23, 1937, edition of the *New York Sunday Mirror* magazine section with a caption emphasizing the novelty of color news photographs: "FIRST— AND ONLY! Today the Sunday Mirror Magazine Presents the Most Remarkable Natural-Color Photographs Ever Taken of an On-the-Spot News Subject, the Only Colorphotos made of the Destruction of the Giant Dirigible Airship Hindenburg at Lakehurst, N.J."[3]

The aesthetic and documentary value of such color photojournalism was appreciated not only by newspaper audiences but also by the museum establishment. In 1938 the Art Institute of Chicago presented the exhibition *Natural Color Photographs from the Studio of the Chicago Tribune*, showcasing the *Tribune*'s early color press photographs. A review of the exhibition details the importance of the museum's support for news photography: "That newspaper color photography is to be exhibited in a great museum whose standards are as lofty as are the Art institute's [sic] is history of cheering significance to art craftsmen the world over."[4] The Museum of Modern Art, New York, followed suit in 1949, displaying color press photographs in *The Exact Instant*, an exhibition reviewing one hundred years of news photography.

In October 1959, the *Minneapolis Star* ran an Associated Press color photograph of the funeral of General George C. Marshall, believed to be one of the first color photographs to appear on the front page of a major U.S. newspaper. One month later, *Time* magazine published an article on the subject, reporting, "Color now appears in more than 800 U.S. dailies."[5]

The article also identifies the outlier to this trend of color in the news, stating, "The only significant color holdout, in fact, is New York City, which prints more big dailies (seven) than any other city in the U.S. Manhattan papers have shown little inclination to depart from the traditional black-and-white news package."[6] New York's aversion to color explains the misconception that color was excluded from newspapers until the 1990s, when the *New York Times* finally acquiesced to printing color photographs. Though New York is often looked to when assessing historical trends in photography, its newspapers were the exception when the rest of the country was successfully exploiting the public's interest in and journalistic potential of color photography.

A. S.

1.
It should be noted that color photographs were regularly published by the *New York Daily News* in their Coloroto section of the Sunday news magazine in the mid-1930s; however, these photographs were more in line with contemporaneous fashion and celebrity color photographs in *Vogue* and *Vanity Fair* than the color photojournalist images that were beginning to be included in newspapers across the country.

2.
Douglas Collins, *The Story of Kodak* (New York: Harry N. Abrams, 1990), p. 213

3.
"First—and Only," *New York Sunday Mirror*, magazine section, May 23, 1937, p. 2.

4.
James O'Donnell Bennett, "Art Institute Shows Tribune Color Photos," *Chicago Daily Tribune*, April 21, 1938, p. 1.

5.
"Color in the News," *Time*, November 2, 1959, p. 56.

6.
Ibid.

NEWSPAPERS

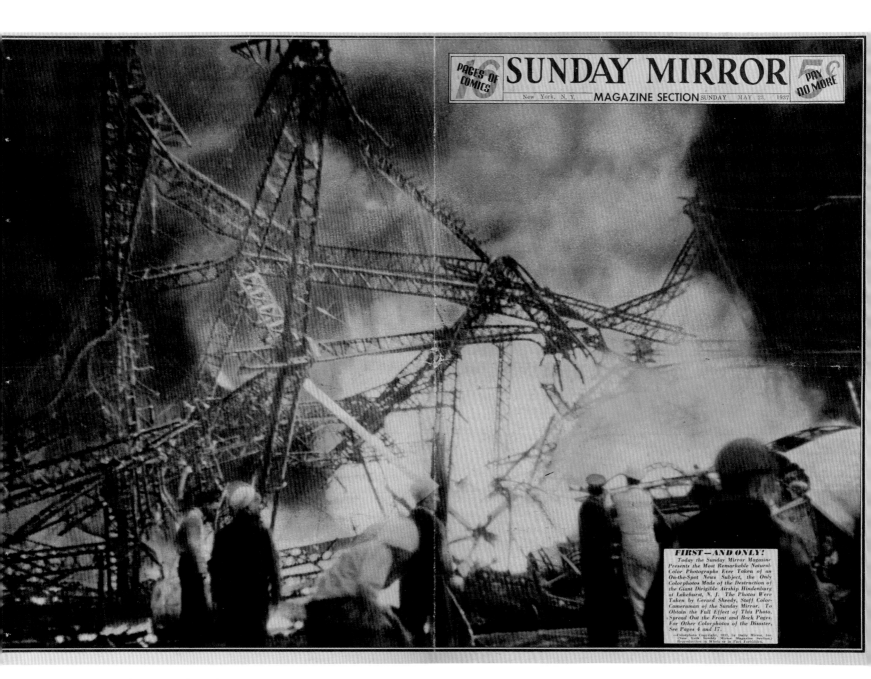

Gerard Sheedy, spread in *New York Sunday Mirror*, May 6, 1937

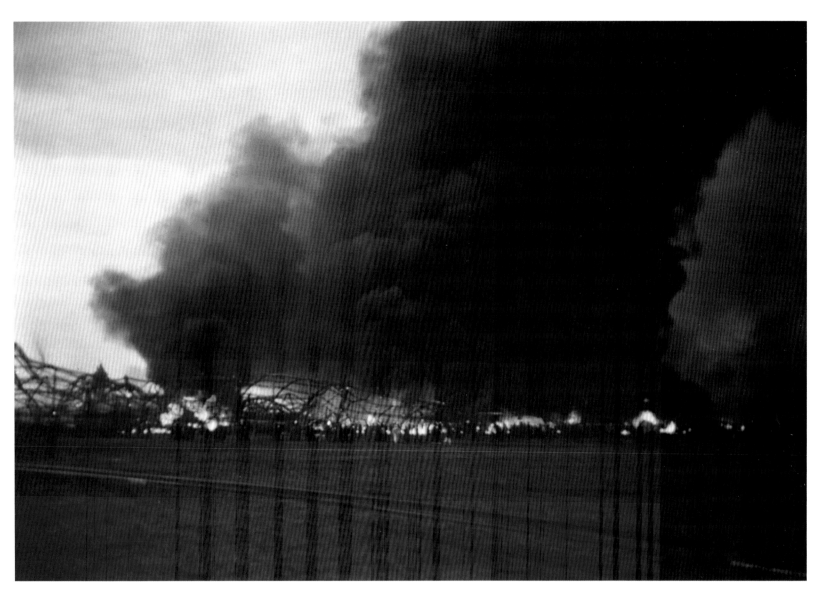

Gerard Sheedy, *A Monster's End*, burned to a bare skeleton of steel lies Germany's pride-of-the-skies,
the largest airship ever built—and the last, very probably, ever to be filled with hydrogen, May 6, 1937

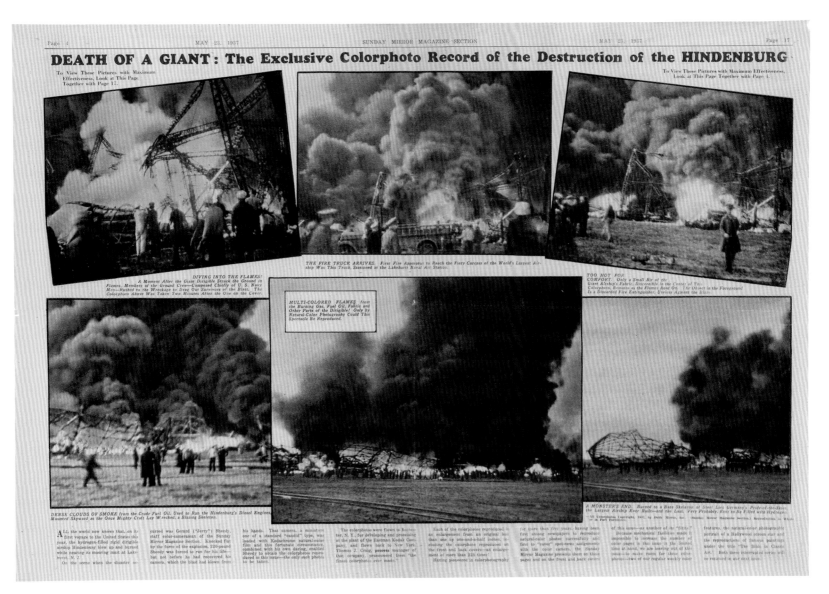

Gerard Sheedy, spread in *New York Sunday Mirror*, May 6, 1937

LOUISE DAHL-WOLFE

1.
Louise Dahl-Wolfe, interview in *American Photographers* 6, no. 6 (June 1981): p. 50.

2.
Louise Dahl-Wolfe, *Louise Dahl-Wolfe: A Photographer's Scrapbook* (New York: St. Martin's/Marek, 1984).

3.
For more on Dahl-Wolfe's relationship with the *Harper's Bazaar* editorial staff, see *Louise Dahl-Wolfe* (New York: Harry N. Abrams, 2000).

In 1937, one year after joining the staff of *Harper's Bazaar*, Louise Dahl-Wolfe began making color photographs. The conclusion of the collaboration between Anton Bruehl and Fernand Bourges at Condé Nast in 1936 had freed Bourges to technically assist Dahl-Wolfe with these works, and the first of them was published in the magazine's January 1938 issue (right). This image of a model in a green and red tropical patterned Bonwit Teller dress prefigures the balanced color palette that would come to define Dahl-Wolfe's work.

Dahl-Wolfe brought a sophisticated color sensibility to fashion photography, largely informed by her art school training: "You have to study color like you do the scales on the piano. It's really scientific. Then, after that, you have to rely on whether you have any taste or imagination."[1] Kodachrome film had a significant impact on her work, inspiring her to shoot fashion photographs at outdoor locations, rather than studio settings, and she became one of the first fashion photographers to consistently use color film on location.[2] Her color photographs from the magazine's January 1940 issue were taken in California, as indicated in the caption: "Kodachrome by Louise Dahl-Wolfe—To the heat of the California Desert, deep into Yuma, we caravanned to photograph our resort fashions" (page 82). These photographs were included in a larger article, "Station Identifications: The Right Clothes for All the Resorts," which offered the magazine's readers advice on what to wear while traveling in tropical locations throughout the globe.

As these photographs suggest, Dahl-Wolfe departed from the aesthetic developed by the Bruehl-Bourges team at Condé Nast. Published by Hearst beginning in the early twentieth century, *Harper's Bazaar* was always in direct competition with Condé Nast's *Vogue*, yet it sought to distinguish itself by cultivating a cosmopolitan readership as interested in fashion as it was in literary content. Dahl-Wolfe's subdued palette, composed primarily of cool hues, stands in contrast to Bruehl's brash and riotous use of color, reflecting the different audiences their respective publications sought to attract. Dahl-Wolfe worked for *Harper's Bazaar* until 1958, when the magazine changed art directors, leaving Dahl-Wolfe with less creative freedom than she had previously enjoyed.[3] By that time, the magazine had featured Dahl-Wolfe's work on numerous covers, as well as six hundred interior pages.

G. D.

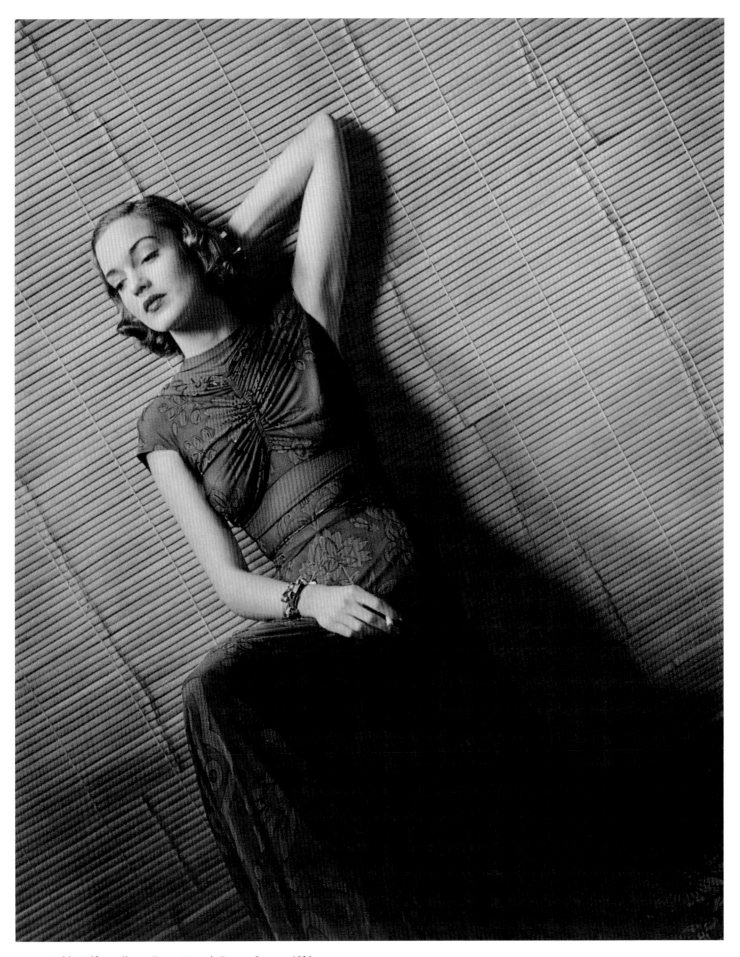

Louise Dahl-Wolfe, *Red/green Dress, Harper's Bazaar*, January 1938

Louise Dahl-Wolfe, *Blue Coat with Hood*, *Harper's Bazaar*, January 1940

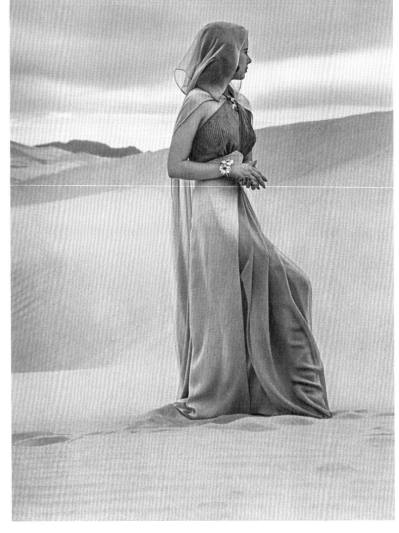

Louise Dahl-Wolfe, *Grey Gown and Cape*, *Harper's Bazaar*, January 1940

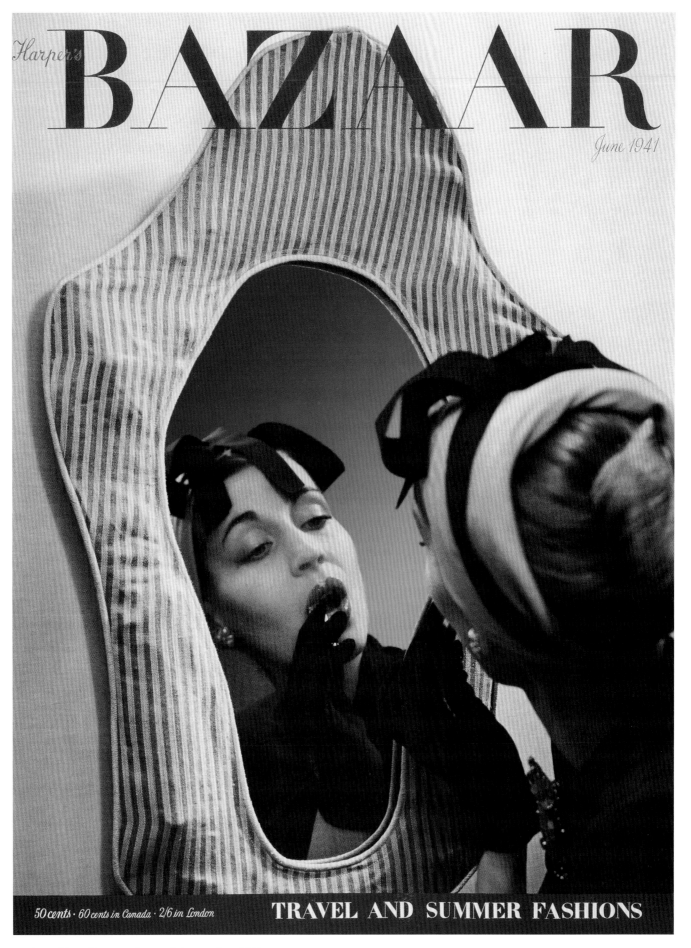

Louise Dahl-Wolfe, cover of *Harper's Bazaar*, June 1941

When László Moholy-Nagy immigrated to America in 1937 to establish the New Bauhaus school in Chicago, he had been experimenting heavily with color photographic materials for several years. His work for an advertising firm in Amsterdam had allowed him to study a variety of color processes under the guidance of experts in the studio's printing department.[1] He also studied color printing in London, where he likely made *Study with Pins and Ribbons* (right).[2] Upon arriving in America, however, he took up color photography in earnest, primarily using 35 mm Kodachrome slides. With this new medium, he further explored ideas that he had pursued in black and white, such as exposing everyday scenes from unusual points of view, moving in close to subjects for portraits, and unusual, even irreverent cropping of his photographs. He also experimented with ways to create images composed purely of color and light. To make some of these images, he stood in traffic at night photographing neon signs and car headlights as they passed by him (page 87).[3] For his studio-based experiments, he constructed apparatuses for manipulating light and then photographed the effect of light passing through them (page 87).

For Moholy-Nagy these color images suggested a new way forward for creative expression: "Among the significant properties of color emulsion and of the photo apparatus is the ability to mechanically reproduce fleeting light and colored reflections as well as colored shadows . . . so that the translation becomes ethereal, not pigment but colored light . . . And exactly there is the territory of new and exciting promise."[4] Eventually, he stated, photographers would leave behind "naturalistic-illusionistic meaning" and reach a point "where color will be understood for its own sake and not as a sign or symbol representing an object."[5] This was his ultimate goal: an art that eschewed convention entirely.

Moholy-Nagy's color slides are attempts to reach that goal. They also represent a step on the way to kinetic colored light display, or the abstract motion picture, which he felt had enormous potential for shaping the future of artistic expression. If, as photo-historian Beaumont Newhall claimed, "Light [was] to Moholy-Nagy the basic medium of the artist,"[6] then color was a close second. His color slides unify these two fundamental components of his art. Although Moholy-Nagy did not make prints from his slides for display in exhibitions, he lectured extensively and showed the slides to classes at the Institute of Design in Chicago (the successor of the New Bauhaus), where they had significant influence. His colleague Harry Callahan, for example, also made images of traffic at night and moving lights in darkened spaces (pages 114 and 115), but the truest inheritors of Moholy-Nagy's ideas may be filmmakers who embraced visual stream-of-consciousness over narrative.

L. H.

1.
For more on Moholy-Nagy's experiments in color photography during his time in Europe, see Jeannine Fiedler, "Moholy-Nagy's Color Camera Works: A Pioneer of Color Photography," in *László Moholy-Nagy: Color in Transparency, 1934–1946*, ed. Jeannine Fiedler and Hattula Moholy-Nagy (Göttingen, Germany: Steidl; Berlin: Bauhaus-Archiv, 2006), pp. 20–21.

2.
Ibid., p. 48.

3.
Ibid., p. 154.

4.
László Moholy-Nagy, *Vision in Motion* (Chicago: Paul Theobald, 1947), p. 172.

5.
Ibid., p. 173.

6.
Beaumont Newhall, "The Photography of Moholy-Nagy," *Kenyon Review* 3, no. 3 (Summer 1941): p. 351.

LÁSZLÓ MOHOLY-NAGY

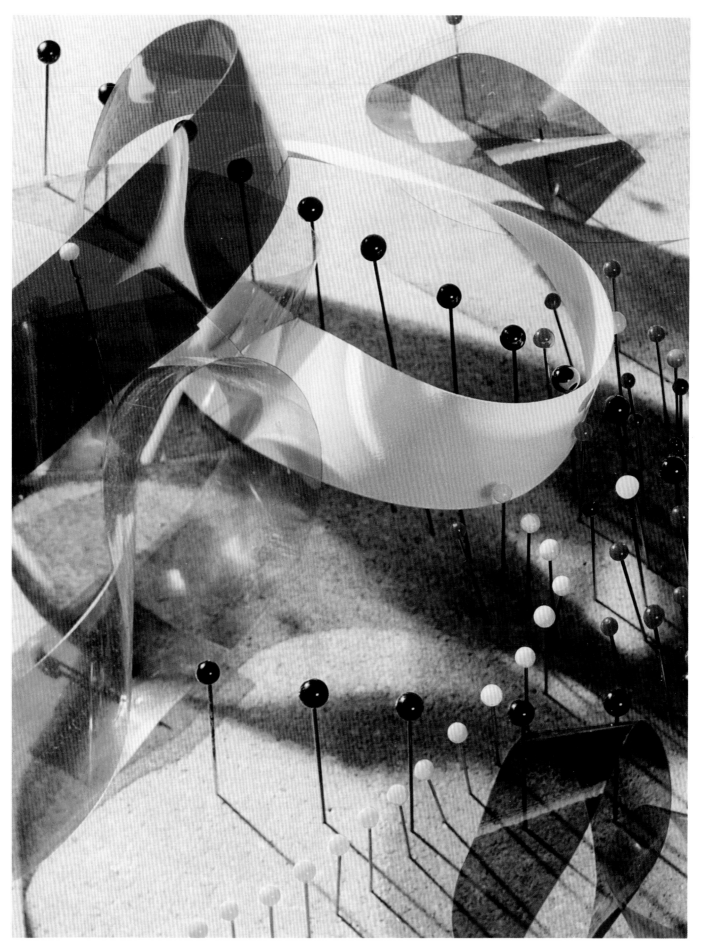

László Moholy-Nagy, *Study with Pins and Ribbons*, 1937–38

László Moholy-Nagy, *Rooftop Parking*, 1938–40

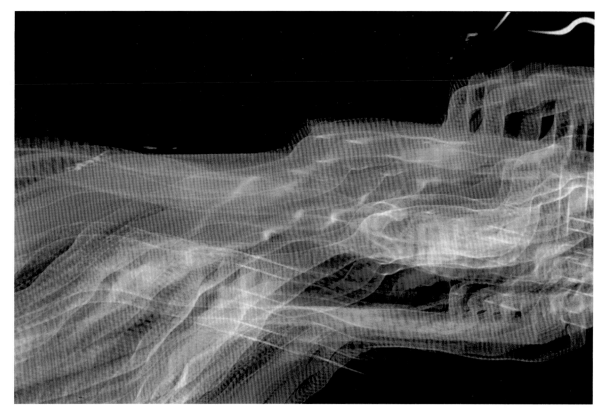

László Moholy-Nagy, *Night-time traffic (Pink, orange, and blue traffic stream), Chicago*, 1937–46

László Moholy-Nagy, *Light painting #1 (Colored reflections cast by light machine) Chicago*, 1942–44

KODAK

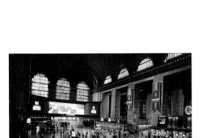

Norm Kerr, Colorama #553 on display in Grand Central Terminal, August 15–September 22, 1988

1.
For more information on Kodak advertising and its how-to publications, see Douglas Collins, *The Story of Kodak* (New York: Harry N. Abrams, 1990).

2.
For more information about the history of Kodak's Coloramas, see Alison Nordström, "Dreaming in Color," in *Colorama: The World's Largest Photographs from Kodak and the George Eastman House Collection* (New York: Aperture, 2004).

"Kodachrome. They give us those nice bright colors. They give us the greens of summers. Makes you think all the world's a sunny day, oh yeah." These lyrics from Paul Simon's 1973 hit song "Kodachrome" embody the American public's fascination with the world's most recognizable color film. By the 1970s, Kodak products had provided generations of professionals and amateurs with the opportunity to capture the colors of everyday life.

Kodak's initial iteration of the popular Kodachrome film, the company's first color product, reached the market in 1914, but its technical limitations, coupled with the beginning of World War I, resulted in limited commercial success. It did, however, establish a general interest in future color processes such as Kodacolor, Ciné-Kodak, Ektachrome, and the more technically advanced version of Kodachrome that debuted as 16 mm motion-picture film in 1935. The updated three-color Kodachrome, which was also offered as 35 mm slides and 8 mm home movies the following year, became the first commercially successful amateur color process since the autochrome. Over the next decades, Kodak continued to perfect its technology, introducing new products and striving to make the creation of color photographs as simple and accessible as possible.

Kodak's extensive printed advertising campaigns and spectacular public displays of color photography testified to the company's widespread presence and impact (pages 89–93). These advertisements were published in popular magazines such as *Life*, ensuring their rapid dissemination across American households. They re-created everyday family snapshots on topical subjects, such as photo albums for soldiers during World War II, emphasizing the importance of preserving familial relationships and experiences. The advertisements also featured the various types of color technology, ranging from slide projections to color enlargements (page 93). Technology-based advertisements were complemented by how-to books written by photographers such as Ivan Dmitri to provide tips for taking successful color photographs (page 90).[1]

At the same time that Kodak was appealing to amateur color photographers, the company was also commissioning several of America's most celebrated art photographers, including Ansel Adams and Edward Weston, to use their color film. Kodak published these color photographs as multipage spreads in publications like *Popular Photography* in order to promote their products to an art-savvy audience (pages 124 and 128–29).

Kodak also advertised by creating large-scale public displays of color photography. In 1939 the Kodak building at the New York World's Fair featured the Great Hall of Color, a continuous projection of color slides across a 22-by-187-foot screen. The company's dedication to elaborate displays of color photography continued in 1950 with the inauguration of its series of 18-by-60-foot Colorama transparencies overlooking the main terminal of Grand Central Station in New York City (above left). On view for forty years, Kodak's Coloramas, created by notable photographers including, Adams, Ernst Haas, and Eliot Porter, were seen by an estimated seventy-eight million commuters and tourists each year.[2] By addressing both amateur and professional photographers in their advertisements and public displays, Kodak succeeded in establishing color photography as America's medium for preserving its memories and documenting its experiences.

A. S.

"Seems as if she could walk right out of the picture"

FROM A KODACHROME ORIGINAL

This summer—don't fail to bring back some Kodachrome color movies of your vacation.

There's a fascination about Kodachrome color movies that holds you spellbound when you see them flash on the screen. Their beauty. Their reality.

That stretch of sand glowing in the sunlight—you can almost feel the heat waves rising from it. People seem vividly alive. Your Kodachrome Film catches every subtle hue of tree and flower, earth and sky—even the delicate tints of a child's face.

If you haven't yet taken Kodachrome color movies—get started this week. They're easy to take—just load your Ciné-Kodak with Kodachrome instead of black-and-white. No extra equipment.

Ask your dealer to show you some of his sample reels. Only actually seeing them will give you any idea.

All these movie cameras take pictures in Kodachrome, as well as black-and-white: You can use Kodachrome Film with any of the following home movie cameras: Ciné-Kodak Eight, the economy movie maker, Model 20, at the new low price of $29.50; Model 25, at $42; Model 60, at $67.50. Ciné-Kodak "E," the low-priced "sixteen" that has so many high-priced camera features, $39.50. Ciné-Kodak "K," the world's most widely used 16 mm. home movie camera, $80—the new low price. Magazine Ciné-Kodak, 3-second magazine loading, $117.50 . . . Eastman Kodak Company, Rochester, N. Y.

Going to the New York Fair? Be sure to take your Ciné-Kodak. Stop at the Kodak Building, where Eastman experts will advise you what to take and how to take it. See the Cavalcade of Color— the Greatest Photographic Show on Earth.

Kodachrome Film EASTMAN'S FULL-COLOR HOME MOVIE FILM

Kodachrome film advertisement, 1939

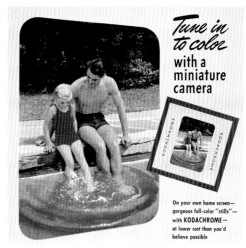

Kodachrome film advertisement,
August 1941

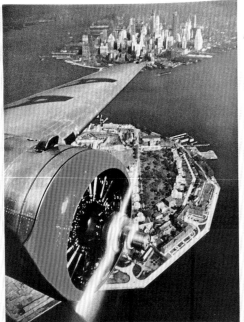

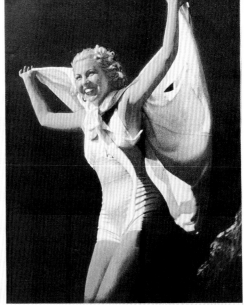

SPEAKING OF PICTURES . . .
. . . THESE ARE KODACHROMES

Ivan Dmitri, spread in *Life* magazine, April 1, 1940

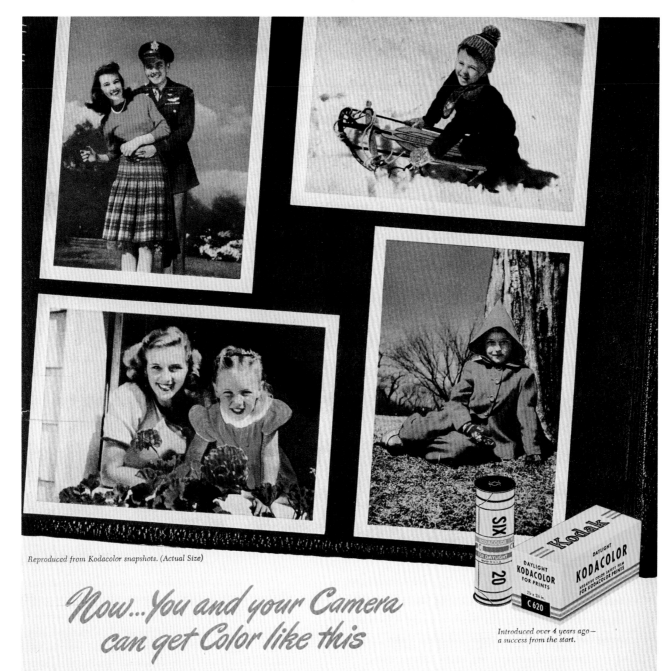

Reproduced from Kodacolor snapshots. (Actual Size)

Introduced over 4 years ago—
a success from the start.

Now... You and your Camera can get Color like this

THINK what Kodacolor Film is going to mean in *your* picture-taking—how it will bring to your snapshots the thrilling colors of trees, sky, water . . . the lovely coloring of children, of a pretty girl . . .

Remember, anyone . . . beginner or advanced picture-taker . . . Dad, Mother, even the youngsters . . . can make full-color Kodacolor snapshots—with an ordinary Kodak or Brownie . . . in bright, direct sunlight. You take the exposed film to your Kodak dealer, as usual, and he tells you when to come back for your negatives and prints.

Remember, too, that Kodacolor snapshots are true snapshots. They're printed on paper just like black-and-white snapshots.

You can carry them in your pocket, pass them around, tuck them safely away in an album. You can have extra prints from each negative.

It's snapshooting as usual, but with a new and deeper pleasure. And prints now cost less than ever. See if your Kodak dealer doesn't have some Kodacolor Film right now . . . Eastman Kodak Company, Rochester 4, N. Y.

Kodak announces a steadily increasing supply of Kodacolor Roll Film

Kodak

Kodacolor film advertisement, 1946

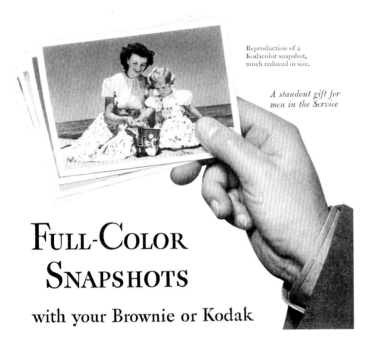

Reproduction of a Kodacolor snapshot, much reduced in size.

A standout gift for men in the Service

FULL-COLOR SNAPSHOTS

with your Brownie or Kodak

REVOLUTIONARY! . . . full-color snap-shots on the new Kodacolor Film. They're the biggest news in photography since roll film was introduced.

With Kodacolor Film you can now take color snapshots in good sunlight with any Kodak or Brownie—and from the negatives the Kodak Company makes Kodacolor Prints —full-color snapshots printed on paper.

At present the supply of Kodacolor Film is limited—but there's a modest amount available. Use it for important occasions.

All Kodacolor Film is processed at Kodak's laboratories. Ask your Kodak dealer to give you details.

Kodak Minicolor Prints . . . Have beautiful full-color photographic enlargements made from your 35-mm. or Bantam Kodachrome transparencies. In three sizes—2 X (about 2¼ x 3¼ in.), 5 X (about 5 x 7½ in.), and 8 X (about 8 x 11 in.).

Home Movies with Kodachrome Film . . . There's still a fair amount of full-color Kodachrome Film on hand, for 8-mm. and 16-mm. Ciné-Kodaks. Use it for the high spots . . . Eastman Kodak Company, Rochester, N. Y.

Kodak Research has made
Color Photography a part of everyone's life

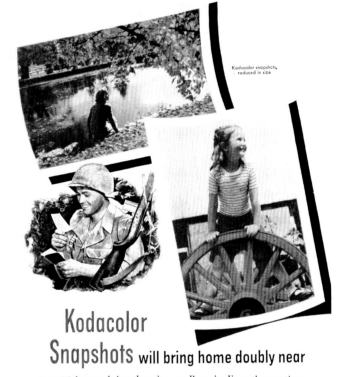

Kodacolor snapshots, reduced in size

Kodacolor
Snapshots will bring home doubly near

NEXT best to being there is seeing the folks in color snap-shots. Looking so bright and real, they seem to bring home right along with them.

Send Kodacolor snapshots to your man in the service whenever you get a chance. With Kodacolor Film, anyone—in bright, direct sunlight—can take beautiful color snapshots with an ordinary Kodak

or Brownie. From the negatives, the Kodak Company makes Koda-color Prints—full-color snapshot prints on paper—as many as you want for your folks. Order through your Kodak dealer.

Of course, Kodacolor Film, like all film, is still scarce; but there's a roll to be had now and then.

EASTMAN KODAK COMPANY, ROCHESTER 4, N. Y.

Kodak Research HAS MADE COLOR PHOTOGRAPHY A PART OF EVERYONE'S LIFE

Kodachrome film advertisement, June 1943

Kodacolor film advertisement, October 1945

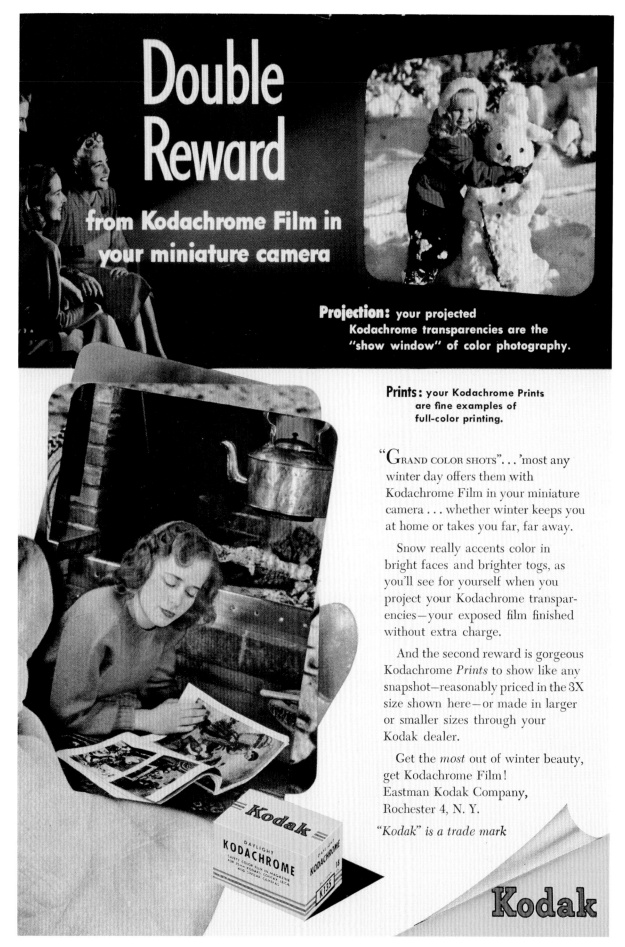

Kodachrome film advertisement, 1948

1.
Paul Hendrickson, "The Color of Memory," *Bound for Glory: America in Color, 1939–43* (New York: Harry N. Abrams; Washington, D.C.: Library of Congress, 2004), p. 12.

2.
For Stryker's reference to photographers' "losing their heads" in the face of color, see Sally Stein, "The Rhetoric of the Colorful and the Colorless: American Photography and Material Culture between the Wars" (PhD diss., Yale University, 1991), p. 209. For a thorough discussion of Stryker's attitude toward color photography and the involvement of FSA photographers with color, see ibid., chapters 5–8.

3.
Ibid., pp. 307–8.

4.
For the use of the slide show and filmstrip format by the FSA, see ibid., pp. 254–68.

5.
Sally Stein, "FSA Color: The Forgotten Document," *Modern Photography* (January 1979): pp. 90–98, 162–64, 166; Andy Grundberg, "FSA Color Photography: A Forgotten Experiment," *Portfolio 5* (July/August 1983): pp. 52–57; Ellen Handy, "Farm Security Administration Color Photographs," *Arts Magazine*, January 1984, p. 18.

Although the best-known Farm Security Administration (FSA) photographs are in black and white, the organization did support the creation of color images. Photographers John Collier, Jack Delano, Russell Lee, Arthur Rothstein, John Vachon, and Marion Post Wolcott produced 644 color images between 1939 and 1942, when the FSA was absorbed into the Office of War Information (OWI). Most of the photographs are 35 mm Kodachrome slides,[1] and their subjects remain consistent with those of their black-and-white counterparts: rural farmland, the rugged people who worked that land, and small-town life.

In their day, they were little known. The head of the FSA, Roy Stryker, was ambivalent about the use of color for serious documentary imagery. He thought that photographers of the time had a tendency to "lose their heads" when shooting color film, and he was unsuccessful in placing FSA color images in magazines, which had been one of his primary goals when he initially issued color film to the photographers.[2] The photographers, for their part, often reserved color film for special occasions, in particular country fairs. Examples include Jack Delano's images of the Vermont State Fair in Rutland (right) and Russell Lee's of the Delta County Fair in Colorado. There were two major reasons why magazines rejected FSA color imagery: first, the 35 mm slide format was considered to be too small for high quality color reproduction; second, color photography was closely tied to the escapism associated with commercial photography at the time, thereby limiting the appeal of socially conscious photography that was in color.[3] The chief applications of FSA color slides became silent filmstrips and slide shows at regional FSA offices.[4] Once the FSA was absorbed into the OWI in 1942, the output of color images increased, as the organization's focus shifted to the war mobilization effort, the patriotic thrust of which seemed naturally suited to colorful hues.

After the war, FSA and OWI materials were transferred to the Library of Congress, and during that process the FSA Kodachromes were misfiled with OWI imagery and promptly forgotten. Sally Stein discovered them while doing dissertation research in the late 1970s and published an article about them in the January 1979 issue of *Modern Photography*. This, along with a subsequent article by Andy Grundberg and Ellen Handy's review of an exhibition at LIGHT Gallery in 1983, helped register the existence of the FSA's color images in art history.[5] Nevertheless, as late as 2004, when the Library of Congress published a number of the color FSA/OWI images in *Bound for Glory: America in Color, 1939–43*, the existence of these color images still came as a revelation to many, since black-and-white images of Depression-era America have remained so firmly lodged in collective memory.

L. H.

FSA PHOTOGRAPHERS

Jack Delano, *At the Vermont State Fair, Rutland*, September 1941

John Collier, *Bean Fields, Seabrook Farm, Bridgeton, N.J.*, 1942

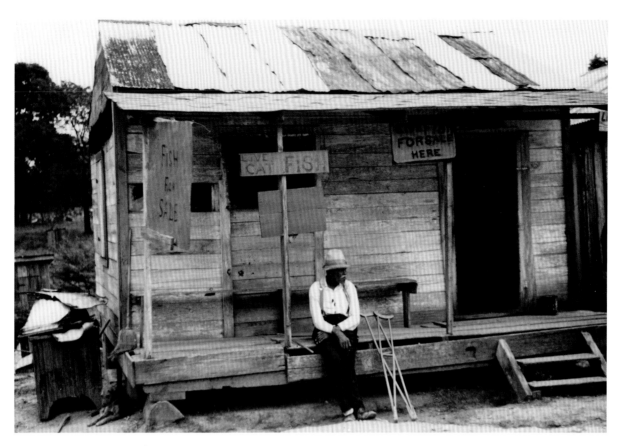

Marion Post Wolcott, *A Store with Live Fish for Sale*, July 1940

Russell Lee, *Hauling Crates of Peaches from the Orchard to the Shipping Shed, Delta County, Colo.*, September 1941

Arthur Rothstein, *Woman at the Community Laundry on Saturday Afternoon, FSA . . . Camp, Robstown, Tex.*, January 1942

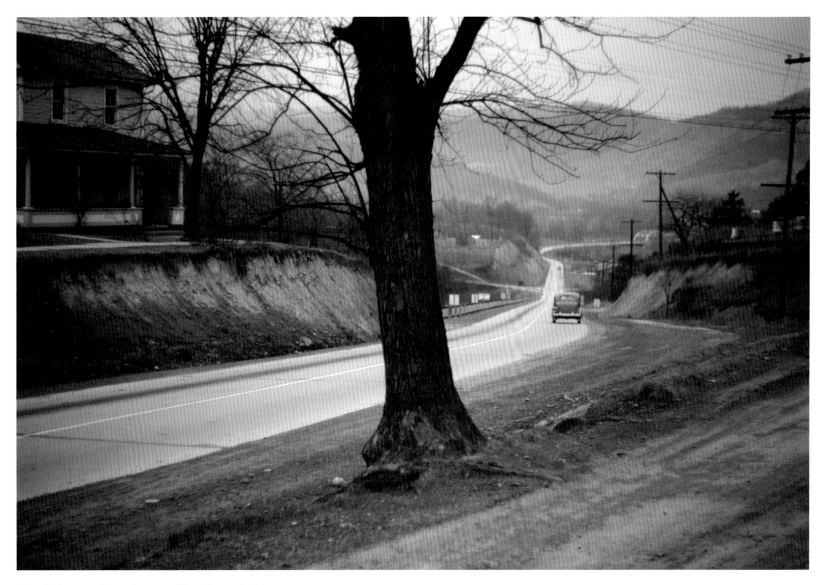

John Vachon, *Road Out of Romney, West Va.*, ca. 1942

Installation view of *The Photo Essay*
at the Museum of Modern Art, 1965

1.
For more information about this period in *Life* magazine publishing, see Philip B. Kunhardt, Jr., ed., *Life: The First Fifty Years, 1936–1986* (Boston: Little, Brown and Company, 1986).

2.
Eliot Elisofon, *Color Photography* (New York: Viking Press, 1961), p. 12.

3.
"The Photo Essay Opens at the Museum of Modern Art March 16" (press release, Museum of Modern Art, New York, March 1965). www.moma.org/learn/resources/press_archives/1960s/1965.

Most of America was exposed to color photography in the 1930s by way of the printed page, primarily through advertisements or features on fashion and society. Though later to adopt color than the popular lifestyle magazines, *Life* was the first major news publication to make color photography an integral part of their weekly news reportage. The first color photograph on the cover of *Life* (right) hit newsstands on July 7, 1941, as part of the Independence Day Defense Issue, a special visual treat to celebrate America in the midst of World War II. Color photographs would only occasionally run on the cover of *Life* for the next decade. It took until 1955 for nearly all covers to feature color photographs.

While *Life* covers were slow to embrace color photography consistently, the magazine's inside pages implemented color more quickly as an effective means of storytelling. The tradition of the photo-essay, a collection of photographs used to create a visual narrative that generally does not need more than textual captions to articulate its message, was taken to new heights of creativity by *Life*.[1] By 1948 color photographs by many of the art world's most important photographers began to be printed in the magazine.

The Museum of Modern Art, New York, featured a number of *Life* color spreads in the 1950 exhibition *Color Photography*, including tear sheets by Fritz Goro, Andreas Feininger, and Eliot Elisofon. Elisofon later remarked on the power of color in the context of printed publications: "Color photographs I like best are often almost monochromatic, and at first glance might seem hardly worth four color plates for reproduction. But were they to be reproduced in black and white, most of the subtleties would be gone. . . . In the hands of the creative photographer controlled color can add a fine dimension to a flexible medium."[2]

As the interest in color spreads increased, *Life* presented Ernst Haas with the opportunity to publish an extended photo-essay in 1953. His color series of New York City, split between two issues because of its size, was the first major color photo-essay produced by the magazine. In 1965 MoMA dedicated an entire exhibition, *The Photo Essay*, to the growing popularity of photojournalism by artists such as Haas. The show's press release explains that an entire wall of the gallery was composed of color spreads and many enlarged color photo-essays were projected onto the exhibition walls (left).[3] A significant number of these international color photo-essays, shown as spreads or as projections, came from the pages of *Life*, including Haas's motion studies in Spain, Elisofon's travel scenes in the South Seas, and Larry Burrows's first Vietnam War photo-essay.

A. S.

LIFE MAGAZINE

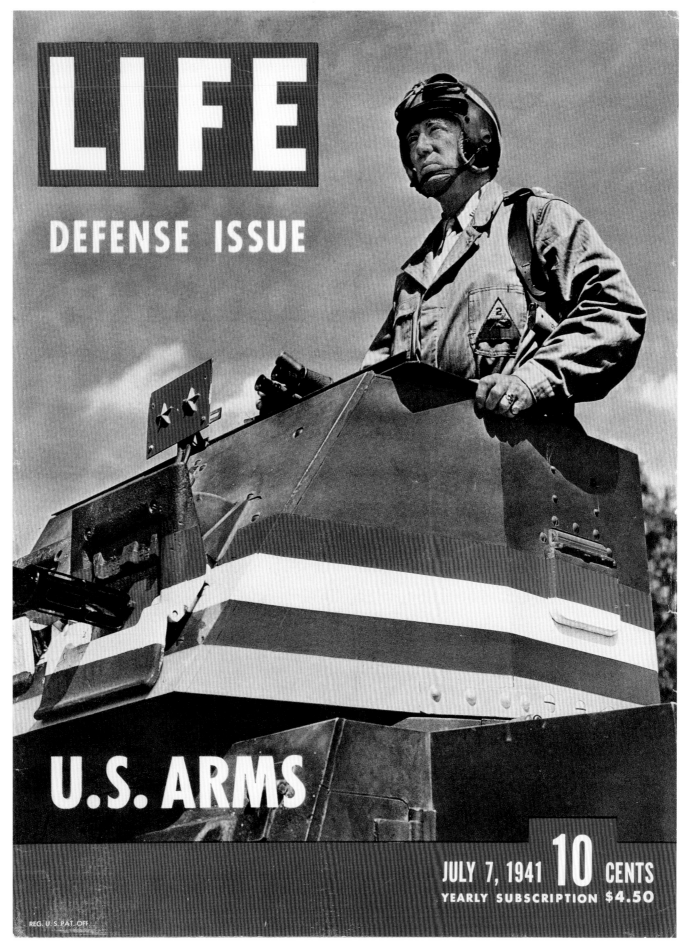

Eliot Elisofon, cover for *Life* magazine, July 7, 1941

Fritz Goro, spread in *Life* magazine, May 16, 1949

Eliot Elisofon, spread in *Life* magazine, January 24, 1955

Andreas Feininger, spread in *Life* magazine, July 28, 1947

DREAM ROLES CONTINUED

RODDY McDOWALL
in 'The Tempest'

*All hail, great master! grave sir, hail! I come
To answer thy best pleasure; be't to fly,
To swim, to dive into the fire, to ride
On the curl'd clouds. . . .*

Shakespeare's lines are spoken here by Ariel, the sprite who serves the magician Prospero, on his sea-girt island. To play Ariel, Roddy McDowall created his own fantastic make-up to look as if he were spattered with ocean spray and could really ride the "curl'd clouds."

One of Broadway's most versatile young performers, Mc-Dowall finds this complex role a challenge because Ariel is "full of fun and zest, and he is also vengeful. He embodies two conflicting desires: to be free of bondage to his master, and to love his master." McDowall has played Ariel in a summer production, but "I still feel I haven't used up the part."

GWEN VERDON
in commedia dell'arte

Gwen Verdon, who shines as a musical comedy star, feels deeply indebted to Harlequin, a classic character in the 16th Century *commedia dell'arte*. In this free and easy form of Italian theater, strolling players used to improvise their own dialogue as they acted out popular plots. Their comic tricks have been handed down through the years and are still used by circus clowns and burlesque comedians.

"Harlequin is a well-rounded, sensitive person," says Gwen. "His love for Columbine—especially when she breaks his heart—makes a man of him. He's transformed by suffering. The twirl of blue paper in his eye represents tears. The flower on his nose is a symbol of unattainable beauty—like Columbine. He hunts for it everywhere, not realizing that it is right in front of him. Whenever I get a new part I always stop and ask myself how Harlequin would do it. It's helped me a lot."

Eliot Elisofon, spread in *Life* magazine, April 14, 1958

Eliot Elisofon, *Roddy McDowall as "Ariel,"* 1957

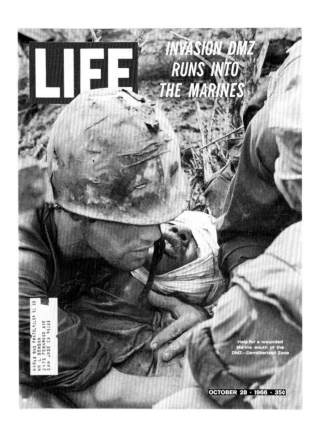

Larry Burrows, cover of *Life* magazine,
October 28, 1966

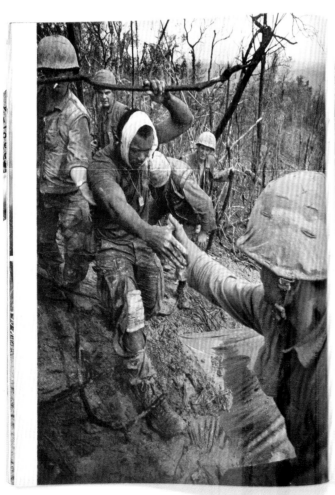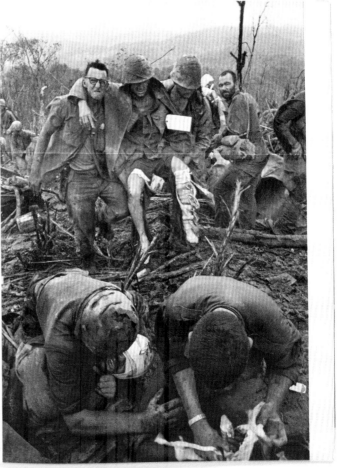

Larry Burrows, spread in *Life* magazine, October 28, 1966

Larry Burrows, *Reaching Out, South Vietnam*, 1966

3

CHOOSING COLOR

ELIOT PORTER

Eliot Porter's experiments in the genre of nature photography persuaded numerous museums to view color photography as a legitimate artistic medium. Porter, who held both engineering and medical degrees, began using photography as a means to complete his scientific research. His biological interest in birds led him to start actively photographing them in black and white in 1937. Two years later, he decided to take up photography professionally and quickly made the switch to color, using Kodachrome film.

In 1943 Porter was given a solo show of his color bird photographs at the Museum of Modern Art, New York, the museum's first single-artist exhibition to feature color photography. Nancy Newhall, acting curator of photography in charge of the exhibition, explained in the April 1943 museum bulletin that through "high achievements in the technical fields of natural history and color photography, Dr. Porter brings us not only living documents, but a profound insight into the beauty and diabolism of nature. . . . Subtly Dr. Porter uses color to accent one particular quality, and black and white for another. . . . In a black-and-white photograph, the young of the meadowlark would be lost in flickering shadows. In color they wait in the grasses like winged demons."[1]

This exhibition proved to be both a critical and popular success, and MoMA continued to display Porter's color work in numerous future exhibitions. Other important museums similarly honored Porter's early color photographs in the following years. George Eastman House and the Art Institute of Chicago both accorded Porter solo exhibitions, the latter marking the museum's first show dedicated to color photography by a well-known fine-art photographer.

While creating his scientific photographs and making prints for museum walls, Porter was also continually publishing books and portfolios of his work intended to raise awareness for wilderness preservation. Porter's photographic book *In Wilderness Is the Preservation of the World*, published in 1962 by the environmentalist Sierra Club, was remarkably popular for its pioneering use of color photography to raise issues about the natural landscape, showing that "while the subject was ancient, the technology to represent it so dazzlingly was new."[2]

In 1979 the Metropolitan Museum of Art, New York—which had been slow to embrace color photography—inaugurated a new era with an exhibition of Porter's color Intimate Landscapes series.[3] By this moment, however, fine-art photographers had embraced color in more adventurous and innovative ways, and Porter's photographs were perceived as historical examples of masterful technical works of color.

A. S.

1.
Nancy Newhall, "Eliot Porter: Birds in Color," *MoMA Bulletin*, April 4, 1943, p. 6.

2.
Rebecca Solnit, "Every Corner Is Alive: Eliot Porter as an Environmentalist and an Artist," in *Eliot Porter: The Color of Wildness* (New York: Aperture, 2001), p. 113.

3.
For a critique of this exhibition, see Gene Thornton, "Reappraising Eliot Porter," *New York Times*, December 16, 1979, pp. 34, 48.

Eliot Porter, *Hooded Oriole*, 1941

Eliot Porter, *Foxtail Grass, Lake City, Colorado,* 1957

Harry Callahan, *Abstraction*, 1943–47

Harry Callahan, *Detroit*, 1951

IRVING PENN

After joining the staff of *Vogue* magazine in 1943, Irving Penn quickly distinguished himself with simple color compositions. As Museum of Modern Art, New York, curator John Szarkowski wrote in a retrospective catalog of Penn's work: "During 1947, the second year after his return [from World War II], the essential Penn—what now might be called the historic Penn—emerged. The calm spareness of vision and manner in his pictures is breathtaking. Seen against the background of the various trilling, ornamental styles that had seemed intrinsic to the very substance of fashion magazines, they seemed to represent a new beginning."[1]

Penn's striking originality is most visible in his color still-life photographs, which frequently depict their subjects in saturated hues with few shadows or extraneous detail. As demonstrated by *Two Liqueurs* (right), his compositions, despite their simplicity, vivify the subjects through a clean, modern aesthetic. Penn described his practice:

> The contemporary color photographer is a man peculiarly equipped to supply the commodity required. He can take the hypernaturalism inherent in his materials, and, making good use of the inclination people have for believing true anything they see in a photograph, he becomes the imager of a remarkable world. . . . In that world there is no room for less than perfection: there women do not wrinkle as they age, fruit does not decay, babies do not cry, bosoms are always ample. Unless he treads carefully, the color photographer will find himself the trustee of all this. His skill must be used to keep the fantasy of perfection always fresh and desirable, to open his lens on the world for all to see and marvel at.[2]

Penn's *Summer Sleep* (page 121), initially published in the June 1949 issue of *Vogue*, indicates his ability to balance the perfect world created by color photography with his desire to avoid wholly embracing it: the flies, which Penn had glued to the mosquito net, are the focus of the composition, while the sleeping woman is depicted in soft focus.

In addition to producing work for *Vogue* throughout his career, Penn created color photography that was shown in several group exhibitions, including MoMA's *Color Photography* (1950), the American Museum of Photography's (in Philadelphia) *A Half Century of Color: 1900–1950* (1951), and Yale University Art Gallery's *Color Photography: Inventors and Innovators* (1976). Penn's deliberate color compositions set the tone for the medium's use in postwar fashion and commercial photography.

G. D.

1.
John Szarkowski, *Irving Penn* (New York: Museum of Modern Art, 1987), p. 23.

2.
Irving Penn, *The Art and Technique of Color Photography* (New York: Simon and Schuster, 1951), p. 2.

Irving Penn, *Two Liqueurs, New York*, 1951

Irving Penn, *Summer Sleep, New York*, 1949

In 1946 Kodak asked acclaimed black-and-white photographer Edward Weston to create color prints of Point Lobos in Monterey, California. This request, intended for Kodak advertisements, ignited Weston's brief-yet-productive interest in color photography. It became the final photographic project of his career, as he was forced to cease working in 1948 due to Parkinson's disease.

With his Kodak funding, Weston used Kodachrome film to re-create many of his most famous monochromatic photographs. The project allowed for a comparison between his black-and-white and color work, which fueled Weston's belief that there were different roles for each photographic medium. He explained in a 1953 essay in *Modern Photography*: "The prejudice many photographers have against color photography comes from not thinking of *color as form*. You can say things with color that can't be said in black-and-white."[1]

A few months after Weston created color photographs of Point Lobos, Kodak released an advertising campaign under the headline "Edward Weston's first serious work in color" (page 124). This multipage advertisement ran in important photographic publications such as *Popular Photography*, *American Photography*, and the *Camera*. Additional advertisements promoting Weston's use of Kodak color products were printed throughout the late 1940s and later reproduced by more general magazines such as *Holiday*, *Life*, *Collier's*, and *Fortune*.

Though Weston's color photographs were intended for Kodak, they were also discussed within the elite circle of fine-art photography. The tastemakers at the Museum of Modern Art, New York, and George Eastman House, Rochester, New York, particularly Beaumont and Nancy Newhall, were enthusiastic about Weston's color production. Nancy Newhall wrote to Weston, "This morning we saw your Kodachromes . . . a superb use of color. Looking forward to more."[2] Beaumont Newhall was similarly interested in Weston's color experiments. He included *Waterfront, Monterey*, an image from Weston's first Kodak color campaign, as the frontispiece of the 1949 edition of *The History of Photography: From 1839 to the Present Day* (page 125). This was the first color photograph reproduced in any edition of the influential publication.

Curator Sally Eauclaire, on the other hand, declared in her exhibition catalog for *The New Color Photography* that "the best results Edward Weston seems to have achieved are simplistic color tableaux."[3] Despite such occasional objections to Weston's color photographs, however, his Kodachromes were still exhibited in major museum exhibitions, solidifying his work in color as an important part of his photographic practice.

Weston remained optimistic about the place of color alongside black and white in fine-art photography even while lamenting the abrupt end to his career. He proclaimed, "I feel I only scratched the surface. But those who say that color will eventually replace black-and-white are talking nonsense. The two do not compete with each other. They are different means to different ends."[4] Though color had mostly replaced monochromatic photography by the 1980s, Weston's insistence on its validity nearly thirty years earlier helped to ensure its acceptance by the artistic establishment.

A. S.

1.
Edward Weston, "Color as Form," *Modern Photography* (December 1953), p. 54.

2.
Quoted in Terence Pitts, "Edward Weston: Color Photography," in *Edward Weston: Color Photography* (Tucson: Center for Creative Photography, University of Arizona, 1986), p. 16.

3.
Sally Eauclaire, *The New Color Photography* (New York: Abbeville Press, 1981), p. 9.

4.
Weston, "Color as Form," p. 54.

EDWARD WESTON

WATERFRONT Edward Weston

In This Issue . . .
PICTURING FLOWERS IN COLOR
SUMMER CAMERA DIARY
EDWARD WESTON AND COLOR
SOFTENING THOSE SUMMER SHADOWS
BIRDS: HOW TO PICTURE THEM

Edward Weston, cover of *Kodak Photo*, June/July 1947

Kodak advertisement, *Popular Photography*, May 1947

Edward Weston, spread in *Life* magazine, November 25, 1957

Edward Weston's *Waterfront, Monterey*, ca. 1947, in Beaumont Newhall's *The History of Photography: From 1839 to the Present Day*, 1949

Spread featuring Edward Weston's *Shell*, ca. 1947, "Test Exposures," *Fortune* magazine, July 1954

ANSEL ADAMS

Though Ansel Adams created a significant number of color photographs throughout his career, he was never completely convinced of their merit in comparison to his black-and-white work. Adams persevered with color photography for decades, however, as part of his fascination with the technical advances and possibilities of the craft of photography. He summarized his conflicting views on color in a 1957 article: "I accept [color photography's] importance as a medium of communication and information. I have yet to see—much less produce—a color photograph that fulfills my concepts of the objectives of art. It may approach it, give pleasure and induce contemplation, but it never seems to me to achieve that happy blend of perception and realization which we observe in the greatest black-and-white photographs."[1]

During the 1940s and '50s, Adams, alongside other professional photographers looking for lucrative photographic opportunities, began shooting in color for commercial projects. He created images using color technology for publications such as *Life* and *Fortune*, as well as large corporations. Adams understood and noted the consumer force behind color: "The taste-makers in color photography are the manufacturers, advertisers in general and the public with their insatiable appetite for the 'snappy snapshot.'"[2]

By the prosperous postwar years, Kodak began to hire recognized fine-art photographers, including Adams, Edward Weston, and Walker Evans, to test their newest color products in an attempt to reframe color as a powerful tool for both the dedicated amateur and the creative professional. Evans later reproduced a portfolio of the Kodak color film experimentations by Adams and Weston in *Fortune*, and many of Adams's color photographs were incorporated into widely circulated Kodak advertisements (pages 128–29).

Adams also participated in Kodak's Colorama campaign, the most extravagant advertising initiative of its time.[3] In 1951, a year after Kodak inaugurated the series, Adams's first Colorama was featured in New York City's Grand Central Station. Adams produced roughly a dozen Coloramas (pages 130–131), noting that they were "aesthetically inconsequential but technically remarkable."[4] Alongside his work for Kodak, Adams became the technical consultant for Polaroid in 1949, where he aided the research division of the company.

While Adams was not always convinced that his color work was worthy of display, the Museum of Modern Art, New York, presented his color photographs and transparencies in several important exhibitions, including *In and Out of Focus: A Survey of Today's Photography* (1948) and *Color Photography* (1950).

Adams never stopped contemplating color photography. He wrote extensively on the topic and declared his hope that others would continue to push the boundaries of color: "I believe that color photography, while astonishingly advanced technologically, is still in its infancy as a creative medium. We must remain objective and critical, plead for greater opportunity for control, and constantly remind ourselves that the qualities of art are achieved in spite of conditions and media—never because of them."[5]

A. S.

1.
Ansel Adams, "Color Photography as a Creative Medium" in *Image: Journal of Photography and Motion Pictures of the George Eastman House* 6, no. 9 (November 1957): p. 217.

2.
Quoted in James L. Enyeart, "Quest for Color," in *Ansel Adams in Color* (Boston: Little, Brown and Company, 1993), p. 13.

3.
For more information on Kodak's Colorama series and other fine-art photographers who participated in the project, see Alison Nordström, "Dreaming in Color," in *Colorama: The World's Largest Photographs from Kodak and the George Eastman House Collection* (New York: Aperture, 2004).

4.
Quoted in Enyeart, "Quest for Color," p. 18.

5.
Adams, "Color Photography," p. 217.

Ansel Adams, *Church at Ranchos de Taos*, 1947

Yosemite National Park—Cloud shadows are used to separate planes and give added depth to the picture

Ansel Adams' America ... in Kodak Color

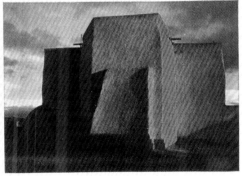

Ranchos de Taos Church in sunset lighting

FOR YEARS Ansel Adams has been living in Yosemite, conducting a school of photography in San Francisco . . . and making magnificent pictures without end. He holds a Guggenheim Fellowship Award, with the mission of depicting the National Parks of America.

To his mastery of the photographic technic Adams adds a rare sensitivity to nature. He has a deep and instinctive understanding of the plains, river valleys, mountains, forests,

Kodak

Kodak advertisement, *Popular Photography*, March 1948

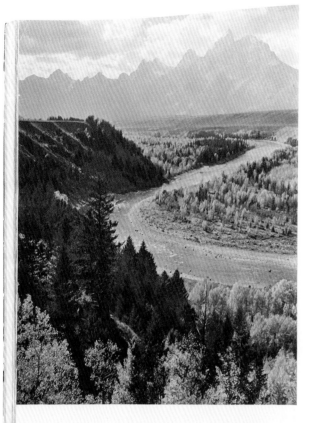

The Teton Range from a point above Snake River—Careful use of backlight turns the water into blue silver

Grand Canyon at sunrise—Adams made three trips over a period of six months before he found lighting effects exactly as he wanted them

Santa Elena Canyon, Big Bend Nat'l Jackson Lake and the Tetons—The yellow—Adams always considers aspen's rich detail is modeled by a sun only integral part of the composition five minutes old

canyons . . . of the mists, serrated skies, and thunderheads that hover over all. As a result, he has been wonderfully successful in "interpreting the natural scene."

While preparing material on his Guggenheim Fellowship, he has made wide use of Kodak color films, adding the dimension of full color to his interpretations. On these pages are reproductions of some of his transparencies. In them he has truly captured the spirit of our

country . . . the "color" of the American Land.

Join him . . . join the multitude of other serious photographers—amateurs and professionals—who are working in Kodak color and finding it a highly rewarding experience.

Kodak color includes Kodachrome Film for most miniature, home-movie, and sheet-film cameras . . . Kodacolor Film for most roll-film cameras . . . home-processed Kodak Ektachrome Film for cameras that take sheet film.

It's Kodak for Color

NOTE: For another Ansel Adams interpretation of nature —this one in black-and-white—see the next page

Kodak

Kodak

Kodak advertisement, *Popular Photography*, March 1948

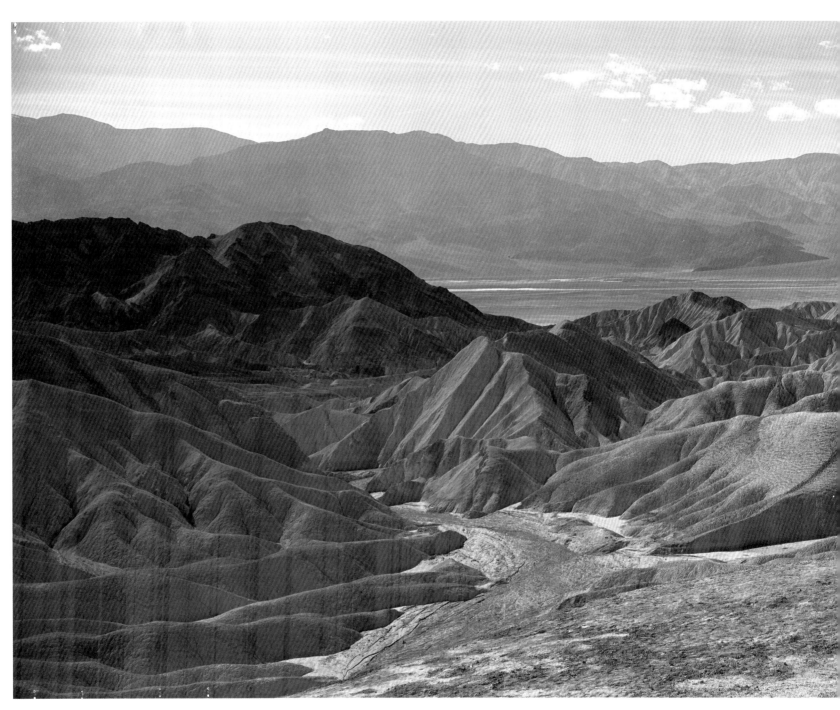

Ansel Adams, *Zabriskie Point, Death Valley, CA*, ca. 1959

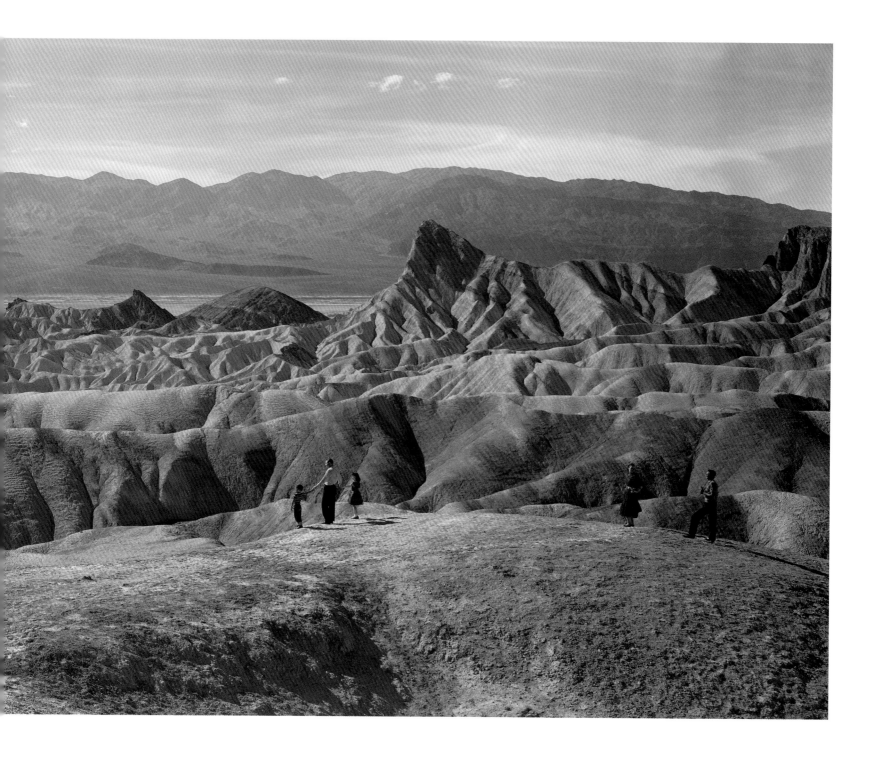

1.
Walker Evans, "Photography," in *Quality: Its Image in the Arts*, ed. Louis Kronenberger (New York: Atheneum, 1969), p. 208.

2.
Ibid.

3.
Lesley K. Baier, *Walker Evans at Fortune, 1945–1965* (Wellesley, Mass.: Wellesley College Museum, 1977), p. 20.

4.
Douglas Eklund, "'The Harassed Man's Haven of Detachment': Walker Evans and the *Fortune* Portfolio," in *Walker Evans* (New York: Metropolitan Museum of Art; Princeton, N.J.: Princeton University Press, 2000), p. 125.

5.
Walker Evans, "Test Exposures: Six Photographs from a Film Manufacturer's Files," *Fortune*, July 1954, p. 80.

6.
For more on Evans's opinions about SX-70 technology, see William Ferris, ed., *Images of the South: Visits with Eudora Welty and Walker Evans* (Memphis, Tenn.: Center for Southern Folklore, 1977).

7.
Jeff L. Rosenheim, *Walker Evans: Polaroids* (Zürich: Scalo, 2002), p. 7.

"There are four simple words for the matter, which must be whispered: *color photography is vulgar.*"[1] With this sentence, Walker Evans, famous for his black-and-white photographs, declared his aversion to color photography in a 1969 essay on the state of the medium. He went on to admit that he found it a "consoling thought that in about fifty years, both color transparencies and paper prints in color . . . will very probably have faded away."[2] From these statements it might come as a surprise that at two distinct times in his career—before and after these comments were made—Evans created color photographs.

Evans's first sustained effort with color came during his time as a magazine photographer working for Henry Luce, the publisher of popular American magazines, including *Time, Life,* and *Fortune.* Though Evans contributed works to several publications, he became most closely associated with *Fortune.* By 1948 he was named special photographic editor, creating numerous photographic portfolios for the magazine.

It is in these portfolios, made after 1950, that Evans began to incorporate color into his practice. Over half of his portfolios consist primarily of color photographs, and a total of 107 of the 215 images Evans created were reproduced in color.[3] Evans's 1950 essay "Along the Right-of-Way," which features color photographs of the landscape taken from inside a moving train car, exemplifies his precise use of color to complement the storylines of magazine spreads (pages 134–35). The photographs are marked by muted tones and "broad patches of unmodulated color (brick, blue sky, dirt roads and grass, patinated lettering), tastefully tuned a decibel or two below the shrieking palette of advertising work."[4] Evans also promoted the work of fellow photographers working in color in articles such as "Test Exposures: Six Photographs from a Film Manufacturer's Files," which consists of Kodak color images taken by Charles Abbott, Ansel Adams, Charles Sheeler, Paul Strand, and Edward Weston (page 125). In the accompanying text, Evans praises these specific color works, though warns against overwhelming the viewer with color as visual noise used to "[blow] you down with screeching hues alone . . . a bebop of electric blues, furious reds, and poison greens."[5]

Despite Evans's declaration of color's "vulgarity" after his work at *Fortune,* he returned to color in 1973, this time using new technology and embracing the loud hues that he criticized twenty years earlier. Over the course of fourteen months, Evans created his final photographic project, producing more than 2,650 photographs with Polaroid's instant color technology, the SX-70 (right).[6]

Evans's SX-70 prints stay true to the subject matter of his earlier work: "vernacular architecture, domestic interiors, portraiture, and road signage. Encouraged by renewed health and an unlimited supply of film courtesy of the manufacturer, he made the most of his final year of work."[7] Thus Evans concluded his fine-art practice by embracing commercial color technology while preserving his compositional sensibilities and the thematic motifs he privileged throughout his career.

A. S.

WALKER EVANS

Walker Evans, *West Street, Dead End (Sign Detail)*, 1973–74

Walker Evans, *Going Out of Business IV*, 1974

Along the Right-of-Way

Iᴺ Roomette 6, Car 287, the light has not yet been switched on. For an hour the train has swayed and rattled across the land. This rented steel cubicle, with its solemn and absorbing printed directions of how to work those basic gadgets, is the harassed man's haven of detachment. The captains and the kings depart. Now if ever, in this place and in this mood, the traveler can abandon himself to the rich pastime of window-gazing.

Along the paths of railroads, the country is in semi-undress. You can see some of the anatomy of its living: a back yard with its citizen poking into a rumble seat for a trusted toolbox; an intent group of boys locked in a sandlot ball game; a fading factory wall; a lone child with a cart. Out on the plains, the classic barns and the battalions of cabbages . . .

To some, these sights gain meaning because men like Mark Twain and Sherwood Anderson and Thomas Wolfe have, in a sense, laid hands on them. For others, one fleeting landscape can flush the mind with images of the enchantment a child feels with train trips: waking at dawn to see a cool cornfield cut by a rutted road; a farmer in his wagon drawn up at the crossing; the *TING TING* TING TING TING ᴛɪɴɢ ᴛɪɴɢ of the warning bell–that heart-rending tinny decrescendo which is an early lesson in relativity of the senses. *W.E.*

Seven photographs by Walker Evans of middle-western and eastern landscapes seen through train windows

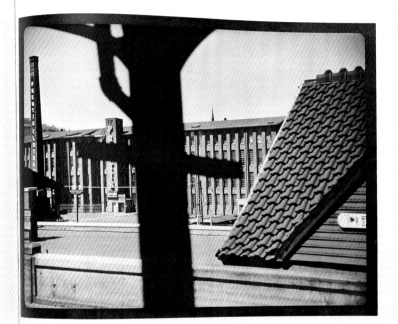

From the Sunday A.M. local, winding through the New Jersey factory towns

Walker Evans, spread in *Fortune* magazine, September 1950

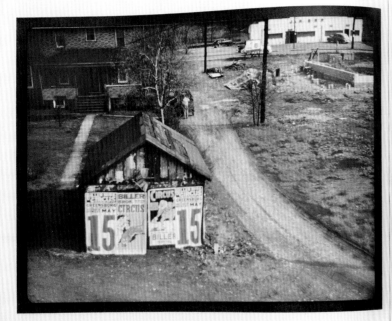

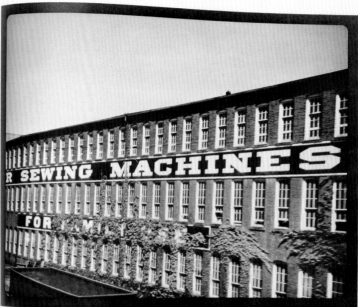

Approaching Pittsburgh: Saturday afternoon beside the Pennsy's roadbed

Past a Connecticut landmark: curving through Bridgeport, Shore Line

Walker Evans, spread in *Fortune* magazine, September 1950

SAUL LEITER

1.
Saul Leiter, interview by Lisa Hostetler, August 3, 2006.

2.
"Review of 'Saul Leiter' at the Tanager," *Art News*, January 1956, p. 68.

3.
See, for example, Bruce Downes, "Color Today—An Appraisal," in *Color Photography Annual 1956* (New York: Ziff-Davis Publishing, 1956), p. 34.

4.
The Club included Willem de Kooning, Franz Kline, Jackson Pollock, Milton Resnick, and Ad Reinhardt, among many other artists. For more on the character and activities of this group, see Geoffrey Dorfman, *Out of the Picture: Milton Resnick and the New York School* (New York: Midmarch Arts, 2003), esp. "Interviews," pp. 13–19; "Milton Resnick and Ad Reinhardt, 'Attack': 1961, the Club," pp. 235–72; and "Out of the Picture: Pat Passlof Remembers," pp. 275–312.

5.
Saul Leiter, telephone interview by Lisa Hostetler, August 10, 2006.

According to Saul Leiter, "The history of art is a history of color."[1] Along with black-and-white photography and painting, color photography became a regular part of Leiter's art-making activity when he began producing 35 mm Kodachrome slides in the late 1940s. His subjects were primarily drawn from his own neighborhood—today's East Village in Manhattan—where he observed the patterns and rhythms of daily life. The resulting photographs are understated soliloquies on the contingent nature of seeing—the precariousness of a point of view or the accidental, brief coalescence of objects and people into a harmonious pictorial composition.

Leiter saw his art as a continuously evolving activity with one work leading seamlessly into the next, an attitude he held in common with other members of the Tenth Street Group. Many of the artists in this group, composed primarily of painters such as Philip Guston and Milton Resnick, were associated with the cooperative Tanager Gallery, founded in 1952. Leiter's 1955 solo exhibition there included color slides shown in small light boxes, slides projected on the wall, and paintings. The *Art News* review notes the effect of the two forms of presenting the slides: "Picking abstract patterns from the flotsam and jetsam of sidewalk and gutter, the slides, as viewed via shadow-box, tend to look like strange jewels while, as projected on the wall, like landscapes or the formation of distant universes."[2] Given the number of those who complained that slides were impractical for art exhibition (and such commentators were many, as testified by the number of articles in amateur photography magazines bemoaning the difficulty and expense of making prints from color slides), Leiter's decision to exhibit his slides in this manner was defiant.[3] In addition to presenting them at Tanager, he held slide shows in his apartment, where he invited artist friends to view his latest work. Twenty of Leiter's slides were included in Edward Steichen's 1957 talk "Experimental Photography in Color" at the Museum of Modern Art, New York, and Leiter also showed his slides at the Club, a loose affiliation of avant-garde artists that met regularly to discuss art and ideas in downtown New York in the 1950s.[4]

Leiter continually sought to demonstrate that painters did not have a monopoly on abstraction: "My point was abstraction exists in the real world—[it was] not invented by artists. You just have to look. Artists often don't really look at the real world, their surroundings. Seeing is a neglected enterprise."[5] Leiter began to produce prints from his slides in the early 1990s. This prompted a revival of interest in his work and a renewed appreciation for his deliberate and sustained attention to color photography at a time when the medium had yet to attain widespread acceptance as a legitimate art form.

L. H.

Saul Leiter, *Bus*, ca. 1955

Saul Leiter, *Window*, 1957

Saul Leiter, *Walk with Soames*, 1958

Saul Leiter, *Through Boards*, 1957

Hy Hirsh's color films and photographs are part of the larger history of Visual Music, a diffuse set of artistic practices aimed at creating visual art that incorporates musical structures. This movement, the origins of which date to the late eighteenth century, has always been deeply engaged with color as a key component to visualizing sound.[1] The advent of commercially available color film in the 1930s allowed for sustained exploration of the relationship between the sonic and the visual through abstract color animation. Hirsh is one of a group of California-based filmmakers who experimented with the creation of abstract color film and photography in this tradition.[2]

Hirsh was especially sensitive to the possibilities of color as a primary subject through which rhythm could be explored.[3] He began creating his own films in 1951 and used a variety of techniques to produce abstract color animation, including filming the patterns made on an oscilloscope—a medical device used to measure electrical pulses—through colored filters. In Hirsh's work, color is an active character, rather than a sign or symbol, free from narrative demands. Instead, it is explored through movement in connection with music. *Come Closer* (1952) presents whirling rings of colorful light that seem to dance along with the music that accompanies the film.

Although at first glance Hirsh's photographs might appear to be still-shots from his films, they were created independently as works of art. Hirsh used the Ansco Printon process for his photographs, a system devised by the U.S. subsidiary of the film corporation Agfa. In the context of Visual Music, these prints might be considered extended chords that allow for sustained reflection on specific relationships between color and light.[4] In 1968, seven years after Hirsh's untimely death, his color slides were presented in a slide show introduced by John Szarkowski at the Museum of Modern Art, New York. Despite its rare inclusion in historical surveys of color photography, Hirsh's work can be understood as a full realization of László Moholy-Nagy's desire for artists to leave behind illusionism in favor of an engagement with color for its own sake.

G. D.

1.
William Moritz, "Musique de la Couleur—Cinéma Intégral," in *Poétique de la Couleur*, ed. Nicole Brenez and Miles McKane (Paris: Musée du Louvre, 1995).

2.
For more on Hirsh's California circle, see Suzanne Muchnic and Leland Rice, *Southern California Photography, 1900–65: An Historical Survey* (Los Angeles: Photography Museum, 1980).

3.
For a more detailed history of Hirsh's photographic practice, see Dennis Reed, "Hy Hirsh: Experiments in Filmmaking and Photography," in *Hy Hirsh/Color Photography*, ed. Paul M. Hertzmann (San Francisco: Paul M. Hertzmann, 2008), pp. 1–5.

4.
Ibid, 5.

HY HIRSH

Hy Hirsh, Untitled, ca. 1950

Hy Hirsh, still from the film *Come Closer*, 1952

ARTHUR SIEGEL

Arthur Siegel's transition to color photography was gradual. Although Siegel began using color film in 1938, he initially employed it to shoot black-and-white scenes, slowly introducing small elements of color into his work. As he became more knowledgeable about the underlying principles of color compositions, he began making full-spectrum color photographs. Eventually, in 1952, Siegel wrote three articles on his methodical approach to color photography, aimed at instructing both amateurs and experts alike on the language of color composition.[1] His texts suggest taking the same gradual approach that he employed in his personal shift to color, and demonstrate a belief that shooting color changes visual experience more broadly: "As you photograph colors, your entire seeing will begin to change. You will begin to see small color differences that never existed before. You may become color conscious to the point where your non-photographic life begins to change."[2]

Siegel's view of the world in color caught the attention of *Life* magazine, which featured his work in the article "Modern Art by a Photographer" in its November 20, 1950, issue. The photographs depict bright spaces framed in ways that emphasize the relationship between color and geometric form (page 144). *Life* introduced these works to the public as images that rival painting in their creative and unexpected uses of color and light. For Siegel, however, the medium of photography was inherently more modern than painting: "The camera is a means of making images that seems to be more suitable to this modern age than the tedious methods of the painter."[3]

Siegel's color photographs were the subject of a major exhibition at the Art Institute of Chicago in 1954. In a press release for the exhibition, the museum's curator of photography, Peter Pollack, suggested that Siegel used color to express his "emotional response" to the juxtapositions of forms he encountered. Siegel's own description of the role of color echoes the personal nature Pollack described: "Creative photographers in color explore objects in a more and more penetrating way until they reveal new meanings. These new meanings are the photographer's contribution to objects in the outside world, and by revealing them, he reveals himself."[4] His studious approach resulted in an understanding of color as both a primary subject of the photograph and as a tool for depicting a personalized worldview that transcends the mechanical nature of the photographic process.

G. D.

1.
Arthur Siegel, "Creative Color Photography," *Modern Photography* 6, no. 2 (January–March 1952): p. 45.

2.
Siegel, "Creative Color Photography," p. 45.

3.
"Modern Art by a Photographer," *Life*, November 20, 1950, pp. 78–84.

4.
Color Photographs: Arthur Siegel (brochure, Art Institute of Chicago, 1954).

Arthur Siegel, *State Street, Jewelry Shop*, ca. 1940

Arthur Siegel, spread in *Life* magazine, November 20, 1950

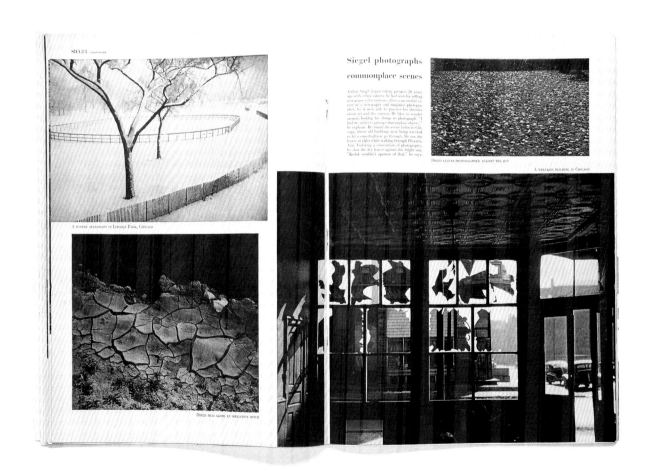

Arthur Siegel, spread in *Life* magazine, November 20, 1950

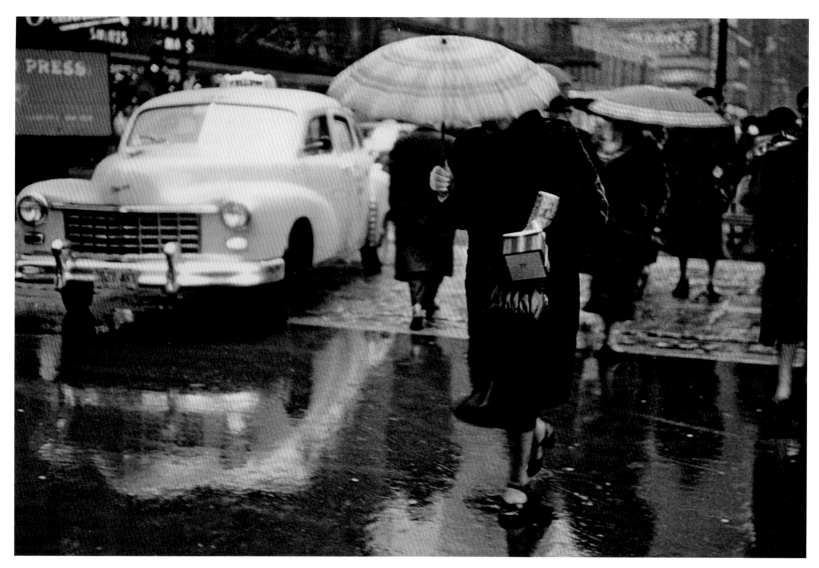

Arthur Siegel, *State Street, Rainy Day*, 1952

1.
Ernst Haas, in *World Photography*, ed. Bryn Campbell (New York: Ziff-Davis Books, 1981), p. 134.

2.
"Images of a Magic City, Part I," *Life*, September 14, 1953, pp. 108–20, and "Images of a Magic City, Part II," *Life*, September 21, 1953, pp. 116–26.

3.
"The Magic of Motion in Color—Famous Photographer Explores New Dimension of His Art," *Life*, August 11, 1958, pp. 64–73.

4.
"Ernst Haas—Color Photography" (press release, Museum of Modern Art, New York, August 4, 1962), www.moma.org/learn/resources/press_archives/1960s/1962/2.

5.
For a salient example of criticism directed at Haas's color photography, see Sally Eauclaire, *The New Color Photography* (New York: Abbeville Press, 1981). For additional information on the contested nature of Haas's legacy, see Phillip Prodger, "Ernst Haas—Another History of Color," in *Ernst Haas: Color Correction*, ed. William A. Ewing (Göttingen, Germany: Steidl, 2011).

In 1949, the same year he joined the press photographers' cooperative Magnum, Ernst Haas began experimenting with color film. Although a number of his Magnum colleagues, most notably Henri Cartier-Bresson, saw color photography as a lesser medium, Haas viewed it as well suited to the promise of the postwar era: "I will always remember the war years—all the war years, including at least five bitter postwar years—as the black and white years, or even better, the gray years. Somehow, maybe quite symbolically, I wanted to express that the world and life had changed—as if everything was suddenly newly painted. The gray times were over; as at the beginning of a new spring I wanted to celebrate in color the new times, filled with new hopes."[1] This exuberance is perhaps best demonstrated by his 1952 photographs of New York City, which were featured in *Life* magazine's first major, multiple-issue color photo-essay that appeared in two parts in September 1953 (page 148).[2]

In 1956 Haas made photographs of bullfights in Spain in which the slow speed of Kodak's 35 mm color film rendered the motion of the sport as vibrant streaks. In August 1958, the results of this experiment were featured in a *Life* photo-essay, "The Magic of Motion in Color—Famous Photographer Explores New Dimension of His Art."[3] The afterlife of this series demonstrates the permeable boundary between popular magazines and art photography at that moment: seven years after the motion studies appeared in *Life*, they were featured in *The Photo Essay*, a 1965 exhibition at the Museum of Modern Art, New York.

In 1962 Haas received a ten-year retrospective at MoMA, *Ernst Haas: Color Photography*. This exhibition was Haas's first solo show in the United States, as well as one of the first MoMA exhibitions fully dedicated to the color photographs of a single artist. In a press release for the retrospective, John Szarkowski heralded Haas's historic contribution: "The color in color photography has often seemed an irrelevant decorative screen between the viewer and the fact of the picture. Ernst Haas has resolved this conflict by making the color sensation itself the subject matter of his work. No photographer has worked more successfully to express the sheer physical joy of seeing."[4]

In addition to being widely shown in museums, Haas's photographs were published in an immensely popular monograph, *The Creation*, in 1971. Although Haas has been admonished in historical surveys of photography for his painterly use of color, his contributions to the development of the medium as a fine art cannot be overstated.[5] He was the photographer most associated with color photography in the immediate postwar years. As such, his work had an appreciable impact on color photography of the 1960s and '70s.

G. D.

ERNST HAAS

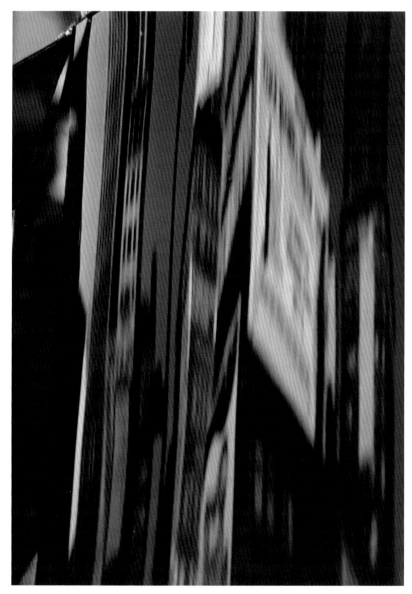

Ernst Haas, *New York (Mirror)*, 1949–53

Ernst Haas, *New York (Reflections in Water on Street)*, 1949–53

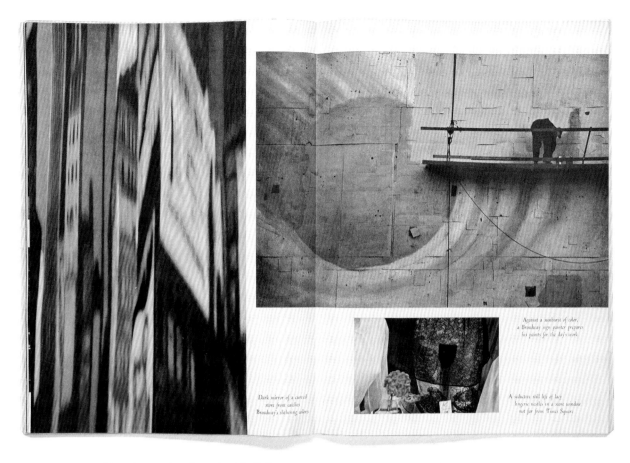

Ernst Haas, spread in *Life* magazine, September 14, 1953

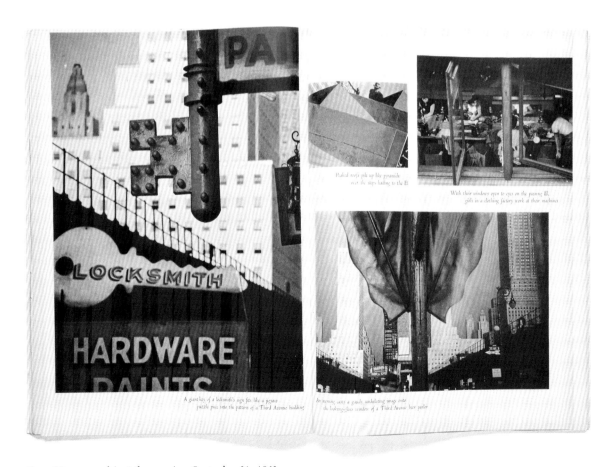

Ernst Haas, spread in *Life* magazine, September 21, 1953

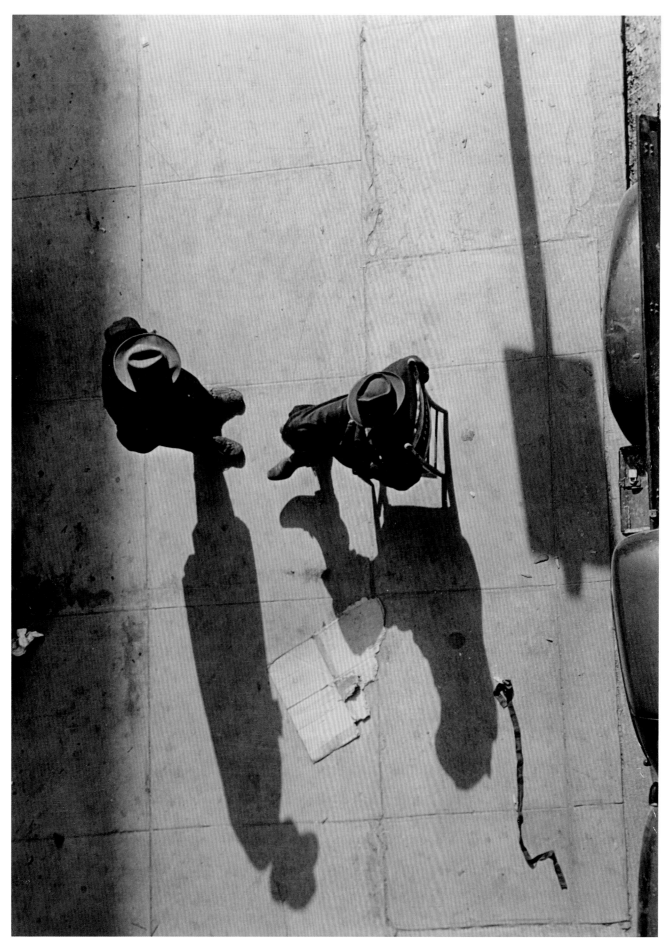

Ernst Haas, *New York (Two Men on Sidewalk)*, 1949–53

SYL LABROT

In his essay "The Invention of Color Photography," Syl Labrot explained, "In my own photography I have worked for color images almost from the beginning and the various materials I used have been those commonly available at the time. I have originated almost nothing of interest technically. Yet, the feeling of being engaged in the invention of color photography is—was unmistakable."[1] As soon as Labrot began his career in the early 1950s, he felt it necessary to physically work through the evolution of color technology as a way of inserting himself into the history of the medium. He investigated the work of the early color practitioners, such as the carbro prints of Nickolas Muray and Paul Outerbridge, and insisted on completing the often difficult and complicated chemical work of creating color prints rather than sending his work to a laboratory for development. Labrot's technical mastery of color became a notable aspect of his color production. The press release of his first major solo exhibition at George Eastman House, Rochester, New York, in 1959, noted that "utilizing one of the two oldest color reproduction processes still in use today, Mr. Labrot's carbro prints . . . display a remarkable understanding of this time-consuming, exceedingly temperamental process. The quality of the prints themselves, a matt textural surface is rendered in the highlights while a somewhat glossy surface is maintained in the deep shadow, add to an increased feeling of depth and brilliance and produce a wide contrast range."[2]

Labrot began his professional practice as a freelance commercial color photographer, producing covers for popular magazines, including *Life*, *Time*, *Ladies' Home Journal*, and *Woman's Day*.[3] Labrot remarked that these images were typical of stock photography ranging from idyllic landscapes to portraits of children: "I had no desire to innovate here, and followed in the tradition."[4] Labrot's color magazine photographs were commercially successful and presented in early exhibitions of his work, including *Photographs in Color and Black and White by Syl Labrot* at the Art Institute of Chicago in 1961.

By the time of that exhibit, however, Labrot had already transitioned into experimental fine-art photography. While maintaining his interest in using complicated color technology and developing his own prints, Labrot began employing color as a creative, abstract lens through which to probe everyday objects. Color was no longer used to accurately illustrate the world or entice consumers with bright hues; instead, it became an essential subject in the photograph (pages 151–53). Labrot proclaimed that "absolute ideas of color fidelity have little validity in creative work. Neither do pictorial ideas of color harmony, for a whole new set of relationships occurs within the space of the color photographs, and there is a quite different sense of color validity in this context."[5]

Labrot's abstract use of color and form situated him within a group of photographers similarly investigating new avenues for color abstraction, including Ernst Haas and Eliot Porter, whose work was shown together in the influential 1960 group exhibition *The Sense of Abstraction in Contemporary Photography* at the Museum of Modern Art, New York.

A. S.

1.
Syl Labrot, "The Invention of Color Photography," in *Pleasure Beach: A Book in Three Parts* (New York: Eclipse, 1976), n.p.

2.
"The Color Photographs of Syl Labrot on View at George Eastman House from August 11 to September 25" (press release, George Eastman House, Rochester, New York, August 6, 1959).

3.
Arnold Gassan, "Syl Labrot: Photographic Printmaking, a Didactic Conversation," in *Three Photographic Visions* (Athens: Trisolini Gallery, College of Fine Arts, Ohio University, 1977), p. 40.

4.
Labrot, "Invention of Color Photography," n.p.

5.
Syl Labrot, *Under the Sun: The Abstract Art of Camera Vision* (New York: George Braziller, 1960), n.p.

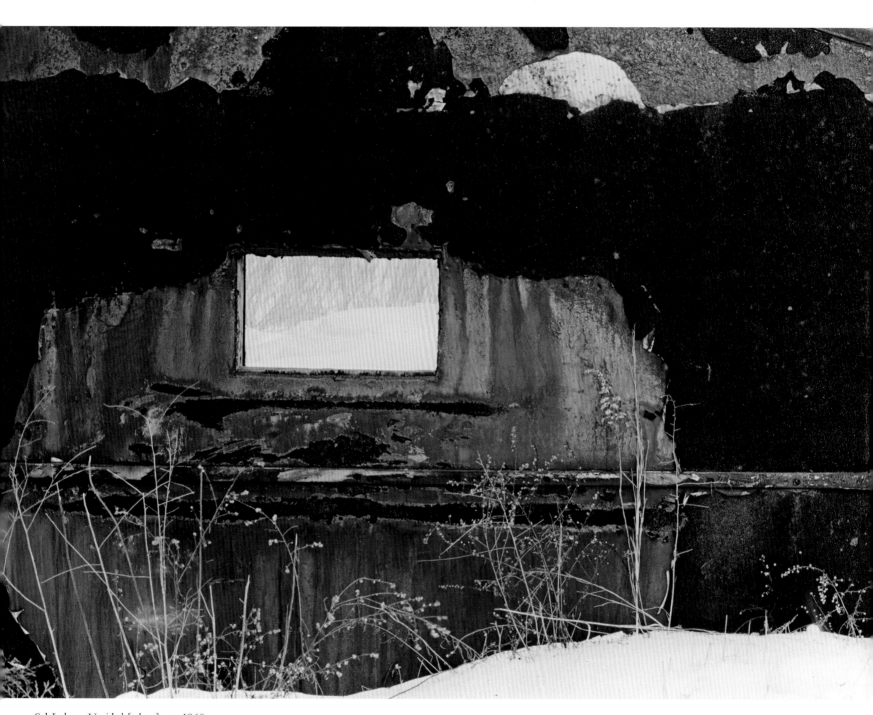

Syl Labrot, Untitled [wheat], ca. 1960

Syl Labrot, *Burlap: Close-up Study #9*, 1956

Syl Labrot, Untitled [hinge on steel painted red], ca. 1960

Syl Labrot, Untitled, 1958

4

AN EXPLOSION OF COLOR

Pete Turner refused to categorize himself as strictly a commercial or creative photographer. Throughout his career, he manipulated and exploited color photography in order to create technically and formally complex fine-art prints that were also used in the commercial world of advertising and publishing. Turner's interest in photography was driven by an early fascination with photographic chemistry that increased when he enrolled in the Rochester Institute of Technology.[1] He was one of the first students to participate in the school's new photography degree program that featured a technology-heavy curriculum and emphasized the importance of carefully controlling the medium.

Upon joining the U.S. military and being placed in the Army's color photography laboratory, Turner quickly became an expert color printmaker, taking full advantage of his unlimited access to the highest-quality materials for taking and developing color photographs. He took this technical knowledge of color processes to New York City in 1958 where he presented his portfolio of color work to publications and advertising agencies. Turner recalled that magazine art directors were immediately impressed by his proficiency in creating photographs replete with saturated, rich color.[2] Turner received his first large-scale commission from *Esquire* magazine to travel across the country taking color photographs for a feature on trains. The exposure from the photo-essay resulted in numerous requests for his color work as advertising images, photojournalism, photographs for popular publications, and Hollywood publicity shots.

Turner's interest in photographic chemistry and technology remained an important part of his color practice. He used techniques such as special filters and infrared film to create surreal chromatic effects often defined by their "absolute lack of nuance, the constant presence of strong and decisive hues."[3] Turner almost exclusively used Kodachrome film because of its ability to create vivid, full colors while maintaining chemical stability. When Turner created prints dominated by vibrant colors, he ensured that the subject matter of his work was relatively basic, often distilling objects to fundamental geometric shapes.

Turner's color photographs were seen at home and abroad throughout the 1960s, largely due to the support of George Eastman House, Rochester, New York, which purchased his classic *Rolling Ball* (right) in 1960 and displayed it alongside other color prints such as *Fisherman* (page 159) on multiple occasions. George Eastman House later gave Turner his first solo show, which traveled internationally.

As his own color work was being promoted in museum exhibitions, Turner sought to help other color practitioners break into the art market largely dominated by black-and-white photography. In 1977 Turner, with Ernst Haas and Jay Maisel, opened the Space Gallery in New York "in an effort to promote color photography as fine art and to present the work of contemporary color photographers,"[4] marking a significant stride in the acceptance of color photography as a legitimate art form.

A. S.

1.
For more on Turner's interest in photographic chemistry, see Myrna Masucci, "Pete Turner: Portrait of the Artist as a Commercial Photographer," in *Pete Turner* (Upper Saddle River, N.J.: Prentice Hall, 1982), p. 4.

2.
Attilio Colombo, *Pete Turner* (London: William Collins Sons and Company, 1984), p. 5.

3.
Ibid., p. 59.

4.
Pete Turner, *Pete Turner Photographs* (New York: Harry N. Abrams, 1987), p. 141.

PETE TURNER

Pete Turner, *Rolling Ball*, 1960

Pete Turner, *Fisherman*, 1961

HELEN LEVITT

Helen Levitt, [Man in green jacket leaning on car] from Levitt's slide show, 1959–60

1.
"Guggenheim Fund Grants $1,500,000," *New York Times*, April 20, 1959, p. 23.

2.
John Szarkowski, foreword to *Slide Show: The Color Photographs of Helen Levitt* (New York: PowerHouse Books, 2005), n.p.

3.
Quoted in Douglas Davis and Mary Rourke, "New Frontiers in Color," *Newsweek*, April 19, 1976, p. 56.

4.
Roberta Hellman and Marvin Hoshino, *Helen Levitt: Color Photographs* (El Cajon, Calif.: Grossmont College, 1980), p. 6.

Helen Levitt subtly integrated color into her monochromatic practice of street photography. After working in the 1940s as a black-and-white still photographer and experimenting with motion-picture film throughout the 1950s, Levitt returned to capturing the unmediated moments of everyday life, this time in color.

Levitt received a Guggenheim Fellowship in 1959 to pursue a study of "the techniques of color photography,"[1] an honor she was again awarded the following year. Levitt revisited the sites and neighborhoods of her earlier black-and-white New York street photographs. Museum of Modern Art, New York, curator John Szarkowski explained that Levitt's "objective was to use color neither in a decorative nor in a purely formal way, but as a descriptive and expressive aspect of the subject, as inherent to it as gesture, shape, space, and texture."[2] Levitt herself remarked on the veracity of color to capture the full story of her scenes: "I thought my photographs would be closer to reality if I got the color of the streets. . . . Black and White is an abstraction."[3]

Levitt's first attempts at color photography in 1959 and 1960 were exhibited at MoMA in 1963 as part of Szarkowski's one-day color slide presentation "Three Photographers in Color" (the other photographers were William Garnett and Roman Vishniac). Seven years later, the majority of Levitt's color prints and negatives were stolen from her apartment. Only a few known images of this original color series survive (left).

Shortly after losing her early color work, Levitt returned to shooting life in New York City in color, creating a new series of slides. Szarkowski continued his support of Levitt's color photographs by organizing a 1974 solo show of forty color slides, selected mainly from work created since 1971 (pages 161–63). The slide show was "easily mistaken for the work of the then budding movement of formalist color photographers, even though [Levitt] began working in color a decade before they did."[4] Like the new generation of color photographers, Levitt viewed color as an important aspect of recording everyday life, a documentary tool that she seamlessly incorporated into her street photographs.

A. S.

Helen Levitt, [Boys with Bubble] from Levitt's slide show, 1971–74

Helen Levitt, [Woman on Street] from Levitt's slide show, 1971–74

Helen Levitt, [Three Chickens] from Levitt's slide show, 1971–74

Helen Levitt, [Woman in Window] from Levitt's slide show, 1971–74

Although photographers working in color began producing how-to guides that were illustrated with color images as early as the 1940s, the color monograph, dedicated to the work of a single artist, only became a common practice in the mid-1970s, due to a constellation of funding and publishing organizations that emerged at that time. Prior to this, artist's books of color photography began appearing in the late 1960s, but these early examples often used the photographs as illustrations for a literary text or were self-produced endeavors.

New York Proclaimed (1965), for instance, featured Evelyn Hofer's color photographs alongside V. S. Pritchett's narrative account of the city (page 166).[1] Until Hofer's color photographs were shown at the Witkin Gallery, New York, in 1977, *New York Proclaimed* was the only way to see these works. The book demonstrates one of the options available to artists for publishing their work before the rise of publishing houses dedicated to photobooks.[2]

Ed Ruscha's self-published *Nine Swimming Pools and a Broken Glass* (1968) represents the other possibility open to artists interested in creating color books at the time (page 166). Prior to this, he had self-published six monochromatic books, and he would go on to publish a total of sixteen small books by 1978. Priced at a mere $3.50 at the time it was published, the book suggested a "throwaway" aesthetic commensurate with consumer culture.[3]

When color monographs began to appear more frequently, with the support of art-focused publishing houses, they were most often created in conjunction with major exhibitions of the artist's work. One of the most discussed books of this variety is *William Eggleston's Guide* (1976), published by the Museum of Modern Art, New York (right). Long seen as a watershed color photobook, it is one of the earliest dedicated to a single photographer to be published by a major institution.[4] Joel Meyerowitz's *Cape Light* (1979) is another early book of color photographs, published by the New York Graphic Society and the Museum of Fine Arts, Boston, shortly after exhibitions of the photographs in both New York and Boston (page 167).

As dedicated photography publishers such as Aperture and Lustrum Press emerged in the 1960s, granting organizations such as the National Endowment for the Arts and the Guggenheim Foundation also began to support photography more frequently.[5] The rise of color photography in the art world at this time eased the way for photographers working in this medium to enjoy this support as well. Photographs in Neal Slavin's *When Two or More are Gathered Together* (1978), for instance, were supported with funding from a National Endowment for the Arts grant. These select examples demonstrate that, through the color monograph, artists gained the opportunity to reproduce their work in a format consistent with their larger oeuvre.

G. D.

1.
The book was published by Harcourt Brace and World and was well reviewed in both the *New York Times* and the *New York Review of Books* at the time of its publication.

2.
This work also included monochromatic images by Hofer. A selection of Evelyn Hofer's other photobooks include: *London Perceived* (1962), *The Evidence of Washington* (1966), and *Dublin: A Portrait* (1967).

3.
A. D. Coleman, "My Books End Up in the Trash," *New York Times*, August 27, 1972, p. D12.

4.
Martin Parr and Gerry Badger, *The Photobook: A History, Volume I* (New York: Phaidon Press, 2004), p. 238.

5.
For more on the rise of the photobook in the 1970s in the United States, see Martin Parr and Gerry Badger, *The Photobook: A History, Volume II* (New York: Phaidon Press, 2006), pp. 11–17.

MONOGRAPHS

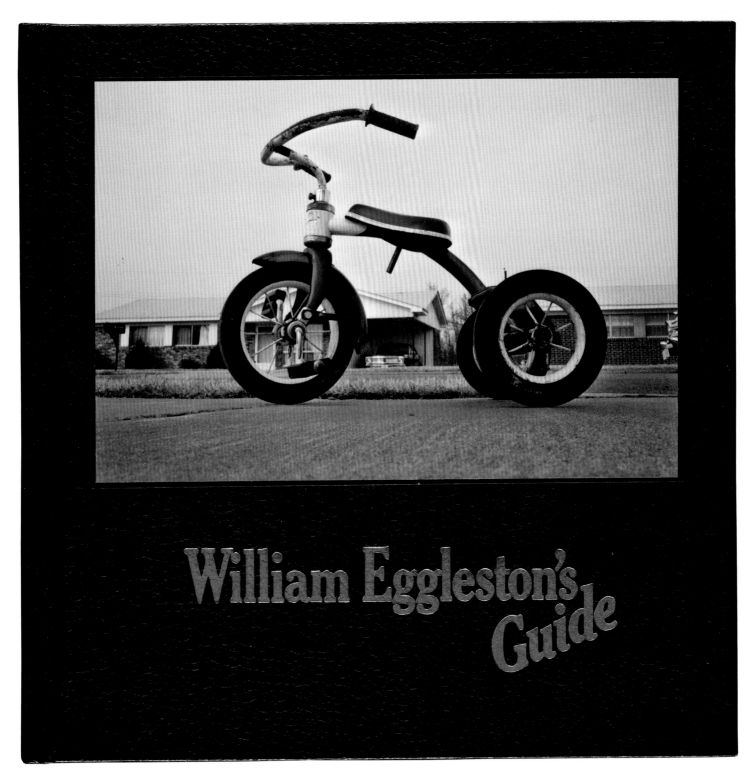

William Eggleston and John Szarkowski, cover of *William Eggleston's Guide*, 1976

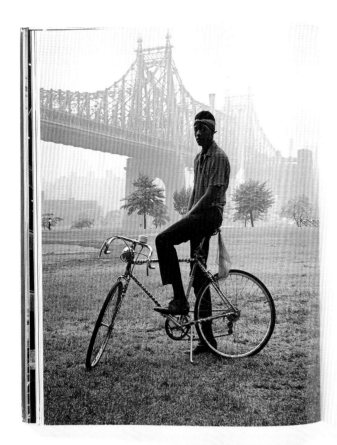

Evelyn Hofer, spread in *New York Proclaimed*, 1964

Ed Ruscha, spread in *Nine Swimming Pools and a Broken Glass*, 1968

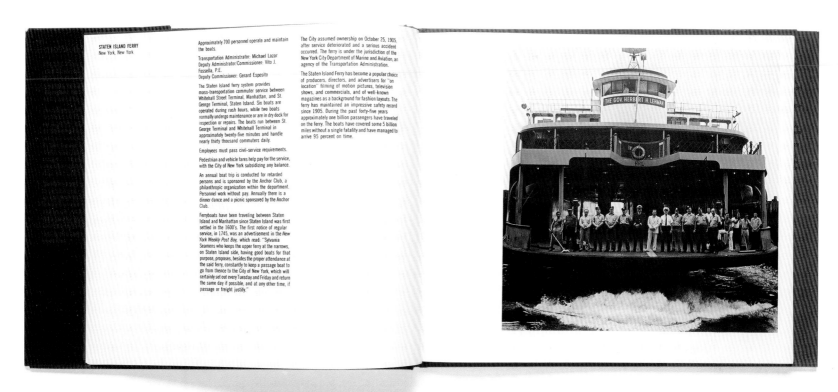

Neal Slavin, spread in *When Two or More Are Gathered Together*, 1976

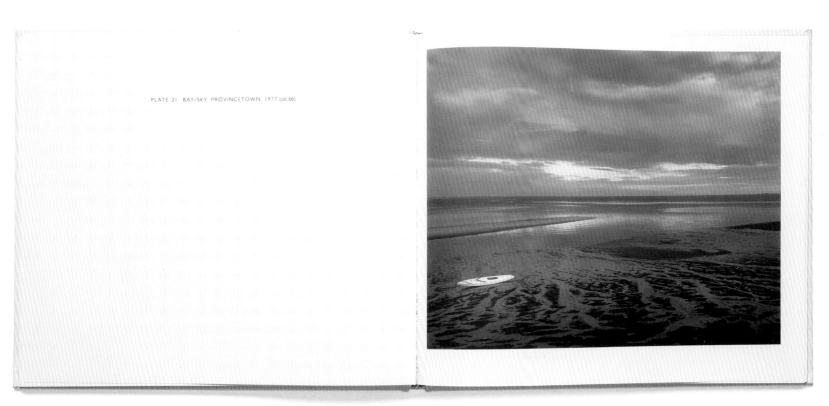

Joel Meyerowitz, spread in *Cape Light*, 1978

MARIE COSINDAS

While studying photography with Ansel Adams, Marie Cosindas shifted from black and white to color after he told her, "You shoot in black and white, but you think in terms of color."[1] Cosindas's transition to color, however, was not a smooth one; she found herself frustrated by most color processes, as they were time consuming and failed to yield the desired results. The solution came in 1962 when Polaroid gave her and a dozen other photographers its new Polacolor film to test. Cosindas embraced the system's simplicity; she could focus her attention on the construction of her portraits and still-lifes while still achieving sumptuous color. Polacolor provided almost instant results that made it possible to quickly see the finished project and make adjustments accordingly, serving as the needed catalyst for Cosindas's career. She recalled, "To be able to see the results immediately was like a little miracle. I could hold an entire darkroom in the palm of my hand."[2]

Cosindas's approach to color photography developed while making portraits of friends in their homes, where she collaborated with them to carefully incorporate their surroundings into the overall image. From there, Cosindas expanded her range of subjects to include intriguing strangers and celebrities, including Paul Newman, Robert Redford, and Andy Warhol. Cosindas's interest in props, which emerged in her early portraits, led to the creation of lush still-lifes focusing on personal objects. Polaroid's rich color tonality provided the vehicle through which dolls, masks, and other small household trinkets became the inhabitants of mysterious worlds (right).[3]

In 1966 Cosindas had solo exhibitions at the Museum of Fine Arts, Boston, and at the Museum of Modern Art, New York, where forty-five of her color Polaroids were presented. The MoMA exhibition was the first in the institution's history devoted entirely to Polaroid photographs, and Cosindas received another solo exhibition at the Art Institute of Chicago the following year. Cosindas's visibility in the 1960s exceeded museum exhibitions; for example, in 1967 *Ladies' Home Journal* commissioned her to photograph asparagus, and in doing so she translated her taste for saturated compositions into the realm of commercial photography. One year later, Cosindas was featured in the *Life* magazine article "Beyond Realism," which presents her photographs as mysterious compositions that transcend the "realism that is a prison for so much photography" through the artist's creative use of what was typically considered snapshot quality film.[4]

Cosindas's Polaroid photographs continued to be widely shown, and the New York Graphic Society published a monograph of her work, *Marie Cosindas: Color Photographs*, in 1978. In his introduction to *William Eggleston's Guide*, John Szarkowski credited the artist's portraits as one of the few "conspicuous successes"[5] in color photography before 1976, indicating the important role Cosindas played in the swell of color photography in the 1960s and '70s, as well as the acceptance of color Polaroid film as a legitimate artistic medium.

G. D.

1.
"Beyond Realism," *Life*, May 3, 1968, p. 51.

2.
Ibid.

3.
For more on the relationship between Cosindas's portraits and still lifes, see *Marie Cosindas: Color Photographs* (Boston: New York Graphic Society, 1978).

4.
"Beyond Realism," p. 46.

5.
John Szarkowski, untitled essay, in *William Eggleston's Guide* (New York: Museum of Modern Art, 1976), p. 9.

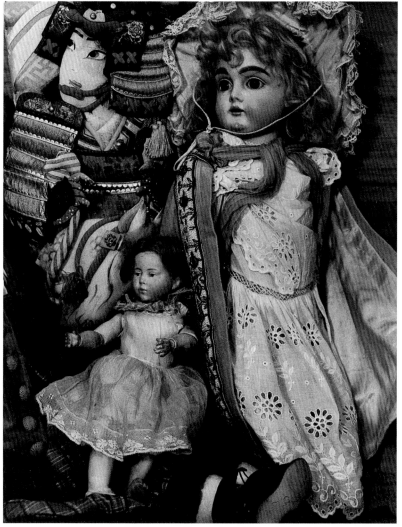

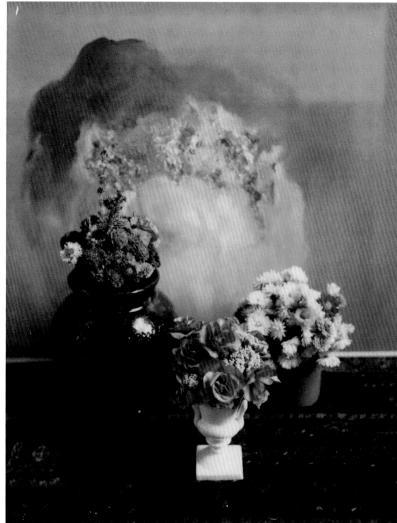

Marie Cosindas, *Dolls, Boston*, 1966

Marie Cosindas, *Still Life*, 1962–63

Installation view of Bruce Nauman's exhibition at Leo Castelli Gallery, New York, January 27–February 17, 1968

1.
Nauman has claimed, "If I was an artist and I was in the studio, then whatever I was doing in the studio must be art. At this point art became more of an activity and less of a product." "Bruce Nauman," website for Public Broadcasting System's Art21, www.pbs.org/art21/artists/bruce-nauman, accessed August 11, 2012.

2.
For more on the process of making *Eleven Color Photographs*, see Constance M. Lewallen, "A Rose Has No Teeth," in *A Rose Has No Teeth: Bruce Nauman in the 1960s* (Berkeley: University of California Press, 2007), p. 63.

3. Matthew S. Witkovsky, ed., *Light Years: Conceptual Art and the Photograph, 1964–1977* (Chicago: Art Institute of Chicago; New Haven, Conn.: Yale University Press, 2011), p. 20.

4.
Ibid., pp. 20–21.

Bruce Nauman's pioneering conceptual practice—which spans photography, video, sculpture, and drawing—is grounded in the idea of process-as-art.[1] In his earliest works, he used his body to blur the lines between photography, performance, and sculpture. Color photography, with its vernacular and commercial underpinnings, played an important role for conceptual artists such as Nauman, John Baldessari, and Dan Graham, and their ongoing investigations of art as idea.

Eleven Color Photographs, a 1970 portfolio comprised of photographs created between 1966 and 1967, depicts his literal enactments of common phrases.[2] These works were among the earliest examples of "straight" color photography exhibited by an artist operating outside the realm of fine-art photography.[3] A work from this portfolio, *Self-Portrait as a Fountain*, was included in Nauman's debut exhibition at Leo Castelli Gallery, New York, in 1968 (right). The color photograph—which was unframed and mounted directly to the gallery wall—depicts a shirtless Nauman deftly spitting an arc of water out of his mouth. Adjacent to the photograph is another work with a phrase that serves as a description of the act: "The True Artist Is an Amazing Luminous Fountain" (left). Together, the two works reverse the scale and function of conventional image and caption.[4] Straddling sculpture, studio photography, and deadpan documentation, the image becomes a record of the "activity" of art in the studio. Ultimately, Nauman's use of color photography, along with his choice of presentation, challenged the processes of valuation associated with the art gallery and art in general.

M. R. R.

BRUCE NAUMAN

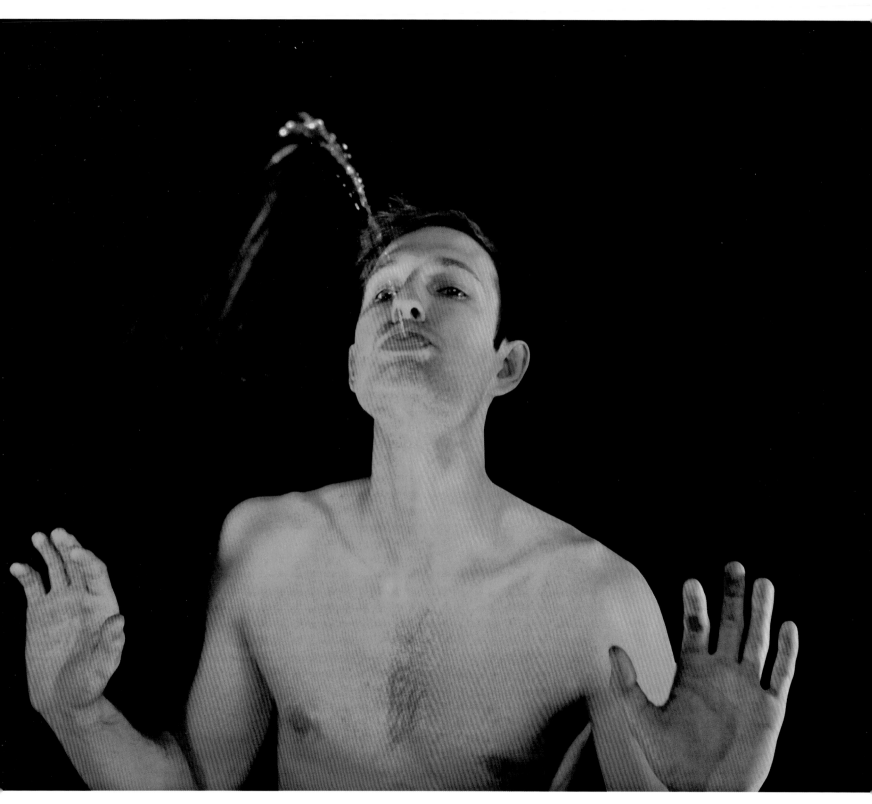

Bruce Nauman, *Self Portrait as a Fountain*, 1966–67

WILLIAM EGGLESTON

6 July 1976

Dear John Szarkowski,

Belated thanks for the Eggleston book. The pictures are eye-opening, & so too is your essay. Once again I'm made to realize that anything is possible in art—not that I hadn't thought that good color photography was possible, but it had begun to seem improbable except by accident. Yes, I'd seen many accidently good color photos (I've made two myself), but because they were accidental they didn't "accumulate." Eggleston's do, & accidental is the last thing I'd call them.

Yrs sincerely,

Clement Greenberg

Letter from Clement Greenberg
to John Szarkowski, July 6, 1976

1.
Janet Malcolm, "Photography: Color," *New Yorker*, October 10, 1977, p. 107. Malcolm wrote that, in comparison to Photo-Realist paintings, artistic color photography looked "insignificant, dull, even tacky, on the wall." Ibid., pp. 107–8.

2.
John Szarkowski, *William Eggleston's Guide* (New York: Museum of Modern Art, 1976), p. 14.

3.
Ibid., p. 9.

4.
Hilton Kramer, "Art: Focus on Photo Shows," *New York Times*, May 28, 1976, p. 62.

5.
For more on Eggleston's relationship to his Southern origins, see Richard B. Woodward, "Memphis Beau," *Vanity Fair*, October 1991, pp. 215–20, 238, 240–41, 244–45.

6.
For more, see Adam Welch's excellent chronology in *William Eggleston: Democratic Camera; Photographs and Video, 1961–2008* (New York: Whitney Museum of American Art; Munich: Haus der Kunst, 2008) pp. 269–77.

7.
See this catalog's chronology for MoMA's history of solo exhibitions of color photographs.

Whether a pensive consideration of a simple everyday object like a light bulb (right) or a moment of perfectly mirrored gestures (page 174), William Eggleston's color photographs created a sensational stir in 1976. That year the Museum of Modern Art, New York, gave Eggleston his first solo exhibition, at a time when color images, as art critic Janet Malcolm wrote, were associated with the "most retrograde applications—advertising, fashion, [and] *National Geographic*–type travel pictures."[1] Nevertheless, curator John Szarkowski, who organized the exhibition and authored the accompanying catalog, *William Eggleston's Guide* (page 165), claimed: "[They] seem to me perfect: irreducible surrogates for the experience they pretend to record, visual analogues for the quality of one life, collectively a paradigm of a private view, a view one would have thought ineffable, described here with clarity, fullness, and elegance."[2] Previously, Szarkowski argued color photographs had lacked either form or content. Eggleston, however, worked "not as though color were a separate issue, a problem to be solved in isolation . . . but rather as though the world itself existed in color, as though the blue and the sky *were* one thing."[3] Clement Greenberg was one of the few critics who appreciated, let alone agreed with, this stance; many were incensed by the Eggleston exhibition. The conservative critic Hilton Kramer rebuffed Szarkowski's claim that Eggleston's photographs were "perfect," calling them "perfectly banal, perhaps. Perfectly boring, certainly."[4]

Eggleston had begun taking photographs of his native South on color film in 1965 and soon worked exclusively in color, producing rich, saturated dye transfer prints.[5] In 1967 Eggleston traveled to New York to meet for the first time with Szarkowski, who responded positively to the photographs studiously extracted from the everyday, color-filled world. On that same visit to New York, Eggleston met several artists working in color, including Joel Meyerowitz, who showed Eggleston his Kodachrome slides and inspired Eggleston's work with color transparency film upon his return to Memphis. Over the next several years, Eggleston embarked on several road trips with curator Walter Hopps of the Corcoran Gallery of Art, Washington, D.C., and an image from these trips became his first dye transfer print in 1972.[6] Eggleston chose this type of rich, saturated print, evocative of commercial photography, for the photographs in his first portfolio, *Los Alamos* (1974). Szarkowski included many of these images in the 1976 exhibition, which featured seventy-five dye transfer prints. Although heralded as a historic breakthrough for color photography at the time—a view reinforced in subsequent decades of scholarship—the exhibition was certainly not the museum's first show of support for the work of a single color photographer.[7] The accompanying publication, *William Eggleston's Guide*, however, was a milestone, marking the museum's first book dedicated to color photography. Despite reproducing significantly fewer images than the exhibition checklist contained, it amplified the debates about the acceptance of contemporary color photography as art that intensified in the late 1970s.

K. B.

William Eggleston, *Greenwood, Mississippi*, 1970

William Eggleston, *Halloween, Morton, Mississippi*, 1970

William Eggleston, *Sumner, Mississippi*, ca. 1972

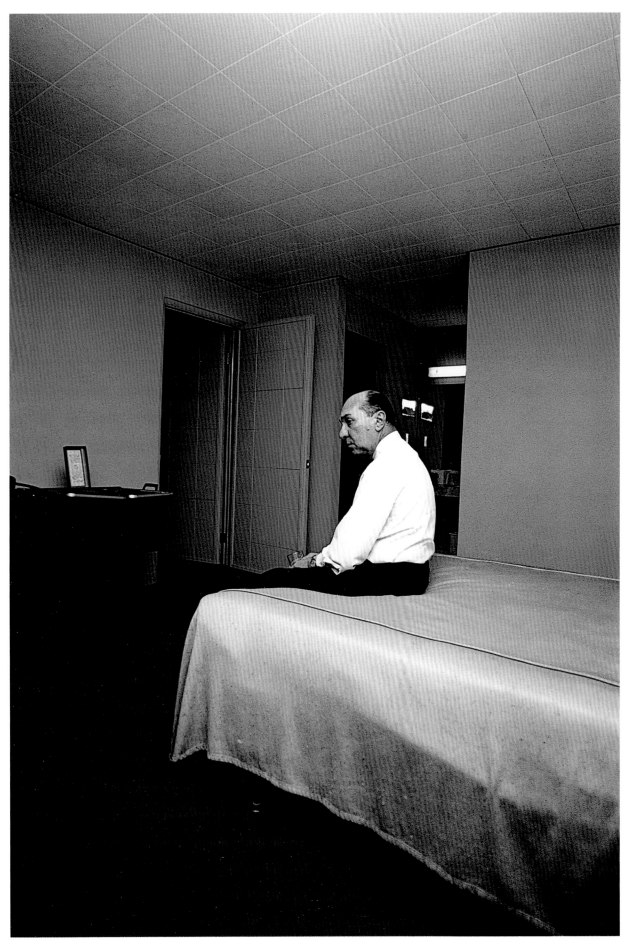

William Eggleston, *Huntsville, Alabama*, 1978

William Christenberry, slide of *Church, Sprott, Alabama*, 1977

1.
William Ferris, "Those Little Color Snapshots," *Southern Cultures* 17, no. 2 (Summer 2011): p. 70.

2.
Richard B. Woodward, "All of a Color: WIlliam Christenberry's Kodachromes" in *William Christenberry: Kodachromes* (New York: Aperture, 2010), n.p.

3.
Quoted in Philip Gefter, "Southern Exposures: The Past Transformed," *New York Times*, July 2, 2006, p. A22. Christenberry was in part inspired to create photographs of Hale County by Evans's and James Agee's book, *Let Us Now Praise Famous Men* (1941), which included photographs not just of Hale County but of people his grandparents knew.

4.
Walter Hopps, "The Bricoleur," in *William Christenberry* (New York: Aperture, 2006), p. 17.

Although William Christenberry began his career as a painter, his color photographs—like those of Walker Evans and William Eggleston—have come to embody the visual language of the Southern United States. Christenberry took up photography in 1958, using a Brownie camera he received for Christmas as a child, with the intent of creating images as references for paintings. That Christenberry's camera was a family keepsake serves as a fitting metaphor for the larger concerns of his photographic practice: themes of memory and decay are addressed in his work, which captures the effects of time on the architecture and landscape surrounding his ancestral home in Hale County, Alabama. Unlike other photographers of his generation who transitioned from black-and-white to color photography, Christenberry has always used color film and squarely defines his practice as stemming from vernacular image-making: "I can't say why a certain object appeals to me more than the other. It's just there, and I don't think of it as, 'Hey, that would make a good color photograph.' In my case, I never really made anything but color photographs. I just started making snapshots, and they were always in color."[1] Christenberry's snapshot aesthetic is further demonstrated by his use of Kodachrome slide film beginning in the mid-1960s (left). Although this film was originally marketed to amateur photographers, it allowed Christenberry to create photographs in sharper focus than those produced by the Brownie camera, and he continued to use both formats until their obsolescence.[2]

The vivid colors of his early photographs moved Christenberry, and he began returning annually to the same sites—the white church in Sprott, the Green Warehouse, and the Palmist Building, to name a few—to document their chromatic and structural changes. Walker Evans encouraged Christenberry to take his photographs seriously as a part of his art-making practice after the two met in New York in the 1960s, and Evans later described Christenberry's color photographs as "perfect little poems."[3]

The Corcoran Gallery of Art, Washington, D.C., held Christenberry's first major exhibition of photographs in 1973, and this was quickly followed by his inclusion in *Straight Color*, a group show at the Rochester Institute of Technology, Rochester, New York, which also included Eggleston's work. The two photographers had previously met in 1962 in Memphis, where Eggleston was still working exclusively with black-and-white film as a studio photographer. Curator Walter Hopps has argued that seeing Christenberry's work may have encouraged Eggleston to transition to color.[4]

At the Zabriskie Gallery in New York in 1976, Christenberry's photographs were displayed along with his small-scale sculptures of the same architecture he photographed; reviews of the show are largely ambivalent about the photographs. At the time, their artificial color tonality and miniaturizing distortion stood in stark contrast to both fine-art photography and the polished look of fashion and commercial imagery. In 1977, upon Lee Friedlander's suggestion, Christenberry began using a large-format camera, which rendered the image in greater detail (right). In whatever format Christenberry uses, the records of his ritual returns to Hale County take on a cinematic quality through their emphasis on the passage of time.

G. D.

WILLIAM CHRISTENBERRY

William Christenberry, *Palmist Hand, Havana Junction, Alabama*, 1980

William Christenberry, *Church, Sprott, Alabama*, 1971

William Christenberry, *Corn Sign with Storm Cloud, Near Greensboro, Alabama*, 1977

JOHN BALDESSARI

Throughout his career, John Baldessari has employed a diverse range of mediums—including photography, painting, film, and text—in works that defy formalist concerns in favor of the presentation of information. Baldessari studied art, literature, and art history at the University of California, Berkeley, and Los Angeles, and received his master of arts from San Diego State College in 1957. As a West Coast pioneer of Conceptual art in the 1960s, he advocated the movement's deadpan, document-based approach to image-making. This practice includes a broad investigation of photography's documentary value as well as its vernacular functions.

Although Baldessari's earliest works, created between the mid-1950s and mid-1960s, are painted canvases made with the help of professional sign painters, by the late 1960s he had begun producing photo-based works that are structured according to a set of found or arbitrary rules. Many are often aided by or based on color—as both medium and subject matter. These photographic works were featured in influential exhibitions of color photography in the 1970s, such as *Some Color Photographs* at Castelli Graphics, New York, in 1977.

Color photography, with its vernacular underpinnings, allowed Baldessari to investigate ideas about chance and selection inherent to photography. His early engagement with color as subject matter took on the modernist concerns of Color-Field and Minimalist painting as a means by which to reflect on art as information. In *Floating Color* (pages 182–83), Baldessari tested the limits of the modernist reduction of painting to a monochromatic object by staging color as an object and releasing it from the window of his own house. As art historian Robin Kelsey noted, the suspension of color sheets in mid-air "is poised between rejection and reinscription. The monochrome is being thrown out a window by the artist, ejected and discarded, but at the same time it is being offered up to the camera."[1] For Baldessari, color acts as an abstract coding system, a means by which to unsettle or question the presentation of art.

M. R. R.

1.
Robin Kelsey, "Hazarded into the Blue: John Baldessari and Photography in the Early 1970s," in *Light Years: Conceptual Art and the Photograph, 1964–1977*, ed. Matthew S. Witkovsky (Chicago: Art Institute of Chicago; New Haven, Conn.: Yale University Press, 2011), p. 138.

John Baldessari, *Floating: Color* (detail), 1972

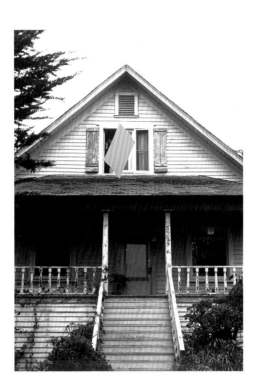
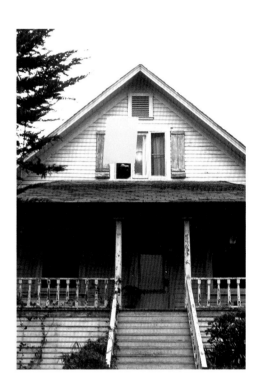

John Baldessari, *Floating: Color*, 1972

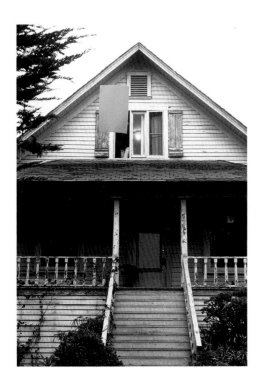 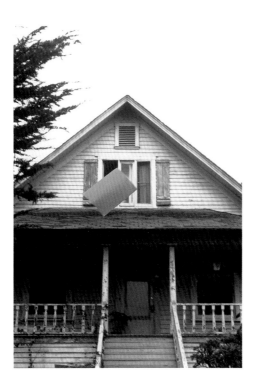 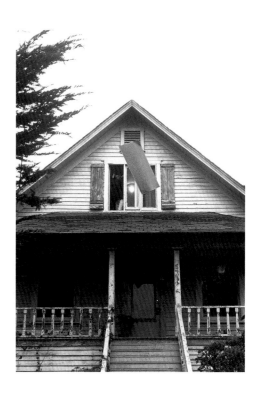

Stephen Shore is best known for color photographs taken on cross-country road trips, depicting everyday encounters, banal urban scenes, and the vernacular architecture that has become characteristic of the American landscape. Shore began his photographic career as a teenager documenting life in and around Andy Warhol's Factory. Soon after, he turned to conceptual practices with a series of sequential black-and-white photographs. With this work, in 1971 he became the first living photographer to have a solo exhibition at the Metropolitan Museum of Art, New York.

Shore first turned to color photography with the series Greetings from Amarillo: Tall in Texas, created in 1971 during a road trip. Influenced by Ed Ruscha's photobooks (page 166), Shore took a series of photographs depicting the town's nondescript urban scenery. He then commissioned the largest postcard printer in the United States, Dexter Press, to print ten images as postcards. The images feature intensified colors imposed by the printer (to "correct" overcast skies and yellowed grass). On the back of the postcards, only building or street names were printed—neither the name of the town nor Shore's name appears—adding a layer of confusion to their function. Shore later returned the cards to their conventional use by slipping them into racks in tourist shops across the country.

Greetings from Amarillo is the precursor to Shore's two best-known series of color photographs, American Surfaces (1972–73) and Uncommon Places (1973–83), both of which also document road trips across the United States. American Surfaces is a visual diary of the artist's encounters with American culture—both routine and unexpected—rendered in harsh color, unsentimental lighting, and deadpan compositions. Included among these 35 mm photographs are images of slept-in motel beds, unfinished meals set against the backdrop of roadside diner tables, and empty small-town intersections—all shot in a similar manner that emphasizes each image's function as a document. For Uncommon Places, Shore switched to an 8-by-10-inch view camera, resulting in images that mimicked his earlier snapshot style but with a greater level of detail and control.

Shore's early and groundbreaking interest in color photography and its vernacular forms extended to the first installation of American Surfaces at LIGHT Gallery, New York, in 1972. For this exhibition, Shore had 174 images printed as 3-by-5-inch glossy Kodak color prints with white borders, the kind commonly associated with tourist or family snapshots.[1] (The appeal of the drugstore prints' intimate scale is made clear in an image from the series; see above left.) Although photography's vernacular forms were regularly appropriated by artists, nearly every aspect of Shore's series was unprecedented within the realm of fine-art photography. A critic for the *Village Voice* echoed this sentiment: "*American Surfaces* is thin, benumbing and banal. . . . Historians of the future will, of course, turn to this sort of material for the purposes of visual anthropology. . . . Collectors of the future will also get into Kodacolor imagery—if only because there is nothing in a disposable culture which will not be 'collectible.' . . . It's not only dull, it isn't even archival."[2]

M. R. R.

Stephen Shore, *New York City, New York*, from American Surfaces, 1973

1.
At LIGHT, the series was hung unframed in a grid three rows high that covered three walls. Michal Raz-Russo, "LIGHT Gallery: Body of Work" (M.A. thesis, School of the Art Institute of Chicago, 2009), pp. 16–17.

2.
A. D. Coleman, "American Yawn, Irish Wail," *Village Voice*, October 5, 1972, p. 31.

STEPHEN SHORE

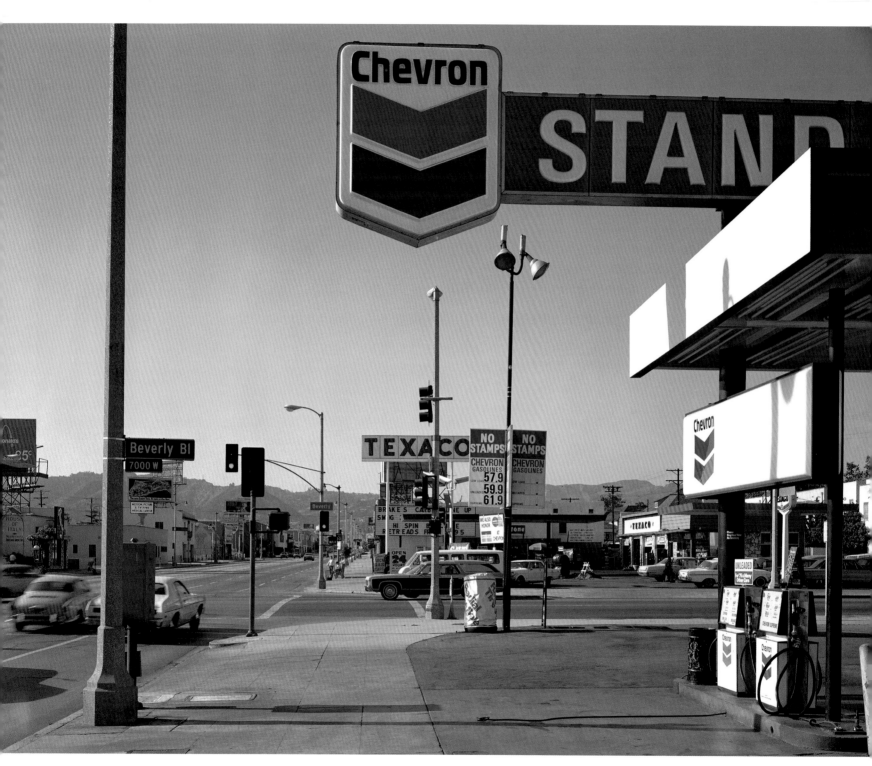

Stephen Shore, *Beverly Boulevard and La Brea Avenue, Los Angeles, California, June 21, 1975*

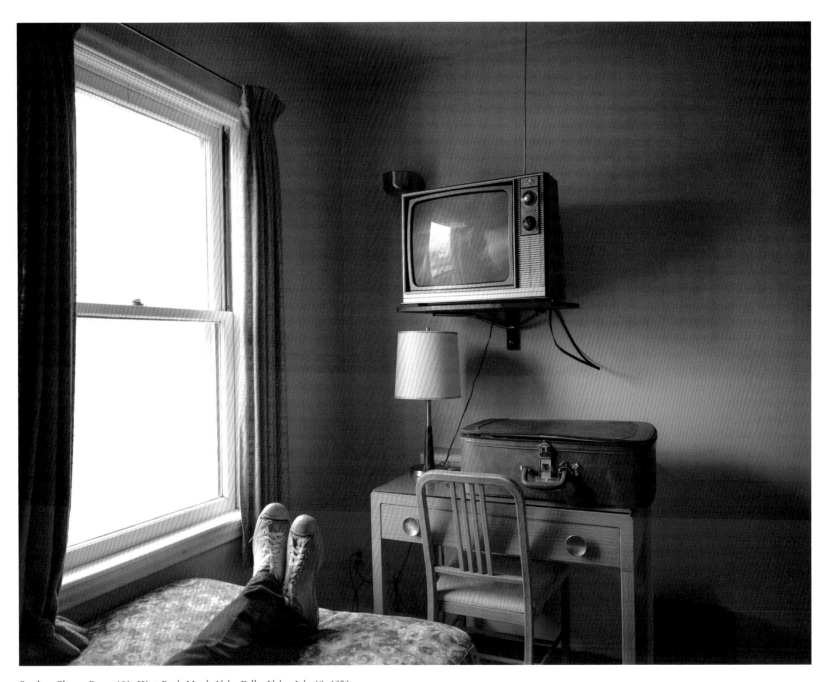

Stephen Shore, *Room 125, West Bank Motel, Idaho Falls, Idaho, July 18, 1973*

Stephen Shore, *Trail's End Restaurant, Kanab, Utah, August 10, 1973*

Stephen Shore, *Presidio, Texas, February 21, 1975*

JOHN PFAHL

John Pfahl became interested in color photography as a student of advertising and graphic design and later as a commercial photographer. Pfahl is best known, however, for his color images that document his subtle interventions in the landscape. Pfahl's manipulated landscapes are indebted to the foundational work of photographers such as Eliot Porter, whose color photographs forged a place in fine art for vibrantly hued depictions of the natural world. Publications and organizations such as *National Geographic* and the Sierra Club embraced this work and provided a platform for photographs of landscapes in color to reach the American public.

Critic Andy Grundberg contextualized Pfahl's work within this history, as well as within the broader 1960s and '70s practice of inserting serial, linguistic, or mathematical ideas and models into traditional forms of art. In short, Grundberg called Pfahl's seminal early color photographs "Conceptualist send-ups of Sierra Club style photographs."[1] However, unlike the photographers he admired (such as John Baldessari), Pfahl explained that he had "never been a Conceptual artist with a capital *C*," though there had "always been a conceptual bias to my work."[2]

Pfahl first physically engaged with the landscape as part of a collaboration with musician and composer David Gibson, with whom he marked trees with colored tape to create a musical composition with the intention that the "visual configuration was to be recorded in notion form and played. The photographic image would serve as a visual backdrop to the musicians."[3] While the project was never fully realized aside from several photographs of taped trees, the idea of marking the landscape became the conceptual foundation for his continued work on the subject (right).

For the series Altered Landscapes, created between 1974 and 1978, Pfahl demarcated specific elements in nature, often with string or tape, to play with the scientific principles of perspective and optics while constructing a cohesive vision of the picturesque scene. Although Pfahl deliberately used color film to capture the vibrantly colored strings, balls, lights, and tape set into and against the natural landscape, he often made preparatory drawings on black-and-white Polaroids before taking the final color image to ensure that the perspective of his added elements morphed into the photographic image. In his introduction to the publication of the series, curator Peter Bunnell claimed: "The glorious color, sometimes pushed to the extreme of decorativeness and verisimilitude, only enhances the tension created by this forced inhibition of movement, a restraint that fully recognizes our need to see a picture and not recreate an experience. The picture is the experience."[4] Through his visual manipulations, Pfahl extended the practice of the mid-century color landscape photographers, reinvigorating that tradition by challenging it conceptually.

A. S.

1.
Andy Grundberg, "Photography View: He Records Nature with Humor and Reverence," *New York Times*, April 22, 1984, p. H29.

2.
Quoted in Estelle Jussim, "Passionate Observer: The Art of John Pfahl," in *A Distanced Landscape: The Photographs of John Pfahl* (Albuquerque: University of New Mexico Press, 1990), p. 10.

3.
Peter C. Bunnell, introduction to *Altered Landscapes: The Photographs of John Pfahl* (San Francisco: Friends of Photography, 1981), n.p.

4.
Ibid.

John Pfahl, *Music 1, Ellicottville, New York*, 1974

John Pfahl, *Big Dipper, Charlotte, North Carolina,* 1976

Eve Sonneman began using color film in 1973, and her Coney Island series of the next year represents the transitional moment between her exclusive use of monochromatic film and her full engagement with color (right). In this series, Sonneman paired both black-and-white and color images, creating compositions that include four photographs of the same scene taken moments apart. In displaying images shot in rapid succession, Sonneman challenged the concept of the "decisive moment"—Henri Cartier-Bresson's theory that a photographer should wait for the precise moment when the motion, content, and form of a scene are united before releasing the shutter—instead offering a view of the world that suggests the arbitrary nature of the artist's composition. At the same time, Sonneman's photographs share a kindred spirit with tourist snapshots, as her work depicts popular destinations, including Coney Island and the former World Trade Center.

In 1975, Sonneman began working exclusively in color and also altered her approach by pairing images that were not adjacent negatives, as her early works had always been. This change confers a disjointed quality upon the color pairings akin to the filmic jump cut.[1] The works simultaneously depict the world more naturalistically through the use of color and introduce a sense of disorder through the ambiguous relationship between the paired images. The diptychs forestall being read as narratives by refusing to provide a beginning, middle, and end, ultimately leaving the viewer with a disorienting impression of the scenes they present.[2]

Although initially Sonneman created traditional color prints, she expanded her use of color film to include Polaroid film in 1976. Sonneman's color photographs were the subject of a solo exhibition at Castelli Graphics, New York, in 1978, and continued to be shown widely thereafter. Sonneman has been celebrated for her use of multiple frames as a means of engaging the medium of color photography and representing social experience.

G. D.

1.
Kevin Moore, *Starburst: Color Photography in America 1970–1980* (Ostfildern, Germany: Hatje Cantz; Cincinnati: Cincinnati Art Museum, 2010), p. 23.

2.
Jonathan Crary, "Eve Sonneman," *Arts Magazine* 53, no. 3 (November 1978): p. 3.

EVE SONNEMAN

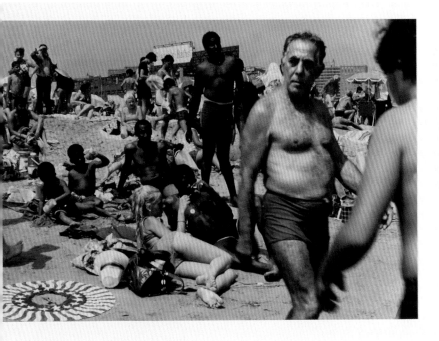
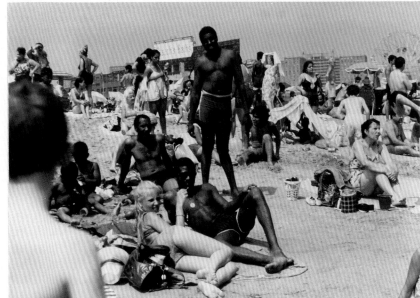
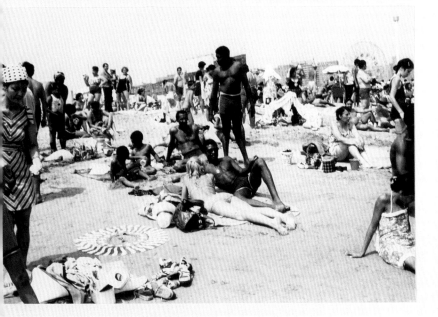

Eve Sonneman, *Coney Island*, 1974

Eve Sonneman, *July 4, 1976*

LUCAS SAMARAS

1.
Kevin Moore, *Starburst: Color Photography in America 1970–1980* (Ostfildern, Germany: Hatje Cantz; Cincinnati: Cincinnati Art Museum, 2010), p. 23.

2.
For more on Samaras's SX-70 process, see Ralph Gibson, *SX-70 Art* (New York: Lustrum Press, 1979).

In 1973 Lucas Samaras received what he described as "one of the greatest gifts anyone could give an artist": an SX-70 Polaroid camera. Polaroid asked him to experiment with the camera to produce work for an exhibition at New York's LIGHT Gallery later that year. The SX-70 quickly gained popularity among artists and amateurs alike; its fixed lens made the process simpler than Polacolor, while still rendering vivid color.

Samaras's initial experiments with color film began in 1969 with the purchase of a Polaroid 360, the camera he used to create the photographs for *Samaras Album: Autobiography, Autointerviews, Autopolaroids* (1971), a photobook published by the Whitney Museum of American Art as part of his 1972 retrospective. The book, although primarily composed of monochromatic photographs, established the visual language on which Samaras would later expand in his work with the SX-70 camera. In *Samaras Album*, he experimented with manipulating the film by mixing the layers of dye to create painterly distortions that still retain elements of realism inherent to color photography. The photographs in *Samaras Album*, as well as his subsequent work, primarily feature the artist in the nude, in contorted poses exaggerated by manipulated emulsion. Polaroid was the ideal vehicle for Samaras, in large part because the privacy of its processing system allowed him, as well as other artists including, Robert Heinecken, to create images that would have likely been censored by commercial processors.[1]

Shortly after receiving the SX-70 film, Samaras began creating Photo-Transformations, a series of photographs that extend the experiments of *Samaras Album*. The SX-70 film allowed for more extreme manipulations than previous Polaroid films, and Samaras exaggerated the surreal quality of his experiments with the intense colors he coaxed out of the film by warming it before exposure.[2] The result is a series of uncanny images that depict Samaras's body multiplied, in fragments, and on the verge of disappearance. Polaroid's unique internal dye process allowed Samaras to deform the photograph's surface in ways that mirrored his obsessive, and at times masochistic, explorations of his own body.

G. D.

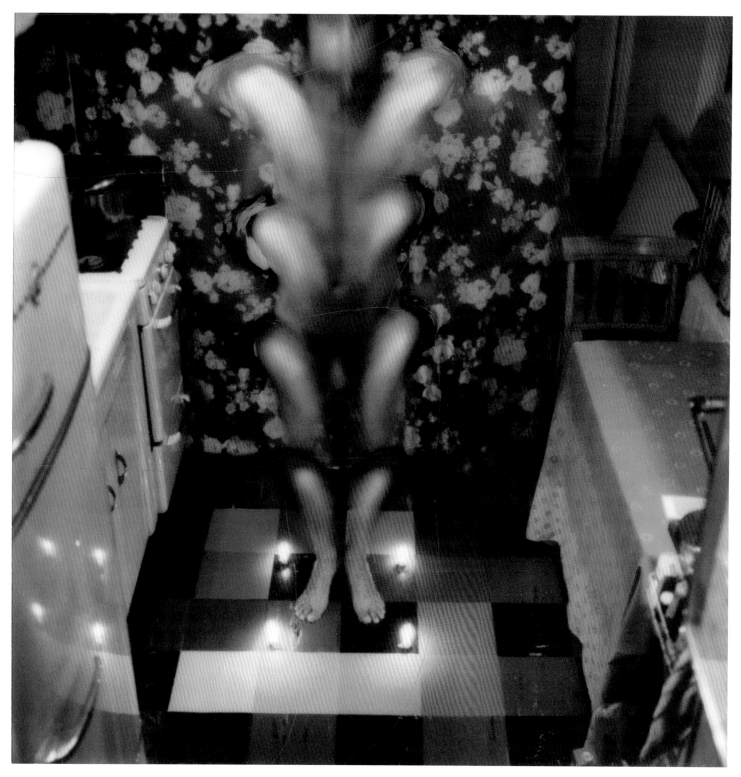

Lucas Samaras, *Photo-Transformation*, 1976

Jan Groover's initial interest in color photography was a by-product of her transition from painting to photography in the early 1970s. By 1973 Groover was shooting with color film, and less than two years later, her color work was presented for the first time in a solo show at LIGHT Gallery in New York. The exhibition featured a series of triptychs depicting moving objects, suburban landscapes, and architectural details. Groover explained that she chose color for these works for the practical reason of clarifying the image, stating that color "was the surest way I knew to distinguish one subject from another. It was a way to name things."[1]

Groover moved her camera indoors and away from the triptych format in 1977 to begin a series of color photographs of banal, everyday objects in her home. Carefully constructing the images using artificial light, she photographed kitchen items, including cutlery, dishes, cooking utensils, and even produce and plants. When these large, color close-ups of objects in her kitchen sink were presented in 1978 at Sonnabend Gallery in New York, the *Village Voice* heralded it as "the most exciting event in photography this fall."[2] Susan Kismaric, on the occasion of Groover's 1987 mid-career retrospective at the Museum of Modern Art, New York, referenced the 1978 Sonnabend show: "People who rarely visited photography galleries . . . were startled to find pictures that expanded conventional notions of what photographs looked like, while some photographers and connoisseurs of the medium were disturbed by photographs that seemed to them to retreat from the central issues of advanced photography."[3] Groover's perceived "retreat" was understood by others as an advancement due to her injection of color into the history of the medium, specifically the classic—albeit black-and-white—still-lifes by the likes of Edward Weston and Paul Strand in the 1920s and '30s.

Groover's popularity was apparent in the numerous exhibitions of her color work at museums and galleries, including George Eastman House, Rochester, New York, and the Whitney Museum of American Art and Castelli Graphics, both in New York, through the early 1980s. Despite these fine-art successes, Groover's color photographs retain a commercial quality that links them to those printed in fashion and lifestyle publications of the previous decades. One critic, clearly well versed in the history of color photography in more commercial modes, even exclaimed, "I can imagine a clever art director at *Vogue* or [advertising firm] J. Walter Thompson snapping up one of Jan Groover's immaculate still lifes if she would consent to including a bottle of whisky or a diamond bracelet among the house plants and kitchen utensils."[4]

A. S.

1.
Quoted in Laurence Shopmaker, foreword to *Jan Groover* (Purchase: Neuberger Museum, State University of New York at Purchase, 1983), n.p.

2.
Ben Lifson, "Jan Groover's Abstractions Embrace the World," *Village Voice*, November 6, 1978, p. 117.

3.
Susan Kismaric, *Jan Groover* (New York: Museum of Modern Art, 1987), n.p.

4.
Gene Thornton, "Photography View: Is the New Color Work So Different from the Old?" *New York Times*, November 8, 1981, p. 27.

JAN GROOVER

Jan Groover, *Untitled*, 1978

Jan Groover, *Untitled*, 1977

Jan Groover, *Untitled*, 1979

JOEL MEYEROWITZ

1.
Gene Thornton, "The Masterly Style of Meyerowitz," *New York Times*, August 10, 1980, p. 25.

2.
Ibid.

3.
Clifford S. Ackley, foreword to *Cape Light: Color Photographs by Joel Meyerowitz* (Boston: Museum of Fine Arts, Boston; New York: New York Graphic Society, 1978), n.p.

4.
"A Conversation: Bruce K. MacDonald with Joel Meyerowitz, July 22–26, 1977," in *Cape Light*, n.p.

In a 1980 *New York Times* article about Joel Meyerowitz, art critic Gene Thornton wrote: "There is no doubt that Meyerowitz would have been a successful travel magazine photographer. No color photographer working today is better at spectacular sunsets. . . . In a sense Meyerowitz is the third turn in the logical progression from the photographers of *National Geographic* to those of the old *Holiday* [magazine] to . . . himself."[1] Thornton suggested the complex relationship between Meyerowitz's work and the popular color travel and lifestyle photography of the past several decades.

Thornton, however, also noted a crucial difference: "Unlike the *National Geographic* and *Holiday* photographers, Meyerowitz is a product of the photographic esthetic promoted by the Museum of Modern Art [New York]."[2] Meyerowitz was surely aware of the color photography exhibitions at MoMA in the mid-1970s, particularly those of William Eggleston and Stephen Shore, and by 1978, his own color photographs were included alongside their work in MoMA's exhibition *Mirrors and Windows: American Photography Since 1960*.

Though Meyerowitz first started shooting color in the late 1960s, it was his Cape Light series, exhibited at Witkin Gallery, New York, in 1977, and then at the Museum of Fine Arts, Boston, in 1978, that brought him national recognition. The project consists of color photographs taken in Cape Cod, Massachusetts, and its surrounding areas during the summers of 1976 and 1977. Meyerowitz created these photographs using an 8-by-10-inch camera and tripod to capture the detailed effects of light and color. As explained in the foreword to the accompanying catalog: "The large-format negatives and their sensitive contact (same size) printing by the photographer insure not only the maximum intensity of documentary detail but also that the finest nuances of color are reproduced. These subtler passages are often fully experienced only upon a second or third reading of the photographic print."[3] Unlike many of his contemporaries, Meyerowitz employed color in a subdued, contemplative fashion as a way to access emotions, rather than to explore vernacular concerns.

Meyerowitz was clear about his decision to use color, stating simply, "It describes more things." He elaborated, "When I say description, I don't mean the mere fact and the cold accounting of things in the frame. I really mean the *sensation* I get from things—their surface and color—my memory of them in other conditions as well as their connotative qualities. Color plays itself out along a richer band of feelings—more wavelengths, more radiance, more sensation."[4] Meyerowitz's insistence on the emotional resonance of color was a more subtle twist on commercial photography's longstanding engagement with color to stimulate consumer interest.

From Cape Light—the catalog of which was reprinted in several editions and became one of the most important publications of color photography (page 167)—through Meyerowitz's later work, color remained an essential element of his practice, establishing him as a crucial figure in the generation of color photographers emerging in the 1970s.

A. S.

Joel Meyerowitz, *Red Interior, Provincetown*, 1977

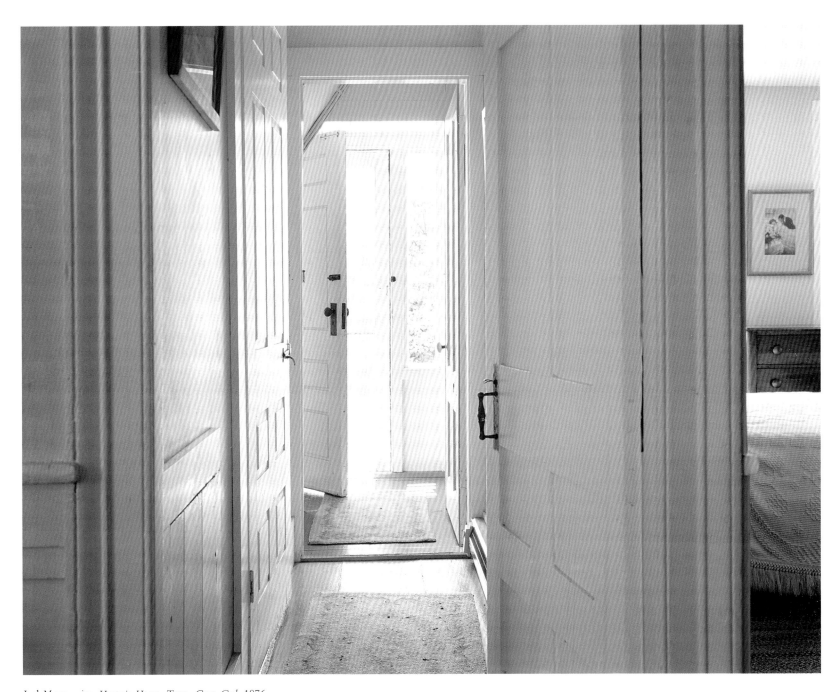

Joel Meyerowitz, *Hartwig House, Truro, Cape Cod*, 1976

Joel Meyerowitz, *Roseville Cottages, Truro*, 1976

Joel Meyerowitz, *Porch, Provincetown*, 1977

Joel Sternfeld started his career firmly dedicated to using color film. His major artistic shift came in the late 1960s, when he transitioned from capturing street scenes with a small camera to more landscape-based studies of American life with a large-format camera. Though his method changed, Sternfeld was consistent in advocating for color, which he described as an aesthetic tool that brought forth important themes in his work: "In the good or successful color photographs the meaning or the definition of the picture will arise, somehow, through the use of color."[1]

Sternfeld's interest in color grew out of his appreciation of photographers who had already made significant strides in bridging the gap between color photography and the fine-art world, particularly Ernst Haas, Eliot Porter, Stephen Shore, and most notably, Helen Levitt, who encouraged Sternfeld to create color street photographs.[2] However, Sternfeld's 1978 Guggenheim grant—awarded specifically for color photography—gave him the opportunity to dramatically shift his practice away from street photography and to embark on a nearly decade-long project that began as a cross-country drive. This photographic pilgrimage echoed the tradition of other notable photographers such as Walker Evans and Robert Frank, both of whom chronicled the sites and people of America.

Sternfeld's project eventually concluded in 1987 with the influential publication *American Prospects: Photographs by Joel Sternfeld*. Anne W. Tucker's catalog essay situates Sternfeld's series as both objectively documenting and critically commentating on American life: "By the title *American Prospects*, Joel Sternfeld might be referring both to America's future and to its commanding views. . . . Eschewing both the heart of the cities and America's remaining wilderness, Sternfeld concentrates instead on the juncture of the two, where man has altered the land for purposes of domesticity, agriculture, industry, or pleasure."[3] The *American Prospects* photographs are replete with details, captured as a consequence of the large-format negative. However, the most compelling subject matter is often hidden, masked by Sternfeld's deliberate use of perspective and color to add layers of complexity to seemingly straightforward images. Sternfeld took a nearly anthropological stance toward his subjects, keeping himself and the camera distant from the more dramatic aspects of the scene, such as a house on fire in the background of his photograph of McLean, Virginia (page 213). Similarly, Sternfeld obscured the details of scenes by photographing images where man-made objects bleed into the natural landscape, as in *After a Flash Flood, Rancho Mirage, California, July 1979* (page 215), where the earth-toned hues of the ravine, homes, and trees initially mask the destroyed car embedded in the uniformly brown landscape. The variety and scope of Sternfeld's images prompted curator Kevin Moore to claim that the series embodies the "synthetic culmination of so many photographic styles of the 1970s, incorporating the humor and social perspicacity of street photography with the detached restraint of New Topographics photographs and the pronounced formalism of works by so many late-decade colorists."[4]

A. S.

1.
Quoted in Jessica May, "Joel Sternfeld's Early Pictures," in *Joel Sternfeld: First Pictures* (Göttingen, Germany: Steidl, 2011), n.p.

2.
For more on Levitt's influence on Sternfeld's early street photography, see ibid.

3.
Anne W. Tucker, "American Beauty in Atypical Places," in *American Prospects: Photographs by Joel Sternfeld* (San Francisco: Friends of Photography, 1994), n.p.

4.
Kevin Moore, "Starburst: Color Photography in America, 1970–1980," in *Starburst: Color Photography in America 1970–1980* (Ostfildern, Germany: Hatje Cantz; Cincinnati: Cincinnati Art Museum, 2010), p. 34.

JOEL STERNFELD

Joel Sternfeld, *Wet 'n Wild Aquatic Theme Park*, *Orlando, Florida, September 1980*

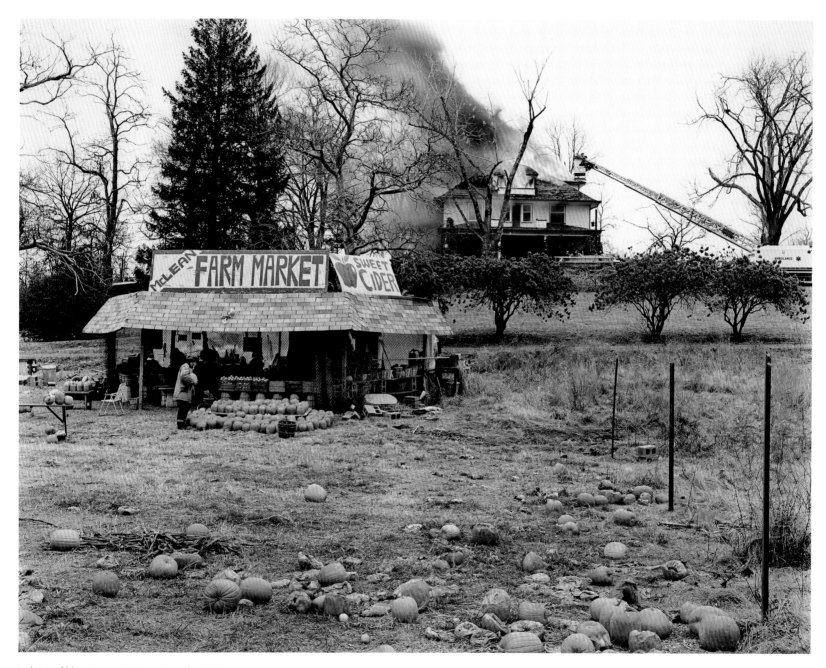

Joel Sternfeld, *McLean, Virginia, December 1978*

Joel Sternfeld, *Cato, New York, May 1980*

Joel Sternfeld, *After a Flash Flood, Rancho Mirage, California, July 1979*

PHILIP-LORCA DICORCIA

Philip-Lorca diCorcia, *Hartford*, 1978

1.
For more on his early practice, see Peter Galassi, *Philip-Lorca diCorcia* (New York: Museum of Modern Art, 1995), p. 10, and "Philip-Lorca diCorcia Speaks with Nan Richardson," in *Conversations with Contemporary Photographers* (New York: Umbrage Editions, 2005), p. 173.

In his first year of graduate school at Yale University in 1977, Philip-Lorca diCorcia chose to begin photographing in color, rather than black and white. His choice of subject matter was equally definitive: family. At that time, black-and-white documentary photographs like those by Walker Evans and street photographs like those by Garry Winogrand were widely celebrated. Realizing that the latter relied on fast-paced responses to serendipitous situations, diCorcia instead embraced control in his early practice, deliberately orchestrating every detail of the room, lighting, and gesture.[1]

During his holiday break, diCorcia made pictures of his family at home in Hartford, Connecticut. These precisely planned but completely banal scenes present his family as characters in seemingly narrative tableaux. Indeed, some photographs from that visit present only the tableau, as in the carefully created domestic ritual of a decorated Christmas tree in a living room laden with gifts, all bathed in a warm, pink light (above left). The image suggests a set that is momentarily devoid of its cast.

The photographs including diCorcia's family members appear like extracted scenes from more complete narratives, as in *Mario*, where a man peers into a refrigerator amidst the otherworldly green glow of a seemingly hushed family kitchen. Although the photograph plays off the long history of color snapshots (and, in fact, the man is diCorcia's brother), diCorcia purposefully amplified the fluorescent light from the refrigerator to achieve an uneasy green cast, full of drama that would be unusual in an everyday snapshot. Because of this connection, meaning shifts and morphs in diCorcia's work in relation to each viewer's own personal photographs. The carefully constructed narrative is continually altered.

K. B.

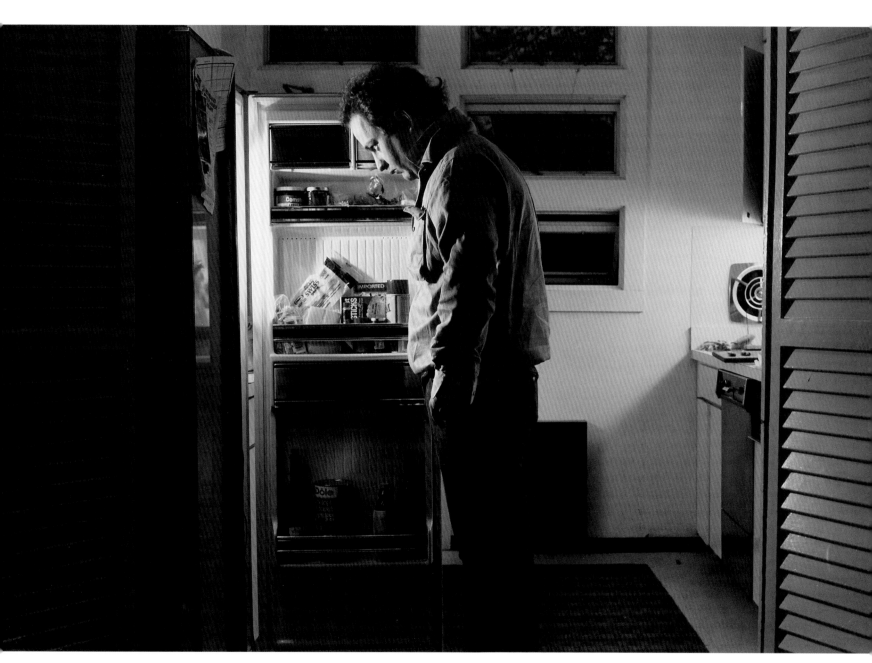

Philip-Lorca diCorcia, *Mario*, 1978

> I remember waking up one day at the end of 1977 and realizing that everything I had been shooting in black-and-white really existed in living color in my mind's eye. I thought I'd made a mistake, and so I bought my first roll of color film, shot some bathroom scenes, and took the prints to the drugstore to be developed. Even given the low-tech quality of the prints I could see there was a whole other world to explore in the set-ups. I'd always loved the part of the *Wizard of Oz* when Dorothy wakes up in a Technicolor world. Kansas looks pretty good in black-and-white, but suddenly the Yellow Brick Road, the red poppies, the ruby slippers make the world on the screen glow. It's as though the lights in a dark room have been switched on.[1]

Laurie Simmons launched her career as a commercial photographer. She created a portfolio of black-and-white prints of miniature household interiors, furnishings, and dolls in an effort to receive a commission from a toy company catalog. Though she was not hired, Simmons realized that these setups provided an interesting method of constructing fictitious, commercialized, domestic scenes.

Simmons's dollhouse photographs remained in black and white until her color epiphany in 1977. The vibrant, artificially colored, miniature objects in her Interiors series—1950s-style housewife dolls occupying wallpapered kitchens and bathrooms—are mimicked by the diminutive size of Simmons's prints. Measuring 3-by-4 inches, the small, brightly colored prints only intensify "the claustrophobic and busy effects of the patterned wallpaper" in her dollhouses.[2]

Beginning her career in New York in the mid-1970s, Simmons was acutely aware of the city's museum and gallery scene, as well as the critical debate surrounding color photography. She was particularly intrigued by the reception of exhibitions such as *William Eggleston* at the Museum of Modern Art, in 1976, and *Some Color Photographs* at Castelli Graphics, in 1977. Simmons explained, "I still remember the Eggleston show in 1976. It was considered the watershed moment for color photography. My own father, the king of amateur photography, had switched to color film years before. Who were those people who thought that color photography had just arrived in 1976?"[3] The widespread use of color in both contemporary culture and fine-art circles encouraged Simmons to maximize the explicitly commercial connotations of color in her Interiors, exploiting color as a creative tool with a specific conceptual purpose.

A. S.

1.
Laurie Simmons, "In and Around the House," in *Laurie Simmons In and Around the House: Photographs, 1976–78* (New York: Carolina Nitsch Editions, 2003), p. 23.

2.
Michael Kimmelman, "Art in Review; Laurie Simmons—Photographs, 1978–79: 'Interiors' and 'Big Figures,'" *New York Times*, June 7, 2002, p. E36.

3.
"Laurie Simmons and Marvin Heiferman," *Art in America*, April 3, 2009, www. artinamericamagazine.com/features/laurie-simmons-and-marvin-heiferman.

LAURIE SIMMONS

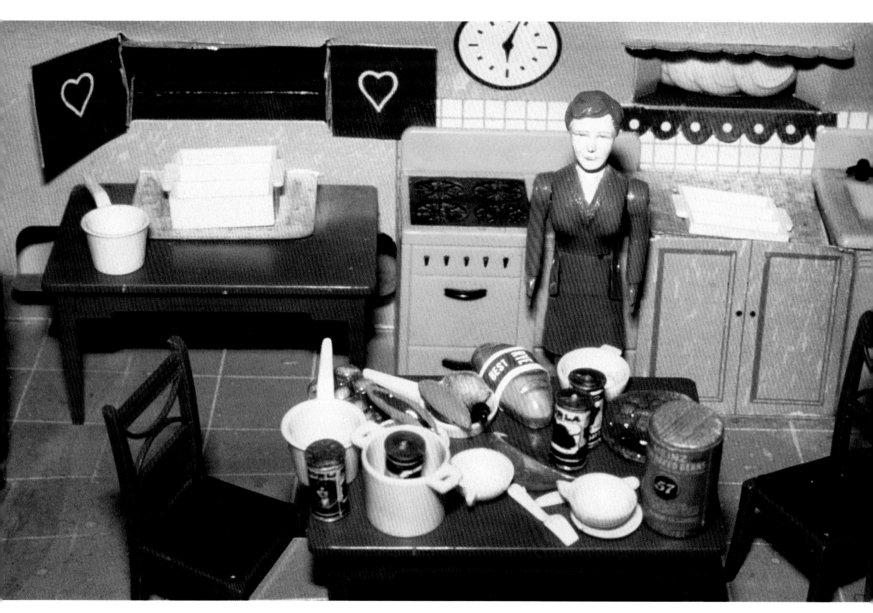

Laurie Simmons, *Purple Woman/Kitchen*, 1978

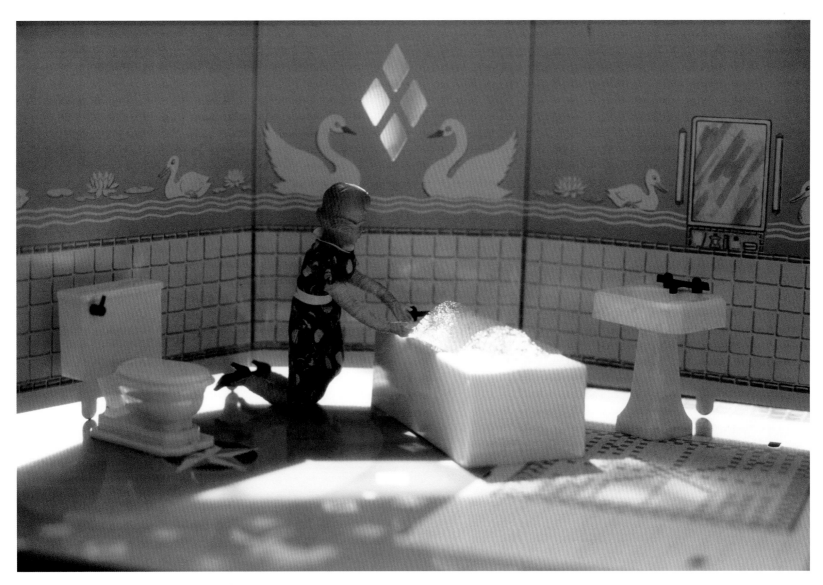

Laurie Simmons, *New Bathroom/Woman Kneeling/First View*, 1979

SUSAN MEISELAS

Susan Meiselas, cover of *Nicaragua*, 1981

1.
Kristen Lubben, ed., *Susan Meiselas: In History* (New York: International Center of Photography; Göttingen, Germany: Steidl, 2008), p. 116.

2.
Martha Rosler, "The Revolution in Living Color: The Photojournalism of Susan Meiselas," *In these Times*, June 17–30, 1981, repr. as "Wars and Metaphors," in *Decoys and Disruptions: Selected Writings, 1975–2001*, ed. Martha Rosler (Cambridge, Mass.: MIT Press, 2004).

When Susan Meiselas chose color to document the Sandinista uprising in Nicaragua, she unwittingly intervened in the larger discussion about the use of color in war photography. She recalled: "At the time, I wasn't taking a position in the debate about whether war should or shouldn't be shown only in black and white. . . . I initially worked with two cameras, one in black and white and the other in color, but increasingly came to feel that color did a better job of capturing what I was seeing. The vibrancy and optimism of the resistance, as well as the physical feel of the place, came through better in color."[1]

Meiselas was inspired to go to Nicaragua in January 1978, after reading about the assassination of Pedro Joaquín Chamorro, editor of *La Prensa*, a newspaper opposed to the Somoza regime. In June 1978 Meiselas arrived in Nicaragua without knowledge of Spanish or a specific assignment, determined to capture the burgeoning revolution. During her six-week visit, she photographed a group of young rebels wearing traditional masks in Monimbo; the photograph was picked up by the *New York Times Magazine* and ran as the cover image on July 30, 1978. This was Meiselas's first cover story, and newspapers around the globe quickly sought out her photographs after rebel forces captured the national palace in August.

In response to the wide interest in her work, Meiselas decided to create a book of her photographs as a way to gather them together in a format more enduring than the ephemeral pages of a newspaper. *Nicaragua* was published by Pantheon Press in 1981, and the publication became a lightning rod in the debate over the merits and pitfalls of color photojournalism. In her review of *Nicaragua*, artist and critic Martha Rosler argued that the use of color photography conferred a "fairy-tale" quality on the revolution that threatened to commodify the political violence by associating it with the fantasy world of advertising.[2] Since *Nicaragua*'s publication, color photojournalism has become so widespread that it is hard to imagine the controversy it caused. Today the book stands as a testament to Meiselas's pioneering commitment to color and its ability to capture the mood and atmosphere of a place.

G. D.

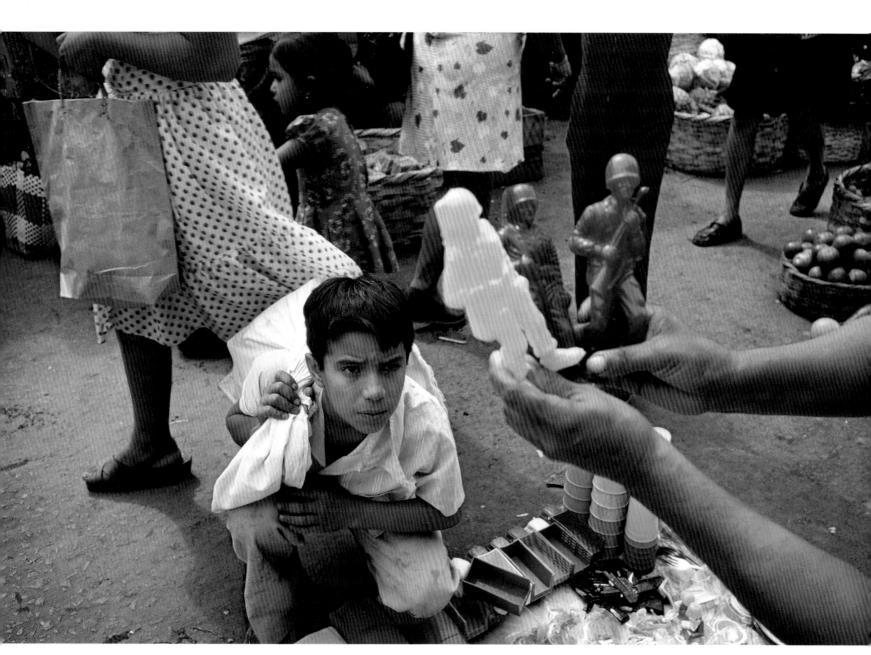

Susan Meiselas, *Marketplace in Diriamba, Nicaragua*, 1978–79

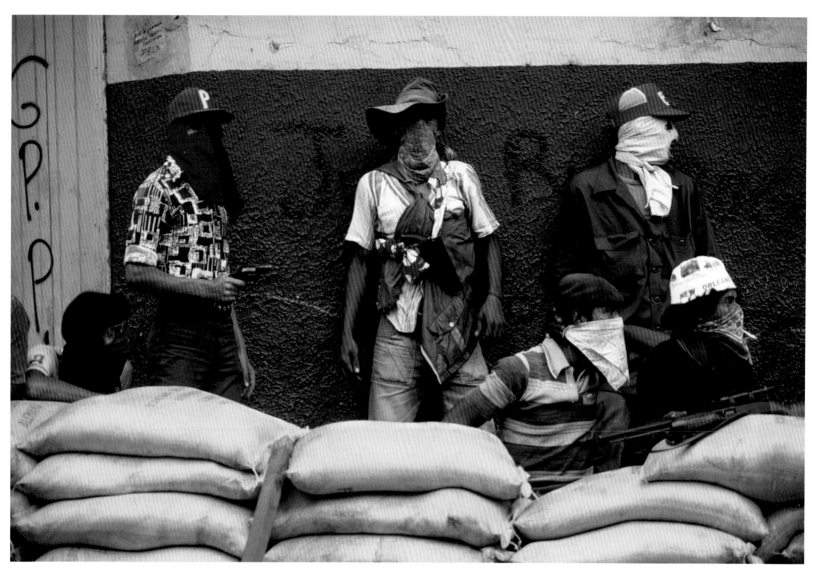

Susan Meiselas, *Awaiting Counter Attack by the Guard in Matagalpa, Nicaragua*, 1978–79

Nan Goldin began photographing in black and white, but by the time she moved to New York City in 1978, she had switched to color slide film. She had also begun what would become *The Ballad of Sexual Dependency*, a photographic diary of her life on the Lower East Side of Manhattan. Initially shown as a slide show in underground clubs and cinemas, *The Ballad* is a hybrid of photography, film, and installation art—a looped projection of over seven hundred of Goldin's photographs, sequenced by the artist and accompanied by a specified soundtrack.

Since its earliest presentation, *The Ballad* has always been a slide show arranged thematically. Images representing couples, gender roles, love, dependency, and alienation are paired poignantly with evocative songs such as the Velvet Underground's "Femme Fatale" (1972), Screamin' Jay Hawkins's "I Put a Spell on You" (1956), and Dean Martin's "Memories Are Made of This" (1955). Goldin's pictures, like those garden-variety slides of family vacations or holidays featured in Kodak advertisements (pages 89–93), fully embrace photography's potential for immediacy, emotion, and anecdote. Quite unlike such snapshots, however, they capture the very events and subjects considered to be outside socially accepted notions of identity, relationships, and community. Viewers see Goldin, her friends, and her family in moments of utmost intimacy—lovemaking, violence, addiction, hospitalization—and witness the rollercoaster of human emotions that accompany them. As the slide show progresses, Goldin and her subjects come into view and recede again in a cinematic mimicry of the nonlinear fashion of memories. The artist has said, "I used to think I couldn't lose anyone if I photographed them enough. . . . In fact, they show me how much I've lost."[1]

Goldin's installation offers up a more exposed and potentially more honest version of the domestic slide-show ritual. It is also indicative of the embrace of the slide show format by Conceptual artists during the 1960s and '70s.[2] As the medium's presence in the art world grew, *The Ballad* continued to develop, charting new territory as a self-contained piece with a dedicated soundtrack that codified earlier, more performative presentations in the clubs and cinemas of New York's artistic demimonde.[3]

In the introduction to the book version of *The Ballad of Sexual Dependency*, Goldin identified color as an essential component of personal stories: "Real memory, which these pictures trigger, is an invocation of the color, smell, sound, and physical presence, the density and flavor of life. Memory allows an endless flow of connections. Stories can be rewritten, memory can't. If each picture is a story, then the accumulation of these pictures comes closer to the experience of memory, a story without end."[4]

K. B.

1.
Nan Goldin, *Nan Goldin: I'll Be Your Mirror* (New York: Whitney Museum of American Art/Scalo, 1996), p. 256.

2.
On the history of the use of slide projectors in art, see Darsie Alexander, *Slide Show* (Baltimore: Baltimore Museum of Art; University Park: Pennsylvania State University Press, 2005), pp. 3–32.

3.
Later, in 1986, Goldin published the work in Nan Goldin, *The Ballad of Sexual Dependency* (New York: Aperture, 1986).

4.
Ibid., p. 6.

NAN GOLDIN

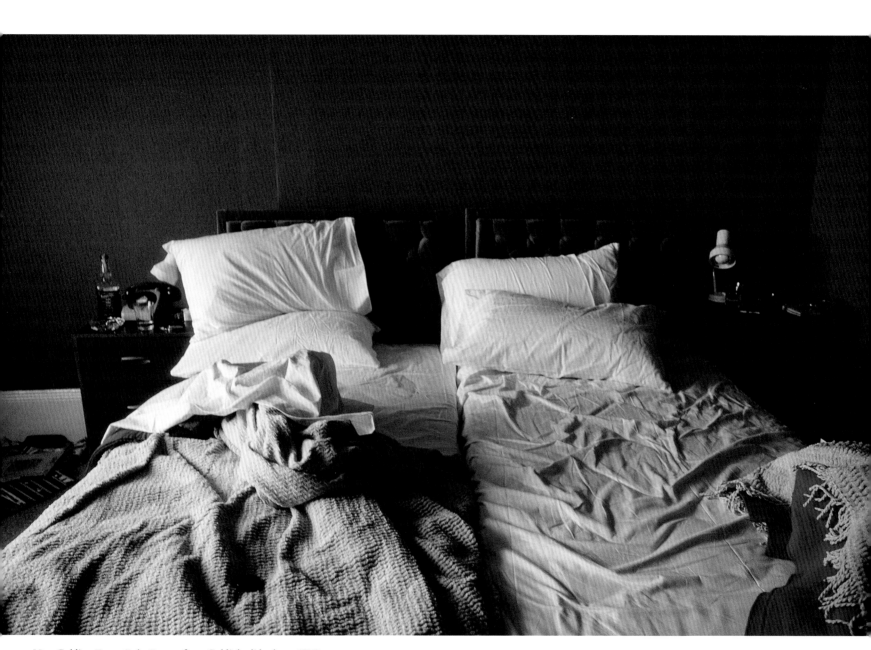

Nan Goldin, *Empty Beds, Boston,* from Goldin's slide show, 1979

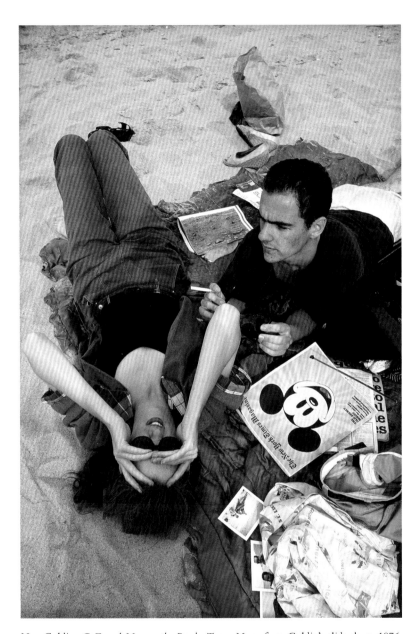

Nan Goldin, *C.Z. and Max on the Beach, Truro, Mass.*, from Goldin's slide show, 1976

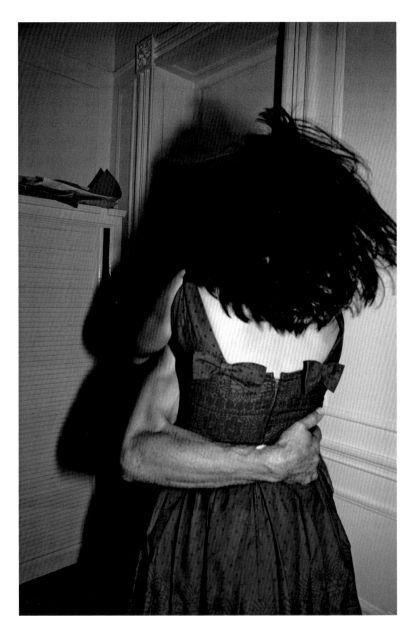

Nan Goldin, *The Hug, New York City*, from Goldin's slide show, 1980

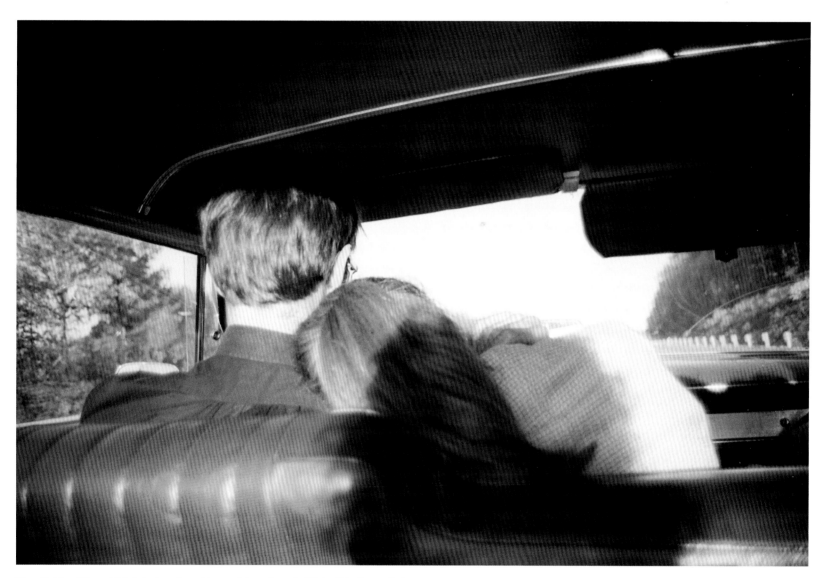

Nan Goldin, *Kim and Mark in the red car, Newton, Mass.*, from Goldin's slide show, 1978

KENNETH JOSEPHSON

Kenneth Josephson, *Chicago*, 1969

1.
Kenneth Josephson (Chicago: Museum of Contemporary Art, Chicago, 1983), p. 48.

2.
Kenneth Josephson, interviewed by Stephanie Lipscomb in Sylvia Wolf, *Kenneth Josephson: A Retrospective* (Chicago: Art Institute of Chicago, 1999), p. 181.

3.
In the early 1960s, Josephson organized an exhibition of snapshots by School of the Art Institute of Chicago faculty and students, one of the first of its kind. *Kenneth Josephson*, (Chicago: Museum of Contemporary Art, Chicago), p. 57.

Reflecting on his student years, Kenneth Josephson recalled his dislike of color photographic processes because of their time consuming and costly nature.[1] His aversion to color carried over into his graduate studies at the Institute of Design in Chicago, despite the influence of his teacher Harry Callahan, who was working in color at that time (1958–60). It was not until 1969 that Josephson began to incorporate color into his work. Even then, he did so selectively and, like Robert Heinecken, he preferred to avoid color processing by using found images and Polaroid film.

Josephson employed color only when it augmented his larger conceptual concerns, particularly the investigation of the nature of photographs as both unique records of specific moments and repetitions of the reality they depict. His earliest experiments with color are collages that juxtapose found color postcards with his own black-and-white photographs. *Chicago* (left), for example, brings together pieces of a colorful postcard of the city's downtown with a photograph taken by Josephson ten years later. The juxtaposition of images from different time periods reveals the changes in the cityscape that occurred in the interval between their creation. Josephson saw these collages as an inexpensive way to use color, while continuing to explore his interest in layering images: "It was an opportunity to introduce color into my work, and I liked the particular kinds of spaces that resulted when parts of the images were added or subtracted from the landscape. So I was interested in mixing color and black-and-white and revisiting a former time—comparing the difference over ten years."[2]

Josephson created Polaroids between 1978 and 1980, after testing the company's new Time Zero film. Polaroid's simplicity allowed him to expand his use of color without the hassle of processing and offered him another outlet through which to explore his interest in vernacular snapshot photography.[3] *Tennessee* (right) examines the inherent nature of the photograph as a repetition of an existing reality; both the color Polaroid and the black-and-white photograph it documents ultimately record the same subject. Here, the descriptive use of both color and black and white further enhances the uncanny duplication captured by the Polaroid in a manner that echoes the postcard collage.

G. D.

Kenneth Josephson, *Tennessee*, 1979

Robert Heinecken's use of color challenges the purity of photography as well as the medium's role in the creation of social norms and values. Although he rarely made his own photographs, he situated himself as a photographer by showing at Witkin and LIGHT galleries in New York. Circumventing the technical aspects of photography, Heinecken instead appropriated and manipulated images from popular culture.

Heinecken's engagement with color began in the 1970s, when he started using magazine pages as negatives and juxtaposing color images from fashion and advertising with those from pornographic publications. In doing so, Heinecken turned these prosaic images into critiques of the context in which they were originally created. Heinecken's work also directly engages with the larger cultural malaise of the Vietnam War era. Through his manipulations of popular imagery, Heinecken attacked the cheerful veneer put forth by television and print culture in the face of the country's political and social crisis.[1]

Heinecken's Polaroids are an exception to his use of appropriated images. Beginning in 1975, Heinecken created He/She, a series of works that situate SX-70 Polaroid film prints alongside brief, semiautobiographical dialogues between an anonymous woman and man (right). Even when Heinecken created his own images, his interest in the materiality of the photograph remained; like the advertisements and pornography he appropriated, the Polaroid becomes embedded within a larger discursive context. Heinecken once said, "A photograph is not a 'picture' of something, but it is an object about something," and his placement of the Polaroid on a page of text emphasizes its status as a tactile object.[2]

After gaining visibility in New York through Peter Bunnell's *Photography into Sculpture* exhibition at the Museum of Modern Art, in 1970, Heinecken was widely exhibited and critically lauded as an experimental photographer who embodied the freedom and irreverence of the West Coast. Heinecken was influential to younger artists of the 1970s in that his work stood as a model of social and institutional critique that remained unconcerned with the established values of the art photography market. His strategy of appropriation was amplified in the late 1970s, as the so-called "Pictures Generation" commandeered and repurposed photographs to draw attention to the malleability of representational modes.

G. D.

1.
For more on social commentary in Heinecken's work, see James Enyeart, ed., *Heinecken* (Carmel, Calif.: Friends of Photography/LIGHT Gallery, 1980).

2.
Quoted in Mark Alice Durant, "Robert Heinecken: A Material History," in *Robert Heinecken: A Material History* (Tucson, Ariz.: Center for Creative Photography, 2003), p. 8.

ROBERT HEINECKEN

She: My friend tells me that you are a photographer.

He: Not exactly.

She: What do you mean?

He: Well - I use photographs, rather than...

She: I know what a photographer is.

He: What?

She: Someone who reads Artweek from the back.

Robert Heinecken, *She: My friend tells me that you are a photographer*, 1981

BARBARA KASTEN

Like John Baldessari or Jan Groover, Barbara Kasten began incorporating photography into an art practice based in other media. In 1975 Kasten created a series of cameraless photographs made by directly exposing objects atop sensitized photographic paper. These minimalist works were soon followed by large-scale studio constructions, which, when captured on either her 8-by-10 camera or a 20-by-24 Polaroid camera, further blurred the lines between painting, sculpture, and photography. The Polaroid process especially emphasized intensely high-contrast objects—a black wire on a white backdrop or a mirror reflecting white, for example—in a way that made the dark objects appear in relief. This subtle dimensionality of the photographic print enhanced Kasten's exploration of the tension of trying to depict complex, three-dimensional, nearly abstract scenarios as two-dimensional representations. The Polaroid also offered the great advantage of instant feedback, so Kasten could determine what adjustments to objects, backdrops, or lighting were necessary. Indeed, she regularly employed elaborate lighting, including strobes, often covered in colored gels, which she sequentially turned on and off during a relatively long exposure. Mixing different hues and intensities of light in this way, Kasten was not "interested in finding ways to push the boundaries of photography but rather in finding ways to be innovative with painting and sculpture."[1] Kasten's Constructs series therefore accomplishes a perfect consolidation of the principles of art espoused by László Moholy-Nagy, who had decades earlier advocated for color photography's ability to "mechanically reproduce fleeting light and colored reflections as well as colored shadows."[2]

K. B.

1.
"Set Pieces," an interview of Barbara Kasten by Anthony Pearson, *Frieze*, Issue 143, November–December 2011, pp. 114–19. For a more contemporaneous consideration of Kasten's Constructs, see Andy Grundberg, "In the Arts: Critics' Choices: Photography," *New York Times*, September 19, 1982, p. G3.

2.
László Moholy-Nagy, *Vision in Motion* (Chicago: Paul Theobald, 1947), p. 172.

Barbara Kasten, *Construct XI-B*, 1981

Barbara Kasten, *Construct I-A*, 1979

Barbara Kasten, *Construct PC 1-B*, 1981

Cindy Sherman's progression from black-and-white to color photography began in 1980 with the conclusion of her critically acclaimed monochromatic Untitled Film Stills series, in which she fashioned herself as clichéd archetypes of female film characters of the 1950s and '60s. In Rear Screen Projections, her first project in color, Sherman continued her exploration of these typically feminine roles, though furthered her work's association with the entertainment industry by incorporating the techniques of modern color filmmaking. For these images, Sherman posed in front of projected color backgrounds depicting various landscapes, channeling the cinematic influences of filmmakers such as Alfred Hitchcock as she followed the Hollywood practice of using color slide projections to create the illusion of an external location.

Sherman explained that her use of color projection technology became an essential aspect of both the composition and overall cinematic effect of her Rear Screen Projections: "[The slide projector] was really so low-tech that I had to balance out the light I was shining on myself, and figure out the distances so as not to wash out the screen . . . in a lot of those pictures, I'm actually as out of focus as the background."[1] Sherman's consciously amateur use of slide projection technology created what art historian Rosalind Krauss referred to as "the special effect of backscreen-projection with its reluctant fissure in the image-field: the split it sets up in the experience of density and substance between the three-dimensional character and her flattened, factitious-looking scenic surrounds. Color, which entered Sherman's work at this moment, heightened this distinction."[2]

The rich color and size of these prints, which are significantly larger than her earlier black-and-white photographs, makes them comparable to a modern color television screen. The series has been perceived as Sherman's way of "[abandoning] the clearly nostalgic mood of the 'film stills' in favor of the present tense immediacy of TV close-up. The allure of the big color format pulls one in, while each figure's disconnection from the background emphasizes TV's alienating effects."[3]

Sherman's second series of color photographs, Centerfolds, similarly hinders straightforward vision with its precarious sense of scale and depth. Centerfolds consists of large horizontal color prints of Sherman, usually wet or dirtied and wearing adolescent clothing, enclosed in dark, shallow spaces (above left). Critic Roberta Smith reflected on Sherman's color work, stating that Rear Screen Projections "made us aware of one pictured illusion within another and of her involvement with and distance from both," while Centerfolds "has brought everything in close and made it bigger so that the feelings and forms really boom out. Once more, we're made extremely aware of something real being depicted and of the means of depiction."[4] From Rear Screen Projections to Centerfolds and onward, Sherman continued to use color as an aesthetic tool to emphasize the cinematic, carefully staged quality of her self-portraits, making it an integral part of her photographic practice.

A. S.

Cindy Sherman, *Untitled #92*, 1981

1.
"Cindy Sherman and John Waters: A Conversation," in *Cindy Sherman*, ed. Kate Norment (New York: Museum of Modern Art, 2012), p. 72.

2.
Rosalind Krauss, *Cindy Sherman: 1975–1993* (New York: Rizzoli, 1993), p. 89.

3.
Lisa Phillips, "Cindy Sherman's Cindy Shermans," in *Cindy Sherman* (New York: Whitney Museum of American Art, 1987), p. 14.

4.
Roberta Smith, "Review: Cindy Sherman," *Village Voice*, November 18, 1981, n.p.

CINDY SHERMAN

Cindy Sherman, *Untitled #77*, 1980

BACK MATTER

CHRONOLOGY
by Alissa Schapiro

1907 June 10: Invented by Auguste and Louis Lumière, the Lumière autochrome color process debuts at the Photo-Club de Paris. Edward Steichen attends the presentation and is inspired to master the technique and teach it to other photographers, including Alfred Stieglitz.

September 27: Stieglitz introduces the Lumière autochrome process to the American public through the exhibition of his own autochromes, along with those by Steichen, at the Little Galleries of the Photo-Secession known as 291.

October: The Lumière autochrome is made available to the American public and quickly becomes the first commercially successful photographic color process.

November 18–December 30: Steichen's autochromes are shown in *Photo-Secession Members' Show* at 291.

1908 March 12–April 2: Steichen displays fifteen autochromes in an exhibition at 291.

April: Stieglitz publishes three of Steichen's autochromes in *Camera Work* no. 22.

1910 January 21–February 5: *Color Photographs: Edward J. Steichen* exhibition at 291 features Steichen's autochromes.

1911 Spring: Arnold Genthe's autochromes are exhibited at the Vickery Galleries, San Francisco.

1912 March 30: *Collier's Weekly* publishes a Genthe autochrome of a rainbow over the Grand Canyon.

1914 July: *National Geographic* prints its first natural color photograph, an autochrome by Paul Guillumette depicting a flower garden in Ghent, Belgium.

October 31: Kodak unveils the first version of its Kodachrome film at the Memorial Art Gallery, Rochester, New York.

Helen Messinger Murdoch travels through Asia and the Middle East creating autochromes that will later appear in *National Geographic*.

1916 April: *National Geographic* reproduces twenty-three autochromes by Franklin Price Knott in "The Land of the Best: A Tribute to the Scenic Grandeur and Unsurpassed Natural Resources of Our Own Country," making *National Geographic* one of the first American magazines to run a series of autochromes.

1917 September 21: The Technicolor Corporation premieres the short film *The Gulf Between*, its first production created using two-color technology, in New York.

1919 The carbro process for creating color photographs is patented in England. Beginning in the 1930s in America, it becomes a popular process for creating color photographic magazine advertisements, championed by artists such as Nickolas Muray, Paul Outerbridge, and Victor Keppler.

1922 November 26: The Technicolor Corporation premieres its first feature film, *The Toll of the Sea*, which employs an updated version of the two-color system used in *The Gulf Between* (1917).

1928 July: Kodak introduces Kodacolor 16 mm amateur motion-picture film.

1931 January 15: *Vogue* publishes its first color photograph, created by Steichen, as part of an article called "The Game Called Color."

June: *Ladies' Home Journal* prints a double-page color spread of Muray's photographs of models in beachwear in Miami, the first color reproduction from a carbro print published in a magazine.

1932 July 1: The cover of *Vogue* features its first color photograph, Steichen's image of a girl in a red and white bathing suit holding a matching beach ball.

July 30: Walt Disney Productions releases the animated movie *Flowers and Trees*, the first commercial film to use the new Technicolor three-color dye transfer system; the technology soon becomes a staple of Hollywood color filmmaking, inaugurating the "Glorious Age of Technicolor" through the mid-1950s.

Condé Nast invests in technology to regularly publish color photographs in its magazines. Anton Bruehl, the chief color photographer for several Condé Nast publications, provides the first color photographic cover to *House & Garden* on July 1, 1932, and *Vanity Fair* on March 1, 1933.

1933 January 2: *Time* publishes its first color photograph on the cover of its annual Man of the Year issue, showing President Franklin D. Roosevelt with the credit line, "Photographed in Natural Color by O. J. Jordan."

1935 April 15: Kodak's newest commercial product, Kodachrome 16 mm motion-picture film, enters the market.

June 28: *Becky Sharp* debuts as the first full-length, blockbuster feature film shot entirely in three-color Technicolor live action film.

1936 Kodak extends its Kodachrome technology to include 35 mm slides and 8 mm home-movie film. Alongside the 16 mm motion-picture film released the year before, Kodachrome products quickly become the most commercially successful amateur color technology ever created.

1937 January 10: The *Milwaukee Journal* publishes the first candid color news photograph to appear in a newspaper's regular run.

January: Kodak introduces the Kodaslide Projector, the first slide projector compatible with 2-by-2-inch glass-mounted 35 mm color slides.

February 18–March 6: The Art Institute of Chicago displays its first color photographs in the exhibition *22 Direct Color Photographs by Charles Harris Miller, Instructor at the School of the Art Institute of Chicago.*

March 17–April 18: The Museum of Modern Art, New York, presents Beaumont Newhall's *Photography 1839–1937*, the first survey exhibition of photography, which includes a section devoted to color photography. It includes work by color pioneers such as the Lumière brothers, Steichen, László Moholy-Nagy, Bruehl and Fernand Bourges, Muray, Outerbridge, and the Eastman Kodak Research Laboratories.

May 23: Gerard Sheedy's color photographs capturing the crash of the German airship *Hindenburg* appear in the magazine section of the *New York Sunday Mirror*.

National Geographic is one of the first American publications to endorse Kodachome film.

1938 January: *Harper's Bazaar* publishes the first of Louise Dahl-Wolfe's color fashion photographs created for the magazine.

April 23–May 14: The Art Institute of Chicago presents the exhibition *Natural Color Photographs from the Studio of the* Chicago Tribune.

1939 April 30: The Kodak building at the New York World's Fair features the Great Hall of Color, a continuous projection of color slides across a 22-by-187-foot screen.

August 12: *The Wizard of Oz* premieres, dramatizing the cinematic progression from the black-and-white to the color experience. The movie's early sequences in Kansas are shot with sepia-toned black-and-white film without color filters, while the scenes in magical Oz are recorded in vibrant three-color Technicolor.

Kodak introduces 35 mm cardboard Kodaslide mounts and the Ready-Mount service, which lets customers send their slide film to Kodak laboratories for processing and mounting.

Farm Security Administration photographers, including John Collier, Jack Delano, Russell Lee, Arthur Rothstein, John Vachon, and Marion Post-Wolcott are given 35mm Kodachrome slide film to capture Depression-era America in color. They will produce a combined 644 color transparencies over the next three years.

1940 April 3–May 1: *American Designs for Abstract Film* exhibition at MoMA explores how artists employ color processes and technologies in the making of abstract films and presents a short color abstract film as a continuous projection in the gallery.

Outerbridge publishes *Photographing in Color*, a book detailing techniques for creating color photographs, complete with color plates of his work.

1941 July 7: The cover of *Life* magazine features its first color photograph, an Eliot Elisofon image of American Major General George S. Patton, Jr. atop a tank, in its defense issue.

Kodak makes it possible to order prints from Kodachrome slides, thus introducing the first commercially available color paper prints.

1942 January: Kodacolor film for prints, the world's first color negative film, is announced.

1943 March 10–April 18: MoMA presents *Birds in Color: Flashlight Photographs by Eliot Porter*, its first single-artist exhibition featuring color photographs.

July: *National Geographic* publishes its first color photograph on the cover, an image of the American flag, in a patriotic effort to assist the U.S. Treasury Department by encouraging the purchase of war bonds.

November 4–December 7: MoMA includes Kodachromes by Bruehl and Dahl-Wolfe in *Portraits*, an exhibition of new acquisitions by the photography department.

1944 March 1–May 10: *The American Snapshot* exhibition at MoMA features a continuous projection of forty-eight Kodachromes and amateur color snapshot photographs, all purchase prize winners from Kodak competitions.

November 8–27: The American Museum of Natural History, New York, presents *Color as We See It, Photograph It, Print It*, the first in a series of color photography exhibitions organized by the American Museum of Photography, Philadelphia.

1945 Kodak's dye transfer process (a variation of the general dye imbibition process) goes on the market and becomes popular with fine-art photographers.

1946 Kodak creates Ektachrome Transparency Sheet Film, the company's first color film that photographers can process themselves with new do-it-yourself chemical kits.

1947 Kodak invites a number of well-known photographers, including Ansel Adams, Edward Weston, and Walker Evans, to experiment with the newest color product, 8-by-10-inch Kodachrome sheet film.

1948 April 6–July 11: *In and Out of Focus: A Survey of Today's Photography* exhibition at MoMA includes mural-size color transparencies by Weston and Adams created specifically for the exhibition.

1949 February 8–May 1: Color photographs are displayed in MoMA's *The Exact Instant*, an exhibition reviewing one hundred years of news photography.

Newhall includes Weston's color photograph of the waterfront in Monterey, California, as the frontispiece of the new edition of his popular book *The History of Photography: From 1839 to the Present Day*, the first color photograph in any edition of the publication.

1950 May 9–July 4: MoMA presents *Color Photography*, the museum's first group exhibition dedicated entirely to color photography. Curated by Steichen, the show features 342 color photographs and color transparencies by eighty-five photographers, including Adams, Harry Callahan, Dahl-Wolfe, Elisofon, Evans, Andreas Feininger, Fritz Goro, Lee, Outerbridge, Porter, Irving Penn, Steichen, and Weston.

May 15: Kodak unveils the first of its long-running series of Colorama display transparencies projected onto an 18-by-60-foot screen overlooking the main terminal floor of New York's Grand Central Station. An estimated seventy-eight million commuters and tourists view this popular attraction every year before it is discontinued in 1990.

George Eastman House, Rochester, New York, hosts its first exhibition of color photographs, *Color in Bermuda and Hawaii: Photographs by Dr. C. E. K. Mees.*

1951 March 15–April 12: *A Half Century of Color 1900–1950* exhibition at the American Museum of Photography, traces the development and use of color photography and photomechanical reproduction, featuring work by Bourges, Bruehl, Dahl-Wolfe, Keppler, Muray, Penn, and Steichen.

May 1–July 4: *Abstraction in Photography* exhibition at MoMA includes color photographs by Callahan, Moholy-Nagy, Porter, Arthur Siegel, and Steichen.

November–December: George Eastman House presents Porter's early color work in the exhibition *Bird Color Print Photographs by Eliot Porter.*

November 29, 1951–January 6, 1952: MoMA offers color photographs of nature by Porter and a color abstraction by Callahan in the *Christmas Photographs* exhibition and sale.

Time begins regularly publishing color photographs.

1952 January 25: *Color Photographs of Atomic Bomb Explosion by Air Force* exhibition at George Eastman House presents the scientific color photographic studies created by the American armed forces.

May: George Eastman House installs a permanent exhibition of the history of color photographic technology, ranging from an 1895 color lantern slide projector to examples of autochromes to prints created using the carbro and dye transfer processes.

May 20–September 1: *Diogenes with a Camera* exhibition at MoMA includes Porter's color photographs.

1953 September 14 and September 21: Haas's New York photographs are published in *Life* as a two-part photo-essay, "Images of a Magic City."

September 15–November 1: *Photographs in Color by Eliot Porter* at the Art Institute of Chicago is the museum's first solo show dedicated to color photography by a well-known fine-art photographer.

Porter's portfolio *American Birds: Ten Photographs in Color* is published by the McGraw-Hill Book Company.

Spring: *Life* begins publishing color photographs on the covers of nearly every issue.

1954 July: Evans reproduces color photographs taken by Adams and Weston, among others, using Kodak film in the article "Test Exposures" in *Fortune* magazine.

August: George Eastman House exhibits color transparencies in *Color Room: Paul Strand, Edward Weston, Eliot Porter.*

September 15–November 1: The Art Institute of Chicago presents *Photographs in Color by Arthur Siegel,* a solo exhibition featuring Siegel's dye transfer prints.

Hy Hirsh exhibits an experimental color film to great acclaim at the California State Exposition.

1955 January 24–May 8: MoMA presents Steichen's blockbuster exhibition *The Family of Man,* which includes one gallery painted black, with the only light emanating from a 6-by-8-foot color transparency of a hydrogen bomb explosion.

Winter 1955–56: Saul Leiter's solo exhibition at Tanager Gallery, New York, features color slides as well as paintings.

Kodak introduces Ektacolor printing paper, allowing color prints to be made from Ektacolor negatives.

1957 February 19: Steichen presents "Experimental Photography in Color," a slide lecture at MoMA, including work by Callahan, Haas, and Leiter.

November 27, 1957–February 2, 1958: *70 Photographers Look at New York* exhibition at MoMA displays fourteen color photographs of New York by Haas, several of which were featured in his 1953 *Life* magazine color photo-essay.

1958 February: George Eastman House displays the work of Ivan Dmitri, author of the popular manual *Kodachrome and How to Use It,* in *Exhibition of Color Photographs by Ivan Dmitri.*

November 26, 1958–January 18, 1959: *Photographs from the Museum Collection* group exhibition at MoMA includes color work by Callahan and Haas.

1959 May–June: *Motion Studies in Color by Ernst Haas* exhibition at George Eastman House features enlarged color transparencies.

August 11–September 25: George Eastman House presents twenty-one color photographs, printed using the carbro process, in the exhibition *Color Photographs by Syl Labrot.*

Spring: The Smithsonian Institution presents a posthumous retrospective exhibition of Outerbridge's photographs, including his color work.

October 21: The *Minneapolis Star* runs an Associated Press color photograph of the funeral of General George C. Marshall, believed to be the first color photograph to appear on page one of a major newspaper.

1960 February 17–April 10: *The Sense of Abstraction in Contemporary Photography* exhibition at MoMA features color photographs by Haas, Labrot, and Porter.

August 12–October 1: *The Seasons: Color Photographs by Eliot Porter Accompanied by Quotes from Henry David Thoreau* exhibition is presented at George Eastman House and later circulated by the Smithsonian Institution Traveling Exhibition Service.

December 21, 1960–February 5, 1961: *Recent Acquisitions* exhibition at MoMA includes two recent works each by Haas and Labrot.

1961 January 20–March 5: The Art Institute of Chicago presents *Photographs in Color and Black and White by Syl Labrot.*

March 28–May 30: *Steichen the Photographer* retrospective at MoMA presents a history of Steichen's photographic practice, including color photographs he made throughout his career.

Kodak introduces the Kodak Carousel Projector, with a round tray that can accommodate eighty slides.

1962 February: *National Geographic* becomes the first major American periodical to publish an all-color issue and prints more color photographs in this year than any other U.S. magazine.

February 9: Steichen presents two hundred color slides in his lecture "Towards Abstraction" at MoMA. He uses examples of color work by Haas and Callahan to discuss the direction of abstraction in photography, with a focus on photography's relationship to abstraction in other visual arts.

August 21–October 28: *Ernst Haas: Color Photography* exhibition at MoMA, organized by newly appointed photography curator John Szarkowski, presents ten years of Haas's work in color.

The Sierra Club publishes Porter's *In Wilderness Is the Preservation of the World*, the first color volume in their Exhibit Format series.

1963 March 14: "Three Photographers in Color" slide presentation at MoMA explores the color photography of William Garnett, Helen Levitt, and Roman Vishniac. After being introduced by Szarkowski, each photographer speaks about his or her work in color.

October 21, 1963–February 10, 1964: *Photography 63/An International Exhibition*, curated by Nathan Lyons at George Eastman House, showcases twenty color photographs, including Pete Turner's *Rolling Ball* and *Fisherman*.

Polaroid introduces Polacolor Type 48, the first instant one-step color film and the easiest and fastest color technology on the market, appealing to both amateurs and professionals.

Kodak sponsors a solo exhibition of Haas's color photography, *Ernst Haas World of Color*, which travels to five continents.

1964 April 22: The Kodak Pavilion at the New York World's Fair unveils five illuminated prints measuring 30 by 36 feet, the largest outdoor color photographs ever displayed, attached to a pentagonal structure towering eight stories above the fair grounds. Also on view in the pavilion are three hundred winning color prints and slides from an international Kodak competition, open to amateurs and professionals, on the theme "The World and Its People."

May 25: The first installation of the new Edward Steichen Photography Study Center at MoMA presents color photographs by Haas, Labrot, Outerbridge, Penn, and Steichen.

May 27–August 23: *The Photographer's Eye* exhibition at MoMA includes Penn's color photograph *Summer Sleep*.

Fall: *Photographs: Harry Callahan* exhibition at the Hallmark Gallery, New York, includes a continuous slide projection of sixty color images.

1965 March 16–May 16: *The Photo Essay* exhibition at MoMA reviews four decades of photojournalistic stories made for publication, dedicating one wall of the gallery to double-page color spreads from numerous magazine essays and featuring projections of enlarged color essays by Larry Burrows, Elisofon, Goro, Haas, and Penn.

June: *New York Proclaimed*, V. S. Pritchett's narrative account of the city is published, illustrated with Evelyn Hofer's color and black-and-white photographs of New York.

1966 April 12–July 4: *Marie Cosindas: Polaroid Color Photographs* exhibition at MoMA features forty-five of Cosindas's Polaroid prints. The exhibition travels to the Museum of Fine Arts, Boston, and the Art Institute of Chicago over the next year.

1967 March 14: *Recent Color*, a photography exhibition in slide form at MoMA, explores abstract and documentary practices by artists such as Hirsh.

Photography in the Twentieth Century exhibition at George Eastman House showcases color photographs by artists, including Haas, Labrot, and Turner.

1968 January 27–February 17: Bruce Nauman's color photograph *Self-Portrait as a Fountain* is displayed unframed and tacked to the wall in his debut solo exhibition at Leo Castelli Gallery, New York.

September: George Eastman House exhibits forty-two color photographs created by Turner.

Fall: The Friends of Photography, Carmel, California, presents the exhibition *Color Photographs*, featuring the work of Cosindas.

Ed Ruscha self-publishes *Nine Swimming Pools and a Broken Glass*, his first color photobook.

1969 February 28–May 11: George Eastman House exhibits color photographs by Robert Heinecken in *Vision and Expression*, curated by Nathan Lyons.

Fall: *Aperture*, a magazine dedicated to promoting fine-art photography, publishes its first color photographs in an article about the Exchange National Bank of Chicago's photography collection.

1970 May 20–July 5: *The Photograph as a Permanent Color Print* exhibition at the New York Cultural Center displays color photographs by Adams, Elisofon, Feininger, Keppler, and Turner.

1971 October 18: Haas's color monograph *Creation* is published by Studio Books and will eventually sell 350,000 copies.

November: LIGHT Gallery, the first commercial New York gallery devoted exclusively to contemporary photography by living artists, opens on Madison Avenue.

The Whitney Museum of American Art and Pace Editions publish Lucas Samaras's photobook *Samaras Album: Autobiography, Autointerviews, Autopolaroids*, featuring his color and black-and-white Polaroids.

Stephen Shore curates *All the Meat You Can Eat* at 98 Greene Street Gallery, New York, an exhibition of found, vernacular photographs ranging from corporate headshots to photo-booth portraits.

Shore creates his Greetings from Amarillo: Tall in Texas series, taking color photographs of mundane Amarillo architecture and landscapes and having them printed as vibrantly colored commercial postcards.

1972 June 27–August 18: *Summer LIGHT* group exhibition at LIGHT Gallery features Shore's color postcards.

September 23–October 28: Shore exhibits his color series American Surfaces at LIGHT Gallery.

Polaroid introduces its popular SX-70 Land Camera, the first single-lens reflex camera for instant color prints. The camera will soon be used by many artists, including Samaras, Shore, and Neal Slavin.

1973 April 13–May 27: The first large exhibition of William Christenberry's color photographs is on view at the Corcoran Gallery of Art, Washington, D.C.

July 6–31: LIGHT Gallery devotes a group exhibition, *Color Photography*, to contemporary color work by photographers, including Labrot, Shore, and Eve Sonneman.

October 9–November 3: LIGHT Gallery presents a solo exhibition of Heinecken's work that includes his color photographs.

November 6–December 1: Samaras exhibits color snapshots, taken with the Polaroid SX-70 camera he was given by Polaroid, in *By SX-70* at LIGHT Gallery.

December 4, 1973–January 5, 1974: LIGHT Gallery dedicates a solo exhibition to Shore's color photographs.

1974 May 8–August 31: George Eastman House surveys Muray's photographic career from 1918 to 1965, including his carbro prints. The archive of Muray's approximately 25,000 photographic prints, negatives, transparencies, and advertising tear sheets is donated to the museum.

September 16–October 20: *Projects: Helen Levitt in Color*, a slideshow projection of forty color photographs of New York street life, is on display at MoMA.

November 16, 1974–March 10, 1975: *The Eye of the Beholder* exhibition at the International Center of Photography, New York, features large color prints by Haas and Porter.

December 10, 1974–January 4, 1975: Jan Groover's recent color photographs are exhibited at LIGHT Gallery.

William Eggleston's portfolio of dye transfer prints, *14 Pictures*, is published by Harry Lunn and distributed by Graphic International, Washington, D.C.

The Rochester Institute of Technology, Rochester, New York, presents the exhibition *Straight Color*, featuring color work by Christenberry and Eggleston.

1975 February 4–March 1: LIGHT Gallery presents a solo exhibition of Shore's work, including his color photographs of everyday American life.

September 27–November 11: *In Just Seconds: A Survey of Polaroid Color Photography* at the International Center of Photography features instant color photographs taken over the past twelve years by photographers, including Adams and Evans.

October 14, 1975–February 2, 1976: Shore is the only photographer working in color to be represented in the exhibition *New Topographics: Photographs of a Man-Altered Landscape* at George Eastman House.

November 11, 1975–January 11, 1976: *Color Photography: Inventors and Innovators* exhibition at Yale University Art Gallery, New Haven, Connecticut, features photographs created through a variety of color processes by Eggleston, Evans, Genthe, Haas, Labrot, Muray, Outerbridge, Penn, Porter, Samaras, Shore, Siegel, Steichen, and Stieglitz.

November 15, 1975–February 1, 1976: *An American Experience: Color Photography by Ernst Haas* at the International Center of Photography is the museum's first solo exhibition dedicated to color photography.

1976 January 13–February 7: Twelve of Slavin's portraits of New York groups are displayed at LIGHT Gallery.

February 16–April 4: *Art of Color* exhibition at the International Center of Photography is held in the museum's gift shop.

Winter: Groover exhibits what are advertised as "color photographs of static situations" at Max Protetch Gallery, New York.

February 10–March 6: Heinecken's work is presented at LIGHT Gallery.

May 6–July 18: *Recent Acquisitions: Photography* exhibition at MoMA features Shore's color photograph *Breakfast, Trail's End Restaurant, Kanab, Utah*.

May 24–August 1: *William Eggleston* exhibition at MoMA presents seventy-five color photographs and is accompanied by the museum's first book of color photography, *William Eggleston's Guide*, by the exhibition's curator, Szarkowski.

Summer: John Pfahl exhibits Altered Landscapes, his series of color photographs of interventions in the landscape, at the Visual Studies Workshop Gallery, Rochester, New York.

September 15–October 15: George Eastman House presents *Jan Groover*, an exhibition of color photographs.

September 24–November 21: Groover's color work is featured in *The Nation's Capital in Photographs, 1976: John Gossage and Jan Groover* at the Corcoran Gallery of Art.

September–October: The Institute of Contemporary Art, Boston, exhibits *Marie Cosindas: Polaroid Photographs 1960–1976*.

October: Images Gallery, devoted exclusively to selling color photographs, opens in New York.

October 6–30: *Neal Slavin: American Group Portraits* exhibition at LIGHT Gallery presents a large selection of color photographs from his recent monograph, *When Two or More Are Gathered Together*.

October 8, 1976–January 4, 1977: *Photographs by Stephen Shore* exhibition at MoMA displays color photographs from Shore's Uncommon Places series.

December 14, 1976–January 8, 1977: Christenberry exhibits color photographs and sculptures at Zabriskie Gallery.

Shore's *Portfolio of Twelve Prints* is published by the Metropolitan Museum of Art.

The Minneapolis College of Art and Design presents *Time Space in Color: A Retrospective*, a one-man exhibition of Turner's work.

1977 January 8–29: Groover displays her color Kitchen Still-Lifes series at Sonnabend Gallery, New York.

Winter: Levitt exhibits color dye transfer prints and color slides in a solo show at Carlton Gallery, New York.

April 3–May 1: Addison Gallery of American Art, Phillips Academy, Andover, Massachusetts, presents color prints by Philip-Lorca diCorcia in *Recent Work by Twelve Photographers*.

April 5–May 10: DiCorcia's color photographs are shown in *Contemporary Photography VI* at the Fogg Art Museum, Harvard University, Cambridge, Massachusetts.

April 6–30: LIGHT Gallery features recent color photographs by Shore.

May 6–15: George Eastman House presents *Kodachrome*, curated by Sally Stein, showcasing work by artists such as Bruehl, Bourges, Dmitri, Keppler, and Muray.

June 3–July 3: *The Athlete: A Collection of Contemporary Sports Photography* exhibition at the International Center of Photography presents sports journalism in color by artists, including Haas.

June–July: Curated by Marvin Heiferman, *Some Color Photographs* exhibition at Castelli Graphics, New York, features the work of John Baldessari, Eggleston, Groover, Levitt, Joel Meyerowitz, Ruscha, Shore, and Slavin.

November: Joel Sternfeld's color street photographs are published in *Camera* magazine.

November–December: Meyerowitz exhibits his color photographs at Witkin Gallery, New York.

November–December: *William Eggleston: Color Photographs 1966–1977* is on view at Castelli Graphics.

Haas and Turner, along with fellow photographer Jay Maisel, open the Space Gallery in New York, a gallery dedicated to exhibiting and selling color photography.

1978 January 3–28: *New York, New York* group exhibition at LIGHT Gallery includes color photographs by Eggleston, Groover, Shore, and Slavin.

February–March: Pfahl exhibits Altered Landscapes at Robert Freidus Gallery, New York.

March 29–April 22: The first solo exhibition devoted exclusively to Callahan's color photography is presented at LIGHT Gallery.

April: Sonneman's color photographic diptychs are featured in a solo exhibition at Castelli Graphics.

Spring: *Jan Groover/David Haxton* exhibition showcases color photographs at the Whitney Museum of American Art, New York.

May 24–June 24: LIGHT Gallery presents *Photographs by Stephen Shore*, featuring his recent color prints.

July 26–October 2: *Mirrors and Windows: American Photography Since 1960* exhibition at MoMA features color photographs by Cosindas, Eggleston, Groover, Haas, Heinecken, Levitt, Meyerowitz, Porter, Samaras, Shore, and Sonneman.

September 16–November 5: *Marie Cosindas: Moments of Affection* exhibition at the International Center of Photography presents a sampling of Cosindas's photographic practice.

November 14, 1978–January 14, 1979: Meyerowitz displays his Cape Light series at the Museum of Fine Arts, Boston.

November 21: The New York Graphic Society publishes *Marie Cosindas: Color Photographs*.

November 28, 1978–January 7, 1979: *Antarctica by Eliot Porter* exhibition at the International Center of Photography displays Porter's color wilderness photographs.

December 21, 1978–February 11, 1979: *William Christenberry: Color Photographs* exhibition is presented at the Corcoran Gallery of Art.

Sonnabend Gallery holds a solo exhibition of Groover's color photographs.

Kenneth Josephson tests Polaroid's new Time Zero film and makes his first color photographs.

1979 January: Art historian Sally Stein publishes "FSA Color: The Forgotten Document," an article about her discovery of never-before-published color photographs taken during the Great Depression by Farm Security Administration photographers, in *Modern Photography*.

January 3–27: LIGHT Gallery presents photographs by NASA, most of which are small color prints.

January 6–February 10: Laurie Simmons's color dollhouse interiors are exhibited for the first time in the hallway of Artists Space, New York.

February 1–March 3: Heinecken's work is featured in an exhibition at LIGHT Gallery.

February 3–March 25: *American Photography in the 1970s* exhibition at the Art Institute of Chicago includes color photographs by Baldessari, Christenberry, Cosindas, Eggleston, Groover, Meyerowitz, Pfahl, and Shore.

Spring: Simmons presents her color photographs in a classroom at MoMA PS1, New York.

June 23–July 27: *Pictures: Photographs* exhibition at Castelli Graphics, curated by Marvin Heiferman, showcases color work by Nan Goldin.

July 3–October 28: *Steichen: A Centennial Tribute* exhibition at George Eastman House presents Steichen's dye transfer color fashion prints.

September 6–November 4: *Color: A Spectrum of Recent Photography* group exhibition at Milwaukee Art Center (now Milwaukee Art Museum) presents color photographs by Christenberry, Eggleston, Meyerowitz, Pfahl, Shore, and Slavin, among others.

October 4–27: *20x24/LIGHT* exhibition at LIGHT Gallery documents the production of large Polaroid color prints created for the exhibition by eighteen photographers, including Groover and Pfahl.

October 13–December 2: *American Images: New Work by Twenty Contemporary Photographers* exhibition at the Corcoran Gallery of Art includes color photographs by Callahan, Eggleston, Groover, Meyerowitz, and Shore.

October 14–November 8: *Harry Callahan: Photographs in Color/The Years 1946–1978*, a retrospective of Callahan's color photography, is on view at the Center for Creative Photography at the University of Arizona, Tucson.

November 14, 1979–January 20, 1980: The Metropolitan Museum of Art exhibits Porter's Intimate Landscapes, comprising fifty-five dye transfer prints. It is the museum's first solo show of color photography.

December: Goldin first exhibits her music-accompanied color slide show of works from *The Ballad of Sexual Dependency* at musician Frank Zappa's birthday party at a downtown New York nightclub.

The Space Gallery presents the exhibition *New York in Color*, a celebration of color photography, in collaboration with the city of New York and Warner Brothers.

1980 January 12–February 10: *American Images: New Work by Twenty Contemporary Photographers* exhibition at the International Center of Photography features color photographs by Callahan, Eggleston, Groover, Meyerowitz, and Shore.

February 2–23: Groover's color work is exhibited in a solo exhibition at Sonnabend Gallery.

March 15–May 4: The Art Institute of Chicago presents *Color Photographs by Marie Cosindas and Eliot Porter*.

April 19–June 15: *One of a Kind: Recent Polaroid Color Photography* exhibition at the Art Institute of Chicago displays color Polaroids by Adams, Cosindas, Eggleston, Groover, Samaras, Sonneman, and Sternfeld.

May 1–31: A survey exhibition of Levitt's photographic career, including her color work, is presented at Sidney Janis Gallery, New York.

September 2–13: *Likely Stories* exhibition, curated by Heiferman at Castelli Graphics, presents contemporary narrative photography, including color photographs by Goldin and Sonneman.

September 12–October 4: LIGHT Gallery exhibits Callahan's color photographs in the exhibition *Harry Callahan Retrospective: Color and Beach Photographs* and publishes a catalog of his color work, *Harry Callahan Color: 1941–1980*.

November 6–26: Shore's color photographs are presented in a solo exhibition at LIGHT Gallery.

December 6, 1980–January 7, 1981: Cindy Sherman presents her Rear Screen Projections series, her first photographs taken in color, at Metro Pictures Gallery, New York.

December 1980–January 1981: Samaras's color Polaroids of artists and their models are displayed at Pace Gallery, New York.

John Pfahl: Altered Landscapes, a portfolio of dye transfer prints, is published by the Sun Valley Center for the Arts and Humanities.

1981 April 12: Susan Meiselas's photobook *Nicaragua* is published by Pantheon Press and becomes the first major photobook dedicated to color war photography.

June 4–July 2: LIGHT Gallery presents an exhibition of Heinecken's photographs, including his recent color work, accompanied by *Heinecken*, a major monograph.

July: *Love Is Blind* exhibition at Castelli Graphics includes color work by Goldin.

October 6–31: Sternfeld's large-format color landscapes of roadside America, known as the American Prospects series, are on view at Daniel Wolf, New York.

October 16–November 11: *The New Color Photography* exhibition, curated by Sally Eauclaire at the International Center of Photography, presents color work by Callahan, Christenberry, Eggleston, Groover, Levitt, Meyerowitz, Pfahl, Samaras, Shore, Slavin, Sonneman, and Sternfeld. Eauclaire also produces an accompanying catalog.

October 23–November 29: Sternfeld exhibits his color street photographs at the San Francisco Museum of Modern Art.

November 7–28: Sherman's second color series, Centerfolds, is presented at Metro Pictures Gallery.

November 20, 1981–January 5, 1982: Young Hoffman Gallery, Chicago, features Sherman's recent color work in *Cindy Sherman: New Color Photographs*.

November 24, 1981–January 3, 1982: Barbara Kasten exhibits her color Polaroid Constructs at George Eastman House.

GLOSSARY

This glossary provides a list of the terms used in this catalog to describe color photographic processes. Each process may have more than one term associated with it, especially if it was developed and branded by a particular corporation.

Autochrome

Introduced in 1907 by the Lumière brothers, the autochrome was the first reasonably simple and commercially successful color process. It relies on a layer of potato-starch grains dyed red, green, and blue, which acted as colored filters over a silver emulsion on a sheet of glass. Exposures are lengthy, but processing is fairly simple, and the result is a subdued but richly colored image, which some considered the greatest advance in photography since the daguerreotype. The luminous transparencies, however, transmit on average only about twelve percent of the light behind them, so a bright source is needed to fully appreciate their colors. Nevertheless, the autochrome became quite popular with amateurs and artists such as Alfred Stieglitz and Edward Steichen, and it was widely used until the 1920s.

Carbro print

The carbro process relies upon an interaction between pigmented carbon tissues and a silver bromide print. Patented in England in 1919 by H. F. Farmer and sold by the Autotype Corporation in London, the process produces vivid colors and had relative permanence, which made it the popular choice of the advertising industry until the 1950s. A slight variation of the tricolor carbro process, known as Vivex, was marketed quite successfully in England until production ceased in 1939.

Chromogenic print

Chromogenic is the generic umbrella term for the vast majority of color prints in existence prior to the digital era. A chromogenic print—such as Ektacolor, Fujicolor, or Kodacolor—is made on paper that has three emulsion layers, each sensitized to blue, green, or red. Unlike in a silver-dye bleach print, however, the color dyes are not contained in each layer prior to printing but are created during the development process. When the manufacturer's product name ends in "-chrome," it simply means the same chromogenic process has unfolded on a transparent film base rather than paper, thus producing a color slide. Kodachrome—introduced in 16 mm film form in 1935 and 35 mm slide form in 1936—used proprietary processing chemicals, making the developing of that film possible in only a few specific Kodak labs. The first commercially available chromogenic printing process, Kodacolor, debuted in January 1942, but its dyes were notoriously unstable and remained so until manufacturers made substantial improvements in the mid-1980s to address these concerns.

Color photomechanical reproduction

This term includes a variety of methods for printing reproductions of photographs in books and in the press. Two of the most common methods, each with their own numerous technological variations, are photolithography and photoengraving (also known as gravure). The former involves the distribution of colored inks across the page surface in varying patterns, based on the amount of ink transferred to the paper during printing. Photoengraving relies on varying densities of inks, the direct result of the depth of etched marks, which hold the ink before being transferred onto the printed page. Unlike photolithography, often the mechanical marks of photoengraving are visible with the naked eye. Magazine and newspaper publishers have used both photolithography and photoengraving to reproduce color photographs. Condé Nast perfected photoengraving in the early 1930s, for example, offering the service to many manufacturers and printers. Photolithography, on the other hand, allowed *Life* magazine to feature color photographs on its cover in 1941.

Color proof

A color proof is a full-color test print showing exactly how the colors will appear in the final printing. Color proofs are submitted before the press proof, and therefore provide the penultimate opportunity to make alterations or correct mistakes. An accurate color proof offers color-true reproduction of the contents intended for printing.

Dye imbibition print

In a dye imbibition print, commonly called a dye transfer print after the Kodak product bearing that name, three separate sheets of negative film are produced from a full-color transparency through red, green, and blue filters. From these negatives, enlarged gelatin matrices are made and immersed in cyan, magenta, and yellow dyes. All three matrices are then rolled out under pressure in exact register on a single sheet of paper, and the combination of transferred dye images creates a final full-color print. Materials for dye imbibition made their commercial debut in 1945, but the intricacy of the process kept it from widespread popularity. Nevertheless, because each color is transferred to the final paper independently, it was possible to obtain enormous control over the look of the finished print, making dye imbibition prints well suited to artists and commercial photographers. The process remained in use until the late 1990s, when materials for it became nearly impossible to locate.

Its potential to yield intense, almost hyperreal colors resonated with the embrace of Technicolor by the Hollywood movie industry, and, in fact, the most sophisticated Technicolor three-color process, inaugurated in 1932, relied on the dye imbibition process. (Technicolor first patented a two-color technology in 1917 that was not a dye imbibition process. The rudimentary system required two projectors, one with a red filter and one with a blue-green filter, running simultaneously to create the effect of color. It was replaced by a more advanced version in 1922 that employed a single projector to produce two dyed strips of film cemented together.) The three-color process was achieved by using a Technicolor camera equipped with three strips of film, each recording blue, green, or red simultaneously, as well as a refined procedure of dye imbibition printing. These techniques ensured the intensely rich colors that were the industry standard for Hollywood color films until February 1975, when the Technicolor imbibition plant closed.

Internal dye diffusion transfer print

An internal dye diffusion transfer print is a one-of-a-kind, "instant" color photograph, such as a Polaroid print. The process uses a film pack that includes up to thirty different layers. The film pack is ejected from the camera immediately after exposure, breaking open a pod of chemistry that begins the development process. Chemicals and dyes migrate precisely between layers to create the full-color image. Internal dye diffusion prints are favored for the instant results they provide and for the way an image can be manipulated by physical pressure due to its malleability during the development process.

Silver-dye bleach print

Silver-dye bleach prints, such as Cibachrome, differ from chromogenic prints in that the dyes are fully formed in the paper at the outset. Processing therefore entails selective removal of unwanted dye, rather than the formation of new dyes during development. Initially this material, sometimes called dye destruction, was available only on a paper with a very hard glossy surface, which limited its popularity. But when a softer, more matte finish paper was marketed, the process was adopted by many photographers with an appreciation for its clarity and permanence.

Tear sheet

This term refers to a page cut or torn from a publication to prove to an advertising agency client that the advertisement was published. The publishers of any periodical are legally required to provide a tear sheet upon request of any advertiser.

EXHIBITION CHECKLIST

ANONYMOUS
American, 20th century
[Three Women in Winter Setting], 1907–15
Stereographic autochrome facsimile
2 ¼ x 5 ⅛ in.
Original in the collection of the Milwaukee
Art Museum, Gift of John Angelos,
M2008.92
Page 16

Ansel ADAMS
American, 1902–1984
"Ansel Adams' America . . . in Kodak
Color," *Popular Photography*, March 1948
Publication
11 ¼ x 16 ½ in. open
Private Collection
Reproduction photographs by John R. Glembin
Used with permission of Kodak
Images © 2012 The Ansel Adams
Publishing Rights Trust
Pages 128–29

Zabriskie Point, Death Valley, CA, ca. 1959
Color transparency (Colorama facsimile)
108 x 270 in. (original 216 x 710 in.)
Original image in the collection
of George Eastman House
Courtesy of George Eastman House,
International Museum of Photography and Film
© 2012 The Ansel Adams Publishing
Rights Trust
Pages 130–31

Church at Ranchos de Taos, ca. 1947
Dye imbibition print, printed 1972
13 ⅝ x 19 ⅝ in.
Museum of Fine Arts, Houston;
The Manfred Heiting Collection
© 2012 The Ansel Adams Publishing
Rights Trust
Page 127

John BALDESSARI
American, b. 1931
Floating: Color, 1972
Six archival inkjet prints
(exhibition copy, 2009)
14 x 11 in. each
Courtesy of John Baldessari and
Marian Goodman Gallery, New York
Pages 182–83

Anton BRUEHL
American, b. Australia, 1900–1982
Cover of *House & Garden*, July 1, 1932
Publication
12 ¾ x 9 ¾ in.
Condé Nast Archive
© Condé Nast
Page 59

Cover of *Vanity Fair*, March 1, 1933
Publication
12 ¾ x 9 ¾ in.
Condé Nast Archive
© Condé Nast
Page 61

Four Roses Whiskey Advertisement, 1939
Color photomechanical reproduction
13 ⅞ x 11 in.
Private Collection
Reproduction photograph by John R. Glembin
Page 60

Bruehl-Bourges
"From American Looms," *Vogue*,
September 1, 1932
Publication
12 ¾ x 19 ½ in. open
Condé Nast Archive
© Condé Nast
Page 62

Bruehl-Bourges
"A Page of Presents for Many Purses" and
"For Brilliant Gifts," *Vogue*, December 1, 1932
Publication
12 ¾ x 19 ½ in. open
Condé Nast Archive
© Condé Nast
Page 60

Color Sells, 1935
Publication
15 x 12 in. closed
Condé Nast Archive
© Condé Nast
Pages vi and 58

Harlem Number, 1943
Carbro print
18 x 14 ⁵⁄₁₆ in.
Anton Bruehl, Jr.
© Anton Bruehl Trust
Page 63

Larry BURROWS
English, 1926–1971
Reaching Out, South Vietnam, 1966
Dye imbibition print, printed October 1998
21 ¾ x 30 in.
Milwaukee Art Museum, Gift of Photography
Council, M1998.225
Reproduction photograph by John R. Glembin
© Larry Burrows Collection
Page 107

"Marines Blunt the Invasion from the North,"
Life, October 28, 1966
Publication
14 x 21 in. open
Private Collection
Reproduction photograph by John R. Glembin
Permission courtesy of Larry Burrows/Life
Magazine, © Time Inc./Time Life Pictures/
Getty Images
Image: Larry Burrows, LIFE, © Time Inc.
Page 106

"Invasion DMZ Runs into the Marines,"
Life, October 28, 1966
Publication
14 x 10 ½ in.
Milwaukee Art Museum, George Peckham
Miller Art Research Library
Reproduction photograph by John R. Glembin
Permission courtesy of Larry Burrows/Life
Magazine, © Time Inc./Time Life Pictures/
Getty Images
Image: Larry Burrows, LIFE, © Time Inc.
Page 106

Harry CALLAHAN
American, 1912–1999
Abstraction, 1943–47
Silver-dye bleach print
9 ⅜ x 7 ½ in.
The Museum of Modern Art, New York
Gift of the photographer
Licensed by SCALA/Art Resource, NY
© The Estate of Harry Callahan
Permission courtesy of Pace/MacGill Gallery,
New York
Page 115

Detroit, 1951
Chromogenic print, printed 1981
8 ¾ x 13 ⅜ in.
James and Dorothy Stadler
Reproduction photograph by John R. Glembin
© The Estate of Harry Callahan
Permission courtesy of Pace/MacGill Gallery,
New York
Page 117

William CHRISTENBERRY
American, b. 1936
Church, Sprott, Alabama, 1971
Chromogenic print
3 ⅛ x 4 ¹³/₁₆ in.
The Museum of Modern Art, New York
David H. McAlpin Fund
Licensed by SCALA/Art Resource, NY
© William Christenberry
Permission courtesy of Pace/MacGill Gallery,
New York
Page 178

*Corn Sign with Storm Cloud, Near Greensboro,
Alabama*, 1977
Chromogenic print
3 ⅛ x 4 ¹³/₁₆ in.
Museum of Fine Arts, Houston; Gift of Betty
Moody in honor of Clinton T. Willour on
the occasion of his receiving the Legend
Award from the Dallas Visual Arts Center
© William Christenberry
Permission courtesy of Pace/MacGill Gallery,
New York
Page 179

*Window of Palmist Building—Havana,
Alabama*, 1980
Chromogenic print, printed 1981
17 ⅜ x 21 ⅞ in.
Milwaukee Art Museum, Gift of Martha
Winter Gross, M1983.295
Reproduction photograph by John R. Glembin
© William Christenberry
Permission courtesy of Pace/MacGill Gallery,
New York
Page 177

Fred Payne CLATWORTHY
American, 1875–1953
Sunset, ca. 1915
Autochrome facsimile
5 x 7 in.
Original in the collection of Mark Jacobs
Reproduction photograph by John R. Glembin
Page 40

*And Huge Aerial Palaces Arise, Like Mountains
Built of Unconsuming Flame*, ca. 1924
Autochrome facsimile
5 x 7 in.
Original in the collection of Mark Jacobs
Reproduction photograph by John R. Glembin
Page 39

John COLLIER
American, 1913–1992
*Low flying planes from which dust or insecticide
is spread onto crops by men who "follow the
season" up the east coast, Seabrook Farm,
Bridgeton, N.J.*, June 1942
*Cultivating a Field, Seabrook Farm, Bridgeton,
N.J.*, June 1942
Bean fields, Seabrook Farm, Bridgeton, N.J.,
June 1942
Page 96

*Part of string bean factory and field system,
Seabrook Farm, Bridgeton, N.J.*, June 1942
Mountains in northern New Mexico, ca. 1943

Color transparencies converted to digital files
Library of Congress, Prints & Photographs
Division, FSA-OWI Collection,
LC-USF35-559, LC-USF35-552,
LC-USF35-555, LC-USF35-557,
LC-USF35-938

Marie COSINDAS
American, b. 1925
Still Life, 1962-63
Dye diffusion transfer print
3 ¹¹/₁₆ x 2 ⅞ in.
Museum of Fine Arts, Houston;
Gift of Manfred Heiting,
The Manfred Heiting Collection
© Marie Cosindas
Page 169

Dolls, Boston, 1966
Dye imbibition print
9 ⅞ x 7 ⅝ in.
Milwaukee Art Museum, Purchase,
Richard and Ethel Herzfeld Foundation
Acquisition Fund, M2011.24
Reproduction photograph by John R. Glembin
© Marie Cosindas
Page 169

Louise DAHL-WOLFE
American, 1895–1989
[Red/green Dress, *Harper's Bazaar*],
January 1938
Color proof
10 x 8 in.
Lent by The Museum at the Fashion
Institute of Technology, New York,
Gift of Louise Dahl-Wolfe
© The Museum at FIT
Page 81

[Grey Gown and Cape, *Harper's Bazaar*],
January 1940
Color proof
10 x 8 in.
Lent by The Museum at the Fashion
Institute of Technology, New York,
Gift of Louise Dahl-Wolfe
© The Museum at FIT
Page 82

[Blue Coat with Hood, *Harper's Bazaar*],
January 1940
Color proof
10 x 8 in.
Lent by The Museum at the Fashion
Institute of Technology, New York,
Gift of Louise Dahl-Wolfe
© The Museum at FIT
Page 82

[Light Blue Open-back Turban with Dark
Blue Bow, *Harper's Bazaar*], June 1941
Color proof
10 x 8 in.
Lent by The Museum at the Fashion
Institute of Technology, New York,
Gift of Louise Dahl-Wolfe
© The Museum at FIT
Page 83

Jack DELANO
American, b. Russia, 1914–1997
A view of the old sea town, Stonington, Conn.,
November 1940
*Brockton, Mass., Dec. 1940, second-hand plumbing
store*, December 1940
*Commuters, who have just come off the train,
waiting for the bus to go home, Lowell, Mass.*,
January 1941
*At the Vermont state fair, Rutland [Man and
Truck]*, September 1941
At the Vermont state fair, Rutland, September
1941
Page 95

Color transparencies converted to digital files
Library of Congress, Prints & Photographs
Division, FSA-OWI Collection,
LC-USF35-28, LC-USF35-3,
LC-USF35-1, LC-USF35-40,
LC-USF35-54

Philip-Lorca DiCORCIA
American, b. 1951
Mario, 1978
Chromogenic print
9 ½ x 13 ½ in.
Courtesy of the artist and David Zwirner,
New York
Page 217

Ivan DMITRI
American, 1900–1968
"Speaking of Pictures . . . These Are
Kodachromes," *Life*, April 1, 1940
Publication
14 x 21 in. open
Private Collection
Reproduction photograph by John R. Glembin
© 1940 The Picture Collection Inc.
Reprinted with permission. All rights reserved.
Page 90

William EGGLESTON
American, b. 1939
Halloween, Morton, Mississippi, 1970
Dye imbibition print
11 ⅞ x 17 ¹¹/₁₆ in.
Restricted gift of the Society for Contemporary
Art, 1979.446, The Art Institute of Chicago
© Eggleston Artistic Trust
Permission courtesy of Cheim & Read,
New York
Page 174

Sumner, Mississippi, ca. 1972
Dye imbibition print, printed 1986
10 ⅞ x 16 ¹⁵/₁₆ in.
Milwaukee Art Museum, Richard
and Ethel Herzfeld Collection, M1991.197,
Reproduction photograph by Efraim Lev-er
© Eggleston Artistic Trust
Permission courtesy of Cheim & Read,
New York
Page 174

Greenwood, Mississippi, 1973
Dye imbibition print
12 ⅝ x 19 ¹/₁₆ in.
The Museum of Modern Art, New York
Gift of the photographer
Licensed by SCALA/Art Resource, NY
© Eggleston Artistic Trust
Permission courtesy of Cheim & Read,
New York
Page 173

Huntsville, Alabama, 1978
Dye imbibition print, printed later
18 ¼ x 12 ¾ in.
Milwaukee Art Museum, Richard
and Ethel Herzfeld Collection, M1991.198
Reproduction photograph by Efraim Lev-er
© Eggleston Artistic Trust
Permission courtesy of Cheim & Read,
New York
Page 175

William Eggleston's Guide by William
Eggleston and John Szarkowski, 1976
Publication (Museum of Modern Art,
New York)
9 ¼ x 9 ¼ in. closed
Milwaukee Art Museum George Peckham
Miller Art Research Library
© 1976 The Museum of Modern Art
Licensed by SCALA/Art Resource, NY
Image © Eggleston Artistic Trust
Permission courtesy of Cheim & Read,
New York
Page 165

Eliot ELISOFON
American, 1911–1973
Cover of *Life*, July 7, 1941
Publication
14 x 10 ½ in. closed
Private Collection
© 1941 The Picture Collection Inc.
Reprinted with permission. All rights reserved.
Permission courtesy of Eliot Elisofon/*Life*
Magazine, © Time Inc./Time Life Pictures/
Getty Images
Page 101

"Voyages to Paradise: A Camera in South
Seas Seeks Famous Scenes in Literature,"
Life, January 24, 1955
Publication
14 x 21 in. open
Private Collection
© 1955 The Picture Collection Inc.
Reprinted with permission. All rights reserved.
Permission courtesy of Eliot Elisofon/*Life*
Magazine, © Time Inc./Time Life Pictures/
Getty Images
Page 102

Roddy McDowall as "Ariel," 1957
Dye imbibition print
19 ¹⁵/₁₆ x 14 ¾ in.
The Museum of Modern Art, New York
Gift of the photographer
Licensed by SCALA/Art Resource, NY
Permission courtesy of Eliot Elisofon/Time
Life Pictures/Getty Images
Page 105

"Eleven Fine Actors Get Their Dream Roles – Stars Create for LIFE Scenes They Would Like To Do: Roddy McDowall in the 'Tempest,'" *Life*, April 14, 1958
Publication
14 x 21 in. open
Private Collection
© 1958 The Picture Collection Inc.
Reprinted with permission. All rights reserved.
Permission courtesy of Eliot Elisofon/Life Magazine, © Time Inc./Time Life Pictures/Getty Images
Page 104

Walker EVANS
American, 1903–1975
"Along the Right-of-Way," *Fortune*, September 1950
Publication
13 x 20 in. open
Private Collection
Reproduction photographs by John R. Glembin
© September 1950 Time Inc.
Used under license.
Images © Walker Evans Archive, The Metropolitan Museum of Art
Pages 134–35

West Street, Dead End (Sign Detail), 1973–74
Internal dye diffusion transfer print
3 $\frac{1}{16}$ x 3 $\frac{1}{8}$ in.
Mary and Leigh Block Endowment, 1993.356, The Art Institute of Chicago
© Walker Evans Archive, The Metropolitan Museum of Art
Page 133

Going Out of Business IV, 1974
Internal dye diffusion transfer print
3 $\frac{1}{16}$ x 3 $\frac{1}{8}$ in.
Arnold H. Crane Endowment, 1993.357, The Art Institute of Chicago
© Walker Evans Archive, The Metropolitan Museum of Art
Page 133

Andreas FEININGER
American, 1906–1999
"Cape Cod Art Schools," *Life*, July 28, 1947
Publication
14 x 21 in. open
Private Collection
© 1947 The Picture Collection Inc.
Reprinted with permission. All rights reserved.
Permission courtesy of Andreas Feininger/Time & Life Pictures/Getty Images
Page 103

Arnold GENTHE
American, 1869–1942
Poppies, 1912
Autochrome facsimile
4 x 5 in.
Original in the collection of George Eastman House
Courtesy of George Eastman House, International Museum of Photography and Film
Page 37

Nan GOLDIN
American, b. 1953
The Ballad of Sexual Dependency, 1979–2001
Multimedia installation including 720 35 mm color slides, running time 43:00 minutes
Through prior bequest of Marguerita S. Ritman; restricted gift of Dorie Sternberg, the Photography Associates, Mary L. and Leigh B. Block Endowment, Robert and Joan Feitler, Anstiss and Ronald Krueck, Karen and Jim Frank, Martin and Danielle Zimmerman, 2006.158, The Art Institute of Chicago
© Nan Goldin, Courtesy of Matthew Marks Gallery
Pages 227–29

Fritz GORO
American, b. Germany, 1901–1986
"The Simplest Atoms: Photo-Models Show Their Inner Structure," *Life*, May 16, 1949
Publication
14 x 21 in. open
Private Collection
© 1949 The Picture Collection Inc.
Reprinted with permission. All rights reserved.
Permission courtesy of Fritz Goro/Time & Life Pictures/Getty Images
Page 102

Jan GROOVER
American, 1943–2012
Untitled, 1977
Three chromogenic prints
15 x 15 in. each
The Collection of James and Janet Kloppenburg
Permission courtesy of Janet Borden, Inc.
Page 202

Untitled, 1978
Chromogenic print
14 $\frac{13}{16}$ x 19 $\frac{1}{16}$ in.
The Museum of Modern Art, New York. Richard E. and Christie Calder Salomon Fund
Licensed by SCALA/Art Resource, NY
Permission courtesy of Janet Borden, Inc.
Page 201

Untitled, 1979
Chromogenic print
14 $\frac{3}{4}$ x 18 $\frac{3}{4}$ in.
The Museum of Modern Art, New York. Lois and Bruce Zenkel Fund
Licensed by SCALA/Art Resource, NY
Permission courtesy of Janet Borden, Inc.
Page 203

Ernst HAAS
American, b. Austria 1921–1986
New York (Reflections in Water on Street), 1949–53
Dye imbibition print
13 $\frac{5}{8}$ x 9 $\frac{5}{8}$ in.
The Museum of Modern Art, New York
Gift of Leo Pavelle
Licensed by SCALA/Art Resource, NY
Permission courtesy of Ernst Haas/Ernst Haas/Getty Images
Page 147

New York (Two Men on Sidewalk), 1949–53
Dye imbibition print
13 $\frac{3}{4}$ x 9 $\frac{15}{16}$ in.
The Museum of Modern Art, New York
Gift of Leo Pavelle
Licensed by SCALA/Art Resource, NY
Permission courtesy of Ernst Haas/Ernst Haas/Getty Images
Page 149

New York (Mirror), 1949–53
Dye imbibition print
13 $\frac{7}{16}$ x 9 $\frac{1}{2}$ in.
The Museum of Modern Art, New York
Gift of Leo Pavelle
Licensed by SCALA/Art Resource, NY
Permission courtesy of Ernst Haas/Ernst Haas/Getty Images
Page 147

"Images of a Magic City, Part I," *Life*,
September 14, 1953
Publication
14 x 21 in. open
Private Collection
Reproduction photograph by John R. Glembin
© 1953 The Picture Collection Inc.
Reprinted with permission. All rights reserved.
Image permission courtesy of Ernst Haas/
Ernst Haas/Getty Images
Page 148

"Images of a Magic City, Part II," *Life*,
September 21, 1953
Publication
14 x 21 in. open
Private Collection
Reproduction photograph by John R. Glembin
© 1953 The Picture Collection Inc.
Reprinted with permission. All rights reserved.
Image permission courtesy of Ernst Haas/
Ernst Haas/Getty Images
Page 148

Robert HEINECKEN
American, 1931–2006
She: My friend tells me that you are a
photographer, 1981
Dye diffusion transfer print and graphite
on paper
20 x 16 in.
Milwaukee Art Museum, Purchase, Richard
and Ethel Herzfeld Foundation Acquisition
Fund, M2004.576
Reproduction photograph by John R. Glembin
Permission courtesy of Rhona Hoffman
Gallery and The Robert Heinecken Trust
Page 233

Hy HIRSH
American, 1911–1961
Untitled, ca. 1950
Chromogenic print
9 7/8 x 7 7/8 in.
Milwaukee Art Museum, Purchase, Richard
and Ethel Herzfeld Foundation Acquisition
Fund, M2010.46
Reproduction photograph by John R. Glembin
Permission courtesy of the Estate of Hy Hirsh
Page 141

Come Closer, 1952
16 mm film transferred to DVD
Angeline Pike and the Iota Center
Courtesy of Angeline Pike-Creative Film Society
Page 141

Evelyn HOFER
American, b. Germany 1922–2009
New York Proclaimed by V. S. Pritchard, 1964
Publication (Harcourt, Brace & World, Inc.)
11 1/4 x 18 1/4 in. open
Milwaukee Art Museum George Peckham
Miller Art Research Library
Reproduction photograph by John R. Glembin
© Estate of Evelyn Hofer
Page 166

HOLLYWOOD
Universal Studios
The Phantom of the Opera, 1925
35 mm film clip, transferred to DVD,
1:59 minutes
Private Collection
Page 66

Universal Pictures
Technicolor Fashion Parade, 1928
35 mm film clip, transferred to DVD,
0:22 minutes
Courtesy of Lobster Films,
France Pioneer Pictures

Promotional Trailer for *Becky Sharp*, 1935
35 mm film clip, transferred to DVD,
0:38 minutes
Rouben Mamoulian, Courtesy
of Lobster Films, France
Page 67

Metro-Goldwyn-Mayer
Starlit Days at the Lido, 1935
35 mm film clip, transferred to DVD,
0:45 minutes
© Warner Bros. Entertainment INC.

Metro-Goldwyn-Mayer
Wizard of Oz, 1939
35 mm film clip, transferred to DVD,
0:41 minutes
© Warner Bros. Entertainment INC.
Page 65

Kenneth JOSEPHSON
American, b. 1932
Tennessee, 1979
Internal dye diffusion
transfer print
3 1/8 x 3 1/16 in.
Gift of Jeanne and Richard S. Press,
1998.590, The Art Institute of Chicago
© Kenneth Josephson/Higher Pictures
Page 231

Barbara KASTEN
American, b. 1936
Construct I-A, 1979
Internal dye diffusion transfer print
8 x 10 in.
Lent by the artist
Courtesy of the artist and Bortolami,
New York
Page 236

Construct PC 1-B, 1981
Internal dye diffusion transfer print
20 x 24 in.
Lent by the artist
Courtesy of the artist and Bortolami,
New York
Page 237

Construct XI-B, 1981
Internal dye diffusion transfer print
10 x 8 in.
Lent by the artist
Courtesy of the artist and Bortolami,
New York
Page 235

Victor KEPPLER
American, 1904–1987
Cover of the *Saturday Evening Post*,
March 6, 1937
Publication
13 5/8 x 10 1/2 in. closed
Private Collection
Reproduction photograph by John R. Glembin
© SEPS. Licensed by Curtis Licensing
Page 72

A Life of Color Photography:
The Eighth Art, 1938
Publication (W. Morrow & Company)
12 5/16 x 20 in. open
Milwaukee Art Museum George Peckham
Miller Art Research Library
Reproduction photograph by John R. Glembin
Courtesy of George Eastman House,
International Museum of Photography and Film
Page 74

[General Mills Ad Campaign –
Apple PyeQuick], 1947
Carbro print
18 7/8 x 14 11/16 in.
Collection of George Eastman House
(Gift of the photographer)
Courtesy of George Eastman House,
International Museum of Photography and Film
Page 75

[General Mills Ad Campaign –
Apple PyeQuick], ca. 1947
Tear sheet
7 1/2 x 9 7/16 in.
Collection of George Eastman House
(Gift of Victor Keppler)
Courtesy of George Eastman House,
International Museumof Photography
and Film
Page 74

[Camel Cigarettes Ad Campaign,
Woman in Red Convertible], May 1951
Carbro print
12 3/8 x 18 3/8 in.
Collection of George Eastman House
(Gift of 3M Foundation; ex-collection
of Louis Walton Sipley)
Courtesy of George Eastman House,
International Museum of Photography
and Film
Page 73

Franklin PRICE KNOTT
American, 1852–1930
"The Land of the Best: A Tribute to
the Scenic Grandeur and Unsurpassed
Natural Resources of Our Own Country,"
National Geographic, April 1916
Publication (two copies)
10 x 14 in. open
Private Collection
Reproduction photographs by John R. Glembin
Pages 42–43

KODAK
Kodachrome Film Advertisement
[Sunbathing Woman], 1939
Tear sheet
10 1/5 x 7 in.
Collection of George Eastman House
(Gift of Eastman Kodak Company)
Reproduction photograph by John R. Glembin
Used with permission of Kodak
Page 89

Kodachrome Film Advertisement
[Horseback Couple], 1940
Tear sheet
10 3/4 x 7 in.
Collection of George Eastman House
(Gift of Eastman Kodak Company)
Reproduction photograph by John R. Glembin
Used with permission of Kodak
Page x

Kodachrome Film Advertisement:
"Tune in to Color with a Miniature Camera,"
August 1941
Color photomechanical reproduction
10 x 6 3/4 in.
Private Collection
Reproduction photograph by John R. Glembin
Used with permission of Kodak
Page 90

Kodachrome Film Advertisement:
"Full-Color Snapshots with Your Brownie
or Kodak," June 1943
Color photomechanical reproduction
10 x 6 5/8 in.
Private Collection
Reproduction photograph by John R. Glembin
Used with permission of Kodak
Page 92

Kodacolor Film Advertisement:
"Kodacolor Snapshots Will Bring
Home Doubly Near," October 1945
Color photomechanical reproduction
10 x 6 5/8 in.
Private Collection
Reproduction photograph by John R. Glembin
Used with permission of Kodak
Page 92

Kodachrome Film Advertisement:
"Full-Color Pictures with Your Miniature
Camera," 1946
Color photomechanical reproduction
11 1/8 x 7 15/16 in.
Private Collection
Reproduction photograph by John R. Glembin
Used with permission of Kodak
Page 20

Kodacolor Film Advertisement:
"Now . . . You and Your Camera Can Get
Color Like This," 1946
Color photomechanical reproduction
14 x 10 in.
Private Collection
Reproduction photograph by John R. Glembin
Used with permission of Kodak
Page 91

Kodachrome Film Advertisement:
"Double Reward from Kodachrome Film
in Your Miniature Camera," 1948
Color photomechanical reproduction
10 x 6 3/8 in.
Private Collection
Reproduction photograph by John R. Glembin
Used with permission of Kodak
Page 93

Syl LABROT
American, 1929–1977
Burlap: Close-up study #9, 1956
Dye imbibition print
14 3/8 x 18 9/16 in.
The Museum of Modern Art, New York
Purchase
Licensed by SCALA/Art Resource, NY
Permission courtesy of Visual Studies
Workshop, Rochester, NY
Page 152

Untitled, 1958
Dye imbibition print
12 9/16 x 17 13/16 in.
The Museum of Modern Art, New York
Purchase
Licensed by SCALA/Art Resource, NY
Permission courtesy of Visual Studies
Workshop, Rochester, NY
Page 153

Untitled [hinge on steel painted red], ca. 1960
Dye imbibition print
10 7/8 x 14 3/8 in.
Visual Studies Workshop
Courtesy of Visual Studies Workshop,
Rochester, NY
Page 153

Untitled [wheat], ca. 1960
Dye imbibition print
13 x 16 1/16 in.
Visual Studies Workshop
Courtesy of Visual Studies Workshop,
Rochester, NY
Page 151

Russell LEE
American, 1903–1986
*Faro and Doris Caudill, homesteaders,
Pie Town, New Mexico*, October 1940
*Filling station and garage at Pie Town,
New Mexico*, October 1940
Delta County Fair, Colorado [Ferris wheel],
October 1940
On main street of Cascade, Idaho, July 1941
*Hauling crates of peaches from the orchard
to the shipping shed, Delta County, Colo.*,
September 1941
Page 97

Color transparencies converted to digital files
Library of Congress, Prints & Photographs
Division, FSA-OWI Collection,
LC-USF35-317, LC-USF35-328,
LC-USF35-259, LC-USF35-212,
LC-USF35-230

Saul LEITER
American, b. 1923
Shoeshine Man, 1950
Blue Door, Paterson, New Jersey, ca. 1950s
Dumpster, ca. 1950s
Greenlight Against Grey, ca. 1950s
Palm Trees, ca. 1950s
Barbershop, 1951
Dog in Doorway, Paterson, 1952
Don't Walk, 1952
Foot on El, 1954
Near the Tanager, 1954
Seeds, 1954
Sign Painter, 1954
Bus, ca. 1955, Page 137
Through Boards, 1957, Page 139
Window, 1957, Page 138
Canopy, 1958
Snow Scene, 1958
Street Scene, New York, 1958
Walk with Soames, 1958, Page 138
Harlem (House), 1960
Twenty 35 mm color slides
Howard Greenberg Gallery, New York
© Saul Leiter, Courtesy of Howard
Greenberg Gallery, New York

Helen LEVITT
American, 1913–2009
Projects: Helen Levitt in Color,
The Museum of Modern Art, 1974
Forty 35 mm color slides
Estate of Helen Levitt
© Estate of Helen Levitt
Pages 161–63

Susan MEISELAS
American, b. 1948
Awaiting Counter Attack by the Guard
in Matagalpa, Nicaragua, 1978–79
Silver-dye bleach print
12 15/16 x 19 1/2 in.
National Endowment for the Arts Museum
Purchase Grant, 1989.114, The Art Institute
of Chicago
© Susan Meiselas/Magnum Photos
Page 225

Marketplace in Diriamba, Nicaragua, 1978–79
Silver-dye bleach print
12 13/16 x 15 7/16 in.
National Endowment for the Arts Museum
Purchase Grant, 1989.113, The Art Institute
of Chicago
© Susan Meiselas/Magnum Photos
Page 223

Nicaragua: June 1978–July 1979 by Susan
Meiselas and Claire Rosenberg (Editor), 1981
Publication (Pantheon Books)
8 3/4 x 11 1/2 in. closed
Milwaukee Art Museum, George Peckham
Miller Art Research Library
Reproduction photograph by John R. Glembin
© Susan Meiselas/Magnum Photos
Page 222

Joel MEYEROWITZ
American, b. 1938
Hartwig House, Truro, Cape Cod, 1976
Chromogenic print, printed 1979
15 3/8 x 19 1/2 in.
Restricted gift of the Society for Contemporary
Art, 1979.442, The Art Institute of Chicago
© Joel Meyerowitz
Permission courtesy of Edwynn Houk Gallery,
New York
Page 206

Roseville Cottages, Truro, 1976
Chromogenic print, printed 1977
16 x 20 in.
Christine A. Symchych
Reproduction photograph by John R. Glembin
© Joel Meyerowitz
Permission courtesy of Edwynn Houk Gallery,
New York
Page 207

Red Interior, Provincetown, 1977
Chromogenic print, printed 1985
18 9/16 x 23 3/8 in.
Milwaukee Art Museum, Purchase, with
funds fromChristine A. Symchych M2010.44
Reproduction photograph by John R. Glembin
© Joel Meyerowitz
Permission courtesy of Edwynn Houk Gallery,
New York
Page 205

Porch, Provincetown, 1977
Chromogenic print, printed 1978
10 x 8 in.
Christine A. Symchych
Reproduction photograph by John R. Glembin
© Joel Meyerowitz
Permission courtesy of Edwynn Houk Gallery,
New York
Page 209

Cape Light, 1978
Publication (Museum of Fine Arts, Boston)
9 1/4 x 21 5/16 in. open
Milwaukee Art Museum George Peckham
Miller Art Research Library
Reproduction photograph by John R. Glembin
© 2012 Museum of Fine Arts, Boston
Reproduced by permission.
Image © Joel Meyerowitz
Permission courtesy of Edwynn Houk Gallery,
New York
Page 167

László MOHOLY-NAGY
American, b. Hungary, 1895–1946
Study with Pins and Ribbons, 1937–38
Carbro print
13 3/4 x 10 7/16 in.
Collection of George Eastman House
(Gift of Eastman Kodak Company)
© 2012 Artists Rights Society (ARS),
New York/VG Bild-Kunst, Bonn
Page 85

Group Portrait with László Moholy-Nagy,
1937-40
Auto Headlights (White, orange, and red traffic
squiggles), Chicago, 1937-46
Light Painting (Red, yellow, white light
segments), 1937-46
Night-time Traffic (Pink, orange, and blue traffic
stream), Chicago, 1937-46
Page 87

Traffic (City Lights–Eastgate Hotel),
Chicago, 1937-46
Rooftop Parking, 1938-40
Page 86

New York World's Fair, 1939
Neon Signs, Chicago, 1939
Sibyl Moholy-Nagy on Oak Street Beach,
Chicago #1, 1939
Park Scene in Front of the Medicine & Public
Health-Pavilion, New York World's Fair,
1939/40
Rope Still Life, NY Fair (Brazil), 1939/40
Student Class at Somonauk Summer School,
1939-42
3 Shots of Traffic Lights, 1939-46
3 People Walking with Flashlights, 1939-46
New York Billboard Detail, 1940
Light Box Study, School of Design,
Chicago, ca. 1940s
Light Painting #1 (Colored reflections cast
by a light machine), Chicago, 1942-44
Page 87

*Light Painting #2 (Colored reflections
cast by a light machine), Chicago*, 1942-44
*Light Painting #3 (Colored reflections
cast by a light machine), Chicago*, 1942-44
*Light Painting #4 (Colored reflections
cast by a light machine), Chicago*, 1942-44
Twenty 35 mm color slides
Hattula Moholy-Nagy
© 2012 Artists Rights Society (ARS),
New York/VG Bild-Kunst, Bonn

**Nickolas MURAY
American, 1892–1965**
*Bathing Pool Scene, Ladies' Home Journal
(left half)*, 1931
Carbro print
9 ⁵/₁₆ x 9 ½ in.
Collection of George Eastman House
(Gift of Mrs. Nickolas Muray)
© Nickolas Muray Photo Archives,
Courtesy of George Eastman House,
International Museum of Photography and Film
Originally published in the June 1931
issue of *Ladies' Home Journal* ® magazine
Page 56

*Bathing Pool Scene, Ladies' Home Journal
(right half)*, 1931
Carbro print
9 ⁵/₁₆ x 11 ¼ in.
Collection of George Eastman House
(Gift of Mrs. Nickolas Muray)
© Nickolas Muray Photo Archives,
Courtesy of George Eastman House,
International Museum of Photography and Film
Originally published in the June 1931
issue of *Ladies' Home Journal* ® magazine
Page 57

"Diverting Beach Days in Divers
Colorful Ways," *Ladies' Home Journal*,
June 1931
Publication
14 x 21 in. open
Private Collection
Reproduction photograph by John R. Glembin
© Nickolas Muray Photo Archives,
Courtesy of George Eastman House,
International Museum of Photography and Film
Originally published in the June 1931
issue of *Ladies' Home Journal* ® magazine
Page 55

Christmas Cakes and Cookies, ca. 1935
Carbro print
14 ½ x 22 ⁵/₁₆ in.
Collection of George Eastman House
(Gift of Mrs. Nickolas Muray)
© Nickolas Muray Photo Archives,
Courtesy of George Eastman House,
International Museum of Photography
and Film
Page 54

Seabrook Farms, Creamed Onions, ca. 1950
Dye imbibition print
6 ⁹/₁₆ x 7 ⁹/₁₆ in.
Collection of George Eastman House
(Gift of Mrs. Nickolas Muray)
© Nickolas Muray Photo Archives,
Courtesy of George Eastman House,
International Museum of Photography
and Film
Page 53

**Helen Messinger MURDOCH
American, 1862–1956**
[Garden], ca. 1911
Autochrome facsimile
6 ½ x 8 ½ in.
Original in the collection of Mark Jacobs
Reproduction photograph by John R. Glembin

[Ceylon], 1914
Autochrome facsimile with diascope
6 ½ x 8 ½ in.
Original in the collection of Mark Jacobs
Reproduction photograph by John R. Glembin
Page 41

**Bruce NAUMAN
American, b. 1941**
*Self Portrait as a Fountain
(from the portfolio Eleven Color Photographs)*,
1966–67/1970/2007
Ink-jet print exhibition copy
(originally chromogenic print)
19 ⁷/₈ x 23 ¾ in.
Collection Museum of Contemporary Art
Chicago, Gerald S. Elliott Collection,
1994.1.k
© 2012 Bruce Nauman/Artists Rights Society
(ARS), New York
Page 171

**Paul OUTERBRIDGE, JR.
American, 1896–1958**
Avocado Pears, 1936
Carbro print
10 x 15 ⁵/₈ in.
The Museum of Modern Art, New York
Gift of Mrs. Ralph Seward Allen
Licensed by SCALA/Art Resource, NY
Paul Outerbridge, Jr.; © 2012 G. Ray
Hawkins Gallery, Beverly Hills, CA
Page 69

Images de Deauville, 1936
Carbro print
15 ¾ x 12 ¼ in.
The Museum of Modern Art, New York
Gift of Mrs. Ralph Seward Allen
Licensed by SCALA/Art Resource, NY
Paul Outerbridge, Jr.; © 2012 G. Ray
Hawkins Gallery, Beverly Hills, CA
Page 71

Eight O'Clock Coffee Advertisement,
November, 1940
Color photomechanical reproduction
14 x 10 ¼ in.
Private Collection
Reproduction photograph by John R. Glembin
Paul Outerbridge, Jr.; © 2012 G. Ray
Hawkins Gallery, Beverly Hills, CA
Page 70

Photographing in Color, 1940
Publication (Random House)
11 ¾ x 18 in. open
Milwaukee Art Museum George Peckham
Miller Art Research Library

**Irving PENN
American, 1917–2009**
Summer Sleep, New York, 1949
Dye imbibition print, printed ca. 1959
16 ¹³/₁₆ x 22 ¹¹/₁₆ in.
The Museum of Modern Art, New York
Gift of the photographer
Licensed by SCALA/ArtResource, NY
Copyright © 1949 (renewed 1977)
Condé Nast Publications Inc.
Page 121

Two Liqueurs, New York, 1951
Dye imbibition print
18 ¼ x 15 ⅜ in.
The Museum of Modern Art, New York
Gift of the photographer
Licensed by SCALA/Art Resource, NY
Copyright © 1951 (renewed 1979)
Condé Nast Publications Inc.
Page 119

John PFAHL
American, b. 1939
Music 1, Ellicottville, New York, 1974
Dye imbibition print
7 ¹⁵/₁₆ x 10 ⅛ in.
Gift Jack A. Jaffe, 1997.811,
The Art Institute of Chicago Permission
courtesy of Janet Borden, Inc.
Page 191

Big Dipper, Charlotte, North Carolina, 1976
Dye imbibition print
7 ⅝ x 10 ³/₁₆ in.
Gift of Jack A. Jaffe, 1997.793,
The Art Institute of Chicago
Permission courtesy of Janet Borden, Inc.
Page 193

Eliot PORTER
American, 1901–1990
Hooded Oriole, 1941
Dye imbibition print
7 ½ x 9 ¾ in.
The Museum of Modern Art, New York
Gift of the photographer
Licensed by SCALA/Art Resource, NY
© Amon Carter Museum of American Art,
Fort Worth, Texas
Page 111

Aspens, Twining, New Mexico, 1949
Dye imbibition print
10 ¾ x 8 ³/₁₆ in.
Restricted gift of Miss Louise Lutz, 1980.20,
The Art Institute of Chicago
© Amon Carter Museum of American Art,
Fort Worth, Texas
Page 113

Foxtail Grass, Lake City, Colorado, 1957
Dye imbibition print
10 ⅝ x 8 ⅛ in.
Milwaukee Art Museum,
Richard and Ethel Herzfeld Collection
M1992.246
Reproduction photograph by Efraim Le-ver
© 1990 Amon Carter Museum of American
Art, Fort Worth, Texas
Page 112

Arthur ROTHSTEIN
American, 1915–1985
*Woman at the community laundry on Saturday
afternoon, FSA ... camp, Robstown, Tex.*,
January 1942
Page 98

*Boys sitting on truck parked at the FSA . . .
labor camp, Robstown, Tex.*, January 1942
*Migratory worker, FSA . . . camp, Robstown,
Tex.*, January 1942
*[Boy] building a model airplane [as girl watches],
FSA . . . camp, Robstown, Tex.*, January 1942
*Families of migratory workers in front of their row
shelters, FSA . . . labor camp, Robstown, Tex.*,
January 1942
Color transparencies converted to digital files
Library of Congress,
Prints & Photographs Division, FSA-OWI
Collection, LC-USF35-297,
LC-USF35-301, LC-USF35-300,
LC-USF35-295, LC-USF35-290

Ed RUSCHA
American, b. 1937
Nine Swimming Pools and a Broken Glass, 1968
Publication (self-published)
7 ¹/₁₆ x 5 ½ in.
Visual Studies Workshop
Courtesy of Visual Studies Workshop,
Rochester, NY
Page 166

Lucas SAMARAS
American, b. 1936
Photo-Transformation, 1976
Internal dye diffusion transfer print
3 ⅛ x 3 ⅛ in.
Gift of Robert and Gayle Greenhill,
1991.984, The Art Institute of Chicago
© Lucas Samaras
Permission courtesy of The Pace Gallery
Page 199

George SEELEY
American, 1880–1955
[Red Bowls with Red Beads, Green Fabric],
1909
Autochrome facsimile
5 x 7 in.
Original in the collection of Mark Jacobs
Reproduction photograph by John R. Glembin
Page 35

Gerard SHEEDY
American, active 1930s
*A Monster's End. Burned to a Bare Skeleton
of Steel Lies Germany's Pride-of-the-Skies, the
Largest Airship Ever Built — and the Last, Very
Probably, Ever to Be Filled with Hydrogen*, May
6, 1937
Two dye imbibition prints
6 ⁵/₁₆ x 9 ¹/₁₆ in. each
Collection of George Eastman House
(Gift of Eastman Kodak Company)
Courtesy George Eastman House,
International Museum of Photography and Film
Page 78

*Death of a Giant: The Exclusive Colorphoto
Record of the Destruction of Hindenburg*, May
6, 1937
Color photomechanical reproduction
15 ½ x 22 ¹³/₁₆ in.
Collection of George Eastman House
(Gift of Dr. Walter Clark)
Courtesy of George Eastman House,
International Museum of Photography and Film
Page 79

First- and Only!, May 6, 1937
Color photomechanical reproduction
15 ⅜ x 22 ¹³/₁₆ in.
Collection of George Eastman House
(Gift of Dr. Walter Clark)
Courtesy of George Eastman House,
International Museum of Photography and Film
Page 77

Cindy SHERMAN
American, b. 1954
Untitled #77, 1980
Chromogenic print, printed ca. 2006
16 x 24 in.
Courtesy the artist and Metro Pictures,
New York
Page 239

Stephen SHORE
American, b. 1947
Room 125, West Bank Motel, Idaho Falls, Idaho, July 18, 1973
Chromogenic print
8 x 10 in.
Courtesy of the Farber Collection
Permission courtesy of 303 Gallery, New York
Page 186

Trail's End Restaurant, Kanab, Utah, August 10, 1973
Chromogenic print
8 x 10 in.
Courtesy of the Farber Collection
Permission courtesy of 303 Gallery, New York
Page 187

Presidio, Texas, February 21, 1975
Chromogenic print
8 x 10 in.
Christine A. Symchych
Reproduction photograph by John R. Glembin
Permission courtesy of 303 Gallery, New York
Page 189

Beverly Boulevard and La Brea Avenue, Los Angeles, California, June 21, 1975
Chromogenic print
11 15/16 x 15 1/16 in.
Milwaukee Art Museum, Purchase, Herzfeld Foundation Acquisition Fund M2011.36
Reproduction photograph by John R. Glembin
© 1975 Stephen Shore
Permission courtesy of 303 Gallery, New York
Page 185

Arthur S. SIEGEL
American, 1913–1978
State Street, Jewelry Shop, ca. 1940
Dye imbibition print
6 1/2 x 9 15/16 in.
Gift of Arthur Siegel, 1956.1071, The Art Institute of Chicago
© The Estate of Arthur Siegel
Page 143

"Modern Art by a Photographer," *Life*, November 20, 1950
Publication (two copies)
14 x 21 in. open
Private Collection
Reproduction photographs by John R. Glembin
© 1950 The Picture Collection Inc.
Reprinted with permission. All rights reserved.
© The Estate of Arthur Siegel
Page 144

State Street, Rainy Day, 1952
Dye imbibition print
6 3/4 x 10 3/16 in.
Gift of Arthur Siegel, 1956.1074, The Art Institute of Chicago
© The Estate of Arthur Siegel
Page 145

Laurie SIMMONS
American, b. 1949
Purple Woman / Kitchen, 1978
Silver-dye bleach print
3 1/2 x 5 in.
Laurie Simmons, Courtesy of the artist and Salon 94, New York
© Laurie Simmons, Courtesy of the artist and Salon 94, New York
Page 219

New Bathroom / Woman Kneeling/ First View, 1979
Silver-dye bleach print
3 1/2 x 5 in.
Laurie Simmons, Courtesy of the artist and Salon 94, New York
© Laurie Simmons, Courtesy of the artist and Salon 94, New York
Page 221

Neal SLAVIN
American, b. 1941
Grand Canyon National Park, National Park Service, Grand Canyon, Arizona, 1974
Chromogenic print, printed 1979
10 7/8 x 10 7/8 in.
Neal Slavin
© Neal Slavin

K & P Distributors, Inc., Sabrett Food Products Corporation, New York, New York, 1974
Chromogenic print, printed 1979
10 7/8 x 10 7/8 in.
Neal Slavin
© Neal Slavin

When Two or More Are Gathered Together, 1976
Publication (Farrar, Straus and Giroux)
9 x 21 in. open
Milwaukee Art Museum George Peckham Miller Art Research Library
Reproduction photograph by John R. Glembin
Copyright © 1974, 1975, 1976 Neal Slavin
Page 167

Eve SONNEMAN
American, b. 1946
Coney Island, 1974
Two chromogenic prints and two gelatin silver prints
4 1/2 x 6 1/2 in. each
Museum of Fine Arts, Houston;
The Target Collection of American Photography, gift of Target Stores
Permission courtesy of Nohra Haime Gallery & Eve Sonneman
Page 195

July 4, 1976, 1976
Two silver-dye bleach prints
20 x 30 in. overall
Courtesy of Nohra Haime Gallery and Eve Sonneman
Pages 196–97

Edward STEICHEN
American, b. Luxemburg, 1879–1973
Alfred Stieglitz, 1907
Autochrome facsimile
9 7/16 x 7 1/16 in.
Original in the collection of The Metropolitan Museum of Art, Alfred Stieglitz Collection, 1955 (55.635.10)
© The Metropolitan Museum of Art
Image source: Art Resources, NY
Permission courtesy of the Estate of Edward Steichen
Page 45

Katherine Stieglitz, 1907
Autochrome facsimile
6 7/16 x 4 1/16 in.
Original in the collection of The Metropolitan Museum of Art, Alfred Stieglitz Collection, 1955 (55.635.13)
© The Metropolitan Museum of Art
Image source: Art Resources, NY
Permission courtesy of the Estate of Edward Steichen
Page 45

Cover of *Vogue*, July 20, 1932
Photomechancial reproduction
12 3/4 x 9 3/4 in.
Private Collection
Reproduction photograph by John R. Glembin
Permission courtesy of the Estate of Edward Steichen
Page 47

Bouquet of Flowers – negative image,
December 8, 1939
Dye imbibition print
9 ⁵/₈ x 6 ⁵/₈ in.
Collection of George Eastman House
(Bequest of Edward Steichen by Direction
of Joanna T. Steichen)
Permission courtesy of the Estate of Edward
Steichen, Courtesy of George Eastman House,
International Museum of Photography and Film
Page 48

Bouquet of Flowers – negative image,
December 8, 1939
Dye imbibition print
9 ⁹/₁₆ x 6 ⁹/₁₆ in.
Collection of George Eastman House
(Bequest of Edward Steichen by Direction
of Joanna T. Steichen)
Permission courtesy of the Estate of Edward
Steichen, Courtesy of George Eastman House,
International Museum of Photography and Film
Page 48

Bouquet of Flowers, 1939–1940
Dye imbibition print
9 ¹/₂ x 6 ¹/₂ in.
Collection of George Eastman House
(Bequest of Edward Steichen by Direction
of Joanna T. Steichen)
Permission courtesy of the Estate of Edward
Steichen, Courtesy of George Eastman House,
International Museum of Photography and Film
Page 48

Bouquet of Flowers, 1939–1940
Dye imbibition print
9 ¹¹/₁₆ x 6 ⁵/₈ in.
Collection of George Eastman House
(Bequest of Edward Steichen by Direction
of Joanna T. Steichen)
Permission courtesy of the Estate of Edward
Steichen, Courtesy of George Eastman House,
International Museum of Photography and Film
Page 48

Bouquet of Flowers – Natural Color,
January 8, 1940
Dye imbibition print
9 ¹/₄ x 6 ³/₄ in.
Collection of George Eastman House
(Bequest of Edward Steichen by Direction
of Joanna T. Steichen)
Permission courtesy of the Estate of Edward
Steichen, Courtesy of George Eastman House,
International Museum of Photography and Film
Page 49

Bouquet of Flowers – Negative Print #4,
January 8, 1940
Dye imbibition print
9 ¹/₄ x 6 ³/₄ in.
Collection of George Eastman House
(Bequest of Edward Steichen by Direction
of Joanna T. Steichen)
Permission courtesy of the Estate of Edward
Steichen, Courtesy of George Eastman House,
International Museum of Photography and Film
Page 48

Bouquet of Flowers – Normal Print #5,
January 8, 1940
Dye imbibition print
9 ¹/₄ x 6 ³/₄ in.
Collection of George Eastman House
(Bequest of Edward Steichen by Direction
of Joanna T. Steichen)
Permission courtesy of the Estate of Edward
Steichen, Courtesy of George Eastman House,
International Museum of Photography and Film
Page 48

Bouquet of Flowers – Negative Print #5,
January 8, 1940
Dye imbibition print
9 ¹/₄ x 6 ³/₄ in.
Collection of George Eastman House
(Bequest of Edward Steichen by Direction
of Joanna T. Steichen)
Permission courtesy of the Estate of Edward
Steichen, Courtesy of George Eastman House,
International Museum of Photography and Film
Page 48

Bouquet of Flowers, January 8, 1940
Dye imbibition print
9 ⁹/₁₆ x 6 ⁵/₈ in.
Collection of George Eastman House
(Bequest of Edward Steichen by Direction
of Joanna T. Steichen)
Permission courtesy of the Estate of Edward
Steichen, Courtesy of George Eastman House,
International Museum of Photography and Film
Jacket (detail) and page 48

Joel STERNFELD
American, b. 1944

McLean, Virginia, December 1978
Chromogenic print
14 ¹³/₁₆ x 19 ¹/₈ in.
Gift of Ralph and Nancy Segall, 1995.358,
The Art Institute of Chicago
© 2012 Joel Sternfeld
Permission courtesy of the artist and Luhring
Augustine, New York
Page 213

*After a Flash Flood, Rancho Mirage,
California, July 1979*
Chromogenic print, printed 1988
15 ⁷/₈ x 20 in.
Milwaukee Art Museum,
Gift of Photography Council M1993.113
© 2012 Joel Sternfeld
Permission courtesy of the artist
and Luhring Augustine, New York
Page 215

Cato, New York, May 1980
Chromogenic print
13 ⁷/₁₆ x 17 ³/₁₆ in.
Gift of Ralph and Nancy Segall, 1995.328,
The Art Institute of Chicago
© 2012 Joel Sternfeld
Permission courtesy of the artist
and Luhring Augustine, New York
Page 214

*Wet 'n Wild Aquatic Theme Park,
Orlando, Florida, September 1980*
Chromogenic print, printed 1986
15 ¹³/₁₆ x 20 ¹/₁₆ in.
Gift of Ralph and Nancy Segall, 1995.346,
The Art Institute of Chicago
© 2012 Joel Sternfeld
Permission courtesy of the artist
and Luhring Augustine, New York
Page 211

Alfred STIEGLITZ
American, 1864–1946

Frank Eugene, 1907
Autochrome facsimile
7 ¹/₁₆ x 5 ¹/₈ in.
Original in the collection of The Metropolitan
Museum of Art, Alfred Stieglitz Collection,
1955 (55.635.18)
© 2012 Georgia O'Keeffe Museum/Artists
Rights Society (ARS), New York
Courtesy of The Metropolitan Museum
of Art, Image source: Art Resource, NY
Page 31

Frank Eugene Seated at Table, 1907
Autochrome facsimile
5 ¹/₁₆ x 7 ¹/₁₆ in.
Original in the Alfred Stieglitz Collection,
1952.311, The Art Institute of Chicago
© 2012 Georgia O'Keeffe Museum/Artists
Rights Society (ARS), New York
Page 32

Mrs. Selma Schubart, 1907
Autochrome facsimile
6 ½ x 4 ⁹/₁₆ in.
Original in the collection of The Metropolitan
Museum of Art, Alfred Stieglitz Collection,
1955 (55.635.14)
© 2012 Georgia O'Keeffe Museum/Artists
Rights Society (ARS), New York
Courtesy of The Metropolitan Museum
of Art, Image source: Art Resource, NY
Page 31

Two Men Playing Chess, 1907
Autochrome facsimile
3 ⁹/₁₆ x 4 ½ in.
Original in the collection of The Metropolitan
Museum of Art, Gilman Collection,
Purchase, Mr. and Mrs. Henry R. Kravis
Gift, 2005 (2005.100.476)
© 2012 Georgia O'Keeffe Museum/Artists
Rights Society (ARS), New York
Courtesy of The Metropolitan Museum
of Art, Image source: Art Resource, NY
Page 33

Pete TURNER
American, b. 1934
Rolling Ball, 1960
Dye imbibition print
16 ⅞ x 23 ⅛ in.
Pete Turner
© Pete Turner
Page 157

Fisherman, 1961
Dye imbibition print
14 ½ x 23 in.
Pete Turner
© Pete Turner
Page 159

John VACHON
American, 1914–1975
Lincoln, Nebraska [parked cars], 1942
[Grand Grocery Co.,] Lincoln, Neb., 1942
Negro boy near Cincinnati, Ohio, 1942 or 1943
Church near Junction City, Kansas, 1942 or 1943
Road out of Romney, West Va., 1942 or 1943
Page 99

Color transparencies converted to digital files
Library of Congress,
Prints & Photographs Division, FSA-OWI
Collection, LC-USF35-266,
LC-USF35-268, LC-USF35-276,
LC-USF35-272, LC-USF35-278

Edward WESTON
American, 1886–1958
"Edward Weston's First Serious Work
in Color," *Popular Photography*, May 1947
Publication
11 ⅛ x 16 ½ in. open
Private Collection
Reproduction photograph by John R. Glembin
Used with permission of Kodak
Image permission courtesy of Center
for Creative Photography,
© 1981 Arizona Board of Regents
Page 124

Cover of *Kodak Photo*,
June/July 1947
Publication
9 ⅜ x 6 ½ in. closed
Private Collection
Reproduction photograph by John R. Glembin
Used with permission of Kodak
Image permission courtesy of Center
for Creative Photography,
© 1981 Arizona Board of Regents
Page 123

"Test Exposures" featuring *Shell*, ca. 1947,
Fortune, July 1954
Publication
13 x 20 1/2 in. open
Private Collection
Reproduction photograph by John R. Glembin
© 1954 Time Inc. Used under license.
Page 125

"Weston's First Color Photos," *Life*,
November 25, 1957
Publication
14 x 21 in. open
Private Collection
Reproduction photograph by John R. Glembin
© 1957 The Picture Collection Inc. Reprinted
with permission. All rights reserved.
Image permission courtesy of Center for
Creative Photography, ©1981 Arizona Board
of Regents
Page 124

*The History of Photography: from 1839 to the
Present Day* by Beaumont Newhall, 1949
Publication (Museum of Modern Art,
New York)
10 ½ x 16 in. open
Milwaukee Art Museum George Peckham
Miller Art Research Library
Reproduction photograph by John R. Glembin
© 1949. The Museum of Modern Art,
New York
Licensed by SCALA/Art Resource, NY
Page 125

Marion POST WOLCOTT
American, 1910–1990
*Day laborers picking cotton near Clarksdale,
Miss.*, November 1939
*A cross roads store, bar, "juke joint," and gas
station in the cotton plantation area, Melrose, La.*,
June 1940
Boys fishing in a bayou, Schriever, La.,
June 1940
*A store with live fish for sale, vicinity
of Natchitoches, La.*, July 1940
Page 97

*Living quarters and "juke joint" for migratory
workers, a slack season; Belle Glade, Fla.*,
February 1941
Color transparencies converted to digital files
Library of Congress, Prints & Photographs
Division, FSA-OWI Collection,
LC-USF35-152, LC-USF35-113,
LC-USF35-112, LC-USF35-135,
LC-USF35-173

INDEX

CONTRIBUTORS

Katherine A. Bussard

is associate curator of photography at the Art Institute of Chicago and author of the exhibition catalog *So the Story Goes: Photographs by Tina Barney, Philip-Lorca diCorcia, Nan Goldin, Sally Mann, and Larry Sultan* (Art Institute of Chicago and Yale University Press, 2006). She has organized an ongoing series dedicated to emerging photography, as well as exhibitions such as *Film and Photo in New York* (2012) and *When Color Was New* (2007) for the Art Institute. Prior to joining the Art Institute, she worked for the J. Paul Getty Museum and the Clark Art Institute. Bussard's doctoral dissertation on street photography at the City University of New York will be revised for publication by Yale University Press in 2014. A related essay appeared in the exhibition catalog *Street Art, Street Life: From the 1950s to Now* (Aperture, 2008).

Grace Deveney

is a doctoral student in art history at Northwestern University. Deveney has practiced photography, which informs her continuing interest in a variety of lens-based practices. Her research ranges from nineteenth-century photography techniques such as the stereograph to the richly complex use of photography publications as expressions of American political thought in the 1960s and '70s.

Lisa Hostetler

is McEvoy Family Curator of Photography at the Smithsonian American Art Museum. Previously, she served as curator of photographs at the Milwaukee Art Museum, where she organized a number of exhibitions, including *Taryn Simon: Photographs and Texts* (2011), *Street Seen: The Psychological Gesture in American Photography, 1940–1959* (2010), and *Saul Leiter: In Living Color* (2006). She came to Milwaukee after several years as research associate in the Department of Photographs at the Metropolitan Museum of Art and earned her doctorate from Princeton University in 2004 with a dissertation on photographer Louis Faurer. Most recently, Hostetler was the author of the exhibition catalog for *Street Seen: The Psychological Gesture in American Photography, 1940–1959* (Prestel and Milwaukee Art Museum, 2010).

Michal Raz-Russo

received her master's in art history and arts administration from the School of the Art Institute of Chicago, completing a thesis on LIGHT Gallery, a prominent gallery that was among the first to exhibit contemporary photography exclusively in the 1970s. She curated an exhibition on this topic, *When Collecting Was New: Photographs from the Robert A. Taub Collection*, at the Art Institute of Chicago in 2012. Raz-Russo is the author of *Three Graces: Snapshots of Twentieth-century Women* (Yale University Press, 2011).

Alissa Schapiro

holds a master's degree in curatorial studies from the Courtauld Institute of Art, London, where her dissertation focused on the U.S. government's support and promotion of American art in London from the 1950s to the present, with a special emphasis placed on museum exhibition histories. She has contributed to exhibitions at the Courtauld Gallery, the Art Institute of Chicago, and Tate Britain. Schapiro recently undertook a significant research project reviewing Edward Steichen's photographic career.

ACKNOWLEDGMENTS

This project was sparked by one of those memorable conversations between colleagues when they discover a shared interest. Over time and many subsequent conversations, the spark we recognized in 2007 became *Color Rush: American Color Photography from Stieglitz to Sherman*. As with any major undertaking, this project would not have been possible without the support of other colleagues, sister institutions, dedicated collectors, and generous donors.

For making the very first pledge of support, we thank Kenneth and Christine Tanaka. We also want to express our gratitude to the Herzfeld Foundation, a longtime supporter of photography at the Milwaukee Art Museum, which has continued its steadfast commitment to photography exhibitions, acquisitions, and programs at the museum with its generous support of *Color Rush*. We are grateful for the additional support of Christine A. Symchych and James P. McNulty, the David C. and Sarajean Ruttenberg Arts Foundation, the Robert Mapplethorpe Foundation, and the museum's Photography Council.

This exhibition and catalog would not have been possible without the many wonderful objects we researched, considered, and were finally able to include thanks to the kindness of institutions and collectors. We gratefully acknowledge: Anthony Bannon, Allison Nordström, Jessica Johnston, Joe Struble, Barbara Puorro Galasso, Wataru Okada, Mark Osterman, Jesse Peers, and Jamie Allen at George Eastman House, International Museum of Photography and Film, Rochester, New York; Douglas Druick, Matthew Witkovsky, Douglas Severson, and Natasha Derrickson at the Art Institute of Chicago; Sarah Meister, Lucy Gallun, Drew Sawyer, and Tasha Lutek at the Museum of Modern Art, New York; Shawn Waldron and Gretchen Fenston at the Condé Nast Archive; Malcolm Daniel, Jeff Rosenheim, Eileen Sullivan, and Anna Wall at the Metropolitan Museum of Art, New York; Mark Jacobs; Valerie Steele, Melissa Marra, and Sonja Dinjilian at the Museum at the Fashion Institute of Technology, New York; Anne Tucker, Del Zogg, and Maggie Williams at the Museum of Fine Arts, Houston; Christine A. Symchych and James P. McNulty; Tate Shaw, Rick Hock, and Jenn Libby at the Visual Studies Workshop, Rochester, New York; Howard Farber of the Farber Collection; Mariska Neitzman at Edwynn Houk Gallery, New York; Alissa Friedman at Salon 94, New York; Anton Bruehl, Jr.; Phil Curtis and Amanda McGough of the John Baldessari studio; Marian Goodman Gallery, New York; Larry Cuba at the Iota Center, Los Angeles; James and Janet Koppenburg; Janet Borden and Matthew Whitworth at Janet Borden Gallery, New York; Margit Erb at Howard Greenberg Gallery, New York; Marvin Hoshino and the Estate of Helen Levitt; Library of Congress, Washington, D.C.; Karine Haimo at Metro Pictures, New York; Hattula Moholy-Nagy; Madeleine Grynsztejn, Jude Palmese, and Christia Blankenship at the Museum of Contemporary Art Chicago; Juliet Myers, artist assistant to Bruce Nauman; Leslie Garrett at Nohra Haime Gallery, New York; James and Dorothy Stadler; David Tippit; Stephen Daiter Gallery, Chicago; and Haley Shaw at David Zwirner, New York. We are thankful for the additional assistance regarding specific works of art provided by Jennifer Belt at Art Resource, as well as John Glembin, Angelina Pike, and Larry Smallwood.

We both remain deeply grateful to the Milwaukee Art Museum for its championing of this project from the start. The early support of Daniel T. Keegan and Brady Roberts has been invaluable to us. Every exhibition is a team effort, and we have been lucky to work with a great one at MAM. Registrar Dawn Gorman Frank worked tirelessly with us on the checklist, along with Assistant Registrar Melissa Hartley Omholt, Librarian/Archivist Heather Winter, and Rights & Reproductions Coordinator/Database Administrator Stephanie Hansen. Designer David Russick offered ideas that enhanced our curatorial vision for exhibition display. We also acknowledge the steadfast support of Vicki Scharfberg and Kristin Settle in Marketing and Communications; Mary Albrecht, Therese Palazzari, and Kathy Emery in Development; Brigid Globensky and Amy Kirschke in Education; Senior Conservator Jim DeYoung; Preparators Joe Kavanaugh, Tim Ladwig, and Chris Niver; and Audio Visual Technician Ted Brusubardis. We owe much to Brooke Mulvaney and Tina Schinabeck for seeing to countless tasks related to this exhibition, always with good cheer.

Lesley Martin, Denise Wolff, Samantha Marlow, and Matthew Harvey at Aperture demonstrated their engagement with this project time and time again. This exhibition catalog is all the better for our collaboration with them. We also acknowledge the editorial efforts of Betsy Stepina Zinn and thank Fernando Gutiérrez and Ali Esen of Studio Fernando Gutiérrez for the compelling design.

Our curatorial colleagues provided inspiration, provocation, and support. We thank Peter Barberie, Julian Cox, Sophie Hackett, Jessica MacDonald, Allison Pappas, Phillip Prodger, John Rohrbach, and Elizabeth Siegel. Interns Kate Brown, Julia Detchon, Ellen Renee Martin, and Danica Willard Sachs offered brilliant assistance with many details. Alissa Schapiro, Grace Deveney, and Michal Raz-Russo contributed to this project truly at every level, and we remain deeply grateful for their enthusiastic engagement. Finally, we acknowledge the artists, especially those who generously loaned their work to the exhibition. Without them—as always—a project like this could never be.

KATHERINE A. BUSSARD & LISA HOSTETLER

COLOR RUSH
American Color Photography from Stieglitz to Sherman
Katherine A. Bussard & Lisa Hostetler
with contributions by Alissa Schapiro, Grace Deveney, & Michal Raz-Russo

Front cover: Edward Steichen, *Bouquet of Flowers* (detail), January 8, 1940
Frontispiece: All images by Edward Steichen. Top Row: *Bouquet of Flowers—Normal Print #5*, January 8, 1940; *Bouquet of Flowers—Natural Color*, January 8, 1940; *Bouquet of Flowers*, 1939–40. Middle Row: *Bouquet of Flowers—Negative Print #4*, January 8, 1940; *Bouquet of Flowers—Negative Print #5*, January 8, 1940; *Bouquet of Flowers—Negative Image*, December 8, 1939. Bottom row: *Bouquet of Flowers*, 1939–40; *Bouquet of Flowers—Negative Image*, December 8, 1939; *Bouquet of Flowers*, January 8, 1940

Publisher: Lesley A. Martin
Editor: Denise Wolff
Editorial Assistant: Samantha Marlow
Designer: Studio Fernando Gutiérrez
Production: Matthew Harvey
Senior Text Editor: Susan Ciccotti
Copy Editor: Betsy Stepina Zinn
Production Editor: Brian Sholis
Work Scholar: Francisco Correa-Cordero

Copublished with the Milwaukee Art Museum
on the occasion of the exhibition, *COLOR RUSH: 75 Years of Color Photography in America* on view February 22 to May 19, 2013.

Compilation—including selection, placement, and order of text and images—copyright © 2013 Aperture Foundation, Inc.; "Full Spectrum: Expanding the History of American Color Photography" copyright © 2013 Katherine A. Bussard; "Real Color" copyright © 2013 Lisa Hostetler; all photographs and accompanying texts © 2013 the photographers or authors unless otherwise noted on the Exhibition Checklist, pages 256–67, or the Reproduction Credits (above right). All rights reserved under International and Pan-American Copyright Conventions. No part of this book may be reproduced in any form whatsoever without written permission from the publisher.

Reproductions in this book were made to match the prints in the exhibtion. Please see the Exhibition Checklist on pages 256–67 for details.

First edition
Printed in China
10 9 8 7 6 5 4 3 2 1

Library of Congress Cataloging-in-Publication Data

Bussard, Katherine A.
COLOR RUSH: American Color Photography from Stieglitz to Sherman
Katherine A. Bussard & Lisa Hostetler. – First edition.
Pages cm
Includes index.
Published on the occasion of an exhibition on view
Feb. 22, 2013 to May 19, 2013.
ISBN 978-1-59711-226-0 (Hardcover : Alk. paper)
1. Photography, Artistic--Exhibitions. 2. Color photography
United States--History--Exhibitions. I. Hostetler, Lisa, 1971 – II.
Milwaukee Art Museum III. Title.
TR645.M52M523 2013
778.6--dc23
2012036155

Please note that full reproduction credit and information for images in the exhibition are contained on the Exhibition Checklist on pages 256–67. Page 4: Courtesy of George Eastman House, International Museum of Photography and Film, Used with permission of Kodak; Page 7: Courtesy of George Eastman House, International Museum of Photography and Film, Used with permission of Kodak; Page 10 (top): © William Christenberry, Image courtesy of Aperture Foundation, Permission courtesy of Pace/MacGill Gallery, New York; (bottom) © Dan Graham, Image courtesy of The Art Institute of Chicago, Permission courtesy of Marian Goodman Gallery, New York; Page 36: Courtesy of Library of Congress Prints and Photographs Division; Page 44: © Estate of Edward Steichen, Image courtesy of George Eastman House, International Museum of Photography and Film; Page 52: © Nickolas Muray Photo Archives, Courtesy of George Eastman House, International Museum of Photography and Film; Page 68: Paul Outerbridge, Jr. © 2012 G. Ray Hawkins Gallery, Beverly Hills, CA; Page 88: Courtesy of George Eastman House, International Museum of Photography and Film, Used with permission of Kodak; Page 100: Digital reproduction image © The Museum of Modern Art/ Licensed by SCALA/Art Resource, NY, Reproduction photograph by Rolf Petersen; Page 114: © The Estate of Harry Callahan, Courtesy of Pace/MacGill Gallery, New York; Page 160: © Estate of Helen Levitt; Page 170: Courtesy of Leo Castelli Gallery records, Archives of American Art, Smithsonian Institute, Reproduction photograph by Rudy Burckhardt; Page 172: © The Museum of Modern Art/ Licensed by SCALA/Art Resource, NY; Page 176: © William Christenberry, Image courtesy of Aperture Foundation, Permission courtesy of Pace/MacGill Gallery, New York; Page 184: © Stephen Shore, Courtesy of 303 Gallery, New York; Page 216: © Philip-Lorca diCorcia, Courtesy of the artist and David Zwirner, New York; Page 230: © Kenneth Josephson/Higher Pictures, Image courtesy of the Art Institute of Chicago, Gift of the School of the Art Institute of Chicago, 1970.810, The Art Institute of Chicago; Page 238: © Cindy Sherman, Courtesy of the artist and Metro Pictures, New York; Pages 69, 71, 105, 117, 119, 121, 147, 152–53, 173, 177, 201, 203: Digital reproduction images © The Museum of Modern Art/Licensed by SCALA/Art Resource, NY.

Aperture Foundation books are distributed in the U.S. and Canada by:
ARTBOOK/D.A.P.
155 Sixth Avenue, 2nd Floor
New York, N.Y. 10013
Phone: (212) 627-1999
Fax: (212) 627-9484
E-mail: orders@dapinc.com
www.artbook.com

Aperture Foundation books are distributed worldwide, excluding the U.S. and Canada, by:
Thames & Hudson Ltd.
181A High Holborn, London WC1V 7QX
United Kingdom
Phone: +44 (0)20 7845 5000
Fax: +44 (0)20 7845 5055
E-mail: sales@thameshudson.co.uk
www.thamesandhudson.com

aperture

Aperture Foundation
547 West 27th Street
New York, N.Y. 10001
www.aperture.org

Aperture, a not-for-profit foundation, connects the photo community and its audiences with the most inspiring work, the sharpest ideas, and with each other—in print, in person, and online.